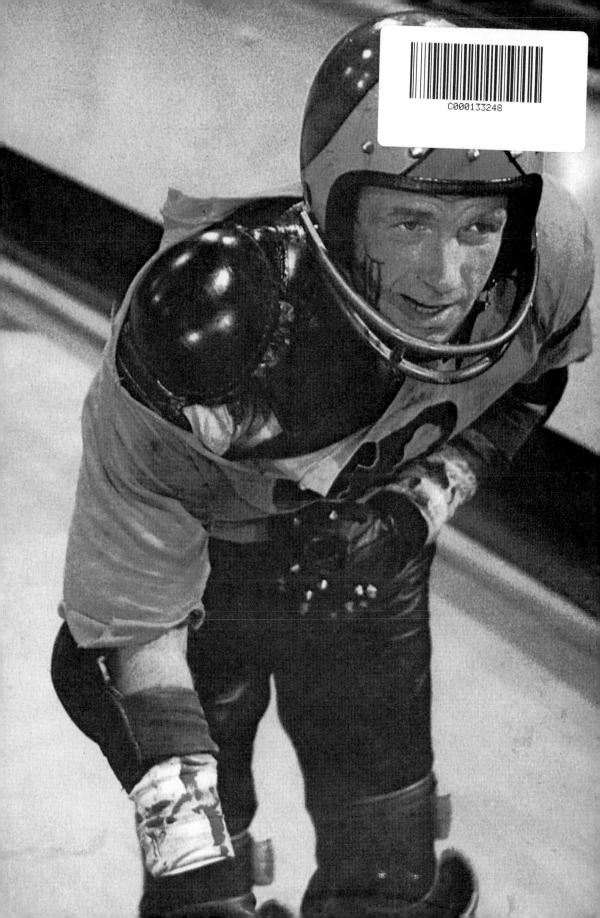

UNRULY PLEASURES
The Cult Film and its Critics

First edition published May 2000
by FAB Press

FAB Press
PO Box 178
Guildford
Surrey
GU3 2YU
England, U.K.
(www.fabpress.com)

Front cover illustration:
From Dusk Till Dawn
Back cover illustrations:
top: *Showgirls* (picture credit: Murray Close)
bottom: *The Exorcist*
Frontispiece:
Rollerball

A CIP catalogue record for this book is available from the British Library

ISBN 1 903254 00 0

the editors

Graeme Harper is the Director of the Development Centre for the Creative and Performing Arts
at the University of Wales at Bangor. He lectures in English and Film Studies and is the general
editor of the journal 'Unscene Film: New Directions in Screen Criticism'.

Xavier Mendik is a Lecturer in Media and Popular Culture at University College Northampton.
His research interests focus on the application of psychoanalysis to cult cinema. He is general
editor of the journal 'Unscene Film: New Directions in Screen Criticism'.

UNRULY PLEASURES

The Cult Film
and its Critics

edited by
Xavier Mendik
and
Graeme Harper

A FAB
PRESS
PUBLICATION

acknowledgements

The editors wish to sincerely thank the fourteen writers for their work in contributing to this volume. We also thank colleagues at University of Wales, Bangor and University College Northampton for their support and encouragement.

For all his support and dedication to the Unruly Pleasures project we give our sincere thanks to Harvey Fenton of FAB Press.

Special thanks to Adrian Luther-Smith and Stephen Thrower for their invaluable contributions.

For the sourcing of rare images we thank: Andy Black, Mitch Davis, Kim Dubuisson, Harvey Fenton, Adrian Luther-Smith, Gary Needham, Bill Osgerby, Jonathan Rayner and Stephen Thrower.

Picture Credits: Allied Troma Ltd., Astra, Atlantis, BFI Stills, Posters and Designs, Century 21 Publishing Ltd., City Magazines Ltd., Murray Close (199 (top)), Columbia-Tristar Home Video, Columbia-Warner Distributors, Entertainment, Fantastic Pictures, Fida International Films, Fine Line Features, Focus Film Distributors, Fox-Rank Distributors, Fulvia Film S.r.l. (Rome), Gentlemen's Video, Hammer Films, Image Ten Inc., ITC Entertainment Group Limited, Douglas Kirkland (188), Kobal Collection, London Postcard Company, Mary Ellen Mark (190, 192, 196, 197, 200, 199 (bottom)), Metro, MGM Home Entertainment Inc., Miramax Buena Vista, Modern Films, PolyGram Licensing International, Ronald Grant Archive, Russ Meyer (RM Film International), Shaw Brothers, Target International Pictures, Touchstone Pictures, Towa, Tristar Pictures, Twentieth Century Fox, United Artists Corporation, Video Film Promotions, VTC plc, Warner Bros., Warner Home Video (UK) Ltd., Wingnut Films, Doris Wishman (JURI Productions)

An earlier version of Barry Keith Grant's article "Second Thoughts on Double Features: Revisiting the Cult Film" appeared under the title "Science Fiction Double Feature: Ideology in the Cult Film", in J.P. Telotte (ed), *The Cult Film Experience: Beyond All Reason* (1981). This version is reproduced by kind permission of the publisher, University of Texas Press.

This volume is dedicated to cult cinema makers and cult cinema audiences everywhere.

contents

Introduction

Several Theorists Ask
"How Was it For You Honey?"
Or Why the Academy Needs Cult Cinema
and its Fans.

Graeme Harper and Xavier Mendik

No one is going to deny it: there's a difference between having an orgasm and just having a pretty good time. This too is the essential difference between a film that achieves cult status and one that is simply popular. The cult film draws on a (hard)core of audience interest and involvement which is not just the result of random, directionless entertainment-seeking, but rather a combination of intense physical and emotional involvement. Such stimulation is more than pleasurable, it's orgasmic! The effect it produces is not merely an affectionate attachment to the text, but a ritualistic form of near obsession. Here, the dialogue of the cult narrative must be remembered and recited correctly, the desired affiliation to the film has to be demonstrated by an in-depth knowledge of the film's crucial scenes. Indeed, just as sexual obsessions have their fetishes and perversions, the cult movie has its imitation, garter-clad Dr. Frank N. Furters, its Star Trek wannabees and its convention-attending Captain Scarlets.

The orgasm is a subject that is often seen as both taboo and unfathomable. Certainly in academic film circles, the question of what constitutes the 'orgasmic' has only really entered the realm of film criticism via gender studies and psychoanalysis - and even then, enough has not yet been done to bridge the gap between what can be defined as intense or even violent excitement (the orgasmic feeling of the cult film fan) and the cerebral pleasures of the theoretical approach. By and large, there has been a separation of cultures. On the one hand, film fans who know what films they afford cult status to, and who talk about them in an informed manner brought about by many hours of watching and discussion. On the other hand, film critics who analyse the interests of this audience and the films it enjoys and draw their conclusions about both.

The first group uses commonsensical and experiential evidence (the evidence of their own experiences) to talk about a cult film. The second group largely uses theoretical models and holistic analysis to do the same job. Neither group benefits by being separated from the other. Both have something to offer. *Unruly Pleasures: The Cult Film and its Critics* brings together fifteen articles which consider the varieties, styles, experiences and attitudes of the cult film. The approaches are varied and distinctive, but each sets out to build a bridge between the cult film fan and the cult film theorist. This volume presents a series of individual interpretations/definitions of various cult film movies and cycles, with the specific nature of these accounts being outlined by each writer in an introduction to their chapters. However, the debates raised by these critics can be extended to the cult movie concept as a whole. Specific questions that this volume addresses include how certain movies come to be ascribed with 'cult' status, how such texts are constructed (and indeed deconstructed) by different user-groups and what possible social, cultural and gender significance we can attach to them.

Many of these central questions around the nature of cult cinema are examined by Barry Keith Grant in his article 'Second Thoughts on Double Features: Revisiting the Cult Film'. Here, he considers the generic construction of the cult film, its reception by movie fans and its place within wider systems of ideology and social belief. Grant demonstrates the social ability of the cult movie to both subvert and maintain the status quo through his concept of the 'double feature'. He notes that cult movies such as *The Rocky Horror Picture Show* (1975) frequently trade on images of 'Otherness' or social, sexual or racial deviancy which are presented in an unconventional, anti-authoritarian and ultimately appealing light. In the case of *The Rocky Horror Picture Show*, this function is fulfilled by the razor witted, gender-bending Dr. Frank N. Furter, whose depiction easily eclipses that of the 'normal' folk who fall under his control. It is Frank N. Furter's transgressive appeal as well as the film's connection with outrageous acts of audience behaviour in midnight screenings (the once favoured mode of cult film consumption) that have assured *The Rocky Horror Picture Show* its 'progressive' status. While not denying the narrative's 'unruly' pleasures, Grant also notes that the 'double feature' frequently recuperates/punishes/rejects the Other in its closing scenes, thus pointing to a complex negotiation of power and ideology in the cult movie.

Some of the issues of social/sexual contradiction that Grant raises are also pursued in Tanya Krzywinska's chapter 'The Dynamics of Squirting: Female Ejaculation and Lactation in Hardcore Film'. Here, we see the use of psychoanalytical theory to approach specialist fetish films. Krzywinska also draws on cultural representations, specific instances of art showing the lactating breast, in order to present her analysis within a historical context. Her combination of cultural interpretation and psychoanalysis brings us closer to the reasoning behind the production and consumption of these specialist films. This chapter, of course, is closest to the notion of the cult film's orgasmic appeal!

While issues of sexuality (and its control) dominate Krzywinska's article, it is social control which concerns C. Paul Sellors in his chapter 'On the Impossibility of "Once Upon a Time..." in *Rollerball*'. One of the key cult films of the 1970s, *Rollerball* (1975) is a combination of dystopian parable and sports flick which adds up to a fast moving action romp. James Caan, playing Jonathan E., shows the same ability to mould himself to sport, technology and the corporate cause that he did in the speedway film *Red Line 7000* (1965), an ability Arnold Schwarzenegger would flaunt in the 1980s. Sellors picks up Jonathan E.'s realisation that the Machine (corporate and otherwise) has grown bigger than the Man to look at the relationship between corporate control and the politics of the 1970s, linking this to the spate of disaster films released during the period and to a discussion of futuristic films with dystopian themes. The point the cult status of *Rollerball* makes, and that Sellors investigates, is that American anxiety about the future was founded on the real disasters of American politics in the 1970s.

Whereas many of the contributors to *Unruly Pleasures* draw on psychoanalysis or cultural studies in their consideration of cult cinema, Michael Grant explores this area with the use of literary theory. In his article 'Fulci's Waste Land: Cinema, Horror and the Dreams of Modernism', Grant explores the depictions of time, space and mortality in Lucio Fulci's *The Beyond* (1981). Here he makes a comparison between this Italian cult horror film and certain narrative features found in modernist literature. Despite the critical rejection of *The Beyond* at the time of its release, Grant argues that the film's apparently incohesive narrative should not necessarily be read as a creative failing, but rather an extension of the tactics used by writers such as T.S. Eliot. Specifically, Grant argues that the film shares modernist literature's aim to produce art which doubles back on itself and examines its own construction in a complex, self-reflexive fashion. In Eliot's work, the creation of often confusing and illogical passages points to an ambivalent construction of depicted time, a feature which the author argues is itself replicated in the finale of Fulci's film. By comparing *The Beyond* not only to literary theory but also to more celebrated examples of horror cinema such as Carl Theodor Dreyer's *Vampyr* (1931), Grant makes a persuasive case for critically re-evaluating this marginal cult film classic.

introduction

As with several other chapters in the volume, Leon Hunt's 'Han's Island Revisited: *Enter the Dragon* as Transnational Cult Film' focuses on Seventies cinema; in this case, the impact of Hong Kong action films on Western audiences. Hunt outlines the ways in which the traditions of Hong Kong cinema met the demands of the Hollywood market and how actors like Bruce Lee were able to draw on the 'comic book' interests of these audiences. Hunt points out that Seventies politics likewise had a great impact on the reception of these films, along with the acceptance of an Eastern 'consciousness' by post-60s counterculture fans. Kung-fu, as both self-defence and 'philosophy' fed a number of Western appetites, not least of which was the hunger to see the 'yellow man' perform in the captivity of Hollywood entertainment.

In his article 'A Lust for Life' Jonathan Crane considers that most comical of softcore porn pioneers: Russ Meyer. Crane argues that Meyer's work, with its detailed attention to a unique style of editing, camera operation and cinematography, allows the director the dual status of maverick entrepreneur *and* cult movie icon. Crane argues that the cult movie is defined by a systematic departure from the rules and regulations of mainstream movie making. In the case of Meyer's cinema, this subversion can be seen as occurring in his parodic depiction of male and female sexuality. Meyer's cinema upturns dominant male fantasies by polarising desire between gargantuan, insatiable females and impotent and inarticulate males. While Tanya Krzywinska turns to psycho-analysis to comprehend the representations of female sexuality in hardcore porn, for Crane, Meyer's 'world view' is born out of historical conditions. (These relate to the strident images of male and female identity which dominated the American home front and propaganda machine during the second world war).

As with the other contributors to *Unruly Pleasures*, Mikita Brottman links cult cinema to the issue of transgression in her chapter 'Star Cults/Cult Stars: Cinema, Psychosis, Celebrity, Death.' However, the focus of her discussion is not a 'deviation' in genre or film style but rather in the cult film's construction of its star actor/performer. Here, Brottman considers how the status of a star in decline, or one whose life is ended by an accident (either on or off-set), can secure a particular cult status for their work. The issue has relevance in assessing the complex ways in which cult film fans identify with the doomed performer. Indeed, the relevance of Brottman's investigations was recently underscored in Tim Burton's movie *Ed Wood* (1994). Here, the depiction of Bela Lugosi's pitiful decline provides an example of what Brottman would define as the 'celebrity death rattle'. This effect is seen in the inability of certain stars to fully recognise their own deteriorating status, a phenomenon which the author considers in a series of case studies. Alongside this category of faded star, Brottman also considers both *Rebel Without a Cause* (1955) and *The Misfits* (1960) as examples of how intimations of impending death can be read into the final performances of stars such as James Dean and Marilyn Monroe.

In his chapter "Stand-By For Action!", Bill Osgerby adopts a historical analysis to consider the cult success of Gerry Anderson's 'Supermarionation' series' such as *Thunderbirds* and *Captain Scarlet and the Mysterons*. Although these productions began life in a television format, Osgerby charts the transition of such shows into cinema productions such as *Thunderbirds Are Go* (1966) and *Thunderbird Six* (1968). While the comparative failure of such cinema adaptations reveals the way in which cult appeal can be lost by alterations in format (and audience), Osgerby argues that both Anderson's film and television work remain relevant as a reflection of the shifting historical and cultural moods of the 1960s. In particular, he notes that *Thunderbirds* very much feeds into the consensus view of British society promoted by governments of the era. With its emphasis on hi-tech gadgetry employed for humanitarian purposes by merito-cratic organisations, Anderson's narrative can be seen as reflecting Harold Wilson's famous call for the use of technology in the creation of a classless society. If the *Thunderbirds* narratives do present the image of a community drained of social tensions, then this feel-good factor is enhanced by its near psychedelic inclusion of 60s pop iconography. (Osgerby even refers to Lady Penelope as a 'sixties pop feminist', whose construction lies at a mid-point between Modesty Blaise and Mary Quant). However, as if to underline the

historical analysis employed by the author, it is noticeable that later Anderson productions begin to jettison their social optimism as the social mood of the era begins to falter.

Victor Sage's chapter, focussing largely on David Cronenberg's *Crash* (1996) and *Shivers* (1975), considers the way in which perverse logic and imaginary perversion work in these films and in the books *The Atrocity Exhibition* (1970) and *Crash* (1973) by J. G. Ballard, and are considered in the theoretical work *The Transparency of Evil* (1993) by Jean Baudrillard. The point is an important one because it locates the interests of these two cult films in the context of what Sage sees as a 'vortex' of taboo. What we expect in these films, he suggests, is so much further extended by what we actually receive. Therefore our response is similarly extended and made more significant.

Elena Gorfinkel's article 'The Body as Apparatus: Chesty Morgan Takes on the Academy' considers the buxotic creation of the exploitation director Doris Wishman. Although Wishman worked in a genre dominated by men, Gorfinkel rejects the view that her films reproduced the female body as a site of visual spectacle for male grind-house audiences. Gorkfinkel turns to psychoanalysis to consider the framing of the female body in Wishman's film *Double Agent 73* (1974). Specifically, she notes how the film's excessive attention to Chesty Morgan's breasts often threaten to overwhelm the limits of the film frame (and the spectator's position beyond). In so doing, it can be argued that the movie displaces the secure, distanced voyeurism implicit in the male Oedipal wish to scrutinize the female body. Gorfinkel concludes that *Double Agent 73* charts a regression to the realm of the pre-Oedipal, dominated by fantastical (and frequently monstrous) images of maternal power.

Although the focus of Julian Hoxter's chapter is the famed 70s cult movie, *The Exorcist* (1973), his approach is based on contemporary rather than historical analysis. Hoxter looks at the role of fan websites in maintaining contact between fans of *The Exorcist* and at the style and character of these sites. 'Taking Possession: Cult Learning in *The Exorcist*' examines the ways in which fan power and the reputation of a film are built up using web resources and internet contact. Hoxter concludes that cult film fandom involves 'taking possession' of a film, controlling the acquisition of knowledge and shaping debates about the film. Hoxter argues that this is a way of effecting a containment, making it possible to cope with material which otherwise would threaten or traumatise the audience. In other words, the film becomes a way of 'making safe' experiences which might otherwise be factual rather than fictional.

Issues of fandom that relate to cult movies are further explored by I.Q. Hunter in his chapter 'Beaver Las Vegas! A Fan Boy's Defence of *Showgirls*'. Here, he argues that Paul Verhoeven's controversial lap-dance melodrama remains unruly, despite having fallen, for most viewers, into the cult category defined by perceived technical and stylistic incompetency. (Hunter even draws on definitions of the movie as 'Plan Nine From Las Vegas'). By examining the film's derided status, the author not only points to its possible merits as a self-referential, ironic example of postmodern cinema but also suggests how the film can be read as an extension of Verhoeven's ability to play up Hollywood conventions. What remains central to the film's passage from big budget calamity to cult viewing is the way in which fans reappropriated the film in both gay and male heterosexual contexts. While the active processes of fan activity add a crucial dimension to Hunter's analysis, the relevance of his explanation is assisted by a series of important comparisons he makes between the activities of the cult film fan and cult academic writer.

While it is the issue of cult appropriation by fans that is central to I.Q. Hunter's work, it is the formation of cult(ural) myths around certain marginal films that dominates Julian Petley's chapter "Snuffed Out": Nightmares in a Trading Standards Officer's Brain'. Petley analyses the cultural myths that have developed around the notion of 'snuff films', and he uses the evidence of media reports to make a case for consideration of just why moral panics have

been generated so readily around the snuff film concept, despite compelling evidence against their actual existence. Petley shows that, in the absence of any material examples, the spectre of the snuff film has been exploited by pro-censorship campaigners and, in Britain, by those committed to limiting the private activities of citizens. The argument is persuasive, and links to wider arguments about excessive media control by government, and the rights of film fans to view the films they want within the privacy of their homes. The case is open, of course, and reports of new discoveries of 'authentic' snuff, even as we write, keep the debate alive. The strength of the mythology surrounding the issue, nevertheless, remains largely useful as a social control mechanism.

In the chapter 'The Cult Film, Roger Corman and *The Cars That Ate Paris*' Jonathan Rayner makes links between some notable film franchises (American car culture films, Gothic Horror and the Western) and Peter Weir's 1970s bizarro tale of small town Australian life. In the same way that J.G. Ballard's novel *Crash* pushes the boundaries of car fanaticism into the arena of sexual transgression, or David Cronenberg's film *eXistenZ* locates the search for the 'big thrill' in an obsession with the technological sophistication of computer games, so Weir's film combines the technologies of the car with transgressive dealings with mind and body. Crashing in the town of Paris is actually no great feat; the townspeople stage accidents like theatrical geniuses. But Rayner's point is that this film, with its iconic 1970s consumerism and moral ambiguity, has the sensibility of the counter-culture, the same kind of sensibility that ignites the interests of cult film fans everywhere. *The Cars That Ate Paris* is a film that achieves cult status, not simply with satire and violence, but with an oblique rethink of what the technology of the car truly means to all of us.

While many of the theorists in *Unruly Pleasures* focus on a single narrative or director, Xavier Mendik and Graeme Harper discuss the cult significance of a specific scene in this volume's final chapter. Here, they consider the transition sequence in Robert Rodriguez's road movie/horror hybrid *From Dusk Till Dawn* (1996). Acknowledging the film's postmodern status as a parodic and self-referential narrative, the authors turn to the work of the Marquis de Sade to consider how issues of audience engagement with multi-layered, open-ended texts result in a dual liberation of body and mind. While Sade's work is dominated by controversial and complex vignettes which challenge both the moral values and narrative sensibilities of his readers, Rodriguez presents a movie which suddenly shifts from being an essentially closed, exploratory (singular) genre piece to one where a number of different cycles collide in an appeal to the depicted and viewing audiences. Sade's literature presents a carefully constructed network of immorality and violence, frequently orchestrated by the brilliantly perverse libertines who populate these works. In *From Dusk Till Dawn*, this role is replicated by Quentin Tarantino's casting as a compelling yet obscene point of audience identification in the film's opening scenes. By analysing both the structure and the film's transitional sequence as well as fan responses to such narrative transgressions, Mendik and Harper point to a Sadean impulse as underpinning many contemporary cult film productions.

By linking the cult movie with the uncontrollable force of the orgasm, this volume views the cult text as a potentially subversive medium. For many psychoanalysts and cultural theorists, extreme states of 'enjoyment' (sexual or otherwise) constitute infrequent and tantalising sources of gratification which continually drive us through otherwise mundane sets of social and emotional encounters. It is this search for the unforgettable cinematic 'thrill' that likewise drives the cult film fan. As with the 'ultimate' orgasm, the cult movie represents an unforgettable experience that remains imprinted on the cinematic thrill-seeker's imagination many years after the encounter. While the cult movie can take many generic forms, its depictions are frequently aligned (as with the orgasm) to excessive, dangerous and even distasteful types of display, which impress themselves on their audience as distinct from the viewing patterns that make up our everyday cinema consumption. While it remains impossible to provide a sufficiently detailed *critical* analysis of every major type of cult movie within one volume, we intend *Unruly Pleasures* to open up a crucial debate on this important and still under-theorised aspect of cinema.

Barry Keith Grant

I have approached cult films from the perspective of genre in order to determine what, if any, common features they may have. Although cult movies come from numerous traditional genres, I argue that it is nonetheless still profitable for us to conceive of the cult film generically, although the cult film genre must be conceived of broadly, not only in textual terms but in what J.P. Telotte, after John Cawelti, calls its supertext.

Exhibition, distribution and of course reception are crucial to any conception of 'the cult film.' Because cult films, by common definition, involve some intense devotion on the part of their audiences (this 'devotion' is manifested in different ways) the genre is more than merely a corpus of texts.

Yet these movies, despite their apparent diversity of genre, style or subject, must be linked in some fundamental ways, at the level in which they structure experience and pleasure for viewers. I argue that cult movies tend to feature ideological strategies by which viewers experience some form of cultural transgression but are ultimately safely recuperated.

Implicit in my argument is that cult movies are conservative texts, particularly heightened or more devious instances of ideological control than classic genre films, which do essentially the same thing. My analysis attempts to be inclusive, considering cult films both old and new, classics and midnight movies, balanced by close textual analysis of specific cult movies. It is my hope that this essay will provide assistance to subsequent scholars looking further into the relationship between cult movies and genre.

Biographical note: Barry Keith Grant is Professor of Film and Popular Culture at Brock University, Ontario, Canada. He is the author or editor of ten books, including *Documenting the Documentary: Close Readings of Documentary Film and Video* (1998, co-edited with Jeannette Sloniowski), *The Dread of Difference: Gender and the Horror Film* (1996), *Film Genre Reader II* (1995), and *Voyages of Discovery: The Cinema of Frederick Wiseman* (1992). His writing has appeared in such journals as *Post Script, Film Quarterly, Journal of Film and Video, Journal of Popular Film and Television, Wide Angle* and *Film/Literature Quarterly* and a number of anthologies.

Second Thoughts on Double Features: Revisiting the Cult Film

Barry Keith Grant

Cult Film Theory....The Sequel!

About a decade ago, I examined the cult film, by definition an intensely popular yet at the same time surprisingly under theorized category of cinema, in considerable detail.[1] In what follows I want to revisit my argument in that essay, testing its premises with some more recent cult movies which have been released since the original essay was published. In the last decade, cinema has undergone a period of significant change in exhibition patterns and the introduction of new home viewing formats. As a result it is fitting to return to the topic of cult films at this point.

The present title may be somewhat misleading since I do not contradict or seriously modify my previous argument. In the earlier essay I suggested that the category of cult movies might usefully be analysed from the perspective of genre, and I want to retain that approach here. As I argued then, despite their surface differences of iconography and conventions many cult films share a common deep structure. In reference to the opening of *The Rocky Horror Picture Show* (1975), I discussed the particular ideological nature of cult movies as a 'double feature,' a frequent textual doublethink that allows them to be transgressive in some way yet ultimately or even simultaneously to be recuperative as well.

I began by noting that the term 'cult' tends to be used rather loosely to describe a variety of films, both new and old, that are now extremely popular and/or have had a particularly devoted audience. The Oxford English Dictionary defines 'cult' as "worship; reverential homage rendered to a divine being or beings." In the case of cult movies, the 'divinity' is the shimmering series of images cast on the screen which our devoted attention lifts above the realm of the merely representational and secular. With cult movies like *Rocky Horror*, where audience participation was first accepted and then ritualized until it became at least as much an attraction as the film itself, the term fits the other two definitions. Firstly, "A particular form or system of religious worship; esp. in reference to its external rites and ceremonies," and secondly "Devotion or homage to a particular person or thing, now esp. as paid by a body of professed adherents or admirers."

The rapt attention of Woody Allen in *Play it Again, Sam* (1972), his face bathed in the beatific light of the movie screen as he reverently mouths Bogie's final speech to Ingrid Bergman in *Casablanca* (1942), is the perfect cinematic expression of this ritualized cult devotion. To a significant extent, it is this very junction between the text and the repeated experience of watching it that distinguishes the site of the cult movie from that of the merely popular film. J.P. Telotte has observed that the close relation between the cult film as a text

1 Barry Keith Grant, 'Science Fiction Double Feature: Ideology in the Cult Film', in *The Cult Film Experience: Beyond All Reason*, ed. J.P. Telotte (Austin: University of Texas Press, 1991), pp. 122-37.

and as an experience allows us to conceive of both aspects together as what he calls the cult "supertext." Unlike John Cawelti, for whom a generic supertext is more like a platonic ideal, Telotte defines the supertext of the cult movie as a combination of text, reception and "a set of industrial practices divorced from a specific film's creation."[2] This feature helpfully distinguishes the cult film from more traditional, conventionally defined genres.

Genre categorization by consumers and critics alike functions perfectly well by pragmatic consensus. Westerns, for example, are over determined by their physical and temporal settings: they must be set in the West, between the Mississippi River and California, usually between 1865 and 1890. If a film is thus set, most of us would call it a Western, no matter what other generic affiliations it also may have; but if it is not set within this time and place, if may still be a Western, but not necessarily. The musical, too, which unlike the western may be set in any time or place, from Ernst Lubitsch's mythical pre-war Europe to the contemporary ghetto of *West Side Story* (1961), is nonetheless readily identifiable, since if a movie contains several instances of song and dance within its diegetic world it is necessarily a musical. The generic categorization of films that do not strictly meet these criteria: *Mighty Joe Young* (1949) and *Junior Bonner* (1972) in relation to the Western, say, or *American Graffiti* (1973) and *Zero Patience* (1994) to the musical, become a matter for critical debate, as they should be. (It is just such debate that keeps the discourse on film genre vital and relevant, after all).

Cult films, by contrast, can come from any of the established genres. Some Westerns are cult (*Johnny Guitar*, 1954; *Man of the West*, 1958), as are some musicals (*The Wizard of Oz*, 1939; *The Harder They Come*, 1973). Many movies commonly said to have cult status are horror films, science fiction, and film noir: *Invasion of the Body Snatchers* (1956), *2001: A Space Odyssey* (1968), and *Detour* (1946), for example. Cult movies can also modify classic generic forms, as *King of Hearts* (1966) does to the war film; mix genres, as *Pulp Fiction* (1994) does with crime films, romantic comedy and film noir; or even defy generic category, like David Lynch's surreal *Eraserhead* (1978).

Perhaps this is why, unlike the case with the more traditional genres, there is no clear critical consensus on the cult film corpus. In their respective books on cult movies, for example, J. Hoberman and Jonathan Rosenbaum call *The Cabinet of Dr. Caligari* (1919) "the cult film par excellence," while Danny Peary nowhere even mentions it.[3] Timothy Corrigan considers *Veronika Voss* (1982) and *After Hours* (1985) to be cult movies, but these choices are by no means uncontentious. As Telotte observes, "The cult film simply transgresses even the boundaries we usually associate with the very notion of genre."[4]

Content, Style and Cult Film Transgression

In an attempt to move beyond this problem, several writers have looked to the ideological dynamic of cult films, emphasizing their apparent transgressiveness. This transgression can manifest itself in terms of subject matter, as with the physical 'difference' of *Freaks* (1932). Or it can be present in terms of attitude, as in the cheerful embrace of an aesthetic of the ugly (or perhaps simply the tacky) in *Pink Flamingos* (1973). Transgression can also operate at the level of style, as in Alejandro Jodorowsky's cinema-of-cruelty approach in *El Topo* (1973) or the industrial anti-narrative imagery of *Tetsuo: The Iron Man* (1989); whether the kinetic visual pyrotechnics of the *Mad Max* movies or, oppositely, the deadpan long takes of *Gummo* (1998).

Some cult films are transgressive insofar as they are very 'badly' made by traditional cinematic standards. Only such aesthetic transgression could explain the cult appeal of unhorrifying (nay, boring) spoof horror films like *Attack of the Killer Tomatoes* (1980) and unconvincing anti-drug propaganda movies such as *Reefer Madness* (1936), which claims that smoking marijuana

[2] J.P. Telotte, 'Beyond All Reason: The Nature of the Cult', in *The Cult Film Experience*, p. 8.

[3] J. Hoberman and Jonathan Rosenbaum, *Midnight Movies* (New York: Harper, 1983), p.23; Danny Peary, *Cult Movies* (New York: Delta, 1981).

[4] Timothy Corrigan, 'Film and the Culture of the Cult', and Telotte, 'Beyond All Reason', in *The Cult Film Experience*, pp. 36 and 6, respectively.

Eraserhead

leads to addiction, rape, murder, and insanity. Frank Capra's *Why We Fight* series of World War II films (1942-45), which are just as sensationalist and which had a large audience of soldiers that one might argue qualifies them as cult, are in fact not cult since they are slickly made and have proven their ability to persuade audiences.

By contrast, the films of Edward D. Wood, Jr., widely acknowledged as one of the worst filmmakers of all time, are cult because they transgress even basic levels of technical competency. Wood's lurid 1952 transvestite movie, *Glen or Glenda* (aka *I Changed My Sex*), is cult partly because of the 'sensationalist' nature of its subject but, more important, because it is so ludicrously inept as a documentary. Similarly, Wood's 1959 effort *Plan 9 From Outer Space* is a cult favourite (having spawned a legion of devoted fans and T-shirts) because it is so obviously awful in the context of the well-made classical narrative film.

To champion such an obviously ineptly constructed film is an act of cultural resistance in so far it is in opposition to established cultural values. As Susan Sontag says of camp, the poorly made cult film "asserts that good taste is not simply good taste; that there exists, indeed, a good taste of bad taste."[5] John Waters' *Pink Flamingos* ends with Divine eating (apparently real) dog faeces in close-up, thus providing the essential image of the cult movie as bad taste!

5 Susan Sontag, 'Notes on Camp', in *Against Interpretation* (New York: Delta, 1966), p. 290.

unruly pleasures

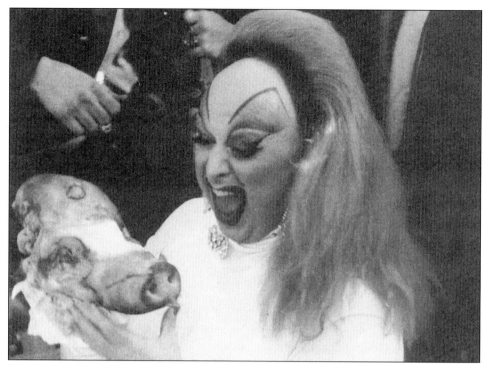

Pink Flamingos

Second Thoughts on Double Features

Supertextual transgression also exists at the level of exhibition. If Waters' films since *Hairspray* (1988) have not achieved the cult status of *Pink Flamingos* and *Female Trouble* (1974), it may be because, unlike these early movies, they were released as mainstream movies with a PG rating. The transgression of exhibition applies especially to the phenomenon of 'midnight movies,' for such screenings by definition go against the logic of traditional 'prime-time' exhibition. There was a time, not too long ago, when attending a film screening at midnight was in itself something of a transgressive act. This was because law-abiding, responsible folk were usually home, tucked safely in bed, by that hour. While most midnight venues have ceased, largely because of the demise of repertory and alternative cinemas as a result of home video, the practice continues in such guises as the 'Midnight Madness' series of potential cult movies screened every year as part of the Toronto Film Festival.

Transgression and Recuperation: Ideology in Cult Cinema

In my original essay I went on to argue that while it may be true that cult films commonly seem to offer some form of transgression, many of them also share an ability to be at once transgressive and recuperative. These are films which reclaim that which they seem to violate. They tend to achieve this ideological manipulation through a particular inflection of the figure of the Other. This figure which, while of course present in and fundamental to several genres, becomes in the cult film a prominent caricature that makes what it represents less threatening to the viewer. This caricature takes many forms, from the hysterical gays of *La Cage aux Folles* (1978) to the nerdy 'normal' folk of Todd Solondz's films (*Welcome to the Dollhouse*, 1996; *Happiness*, 1998).

In the course of championing Russ Meyer as the great American filmmaker of the Seventies, Leslie Fiedler noted that for all the depiction of blood and death in the cult movie *Beyond the Valley of the Dolls* (1970), "one leaves the theatre feeling exhilarated, amused-assured at the level of absolute childlike credence that nowhere is blood or death real."[6] This tendency toward caricature may be essential to the cult film, making an otherwise bitter pill somewhat easier to swallow. As is the case in classic genre films, cult movie viewers also gain the double satisfaction of both rejecting dominant cultural values and remaining safely inscribed within them. The difference, though, is that the supertextual aspect is more crucially involved in this ideological dynamic than in the classic genre film.

My analysis of four cult films: *Night of the Living Dead*, *The Rocky Horror Picture Show*, *La Cage aux Folles* and *The Gods Must Be Crazy* (1981), each coming from different generic traditions, revealed that all of them nonetheless share this representational strategy. All four present a conflict between the normal and the Other by making a clownish spectacle - of caricaturing - the normal while minimizing the threat of the Other. Although writer-director George A. Romero would foreground the humour more in his subsequent *Dawn of the Dead* (1978), even *Night of the Living Dead* lapses into this approach in its broad treatment of the characters (the selfish Harry Cooper and the redneck sheriff). Equally, the film's representation of the 'establishment' and its scenes of the disorganized and dissembling military and government have been described by R.H.W. Dillard as seeming "left over from a Marx Brothers movie."[7]

Dr. Frank N. Furter's Double Feature

The Rocky Horror Picture Show, as another example, is a fundamentally ambiguous text that can comfortably accommodate opposed readings. Because of its well-known phenomenon of audience participation, the movie also is perhaps the clearest demonstration of the cult film's supertextual significance. A pastiche of generic elements from horror, science fiction, and musicals, *Rocky Horror* fits perfectly Umberto Eco's definition of the cult film as collage.[8] Indeed, the film's collage-like construction is signalled immedi-

[6] Leslie Fiedler, 'Beyond the Valley of the Dolls', *American Journal* I, no. 5 (April 10, 1973), p. 5.

[7] R.H.W. Dillard, *Horror Movies* (New York: Simon & Schuster, 1976), p. 80.

[8] Umberto Eco, 'Casablanca: Cult Movies and Intertextual Collage', *SubStance* 47, no. 2 (1985), pp. 3-12.

ately in the opening credit sequence. This features a close-up of a pair of lips singing "Science Fiction Double Feature," a song with lyrics that allude to many classic science fiction movies. But *Rocky Horror* seems to diverge significantly from the classic genre films it pastiches.

Unlike classic horror and monster movies, but similar to the "progressive" horror films of the 1960s and 70s,[9] *Rocky Horror* reverses the conventional appearance and sexual significance of the monster in relation to the normal. Here the eponymous creature is a good-looking hunk of a guy, while the 'normal' couple, Brad Majors and Janet Weiss (Barry Bostwick and Susan Sarandon), are depicted as stereotypes of repression. Dr. Frank N. Furter (Tim Curry in black garter-belt, stockings, and heavy, sensuous make-up) is at once the standard over-reaching scientist figure and alternate monster. As his name crudely suggests, this character threatens to overwhelm the normalcy of the bland bourgeois couple with his unrestrained sexual appetite and pursuit of physical pleasure.

When Brad and Janet arrive at the Doctor's castle after having a flat tyre, their repressed nature is challenged by Furter, who proceeds to seduce first Brad and then Janet. The flat tyre is emblematic of the breakdown of the couple's bourgeois values. This idea is reinforced by both a visual reference to Grant Wood's 'American Gothic' painting in the opening wedding scene and by Nixon's resignation speech, which is heard on the car radio just before their tyre deflates. The two seduction scenes are photographed in the same manner and the dialogue is identical in each, suggesting the common nature of desire, whether hetero- or homosexual. The open sexual attitude suggested by this visual parallel is directly opposed to the dominant heterosexist and monogamous values of Western culture. "Be it, don't dream it," Furter urges, encouraging this subversive polymorphous perversity.

But in the climax, Riff Raff and Magenta, Furter's two alien assistants, burst into the lab explaining that the Doctor must be 'terminated' because of

[9] See Robin Wood, 'An Introduction to the American Horror Film', in *The American Nightmare: Essays on the Horror Film*, ed. by Wood and Richard Lippe (Toronto: Festival of Festivals, 1979), pp. 7-28.

his excessive pursuit of pleasure. His death occurs in a scene marked with castration imagery (the falling RKO tower, the reference to King Kong's death on the Empire State Building) and, significantly, results from a laser blast from Riff Raff's weapon, which resembles the pitchfork in Grant Wood's painting. In other words, the middle American Empire strikes back to restore dominant sexual values. The film thus seems in the end to call the stability of the couple's relationship into question, since Brad has come out of the closet and Janet has revealed her hidden lust ("Toucha toucha touch me, I wanna be dirty," she sings); but narrative closure is achieved and dominant sexual values are restored, as the couple survives and Furter is eviscerated.

In this sense, the film's use of the musical genre becomes especially significant. The musical traditionally develops two central themes: constructing a sense of community and defining the parameters of sexual desire. These themes are, of course, intimately related, since unchanneled desire poses a threat to dominant ideology.[10] *Rocky Horror* shows just how close the musical and horror genres really are. And just as classical musicals inevitably end in the valorized union of the monogamous couple (an ultimate example being the 1954 movie *Seven Brides for Seven Brothers*), so Brad and Janet, having eliminated Furter, can come together as promised at the beginning when Janet catches the bridal bouquet at the wedding.

Hoberman and Rosenbaum are right to identify alternate sexuality as a pronounced motif in cult movies.[11] The motif appears insistently, from *Glen or Glenda* to *The Devils* (1971), from Kenneth Anger's *Fireworks* (1947) and Jack Smith's *Flaming Creatures* (1963) to Waters' movies with Divine, and *Liquid Sky* (1983). But with *Rocky Horror*, it is clear that the theme is shaped by both text and supertext. The film developed a particularly strong sense of community generated by individuals in the audience who came to the screenings dressed like its characters and acted out responses to key points in the narrative. This ritualized audience response itself became part of the attraction; put another way, the actual show consisted of both the film and the audience participation. The predetermined costumes and repetition of the characters' lines and actions (like throwing rice or toilet paper) at specified times during the screening ultimately reconstituted outside the film a community not unlike the one lampooned within it. The performative nature of this audience response was scripted, predetermined; it discouraged spontaneous improvisation by newcomers and suggested that this community of readers was in its own way as conformist and repressive as the middle class satirized on the screen.[12]

The Cult of Bad Taste: The Cinema of Peter Jackson

One can see a similar dynamic in the movies of New Zealand filmmaker Peter Jackson, one of the few cult auteurs to emerge since the publication of my original essay. Jackson's cult movies *Bad Taste* (1988), *Meet the Feebles* (1990) and *Braindead* (aka *Dead Alive*, 1992) are at once cultural critiques and enjoyable entertainment. Generic hybrids dubbed by Jackson as 'splatstick', they blend horror and comedy, combining scenes of graphic bodily violation in the tradition of the 'meat movie' as developed by Herschell Gordon Lewis with the physical comedy of Chaplin and Keaton and the verbal wit of the Marx Brothers. This uneasy combination of tones has the potential to generate a rich and disturbing tension in the viewer.

Because they seem so obviously to fly in the face of respectability, numerous 'splatstick' movies have become cult favourites, including Romero's *Dawn of the Dead*, Sam Raimi's *Evil Dead* films, *Re-Animator* (1985), *Return of the Living Dead* (1985), as well as Frank Henenlotter's *Basket Case* (1982) and *Frankenhooker* (1990). Rather than working as comic relief, the comic aspect of these films sometimes intensifies the horror, making the movies seem morally irresponsible or even gleefully amoral to the degree that they mock the seriousness of violence and death. This apparent amorality, as in the case of

10 On the sexual ideology of the musical, see J.P. Telotte, 'Ideology and the Kelly-Donen Musicals', *Film Criticism*, 8, no. 3 (Spring 1984), pp.36-46; and my own 'The Classic Hollywood Musical and the 'Problem' of Rock 'n' Roll', *Journal of Popular Film and Television* l3, no. 4 (Winter l986), pp. 195-205.

11 Hoberman & Rosenbaum, *Midnight Movies*, p. 263.

12 For more on the audience reception of this film, see Bruce A. Austin, 'Portrait of a Cult Film Audience: The Rocky Horror Picture Show', *Journal of Communications* 31 (1981), pp.450-456; Hoberman and Rosenbaum, *Midnight Movies*; and Robert Wood, 'Don't Dream It: Performance and The Rocky Horror Picture Show', in *The Cult Film Experience*, pp. 156-166.

the deadpan style of cult works such as *Henry: Portrait of a Serial Killer* (released 1989) or Bret Easton Ellis' novel *American Psycho* (1991) seems a direct affront to traditional cultural and aesthetic values because they withhold any liberal humanist reason for presenting the disgusting horrors they depict. It is no coincidence that both *Henry* and *American Psycho* have been regarded (indeed, vilified) by many as exemplars of bad taste and immorality.[13]

Jackson cheerfully pushes the sensibility of 'splatstick' to an extreme in his films, filling them with comic, carnivalesque images of bodily abjection: blood, pus, piss, shit, vomit, guts. The title of Jackson's first feature, *Bad Taste*, suggests a deliberate attempt on his part to attack accepted norms. The film's most famous image, at least in New Zealand, is the blowing up of a sheep (almost a national icon) with a bazooka. The film is throughout excessive, anarchic and irreverent. (In England, the film's billboard, showing an alien 'giving the finger' to the spectator/camera was actually banned on the London underground).

The plot of the film involves an investigation by 'The Boys', a contingent from the 'Astro Investigation and Defense Service' (AIDS!) who have been sent to find out what is going on in the strangely silent and abandoned town of Kaihoro (pop. 75). Upon arrival, The Boys encounter numerous aliens, "intergalactic wankers" whom they eventually discover are gathering humans as "the exotic new taste sensation" for their fast-food franchise, Crumb's Crunchy Delights. The residents of Kaihoro are all dead, their remains packed into five boxes in preparation for shipping. After several bloody skirmishes The Boys penetrate the Homestead, which is actually a disguised spaceship, to thwart the aliens' plan.

Bad Taste blends the iconography and conventions of horror (the proverbial old dark house, bodily violation) and science fiction (aliens, space travel) with comedy. Several aspects of the film invoke *Night of the Living Dead* (1968) ("the head shot's the only true stopper," as one of the Boys advises), while the comic chase of humans by dozens of similar looking aliens recalls the hordes of women chasing Buster Keaton in *Seven Chances* (1925). The film may be read as bending genre to a kiwi context, as in the shot of the exploding sheep. Among those aspects of Kiwi life debunked in the film, one reviewer noted sheep meat processing, government bureaucracy, and "the New Zealand cult of the chainsaw."[14] The film also satirizes the Kiwi masculine ideal of 'mateship,' and the film's vision of the invasion of New Zealand by alien fast food franchises refers to the Americanization of Kiwi dining that was fully underway when the film was in production. It is no mere coincidence that the aliens all wear denim jeans and shirts: their pot bellies and large buttocks, bursting through their clothes, testifies to the conspicuous consumption characteristic of American popular culture.

Bad Taste seems to attack many cherished aspects of Kiwi culture, yet it was enthusiastically embraced by audiences both abroad (it received a standing ovation at Cannes) and at home, where a wildly enthusiastic audience greeted its national premiere at the Auckland Film Festival. It swept the annual New Zealand Film Awards the following year, and the movie later won an award for the creation of a new genre in New Zealand filmmaking, 'comedy splatter,' at the 1992 Wellington Fringe Film Festival. Viewers of *Bad Taste* can enjoy laughing at themselves because in the end it is all in good fun. As Sontag remarks of camp, it is "art that proposes itself seriously, but cannot be taken altogether seriously because it is 'too much.'"[15]

The same duality operates in Jackson's *Braindead*, a horror satire about the repressive bourgeois culture of New Zealand in the 1950s (also one of the themes of Jackson's more serious *Heavenly Creatures*, 1994). Monstrous matriarchy and filial obedience are explored in the film's story about a repressed young man's attempt to assert himself and escape from the clutches of his dominating mother while at the same time dutifully caring for the

13 For more on ideology in and reception of these and other similar works, see my 'American Psycho/sis: The Pure Products of America Go Crazy', in *Mythologies of Violence in Postmodern Media*, ed. by Christopher Sharrett (Detroit: Wayne State University Press, 1999), pp. 23-40.

14 John Parker, 'The Joy of Exploding Entrails', *Metro* (September 1988), p. 202.

15 Susan Sontag, 'Notes on Camp', in *Against Interpretation* (New York: Dell, 1966), p. 284.

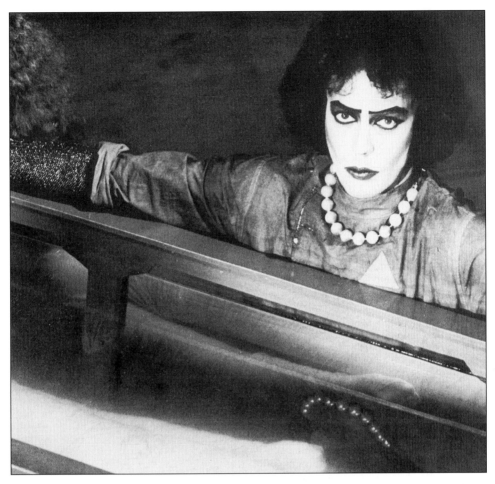

The Rocky Horror
Picture Show

zombies that multiply around the house as a result of his mother's infection. As the narrative unfolds from Lionel's point of view, Mum's veneer of respectability is stripped away to reveal her domineering, jealous and ultimately murderous nature.

Falling in love with Paquita, Lionel begins to have his own desires; as he comes to see his mother differently. He ultimately discovers the truth that, like Norman Bates in *Psycho* (1960), she had killed Lionel's father and his lover. In the film's spectacular climax, Mum literally smothers her son when she mutates into a grotesque giant and engulfs him. Ultimately Lionel must fight his way out from within her enlarged, enveloping body in "cinema's most graphic episode of the vagina dentata."[16] Like *Psycho*, *Braindead* is a psychodrama about a boy and his best friend, his mother; but the absent Mrs. Bates pales in comparison to the emphatically present Mum, who is the ultimate embodiment of the "monstrous-feminine."[17]

On one level, *Braindead* is an uncompromising critique of bland New Zealand culture, particularly its emphasis on the cult of domesticity and motherhood. Like *Bad Taste*, it plays with Kiwi iconography within the context of horror. This is most notable in the film's climax, when Lionel wields his lawnmower like Leatherface's chainsaw while he ploughs his way through a field of zombies, leaving a mounting heap of twitching body parts in his wake. *Braindead*, again like *Bad Taste*, makes explicit its broad critique of the 'mother country' from the outset by beginning with a portrait of the youthful Queen Elizabeth II.

[16] Michael Atkinson, 'Earthy Creatures', *Film Comment* 31, no. 3 (May/June 1995), p. 36.

[17] Lawrence McDonald, 'A Critique of the Judgement of Bad Taste or Beyond Braindead Criticism', *Illusions* 21-22 (Winter 1993), p. 13.

above: **Flaming Creatures**

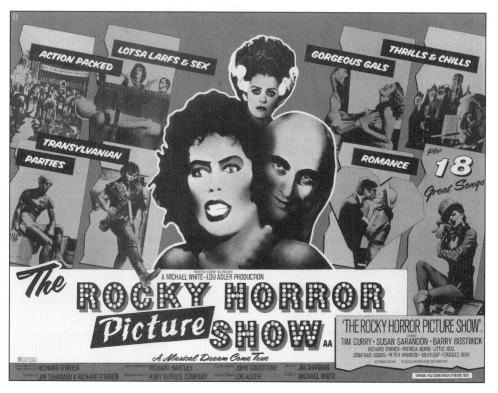

Second Thoughts on Double Features

At the same time, however, the film's strategy of excess crosses the fine line between serious transgression and adolescent humour. Watching the excessive gore, viewers are likely to respond, as someone says during one of the alien's incredible transformations in John Carpenter's *The Thing* (1982), "You've got to be fucking kidding!" One might argue of *Braindead*, as Leonard Maltin in fact does about *The Thing*, that its "nonstop parade of slimy, repulsive special effects turns this into a freak show and drowns most of the suspense."[18] Indeed, *Braindead* was so exuberantly excessive in its gore effects that, as Farrah Anwar rightly predicted, "they have reached a dead end, because it's impossible to imagine anyone out-grossing the New Zealander's effort, or wanting to."[19] Even the horror of the film's dominating mother is neutralized with narrative closure, as Lionel emerges from within her, the boy literally reborn as a man free to enter into normative heterosexuality.

The textual strategies and popular reception of Jackson's movies seem to endorse the ideas I initially explored a decade ago. However, while cult movies continue to work around a central tension between transgression and recuperation, again I would caution that we cannot conclude that no cult films are genuinely disturbing, for some clearly are. *Freaks*, *Flaming Creatures*, and Kenneth Anger's films (*Fireworks*, 1947; *Scorpio Rising*, 1963) come readily to mind. Still, *Freaks* was banned for decades; *Flaming Creatures* was withdrawn from exhibition in New York during a lengthy litigation process; and Anger's films showed only in a few art cinemas in major cities. These movies existed at a far remove from the mainstream narrative tradition that dominates the cult marketplace.

Like classic genre movies, cult movies work in terms of clearly defined oppositions. Because of their reliance on caricature, their conflicts often can be reduced to some version of white hats versus black hats. Indeed, like classic genre movies they often provide satisfactions similar to those of generic entertainment in that ultimately social order is restored. Cult movies may boast of their transgressive qualities through excesses of style or content, treating normally taboo subjects, or violating commonly accepted standards of taste; but they, too, often end by recuperating that which initially has posed a threat to dominant ideology.

Cult Cinema as the Postmodern: The Films of Paul Verhoeven

To what extent this element of the cult film is less defining than typical of contemporary genre movies or postmodern texts generally is a question for further research. Indeed, the films of Paul Verhoeven, another director whose work has become cult, is a case in point. His films are both cult movies and exemplary postmodern texts. Verhoeven's *Total Recall* (1990) is, like its source story, Philip K. Dick's short story *We Can Remember It For You Wholesale* (1966), a postmodern look at the extent to which images have come to define our reality. The protagonist, Douglas Quaid (Arnold Schwarzenegger), finds himself incapable of distinguishing reality from fantasy as a result of a botched (?) memory implant. He does not know whether his adventure is the program he requested at Rekall, Inc, or if his actual identity has been accidentally uncovered.

Viewers share Quaid's lack of epistemological certainty since they are incapable of detecting a flaw in the state-of-the-art special effects, that distinguish between what is 'real' and what is 'imagination.' The world of the film, with its domestic wall projections of make-believe environments, mechanical taxi drivers and holographic projections, is a postmodern simulacrum, just as the visual media are for us in the real world. Even as the film criticizes Quaid's fantasy adventure as thoroughly typical (he defeats the villain, saves the planet, and gets the girl), in watching *Total Recall* we realize that, just like Quaid, we enjoy imagining ourselves as Arnold Swarzenegger in non-stop action movies just like *Total Recall*.

[18] Leonard Maltin, 1999 *Movie and Video Guide* (New York: Signet, 1998).

[19] Farrah Anwar, 'Braindead', *Sight and Sound* 3, no. 6 (June 1993), p. 49.

国際ファンタスティック映画祭　グランプリ3冠達成
アヴォリアッツ／ポルト・ファンタ／モントリオール

ママ、切り刻むほど 愛してる。

Peter Jackson
BRAINDEAD

ブレインデッド

ティモシー・バルム／ダイアナ・ベニャルヴァール／エリザベス・ムーディ／セルウィン／監督：ピーター・ジャクソン
プロデューサー：ジム・ブース／脚本：ピーター・ジャクソン、ステファン・シンクレア、フランシス・ウォルシュ
1992年ニュージーランド映画／⑪／配給：松竹富士株式会社⑪

Illustration by H.SORAYAMA

Second Thoughts on Double Features

The same double feature informs Verhoeven's *Showgirls* (1995) and *Starship Troopers* (1997). *Showgirls* offers a critique of male voyeurism in its story of a lap dancer who wants to be taken as a serious artiste, and at the same time serves nicely, with its ample female nudity, as soft-core pornography that satisfies the visual drive. The film is cult, one presumes, primarily because it fails so spectacularly to be either. *Starship Troopers*, based on Robert Heinlein's 1959 novel, is a rather straightforward account of the military mind-set and values in the future when the human race is threatened by an extraterrestrial army of giant intelligent insects.

opposite:
Japanese poster for
Peter Jackson's
Braindead

Without a trace of irony, Heinlein uses the story to offer extended passages about the benefits of a social order organized by militaristic principles. Verhoeven's film, however, completely subverts the book's conservative ideology by deconstructing military guts and glory even as it provides it so completely. Again with state-of-the-art effects, Verhoeven shows us graphic battles between bugs and humans as soldiers are impaled, eviscerated, and dismembered. But these scenes alternate with images of official government propaganda films (obviously inspired by the *Why We Fight* documentaries) that clearly contradict the bloody truths of the war. The protagonists are all played by beautiful young actors, with whom the audience can easily identify. Yet just as these young people still march off to war full of optimistic faith, so audiences flocked to the film to see the much-touted violence of its battle scenes that alternated with its anti-war implications.

Cult movies clearly construct a microcosmic community of admirers, although in the era of the international blockbuster it becomes increasingly difficult to distinguish a cult audience from a mass one. Audiences were wildly enthusiastic about *Titanic* (1997), and returned for repeat viewings, but can a film be cult if everyone embraces it? Apart from such debatable definitions, most cult films do seem to work in the manner I have suggested. They encourage viewers not to take very seriously the threat of the Other.

Cult movies prod us to laugh at the representatives of the normal, usually our own surrogates on the screen. Viewers cheer when in *The Texas Chain Saw Massacre* (1974) and its numerous splatter imitations their figures of identification are killed off serially in ever more prolonged and gruesome ways. We hardly think of these characters as people, but rather as excuses, pretexts, for splatter or laughter. In cult movies viewers tend to laugh at the normal, tame the Other, but nowhere see themselves. Perhaps this is why cult audiences tend to be composed of teenagers, disenfranchised youths who are caught between childhood and adulthood. There are, of course, other reasons for the cult appeal of specific movies, but it would seem that this "double feature" of transgression and recuperation does account for much of the appeal of this otherwise generically diverse group of films that we have come to describe with the unwieldy term 'cult.'

Tanya Krzywinska

Cult films are those which are deemed to offer something beyond the mainstream usual and they frequently trade on the power of transgression. Hardcore pornographic film actively flouts the values of 'good' taste and tackles tabooed subject matter, promising to show the curious viewer the erotic forbidden in the guise of other peoples' sex lives (placing the viewer in the privileged position of watching their 'performance' without incurring the cost of a returning gaze). The cult-status of hardcore is dependent on its ability to imbue the depiction of explicit sexual acts with a transgressive frisson. Hardcore's illegal, outlawed status in the UK is therefore inherent to its transgressive kudos and because these videos cannot simply be hired or bought legitimately over the counter, an active-user base is promoted. As audience enthusiasm is crucial for the definition of cult status, the fan's devotion in the dissemination of information about the films (mainly on the internet) and their role in the black market distribution economy (such as swapping networks), lends the genre a further claim on the label 'cult film'.

In this chapter I address the transgressions, pleasures and meanings at work in the 'squirting' and lactation film as specialist sub-genres of hardcore film. Although these films may have only a minority appeal, using a psychoanalytic approach I will show that they invoke a matrix of social/psychic investments and dynamics that are intrinsic to the shaping of gender, sexuality and desire in late twentieth-century Western culture. It is this, alongside my general feeling that extant critical debates around hardcore pornography tend to deny the recalcitrant nature of sexual desire, that lures my 'critical' investment in the analysis of this specialist genre.

Biographical note: Tanya Krzywinska lectures in Film and TV Studies at Brunel University. After completing a Ph.D. on video-based hardcore pornography, she has published a number of articles on the topic and is currently writing a book on demonic possession in witchcraft, voodoo and exorcism films.

The Dynamics of Squirting: Female Ejaculation and Lactation in Hardcore Film

Tanya Krzywinska

Lactation Films: The Big Top Cabaret

In recent hardcore video production there has been a small but significant focus on two female bodily fluids - lactation and female ejaculation. Although lactation themed films are less common than the female ejaculation film, from a psychoanalytic point of view they are both interesting additions to the hardcore repertoire. Whilst it is a common assumption that hardcore films are a simple formulaic mode of presenting sexual acts, this chapter argues that what is at stake in these films is a deep engagement with the ontology of desire. By focusing on two cult sub-genres of hardcore, the lactation film and the female ejaculation film, I will show that these productions are bound into a matrix of desire and disgust, and how this relates to what Melanie Klein calls the paranoid-schizoid position.[1]

Hardcore film promises to show authentic sexual pleasure and the visible presence of bodily fluids are supposed guarantors of this authenticity. Bodily fluids are never, however, just what they ostensibly signify. Instead, they are highly over-determined with often contradictory meanings. A psychoanalytic understanding usefully acknowledges that sexuality and desire are rooted in unconscious fantasy and, further, demonstrates that unconscious fantasy is often transgressive and beyond rational control.

Drawing on psychoanalysis, my argument is that the meanings of lactation and female ejaculation are intrinsically bound up with disgust, transgression and the drive to knowledge which are played out through the metonymically linked bodies of mothers and women. The over-determined meanings of the representation of women and their bodily fluids lean upon a reiteration of the paranoid-schizoid position and are also bound into an erotically motivated drive to knowledge - both of which originate in the child's early relation to the body of the mother. This results in the films' promotion of an aggressive curiosity and their ability to interpellate the viewer into a complex knot of contradictory emotions and meanings. The fundamental paradox of these productions is that they seek to show as well as not show desire and this contradiction is bound into complex psychic configurations of gender and desire.

The lactation video is a relatively rare occurrence and has, therefore, a special place within the hardcore market. For example, the video series entitled *Big Top Cabaret*, made in the early 90s, specialises in these types of films. The second video in the series is entitled *Erupting Volcanos*. Of the video's five separate stories, all featuring big-breasted women, three are lactation based stories; entitled *Twin Volcanos*, *Rope Bra* and *Nursing Bra*. The video displays many of the conventions present in more mainstream 'fuck' films - such as

1 Melanie Klein 'Notes on Some Schizoid Mechanisms' and 'A Study in Envy and Gratitude' in *The Selected Melanie Klein*, ed. by Juliet Mitchell (Middlesex: Penguin Books, 1991), pp. 175-200 and pp. 211-229.

heterosexual intercourse - but their lure is the rare chance to see large lactating breasts within a sexual scenario. For a psychoanalytic understanding of the appeal of the lactation film it is necessary to consider the part played by the breast in the child's imagination and how it informs adult sexuality.

Cult and Fantasies

Jean Laplanche, the French psychoanalyst, considers the impact of the interrelation between the mother and child on the formation of adult psycho-sexuality.[2] Laplanche argues that sexuality is not simply about functional reproduction, instead it is grounded in fantasy and the imagination. Fantasy emerges through the child's experience of losing an object that has given it satisfaction. This is bound up with the figure of the mother; she, or part of her, provides (or withholds) the object that satisfies. When a need is not satisfied, the child imagines its presence and, at the same time, begins to relate presence or absence of satisfaction with the mother herself and her desires. The mother's desire is written into her handling of the child and the child reads this handling as enigmatic. In a prototypical way the child feels that there must be reasons for her giving or withholding of its bodily needs. This process is instrumental to the formation of the drive to knowledge and is a means of asserting power and control which is fundamental to the formation of subjectivity.

The enigmatic messages that emanate from the mother's body are the source of fantasised activity on the part of the child. For instance, if milk is taken away then it is replaced by an erotic fantasy about the breast and by extension, the mother. These fantasies are attempts to answer the questions posed by the enigma of the mother's desire. The child begins to manage the anxiety produced by enigmas through splitting the mother, or her 'part-objects', into two (that which satisfies and that which does not). Melanie Klein couches this as the fantasy of the good and bad breast/mother. Beyond this, the questions posed to the child are intrinsically linked to the formation of an epistemological drive which is therefore both erotic in nature and linked to the child's attempt to control its world. These fantasies are not simply discarded by the child. Rather they are sublimated (rendered unconscious) and return in adult sexuality when they are translated through a genital sexual framework and they govern our relations with other people. Explicit sex films lean upon these fantasies and processes. As Laplanche explains it:

"The adult man who sees the child at the wet-nurse's breast retroactively imagines all that he could have drawn erotically from the situation if only he had known. So this is a true example of retrospective fantasy and of hermeneutics: he reinterprets the function of breast feeding in terms of his present situation."[3]

As a result of this retrospective working, the complex meanings of the lactating breast (which in Kleinian terms signifies both plenitude/good and frustration/bad) is also deeply embedded within the cultural construction of motherhood. The meaning of motherhood leans on this contradictory psychic knotting. As such, the representation of motherhood, and by extension women in general, is always cast within the framework of the paranoid-schizoid position (a term used to describe the process of splitting). This is why mothers, and women in general, are often represented in a contradictory way. In other words, women often represent two (or more) things at one and the same time.

We can see these ideas at work in Julia Kristeva and Marina Warner's analyses of the Marian cult in Christianity.[4] The Madonna is deployed as a means of sanctifying the messy business of motherhood. The Virgin-Mary represents a cleaned-up version of motherhood and lactation because it is ostensibly divorced from sexuality and desire (a perfect fantasy of the Oedipal boy-child). Whilst we see images of the Virgin suckling the infant Christ the eroticism of the image is sublated.[5] The erotic is never completely excised and is often suffused within the

[2] Jean Laplanche *New Foundations for Psychoanalysis* (Cambs/Oxford: Blackwell, 1989) (First published in French 1987) in Jean Laplanche: *Seduction, Translation, Drives*, ed by John Fletcher and Martin Stanton (London: ICA, 1992).

[3] Laplanche in Jean Laplanche: *Seduction, Translation, Drives*, p. 221.

[4] Julia Kristeva, *Tales of Love* (New York: Columbia University Press, 1987), pp. 234-263.

[5] Marina Warner, *Alone of All Her Sex: The Myth and The Cult of the Virgin Mary* (London: Picador, 1990).

image of, or discourse on, the Virgin. Warner's citation of medieval devotional writing on the Virgin illustrates this: "He gives her the kiss she had longed for ... and so great is the power of that kiss that she at once conceives and her bosom swells with milk ... and the milk of sweetness will overflow everywhere in a torrent".[6] Whilst the kiss and milk are used as metaphors for spiritual sweetness and purity it is, ironically for a Christian monk, deeply erotic.

Tintoretto's *The Origin of the Milky Way*, from the 18th century, likewise focuses on the image of the lactating mother. The painting is composed around a central figure of a naked goddess whose breasts spray off the stars of the milky way. The mythological framing of the picture lends it an allegorical status which, in high art terms, means that the pornographic value of the picture is aesthetically veiled. This translation is guided by the primary process (a term used by Freud to describe the way in which unconscious ideas are rendered conscious in an altered form through condensation and displacement)[7]. The milky fluid squirting sky-wards as golden stars is metonymically linked to the origin of the universe and thereby betrays the powerful status of the female body, which is frequently elided by Christian creation myths. This painting, however, carries a sign of the goddess's (pagan) jouissance that is not evident in many icons of the Virgin Mary. Her pleasure is signified by her lascivious smile, her nakedness and her open bodily gestures. Her jouissance is rendered as an enigmatic, secret pleasure but also as powerful and creative/creation. As such the image responds to the child's/man's question - what is her desire and pleasure in lactation? The image is remarkable in that it is one of rare explicit images that recognises the creative power of lactation and the mother's desire investment in it. But it does so from the place of the imagination and, as such, it is the product of fantasy.

Promises and Authenticity

The lactation film is not overtly shrouded in such elevated and allegorical meaning. Instead it seeks to unveil, through the aggressive intrusion of the documentary camera, an economy of desire for lactating women. Here there is an insistence on needing to know the 'truth' (which is a need for truth borne of fantasy and the enigma of the mother's body and desire). Hardcore trades on its promise to show the authentic life of the sexual body - and one of the ways of guaranteeing authenticity in today's media-scape is the presence of bodily fluids. Horror films, especially body horror films, also use disgust as a means of blurring the distinction between authenticity and artifice. Those viewers who have not found a method of assigning artifice to a horror film are not able to make this distinction and the films are 'too real' for them to find 'fun'. (Some horror fans are, however, often on the search for films that place them back in that 'too real' position.) As Miller says "No other emotion, not even hatred, paints its object so unflatteringly, because no other emotion forces such concrete sensual descriptions of its object. This, I suspect, is what we really mean when we describe disgust as more visceral than other emotions."[8] Disgust is an extremely powerful emotion and accordingly hardcore films make use of the presence of bodily fluids to substantiate the authenticity of the action and to break the protective shield of representation.

The authenticity of the explicit portrayal of lactation certainly, at one level, fulfils hardcore's promise to deliver the real, but, at another level, it operates through the drive to solve the puzzle of the mother's enigmatic desire. Disgust is an emotion that emerges from knowing too much. If we relate this to the splitting of the mother imago into the good and bad mother, disgust can be felt if the child is overwhelmed by milk which then is read as 'bad' milk and must be spat out if the child is to retain a sense of control. In prototypical form, what is happening here is that what is wished for arrives and is too plentiful - too bad - the fantasy generating puzzle that produces a controllable, comfortable *jouissance* no longer remains and is replaced by a disgusting and annihilating 'too much'. This is very much a Bataillean annihilation of the self

[6] Cited by Warner, *Alone of All Her Sex*, pp. 197.

[7] See Jean Laplanche and Jean-Bertrand Pontalis, *The Language of Psychoanalysis*. (London: Karnac Books, 1988), pp. 339-341.

[8] William Ian Miller, *The Anatomy of Disgust*. (Massachusetts: Harvard University Press, 1997), p. 9.

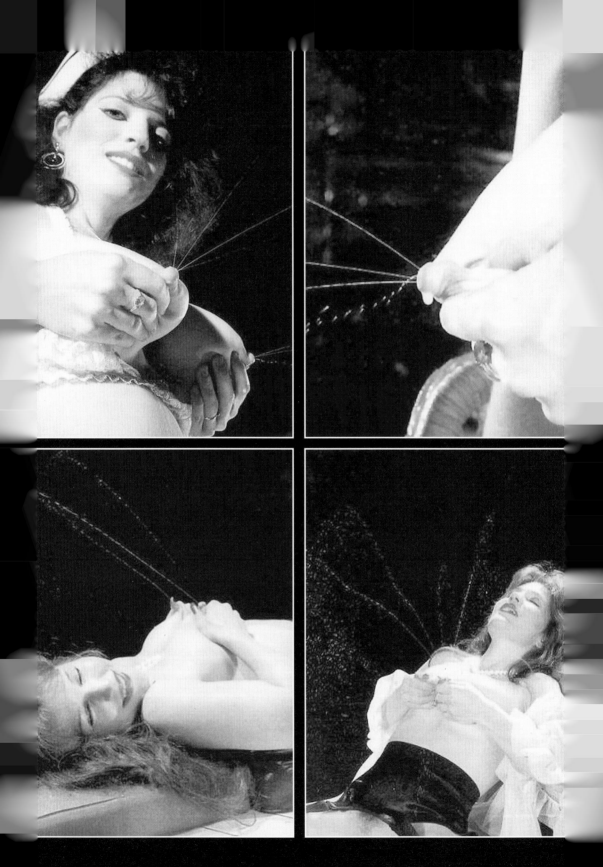

Hardcore film operates through the rule of spectacle and the lactation film is no exception. Spectacle leans for its frisson upon another scene (an ob-scene) if viewers/users of the film are to derive erotic pleasure and/or disgust from it

The Dynamics of Squirting

and I would link it to the Kleinian paranoid-schizoid position. The viewer both desires truth and yet does not want to see it. This is perhaps why the lactation film is a minority part of hardcore production (disgust can obliterate the erotic).

Desiring Mothers

I have focused thus far on the child/man's view of the mother - but what is always missing here is the desire of the mother. The mother's relation to lactation is, in terms of representation, invisible, barely hinted at, and always, as Irigaray says, fantasmagorically mediated.[9] It seems odd that the exploration of the mother's erotic investment in lactation is left to an obscure and disreputable sub-genre of hardcore film. But, despite the films' efforts to uncover the mother's desire, they do not get that far.

Hardcore film operates through the rule of spectacle and the lactation film is no exception. Spectacle leans for its frisson upon another scene (an ob-scene) if viewers/users of the film are to derive erotic pleasure and/or disgust from it. Laplanche's notion that lactation is figured through the adult imaginary (and thereby filtered through the Oedipus complex) goes some way to explaining how this scene retrospectively reworks the enigmatic signifiers of the mother's desire through a genitally based sexuality. Accordingly, there are no babies in *Erupting Volcanos*. Instead we have men-babies who suck and then fuck, indicating a shift from oral pleasure to genital pleasure. It is instructive to read the marketing description of one of the stories (*Nursing Bra*) in the *Erupting Volcanos* collection.

"A middle aged woman has massive mounds full of milk which she squeezes out of her huge dark nipples. She wishes there was someone to drink it and talks all the time about how turned on she is getting. She strips to her stockings and suspenders and masturbates. She is interrupted by a bra salesman. She puts breast milk in his coffee. They strip and she sucks and tit fucks him. Her milk drops onto his balls. He spunks on her firm boobs."[10]

What this demonstrates is a retrospective imaginary re-working of the mother's desire through a genital sexual economy. Strange though it might seem, it also accentuates the repression of the mother's erotic investment in the lactating breast. Womens' responses and emotions in breast-feeding are diverse and rarely discussed, even on TV chat shows. Women can experience one or more of the following: satisfaction, disgust, pleasure, nuisance, confir-mation of mothering. Despite the fact that many women have experienced breast-feeding it is nevertheless the case that their desire investment cannot be represented, precisely because it is so over-determined by fantasy. How then is it possible for women to find a means of articulating the experience of lactation for themselves? We certainly do not see it in *Erupting Volcanos*.

Erupting Volcanos is full of double entendres. Given that the film purports to show our secret desires, why should we need jokes? Certainly the jokes frame tabooed behaviours and perhaps de-fuse the return of the repressed. What is being defended against is the return of the Oedipal scenario which is repressed in line with the child's attempt to gain mastery over the enigma of the mother's desire. The 'difficulty' presented by the sight of lactation is further reworked through a genital economy (a further means of mastery) evident in the womens' dress (stockings and suspenders) and the transition to conventional fucking. The problematic jouissance of lactation is here re-channelled into a controllable and commodified image of woman as the object of desire, thereby, moving away from the dangerous oedipal scenario. The jokes work to contain the implicit paranoid-schizoid position that is evoked by the traces of mother's enigmatic body.

Despite these strategies of containment, the powerful image of lactation transgressively pulls against the dominant representation of mother as holy mother. The complex configuration of pull and counter-pull, containment and

9 See Luce Irigaray 'The Bodily Encounter with the Mother' and 'Women-mothers, the silent substratum of the social order' in *The Irigaray Reader*, ed. by Margaret Whitford (Oxford: Blackwell, 1991), pp. 34-46 and pp. 47-52.

10 Extract taken from mail order catalogue *Your Choice*, August 1991

transgression, operates through the imaginary double meaning of the mother's body - disgust and sublime fulfilment. Through this double meaning the paranoid-schizoid position is resurrected within the contradictory over-determination of the image of lactation and the paranoid-schizoid position brings with it a tantalising promise of the annihilation of the self.

Ejaculation

At least since Aristotle, male ejaculation and its product have had a special status.[11] Ejaculation is encoded as specifically masculine (despite its having a passive, autonomous dimension). Masculinity is conventionally read as active and, by extension, the act of male ejaculation in hardcore is rendered as a triumphant and gender-defining act, often constituting a defensive difference to feminine passivity. The ejaculation/active analogue implicitly promotes certain anxieties for men because ejaculation represents male control. Any evidence of lack of control is a problem for the definition of masculinity (perhaps this is why 'nocturnal emissions' have been blamed on succubi as means of circumventing the implications of involuntary ejaculation).

Nursing Bra makes a paradigmatic and physical link between lactation and male ejaculation by depicting lactation and the come-shot at the same time and in similar ways. In the specular logic of hardcore films, the spurting milk is framed in the same way as male ejaculation. Within hardcore the male come-shot is an undeniable sign of authentic sexual pleasure and here lactation is subject to the same paradigm (this is of course a male genital paradigm). The imposition of this framework on the lactating woman tempers the radical and powerful otherness of the mother's body and the mother's desire again disappears off-scene. The disappearance is, though, partial and the problem presented by women's desire continues as an implicit economy in the film. This is the fundamental contradiction of the hardcore film and the lactation film in particular. It is not, however, simply a problem for male-based representation. I would caution against the notion that women are better able to represent women's desire. Women are always daughters and subject to their own fantasmatic relation to the mother's body which may entail a psychic investment in the erasure of the mother's desire.

Although hardcore film seeks to show explicitly sexual pleasure, desire and the operation of the body in sexual activity, the images are always shrouded in allegorical meaning. This is the product of the drive to knowledge and, counter-wise, the drive to non-knowledge. The tension of the hardcore sex film lies in its promise to show visceral and transgressive sex but they also carry a danger of knowing too much for desire and fantasy to circulate. If the 'truth' of the mother's power over the child returns from its disavowed state then the conventional meanings of femininity and masculinity are thrown in to disarray. Therefore, as a means of denying the powerful otherness of women's jouissance, *Erupting Volcanos* makes the breast the mirror of man's ejaculation as a means of containing the danger to gender. The film attempts to fix the meaning of lactation and its jouissance which could potentially usher in the dizzying chaos of the paranoid-schizoid position. So, despite the apparent explicit rendering of lactation in hardcore film it is nevertheless still enveloped in a mystical, protective caul.

Curious in Bed

So if lactation is read through the male come-shot how then is the female come-shot configured in hardcore film? Is this simply another strategy for erasing difference and otherness? Rather than focus on the male orgasm as a guarantee of pleasure, which is well accounted for in Linda Williams' *Hardcore*, I will focus on the relation of externalised ejaculation to abjection.[12] For Williams and Falk, it is the male come-shot that guarantees the authenticity of the sex in a hardcore film.[13] Does the female come-shot also work to demonstrate the authenticity of the female participants' sexual pleasure and

[11] Aristotle *De Partibus Animalium I* and *De Generatione Animalium I* (Oxford: Clarendon Press, 1992), pp. 64.

[12] Linda Williams, *Hardcore: Power, Pleasure and the 'Frenzy of the Visible'* (London: Pandora, 1990), pp. 93-119.

[13] Pasi Falk, 'Pornography and the Representation of Presence' in *The Consuming Body* (London: Sage, 1994), pp. 186-217.

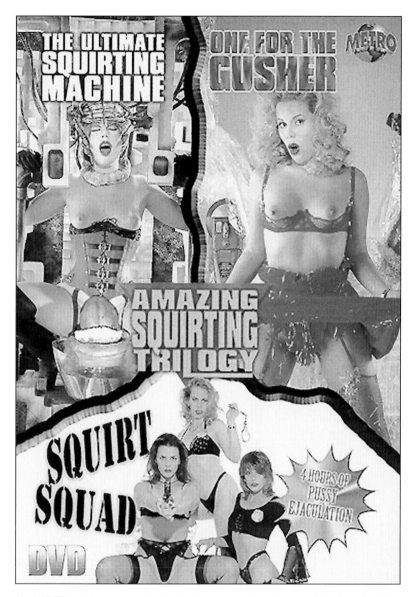

desire? The visible come-shot, whether male or female, could be thought of as a retrospective solution, read through a genital/phallic framework, to the rebus of the repressed fantasy of parental coitus.[14]

 Hardcore purports to allow us see what is forbidden as we are rarely given the opportunity to see what other people do in bed. Curiosity about other peoples' sex lives leans on earlier fantasies about what parents do in bed (often based on over-hearing night-time noises). Again, we see the dynamic of the pull and counter pull of wanting to know, and yet, at the same time, not wanting to know.

 The male come-shot frequently provides closure to a sexual episode, and, thereby, operates as a kind visual punctuation which structures a given film. The female come-shot is a much rarer event in hardcore and its authenticity is open to question in a way that the male come-shot is not. The female come-shot therefore stages a question for the viewer - is it real? is it faked? is it projectile urination? The quest for authentic knowledge of the female come-

14 Jean Laplanche & Jean-Bertrand Pontalis 'Fantasy and The Origins of Sexuality' in eds. Victor Burgin, James Donald and Cora Kaplan *Formations of Fantasy.* (New York/London: Routledge, 1986), pp. 5-34. (First published in French in 1964; retrospect 1986.)

right:
From *The Sluts
and Goddesses
Video Workshop*
(Maria Beatty /
Annie Sprinkle,
1992)

shot again ties into the double-bind of wanting to know but not wanting to know. To know closes down a fertile field for fantasy and renders this apparently magical act into banal physiology or trickery. The drive to knowledge has, however, a powerful propulsion.

Kristeva[15] argues that bodily fluids have an ambiguous status because they transgress the fundamental distinction between inside and outside the body. Bodily fluids are abjected (rendered disgusting) because they were once part of the body and 'at home' with it - but when they become detached from the body, through the defence mechanism of abjection, they become experienced as repulsive. Abjection is a defence mechanism because it aims to maintain subject and bodily integrity. In other words, it seeks to maintain the illusion of autonomy and unity. Bodily fluids engender anxieties because they allude to a time when we were not able to experience our bodies as part of the system of the self. Lacan refers to this disparate body as the 'body in bits and pieces'. This dissembled body lurks beneath the narcissistic illusion of our bodies as unified and under control, and we fear its eruption. Bodily secretions are rarely under control and, as such, intimate the reality of the dissembled and recalcitrant body. This is tied into the social organisation of taboo. Taboos are a means by which a culture constructs its identity both for the subject within that culture and the culture itself. They structure the 'proper' means of dealing with bodily fluids and thus help us to minimise the anxieties that arise from these ubiquitous substances. As the result of the mechanism of abjection, taboos utilise the emotion of disgust to locate a bodily substance as well and truly outside the body - to be disgusted is violently to push something away from ourselves. Hardcore plays on the edges of this.

Bodily fluids carry with them a powerful energy which can be tapped to produce visceral responses. In this sense the portrayal of bodily fluids moves beyond representation - when we see them on-screen their effect can be the same as if we see them in life. Hardcore deploys an armoury of defence mechanisms in order to use this energy and allow its viewers not to be totally in abeyance to the full-force of disgust. Most hardcore couches bodily fluids and the organs that produce them within the framework of sexual transgression so that the substances can be secret(e)ly experienced in a pleasurable way. This is of course a delicate game to play - disgust and fascination are finely balanced.

15 Kristeva, Julia
*Powers of Horror:
An Essay in
Abjection*. (NY:
Columbia
University Press,
1982). (First
published in
French 1980.)

The Dynamics of Squirting

In order for abject bodily fluids to be experienced as transgressively pleasurable, they must be fetishised or contextualised in such a way that an entrancing ambivalence between pleasure and disgust is maintained. Milk and sperm are more easily rendered as least abject because they are traditionally loaded with mythic, sacred and allegorical meaning located around nurture and reproduction. By contrast, vaginal secretions, often conflated with 'discharge', are rendered more abject than milk or semen because they are less obviously linked to reproduction. They are far more infrequently allegorised, although on occasion hardcore film and erotic novels may refer to vaginal secretions as 'honey' or 'dew'. The vagina also produces an array of secretions which easily mingle - blood, discharge, lubrication of varying consistencies - which deepens their abject status. The female come-shot is ambiguous and the fluid that is produced has no apparent nurturing or reproductive value and further it is not at all clear what the fluid actually is.

Having said that the female come-shot is more abject in western culture, I have to point out that it is far more difficult for me personally to write about and watch the male come-shot. It is something I never quite watch, my gaze always wandering away, and I find the male come-shot particularly retch-inducing. Could this be because, as a woman, I have not grown up with having to find strategies for dealing with ejaculation? The allegorical means offered by Aristotle do not help; it remains other to me, and, in spite of Kristeva's otherwise profound words on the function of abjection, cannot be connected with my own sense of bodily integrity. Because of this, I can only understand the pleasures of fellatio as a masochistic activity akin to St. Catherine's drinking of the bowl of pus to prove her religious devotion.[16] Miller argues that sperm is the most abject of bodily fluids and that it is so abject that it contaminates all that it touches with 'femininity' (in the sense of passivity).[17] But this can only apply to men because it is the sign of their own passivity against the force of the body's autonomous and othered nature. Disgust, as medieval Christianity acknowledges, is deeply inter-bound with sexuality and desire. It can be used to produce a liberating self-annihilation which Bataille says is the goal of desire. Containment theory, following Nietzsche, suggests that a temporary self-annihilation, like the paranoid-schizoid position, leads ultimately to a re-affirmation of the self. To be disgusted realises the boundaries of the self. This is a seductive idea but it is nevertheless dangerous ground for gender politics as women may have less opportunity to re-build the self if their bodies are regarded by men (through projection) and discourse as disgusting.

What Miller seems to ignore in his reading of sperm as the most abject bodily substance, is that its visceral nature is elevated through mythic meaning. For example, Aristotle allegorises sperm as the most super-refined of all substances:

"the pneuma enclosed within the seed and the foamy part, and more precisely the nature in the pneuma, being analogous to the element of the stars...the body of the semen, in which there also comes the portion of soul-source - partly separate for the body in all those in which something divine is included . . . and partly inseparate."[18]

Sperm is mystified and the ambiguous status of the us/not us substance is sublimated within an alchemical metaphysical miracle ("partly separate and . . . partly inseparate"). Aristotle casts a linguistic, fetishistic spell to cloak the corporeal snottiness of the substance. His control is enabled through the sublimating function of metaphor: "being analogous to the element of the stars", but nevertheless, the hyperbole of the passage marks the site of a struggle. Aristotle's divine sperm gains its mystical status in that it is a marker of truth. These meanings lend transcendent and fetishistic status which help ward off sperm's abject status. By contrast, female ejaculate has none of these traditional transcendent meanings and therefore retains is base meaning which renders it as more disgusting then male ejaculate.

16 Douglas, Mary *Purity and Danger: An Analysis of the concepts of Pollution and Taboo* (London: Routledge, 1966), p. 7.

17 Miller, *The Anatomy of Disgust*, p. 19.

18 Aristotle, *De Partibus Animalium I* and *De Generatione Animalium I*, p. 64.

Female ejaculation has been out of favour in post-renaissance mappings of the body. Prior to this it was considered by Greek, Roman and Arabic writers on the body as a crucial mechanism for conception and reproduction. This was based on a model of the body in which the female genitals and genital function were seen as an inverted mirror image of male genitals.[19] Although this anatomical imaginary has long been out of scientific favour, a less reproductively focused version of it has recently appeared in sex literature and hardcore films. Pat Califia, for instance, mentions female ejaculation in her sex handbook *Sensuous Magic*.[20] From 1994 hardcore has also featured it in specialist videos, such as *How to Female Ejaculate*; *The British are Coming*; *Gusher* and *Jet Stream*.

Squirting

The status of female ejaculation has been the subject of debate between Linda Williams, Chris Straayer and Chuck Kleinhans.[21] Their disagreements focus on whether female ejaculation in Annie Sprinkle's 'post-feminist porn' film *Deep Inside Annie Sprinkle* is a 'real' physiological event. Kleinhans maintains that the ejaculation performed in this film is in fact simply urination. In response, Straayer states that in Sprinkle's post-modern aesthetic there is no distinct line between a real and faked ejaculation and thereby authenticity is not an issue. Williams, however, continues to argue along the lines taken in her earlier book *Hardcore* that the function of female ejaculation is to guarantee the authenticity of the women's sexual pleasure - thereby giving men the signifier of pleasure that they seek. Straayer argues against this by stating that men do not really want evidence of female pleasure and that hardcore films are more concerned with keeping gender demarcations intact.

I am rather more interested in what the women who squirt in porn films have to say about themselves than the authenticity debate (which I do think is important). None of the critics cited above really addressed the phenomenon in hardcore, preferring to stick with the more politically correct female-authored and targeted 'art-porn'. So what do women who squirt in hardcore say about what they do? Sarah Jane Hamilton articulates the difficulty she has in persuading producers that her ejaculation was not urine. In an interview reprinted from *AVN* in *Pornorama*, a fanzine about hardcore cinema, she says: "As some producers were uncertain of my capabilities of having a genuine wet orgasm, I had a thorough examination by my Doctor in Santa Monica to discover the truth behind the matter. He found that I had 'abundant Bertholin glands causing excessive vaginal secretions' which means I SQUIRT FOR REAL!"[22]

What is raised here seems to hinge on the gendered value of ejaculation as a guarantee of pleasure. The re-location of ejaculation to the vagina, as opposed to the conventional penis, is to make it work as a specular index of pleasure and desire, but most importantly making the female orgasm visible. The fact that urine was not valued by the hardcore market in this instance is that it can be done at any time, and is not therefore a sign of orgasm. If, as Williams argues, the motivation for both using and making of hardcore film is to discover and envision the secrets of female sexuality for viewers, then female ejaculation is a gift to the industry. But this still leaves us with the sticky problems of the articulation of female jouissance as simply the mirror of male jouissance and therein the inherent erasure of sexual difference.

Female ejaculation may be related to the guarantee of authentic pleasure and spectacle, but their significance is not so overt as it might seem. Female ejaculation is positioned as transgressive because it dis-aligns the hegemonic difference between masculine and feminine sexuality (defined as active and passive) and in so doing renders the ejaculating woman's body as abject. This is because the ejaculation is not in its 'proper' place and, through the presence of the 'phallic' woman, engenders castration anxieties for some male users. It may also disrupt masculine identity by divesting ejaculation of its men-only status. The uncanny female body once again becomes re-invested with the

[19] Thomas Lacquer, *Making Sex: Body and Gender from the Greeks to Freud* (Massachusetts: Harvard University Press, 1990), pp. 26-62.

[20] Pat Califia, *Sensuous Magic* (New York: Richard Kasak, 1993), pp. 118-119.

[21] Chris Straayer, 'The Seduction of Boundaries: Feminist Fluidity in Annie Sprinkle's Art/Education/Sex' in *Dirty Looks: Women Pornography Power*, ed. by. Pamela Church Gibson and Roma Gibson (London: BFI, 1993), pp. 156-175.

[22] *Pornorama*, No. 1, p. 35 (London: Media Publications, 1996).

post-oedipal signifier of power. This idea is supported by Kerri Downs, another hardcore video female ejaculator, who has some insightful things to say about both being a porn star and men's reception of her ejaculation:

"Since a number of directors and producers have learned that I not only can squirt, but can do it on command, the first words out of their mouths when I arrive on the set is, 'You're going to squirt, right?' It is difficult to understand why I should now be isolated to performing as a circus novelty, without regard to any other abilities. My only recent referrals have been to those who produce 'strange and unusual' videos. Whether amateur, pro-am or feature production, the producers and directors I have been on sets with aren't the only ones who don't understand female ejaculations. I have been on several sets where my male partner (who has been told I squirt) says he thinks he's ready for it, and when the flood-gates open, he jumps back as if he's been doused with an acid bath, loses his wood and can't get it back for the rest of the scene. This doesn't leave me with a lot of incentive to release my emotions and enjoy what I can

do. If this industry is going to capitalize on the squirting phenomenon, then it should take the time and effort to become educated about the conditions under which it exists, and not treat it as an oddity of nature."[23]

This supports the reading that female ejaculation transgresses conventional markers of gender and sex difference, and adds, therefore, to its abject status; that she can also do it on command might be subject to some envy as well. Her testimony further suggests that men's desire to know does not stretch to actually knowing, implying that a fantasy space is a more comfortable and controllable place to be. She reports a horror of knowing in an experiential sense here, rather like my horror of the male come-shot. This leads us back to the notion of allegories as distancing devices. With no allegorising narrative, female ejaculation can, I suppose, seem a frightening/disgusting phenomenon to the men she has partnered. Williams' reading does not seem to hold good here. Downs' experience shows that female ejaculation, far from providing the holy grail of the perfectly visible guarantee of women's sexual pleasure, actually seems to turn off the men on the set.

What is significant here is that the interviews with Downs and Hamilton are specifically geared towards women and *How to Female Ejaculate* is specifically geared towards a female audience. Perhaps this is because the only texts that address female ejaculation in recent years have tended to be dyke S&M texts. So, rather than offering a solution to men's quest for the female orgasm, the discourse around female ejaculation is more strongly linked to an exploration of the female body as a means of empowering women's sexuality.

One of the pleasures for women here might relate to the decentralisation of the male come-shot as the climactic closure of a hardcore sex scene. The image and sounds of female ejaculation may, in part, be a recuperation of active sexuality for women, but it is also, as Downs points out, a curiosity. The debate around authenticity that is taking place in academia and the hardcore industry supports my argument that desire and sexuality are grounded in enigma and its concomitant fantasy world. This is perhaps why Zizek says that hardcore films are too banal, too unrelentingly real, and simply produce depression because they solve the puzzle.[24] The lure of female ejaculation, for both men and women, is then centred on a performative question that prompts fantasy and speculation and which is grounded in the epistemephilic drive for knowledge in and for itself. Finding the object of the quest, however, only forecloses the fantasmatic arena as it is the site of desire and pleasure.

In conclusion, I would refer back to my earlier linking of Bataille's concept of the annihilation of the self to Klein's paranoid-schizoid position.[25] Hardcore seeks to evade the contemplative position of representation by trying to promote a visceral response. It does so by deploying connections between sex, curiosity and disgust. Hardcore promises to show what is hidden from view as a means of solving the prototypical enigma of the mother's desire and, by extension, the puzzle of parental coitus. This places the viewer back in the position of the child who wants to know in order to consolidate control and subjecthood, but with the cost of closing down fantasy and desire. An analogy would be the child who searches for his/her Christmas presents and after the pleasure of discovering the truth no longer has the pleasure of imagining what they could be. This paradoxical double-bind creates for the viewer a kind of psychic oscillation - the desire to know and yet not to know - which ultimately splits the subject.

Hardcore certainly derives its fascination from the portrayal of obscene and flagrant displays of full-on sex. But what it shows is that sexuality is intrinsically loaded with abjected traces of sublimated desires and these are bound into the configuration of sexual difference. As ideologically problematic as this may be, I follow Bataille in the view that sexual reformers, libertarians and pro-censorship feminists cannot excise the obscenity and transgressive power of sex because they are intrinsic to its ability to fascinate.

[23] *Pornorama*, No. 1, p. 31.

[24] Slavoj Zizek, *Looking Awry: An Introduction to Jacques Lacan through Popular Culture* (Massachusetts: Massachusetts Institute of Technology, 1991), p. 110.

[25] Georges Bataille *Eroticism* (London: Marion Boyars, 1987) (trans. Mary Dalwood. First published in French in 1962.). Georges Bataille *The Accursed Share Volumes II & III* (New York: Zone Books, 1993) (trans. Robert Hurley. First published in French in 1976.)

C. Paul Sellors

'Cult film' is not a genre that can be identified by locating common characteristics of narrative or style. Rather, films become 'cult' only in circulation; the term identifies a text whose life is perpetuated by a spectatorship. 'Cult', therefore, is a status, not a description. Nevertheless, these films often exhibit qualities that repulse some while at the same time fascinate others. Many demonstrate a flagrant disregard for good taste and challenge political and social structures with blatant and vulgar anarchy. Not surprisingly, therefore, these films frequently appear from the periphery of, or even outside of, the main commercial film studios.

From this perspective, Norman Jewison's *Rollerball* (1975) doubly engages discourses surrounding cult film. From its release, *Rollerball*'s extreme violence was a topic of debate. Many found the violence in the film pointless and unnecessary while others revelled in the unflinching presentation of a level of brutality rarely seen on cinema screens previously. Still, the film does not present violence for its own sake, but considers the effects of a strategic use of violence in a highly developed capital society. Its pessimism redevelops both the anarchism of late 1960s cult films like *Night of the Living Dead* (1968) and the social impotence present in mid-1970s conspiracy films like *The Parallax View* (1974). As an 'industry' film, *Rollerball* even challenges the very structures of capital under which it was itself produced. It is this critical stance that most firmly roots *Rollerball* in the traditions of cult film, even if its violence is the likely cause of its endurance.

Biographical note: C. Paul Sellors is a Ph.D candidate in the Department of Cinema Studies at New York University. He is writing a dissertation on the foundations of metaphysical realism in film theory.

On The Impossibility of 'Once Upon a Time...' in *Rollerball*

C. Paul Sellors

"Futuristic fiction is the mode evolved naturally by a technological civilization to consider itself."
I.F. Clark[1]

Futuristic Fictions

Audio-visual media and violent spectacles have, for a long time, made comfortable companions. Throughout the history of the cinema, cameras have recorded wars from the Spanish-American War of 1897, through both world wars, and Korea. Television improved on this reportage, bringing Vietnam, the Gulf War(s), Bosnia and most recently Kosovo (and their always pending sequels) into the home. Where actuality footage of battles has been sparse or proved insufficient, re-stagings and fictional representations have been offered to satiate consumer demands. Critics polarise in their attitudes towards this culture of violence in film and television. On the one hand, some argue that the omnipresence of screen violence presents the human race to itself for its own scrutiny; by preserving our carnage on film and video we can remember and learn from our own history. On the other hand, others propose that these aestheticised conflicts, external to the everyday existence of those watching, numb spectators to representations of extreme brutality. Broadcasts of battle 'highlights' and video-game-like bombings simply participate in the screen culture of violence extant in sport and fiction on film and television. Presented within the daily deluge of screen violence, real violence becomes normalised and, through its narration, sanitised of the events it represents. Pitted against each other, the two sides of this debate reach a stalemate.

Futuristic fiction offers a different perspective to consider this deadlock. Rather than hypothesise on causal relationships, it instead posits a society's material and social structures and extends them into the future, illustrating possible manifestations. In his 1975 film *Rollerball*, Norman Jewison adopts this strategy to study our escalation of screen violence. He avoids simple speculation on whether or not violence on screen manifests violence in society; instead, he considers what the end result of violence in a capital society could be. Interestingly, violence in this context does not lead to political upheaval or social difficulties. On the contrary, violence in the film, reiterated as regulated violent spectacle, re-directs thought and energy towards a trivial field of play, subsequently focusing attention away from the possibility of political and social advancement.

There are certainly dangers, however, representing violence within visual media - even for critical purposes. For example, although he depicted violence to address such topics as freewill, Stanley Kubrick felt compelled to withdraw *A Clockwork Orange* (1971) in Britain because of the copycat

[1] I.F. Clark, 'The Future as History' in *Future Imperfect: Science Fiction and Science Fact*, ed. Rex Malik (London: Frances Pinter, 1980), pp. 11-26 (p. 11).

violence which allegedly ensued. In this instance, those that maintain that brutal representations can foster aggressive behaviour would, at first glance, seem to have a concern. While it is important to study the status and reputations such violent cult films develop, it is equally important to consider historically these films and the critiques they offer. Discussing *Rollerball*, Elizabeth Anne Hull elaborates on this very point. She maintains that violence in the film risks being misrecognised as spectacle rather than a studied contemplation not because of a lack of sufficient textual clues, but because its spectators are already anaesthetised to such violence. The ability for spectators to be critical of *Rollerball*'s brutality is therefore not only the goal the film tries to affect, but also a gauge of contemporary social values.[2]

Jonathan E: a Cult in Dystopia

Michael Ryan and Douglas Kellner offer a different analysis. They examine *Rollerball* within their rubric of dystopic fantasy films, suggesting that the film merely "dichotomizes the world of social alternatives into two possibilities - either individual freedom (linked with male property right over women) or totalitarian domination". Their argument is not entirely satisfactory, however, because they do not pay close attention to details within the film and subsequently reach conclusions based more on their model than on the filmic text. Most notably, they maintain two errors which resultantly overemphasise nationalism in the film.

First, they claim that "the team against which he [Jonathan E, the film's protagonist] has to contest in the end is Japanese, and of course at this time the Japanese were beginning to undercut American world economic power".[3] In fact, Houston plays this Japanese team in the middle of the film; Houston's last game is with New York. The 'metaphoric structures' between the game and economic history these authors point to are, in this case, less an issue in the film than they anticipate.

Second, to call the team 'Japanese' is to misunderstand a fundamental trope of the film. Nations have disappeared and have been replaced by corporations. The team Houston Energy plays is Tokyo.

Despite these textual errors, Ryan and Kellner's conclusions cannot be dismissed outright; the burgeoning multi-nationalism in late 1960s and early 1970s capitalism is not only a target of the film, but also one of the fundamental elements of the film's futurist extension. However, by satisfying themselves with the identification of this element in the film, the authors leave unanalysed much of the film's critical edge, avoiding specific details in the narrative and *mise-en-scène* that motivate the film's violence and characterise the relationship between corporations and individuals. Jewison has greater ambitions than Ryan and Kellner suggest. His film argues that the ecstasy of violent spectacles structured into everyday life dissolves critical discourse, political action and ultimately, historical memory.

Based upon his short story entitled *'Rollerball Murder'*, scriptwriter William Harrison provides a dramatical framework which allows Jewison to encode the future into the film in both its social structure and its technology, offering what at first appears to be the epitome of utopia. Corporations have supplanted governments and evolved into worldwide governing bodies that provide for all basic human requirements. Advanced yet familiar technologies such as 'multivision' and global computerisation allow for a vast choice in entertainment and easy access to a range of information. The corporations have even devised and sanctioned an exciting sport - rollerball - distilled from some of the most brutal and sensational elements of contemporary televised sports and spectacles, including football, hockey, basketball, baseball, motorcycle racing, boxing, wrestling, and rollerderby. The film then asks whether this capitalist logic actually supports the social ideals it appears to offer.

[2] Elizabeth Anne Hull, 'Merging Madness: Rollerball as a Cautionary Tale' in *Clockwork Worlds: Mechanized Environments in SF*, ed. Richard Erlich and Thomas P. Dunn (Westport, CT: Greenwood Press, 1983), pp. 163-80 (pp. 178-9).

[3] Michael Ryan and Douglas Kellner, *Camera Politica: The Politics and Ideology of Contemporary Hollywood Film* (Bloomington: Indiana University Press, 1988), p. 256.

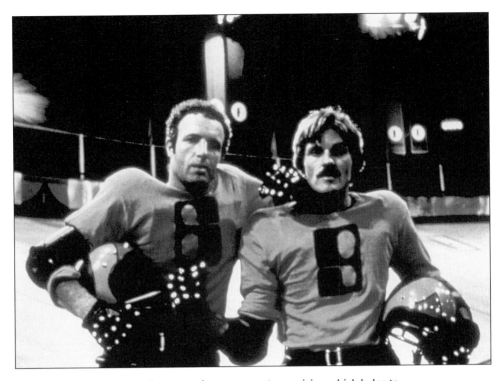

Rollerball is not simply a sport, but a corporate provision which helps to maintain social stability. Unfortunately for the corporations, Jonathan E, the game's best player, has become too successful and threatens to 'become greater than the game itself'. His success potentially jeopardises corporate society because it demonstrates the appeal of individuality and excellence over mediocrity. Mr. Bartholomew, the head of Houston's corporation Energy, consequently attempts to convince Jonathan to quit the game. While doing so, he provides insight into the development and functions of both the game and corporate society itself:

"You know how the game serves us; it has a definite social purpose. Nations are bankrupt, gone, none of that tribal warfare anymore, even the corporate wars are a thing of the past. Now we have the majors and their executives, Transport, Food, Communication, Housing, Luxury, Energy; a few of us making decisions on a global basis for the global good. ... Now everyone has all the comforts, you know that, no poverty, no sickness, no needs and many luxuries which you enjoy just as if you were in the executive class. Corporate society takes care of everything. All it asks of anyone, all it has ever asked of anyone ever, is not to interfere with management decisions."

Stated otherwise, corporate society offers utopia exacted at the price of free will.

Critical of the corporation's decision to separate him from his previous wife Ella, Jonathan refuses Mr. Bartholomew's request unless he is provided with an explanation for her removal. This explanation is not forthcoming. The depth of corporate invasion into private life subsequently becomes apparent. In response to Jonathan's disobedience and in an effort to persuade Jonathan to quit, either for his own safety or for that of his team-mates, the executives change the rules of the game, making it increasingly brutal and dangerous. The game against Tokyo is played without penalties and with limited substitutions. By the end of the film, the Rollerball players of Houston and New York must win at all costs: no penalties, no substitutions and no time limit; the game ends only when the last player standing scores the winning goal. However,

Jonathan resists this persuasion and triumphs. As he circles the burning track in victory, the crowd chants his name, seemingly affirming his mastery over the game and corporate dominance.

Although Jonathan does succeed in the game, partially justifying a reading of the film which affirms the individual, he does not affect social consciousness. At both the first and last games in the film the crowd chants "Jon-a-than, Jon-a-than," demonstrating, as Hull astutely notes, that "at the end of the film Jonathan receives no more than the same worship he received at the beginning. And the crowd worships him simply because he won and not for what he stands for as an individual".[4] The political and social enlightenment that motivates Jonathan's rebellion neither evokes political consciousness in the sport's spectators nor prompts social instability. Italian exploitation films such as Lucio Fulci's *Rome 2033 - The Fighter Centurions* (1983), and Joe D'Amato's *Endgame* (1983) borrowed the basic *Rollerball* plot, while emphasising violence over the evils of corporate capitalism. Yves Boisset's *The Prize of Peril* (1984) also presented a future world in which violence is presented as TV entertainment. Back in Hollywood, scriptwriter Steven E. de Souza and director Paul Michael Glaser mobilised the same point when they adapted Stephen King's none-too-original novel, *The Running Man* (1987) for the big screen. In this film the death of the contestants, the hunters and the show's host meet with an equal response. "The film . . . settles into a prolonged chase format as Richards [Arnold Schwarzenegger] is stalked by the network hunters, whom he dispatches in turn. Eventually he hooks up with the political underground and leads them to the studio, where he dispatches Killian, whose death is cheered by the fans with the same mindless glee the deaths of the previous running men had elicited".[5] In both of these examples of sport, the protagonist's perseverance derives from his personal and political motivations, which remain unacknowledged by the diegetic spectators enraptured by the spectacle of the violent sport. Despite, or in fact because of, Jonathan's actions in Rollerball, the game continues to succeed in its role: to efface political discourse and action. The more he struggles against the executives the more effectively the game fulfils its function.

Sports and Self-Mastery

By centring their analysis of depoliticisation on rollerball, Harrison and Jewison are articulating a trend in professional sports that Umberto Eco had identified half a decade earlier. Eco maintains that the practices of sports spectatorship and chatter diminish the capacity for political thinking and action. Playing sports is both a physical and intellectual tuning of the body that exorcises physical aggression, increases energy, and improves self-mastery. With sport spectation, or "sport squared", the spectator expels excess energy by gesticulating, but does not increase health, energy or self-control. "On the contrary, for the athletes are competing in play, but the voyeurs compete seriously (and, in fact, they beat up one another or die of heart failure in the stands)". Lastly, through the sports press, sport transforms into sports chatter: 'the discussion of sport as something seen. This discussion is in the first place that of the sports press, but it generates in turn discussion on the sports press, and therefore sport raised to the nth power. The discussion on the sports press is discourse on a discourse about watching others' sport as discourse.[6] Engaging in sports chatter exorcises social aggressions which unfortunately, Eco suggests, are necessary for political discourse and action. Chatter about sport exhausts political thought by imitating it.

"Chatter is the ersatz of political speech, but to such a heightened degree that it becomes itself political speech. Afterwards, there's no more room - because the person who chatters about sport, if he didn't do this, would at least realize he has possibilities of judgement, verbal aggressiveness, political competitiveness to employ somehow. But sports chatter convinces him that this energy is expended to conclude something. Having allayed his doubt, sport fulfils its role of fake consciousness."

4 Hull, p. 178.

5 Stephen Prince, *Vision of Empire: Political Imagery in Contemporary American Film* (New York: Praeger, 1992), p. 176.

6 Umberto Eco, *Travels in Hyperreality*, trans. William Weaver (New York: Harcourt Brace Jovanovich, 1986), p. 162.

A future world where violence explodes in duels to the death...

ENDGAME

AL CLIVER MOIRA CHEN JILL ELLIOT

Sports discourse is not simply the manipulation and corruption of an individual consciousness, however, although this is its irreducible locus. Instead, sports chatter is a self-similar phatic discourse: a discourse that has the appearance of communication but in practice discusses nothing of consequence. Sports chatter raises phatic discourse to its highest level, since it, first, can never influence the game, and second, does not address any social environment or effect.[7] Sports chatter serves a political function, therefore, by directing discourse away from society and politics. But more than just discourse, it directs all modes of action towards futile ends. Eco continues:

"Talk about soccer requires, to be sure, a more than vague expertise, but, all in all, it is limited, well-focused; it allows you to take positions, express opinions, suggest solutions, without exposing yourself to arrest, to loyalty oaths, or, in any case, to suspicion. It doesn't oblige you to intervene personally, because you are talking about something played beyond the area of the speaker's power. In short, it allows you to play at the direction of the government without all the sufferings, the duties, the imponderables of political debate."[8]

Eco's discussion of soccer, prefiguring Mr. Bartholomew's statement to Jonathan about rollerball, fits the latter sport equally well. Both of these sports (and by implication the actual spectator sports of which rollerball is composed) endorse the spectator's fervour in the game while ensuring that no one may "interfere with management decisions". The corporations employ rollerball to support a dualist and static social hierarchy maintained through this repression of political thought. The sport does not merely placate its participants and spectators, it impedes their epistemological capacities.

The paternalistic structure in this corporate society establishes the acceptable limits of both social interaction and information available to the general population. Mr. Bartholomew and Jonathan E. stand as metonyms of the two poles in this social paternalism. Following the first game, Jonathan cuts his finger while entering Mr. Bartholomew's office. In a sheepish manner he announces this to Mr. Bartholomew, who offers a handkerchief and then, somewhat pedantically, explains to Jonathan why he should quit rollerball, beginning with the phrase "let's think this through together".

The rigidity of these social boundaries is made plain throughout the film - executives are addressed by their surnames whereas all others are addressed by their first names (except Moonpie). Quite ironically, the executives occupy the role of social guardian. They have access to all information in all media but, in the name of the public good, restrict those below the executive class to copies of texts transcribed and censored by Zero, the central computer. Yet these same executives control the rules of rollerball, the sport that becomes increasingly violent, killing and injuring not only many of its participants, but its spectators also. By limiting access to such information as historical records and promoting rollerball, the executives protect social stability, and hence their own status. The less people know of history the less they understand the mechanisms of social change. Thus, when watching rollerball, executives and non-executives do so differently. Executives remain composed throughout the spectacle, surveying their construction. As long as spectators participate passionately in the fury of the game they are not directing their mental and physical energies outwards toward the corporate state.

To effect this total control over social practice, corporate society has to control not only information and knowledge, but also belief. Prior to each game an anthem is played on an organ, as was typical in the 1970s with such sports as ice hockey and baseball. This choice of instrumentation, along with the solemn melodies of the corporate anthems, betrays the absence of organised religions throughout the film; the corporations have successfully enveloped both church and state. This co-optation of religion is most evident at the beginning of the Tokyo game, where a sportscaster describes the

[7] Eco, pp. 163-5.

[8] Eco, p. 170.

unruly pleasures

On The Impossibility of 'Once Upon a Time...'

anthem as the 'corporate hymn'. Having eliminated religion and fused all power structures, the corporations have established themselves as the only authority.

Mr. Bartholomew's 'executives dreams' speech in the locker room following the Houston-Madrid game further reveals the epistemic restrictiveness of the society's paternalistic structure by evoking the metaphor of a social mind/body dualism. Having offered Moonpie corporate-sanctioned drugs, Mr. Bartholomew adds:

"You know what that habit will make you dream Moonpie? You'll dream you're an executive. You'll have your hands on the controls, you'll wear a grey suit, and you'll make decisions. But you know what, Moonpie? You know what those executives dream about, out there, behind their desks? They dream they're great rollerballers. They dream they're Jonathan. They have muscles; they bash in faces."[9]

The rollerballers, representing the social body, are relieved of the burden of decision and reason, whereas the executives, the social mind, avoid the vulgarity of an undifferentiated mass existence. Contrasting the executives and the rollerballers in Mr. Bartholomew's speech makes this division explicit: the executives wear grey suits (composing the world's grey matter) and therefore control social mechanisms intellectually, whereas the rollerballers are merely physical beings that perform externally-determined actions.

Simulation and Spectation

This dualistic structure in *Rollerball* strongly resembles Max Horkheimer and Theodor Adorno's reading of the Odysseus myth as a parable of "totalitarian capitalism" bound up with the myth of enlightenment. As Horkheimer and Adorno relate the tale, Odysseus binds himself to the mast of his ship and has his rowers fill their ears with wax. As they near the songs of the Sirens, which inevitably call their listeners to their doom, Odysseus' ship passes unharmed because the body (rowers) cannot hear the call and the mind (Odysseus) cannot will itself to move towards the Sirens independently.[10]

Horkheimer and Adorno argue that the social domination of the labouring classes does not pit freedom against slavery and servitude, but binds equally master and slave to each other in an unalterable path. Harrison and Jewison construct *Rollerball* similarly; the players, as the social body, cannot make decisions or determine their own paths and the executives themselves can neither undertake the violence of the public ritual nor alter the peoples' actions. Despite the executives' attempt to eliminate Jonathan's individualisation from the game, the spectators at the end of the film still cheer his name. Likewise, Jonathan's struggle against the executives ends up merely making the game more of a spectacle. Neither pole of the hegemony can alter the societal structure; Jonathan's final skate around the track offers no social progression. His defeat of New York and the executives only reaffirms the film's mechanism of social placation.

Within the film's seemingly civilised society, rollerball, the sport, escapes criticism for its brutality because of both its corporate sanction and its cult status. The devotion to the game extends beyond mere spectation to sports chatter, reducing the most inhumane elements of the game to sanitised statistics. For instance, while setting up to interview Jonathan, the multivision controller describes himself proudly as a statistician and proceeds to relate to Jonathan some factual details of the game. During this rendition, barbaric replays appear on the multivision screens in the background, both corroborating the statistics and reducing the violence to isolated facts. "The greatest number of points scored in a single game, 18; the highest velocity of a ball when actually fielded by a skater, 120 miles per hour; most deaths, ...9, Rome versus Pittsburgh, December last year; the greatest number of players and

9 Quoted in Hull, p. 167.

10 Max Horkheimer and Theodor W. Adorno, *Dialectic of Enlightenment*, trans. John Cumming (New York: Continuum, 1972), p. 59.

substitutes put out of action by a single player in a single game, 13, a world's record courtesy of your dear self". Undoubtedly, as Mr. Bartholomew, the statistics and the video footage attest to, rollerball is excessively violent, yet ironically, sanctioned as beneficial.

By reducing the game to 'highlights' and statistics, Jewison articulates this violence as the simulation of a different violence: war - not as armed conflicts over geo-political boundaries, but as the media spectacle that war has developed into in most western countries. Since corporations no longer compete (each produces something different to supply an organised web of distribution) and have merged into a metacorporation (the executives' video conference expresses this clearly), international war cannot exist. However, as class divisions persist, revolution poses the biggest threat to social stability. To elude this risk, the executives offer the visual spectacle of war contained within the limits of an arena. Since sport spectation deflects citizens from political thought and action, rollerball inoculates against armed conflict by providing limited yet potent violence which has no significant object.

Rollerball does not bear the brunt of depoliticisation alone; strategic deployment of this violent spectacle and the encouragement of its cult status develop the capacity to efface historical memory and, ultimately, history itself. The claim in the film that war has been eliminated refers not only to armed hostilities, but also to memories and records of them - wars future, present and past have been eradicated. Granted, characters in the film mention the wars briefly, but they cannot remember what the wars were about, only that they were brutal. Wars recede toward oblivion because of an inability to discuss them, founded upon a society-wide paucity of historical knowledge. That Clete, Jonathan's friend and trainer, speaks of corporations, sport and war in the same breath, but cannot remember details about any of them, indicates this absence:

"Hell, I forget which corporation is which. Any ass knows that fire is Energy. What about the music? Where does the music come from? Huh. . . . I forget what corporation's running what city. Chicago's still the food city. But what about Indianapolis? What ever happened to that town? . . . Ah, things were much simpler when I was a kid. We still had three nations. That was before the corporate wars, even before rollerball. . . . I remember someone telling me about the national football league and the world cup."

Jonathan asks Clete to elaborate on the development of the corporations and the corporate wars, to which he can only respond that "They were nasty, whew. Well, nobody ever talks about that". This erasure of war in historical memory is compounded by its absence in media - notably multivision and (electronic) books - and the omnipresence of both Jonathan and rollerball on multivision screens throughout the film. People remember Jonathan and the sport better than their own past. Jonathan repeats his question about the corporations, but Clete avoids answering and discusses Jonathan's rookie year instead. Similarly, Jonathan's personal memories about his first wife, Ella, are bound to his multivision tape of her. On the day that Daphne appears, one in a series of companions supplied by the corporation, Jonathan puts on his multivision tape of Ella, literally exteriorising his memories. Following Jonathan's trip to Geneva, Ella returns to Jonathan's house, at the request of the corporation, to persuade him to quit the game. Recognising that she is no longer part of his life, but an extension of the corporation, Jonathan proceeds to erase the tape of Ella, symbolically (perhaps literally) removing her from his memories.

The volatility of both personal and historical records in the film provides the mechanism for this society-wide amnesia. All publicly available information has been transcribed from books and other permanent media to computer records, separating content from material storage. While this transition does have the benefit that information can be disseminated rapidly

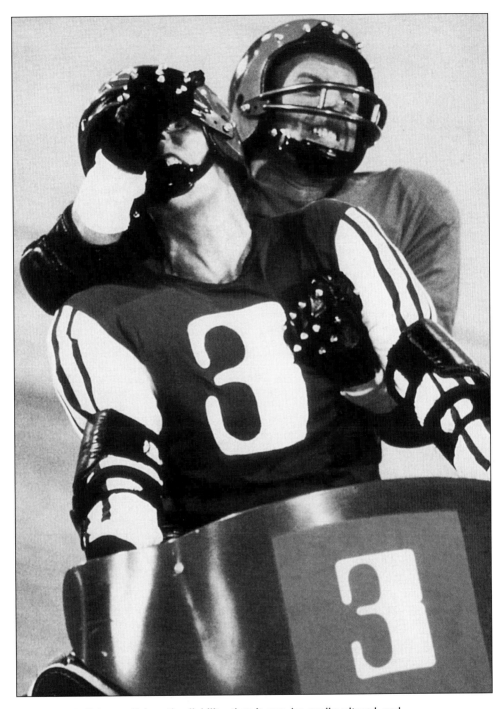

over a vast distance, it has the liability that it can be easily altered and damaged. More is at stake, though, than the need for an infallible backup. In *The Bias of Communication*, Harold Innis maintains that electronic media offer the benefit of being able to traverse vast geographic space rapidly but lack the material permanence and historical authority of non-volatile storage.[11] Ideally, a responsible society will employ both, utilising space-binding media to maintain a sense of community and time-binding media to sustain identity and historical continuity. In *Rollerball*, media with material permanence have all

11 Harold Innis, *The Bias of Communication* (Toronto: University of Toronto Press, 1964).

been translated into space-binding media - necessarily disconnecting knowledge from the verifiability of the material artefact. History and knowledge are only what they are recorded as being at any given moment. As the records of the past are depleted, so too is knowledge of the past, and in any practical sense, the past itself. With the evaporation of the past, people lose references against which they can consider their own social existence.

Rollerball makes explicit the dangers of this trend towards complete digitisation. Zero, the film's fluidic computer, is the epitome of a space-binding medium. Using water for computation and storage, the computer presents the extreme in ephemerality. The advantages of instant recall on any worldwide system are exacted at the cost of the loss of the permanent historical record, however. In one instance, the librarian informs Jonathan that Zero has lost the entire thirteenth century. This is neither a unique instance nor a severe problem, according to the librarian, but a symptom of an ongoing trend. He remarks that the loss of the thirteenth century is not significant though, since it contained only Dante and a few corrupt popes. This statement is itself symptomatic of the existent degradation of historical knowledge prior to Zero's complete erasure of this and other information.

Thus, corporate society doubly displaces social awareness and change by first diminishing the possibility of historical knowledge and second redirecting social energies towards futile ends. With the aid of the game, corporate society maintains the appearance of a stable society, with general parity within each of the two social tiers. Yet the film's attention to brutality and the personal struggle between Jonathan and Mr. Bartholomew betrays the dystopia underlying this utopian surface. Being a futuristic fiction, however, the object of this criticism is not limited to the society depicted in the film, but includes that on which the fiction is founded: early 1970s America. Produced in the heyday of televised sports, including the fictional spectacles of rollerderby and 'professional' wrestling, and following on the heels of severe political splintering and a rapidly forgotten Vietnam, *Rollerball* identified some dangerous trends.

On The Impossibility of 'Once Upon a Time...'

Disaster Films and Dangerous Trends

While *Rollerball*'s primary target may be the manifestations of burgeoning capitalism in both America and the western hemisphere, the film also implicitly engages the right-leaning politics of the disaster films of the early 1970s. According to J. Hoberman, films such as *Airport* (1970), *Earthquake* (1974), and *The Towering Inferno* (1974) insist that "America's enemies remained nature and/or technology. . . . [Disaster films] denied that Americans had become decadent or that consensus had shattered. Indeed, they suggested that the Sixties never happened. . . ."[12] *Rollerball* does not participate in this amnesia, but reveals its processes. These disaster films maintained that a fundamental social union could overcome external threats. *Rollerball* suggests, in contrast, that this consensus is founded on a false consciousness of sorts, which is manufactured and imposed by capital culture itself. He argues further that this division between American society and nature/technology is also a fabrication of capital society and is fundamentally misguided. Those living below managerial status are managed and controlled in the same manner as any other material resource. Corporate society, as the name suggests, effectively runs through the human species, placing executives firmly within society and those governed by them (comfortably) outside it. Staring into a pool of water in a bathhouse in Tokyo, Jonathan remembers Mr. Bartholomew's words and suffers a moment of clarity on this point. "Corporate society was an inevitable destiny. The material dreamworld. Everything man touched became attainable". Jonathan, his face and shoulders reflected in the pool, responds: "I've been touched all my life, one way or the other. Either caressed or hit. Don't much seem to matter which anymore". Like all those living below executive status, Jonathan belongs to the natural, not the corporate order. Being sub-executive he is outside of history and the realm of political intervention.

The corporate control of information technologies in the film helps to maintain this social division. Zero, when confronted by Jonathan requesting information about the nature and processes of corporate decisions, denies his request: "negative". Urged by the librarian, Zero finally offers the following tautologies, revealing not the process of decision-making, but the elements of social control. "Corporate decisions are made by corporate executives. Corporate executives make corporate decisions. Knowledge converts to power. Energy equals genius. Power is knowledge. Genius is energy. Corporate entities control all fundamental elements of economic life, technology, capital, labour and markets". Considered gibberish by the librarian, Zero's words identify the tautological and foundationless reason that underscores executive control. The citizens under corporate society live their natural lives without the possibility of political intervention because the possibility of intervention has been lost to censorship, computer error and rollerball; without knowledge, the masses remain without power. If, as Hoberman argues, the disaster film "suggested that the sixties never happened," *Rollerball* offers an explanation of how this could occur through its strategy of repeatedly supplanting history and politics with violent sport and the ephemerality of its transmission and commentary.

Jewison's film does not merely offer an abstract critique of spectacle and depoliticisation, however; its object seems more historical and concrete: the effacement of Vietnam in American society. A few elements about the film's release and similarities between events in the film and mid-1970s television reinforce this suggestion. First, *Rollerball* was released within the same year as the fall of Saigon. Second, rollerball incorporates almost every televised sport broadcast in the United States during the mid-1970s. Third, the trace of war as a forgotten object throughout the film points to the historical amnesia Hoberman discusses with respect to Vietnam. Fourth, the dissection of battles to televised highlights in our news broadcasts removes context, and with it understanding. Likewise, Jonathan's broadcast interview, which offers mostly clips and statistics, overshadows questions about Jonathan's reasons for leaving the

12 J. Hoberman, 'Vietnam: The Remake' in *Remaking History: Discussions in Contemporary Culture*, ed. Barbara Kruger and Phil Mariani (Seattle: Bay Press, 1989), pp. 175-96 (p. 181).

game. While knowing the replays in the interview not to be from a live broadcast, characters in the film nevertheless revel in the spectacle. So successful are the sports chatter and edited sequences at redirecting energy away from critical thought that, following the broadcast, people from the party proceed outdoors to senselessly incinerate trees with a firearm - a scene remarkably reminiscent of the pointless slaughter of wildlife in Renoir's *La Règle du jeu* (1939).

In addition to the violent content of multivision, Jewison also implicates the medium itself in the process of depoliticisation. Late in the film, just prior to the New York game, Jewison presents a montage sequence of both the rollerball arena and seemingly unconnected exterior shots, suggesting the ubiquity of this worldwide broadcast. In this montage sequence, the bowl-shaped arena is shown to resemble a satellite dish, suggesting a relationship between the two. If phatic discourse can be thought of as a carrier wave which allows communication but transmits nothing significant itself, then *Rollerball* shows that the technology of multivision has succumbed to entropy; the content of the satellite transmission is nothing more than another carrier wave, sport and sports commentary, phatic discourse, chatter without substantial content. Like the fluidic computer system, it is a mode of communication increasingly devoid of content.

If futuristic fiction does illuminate the present by extending its logic into the future, then *Rollerball* foregrounds the degradation of political discourse and historical memory as urgent themes. Rollerball in the film and its constituent 1970s televised sports both occur in the wake of war, yet deflect political contemplation of these and other social issues by replacing their representations with controlled violence void of political significance. But sport does not endure Harrison and Jewison's attack alone - it is an element of the machine that maintains corporate social organisation. Undoubtedly, the film aptly expresses an anxiety with the entrenchment of corporations in the mid-1970s along with a general failure of critical discourse. It also supports Ryan and Kellner's assertions about the fear of losing the individual through the expansion of corporate order. However, in the film these surface as symptoms of a greater loss: history itself. With this ceaseless effacement of the historical record, the film identifies the degradation of a politically-aware society with the immediacy of controlled violent spectacle. In the wake of Vietnam *Rollerball* expresses apt concerns. Screening the film today, however, one should not restrict its arguments to its historical moment of production. With the current consolidation of media, information and technology industries and the transmission of events such as the Gulf War, Bosnia and now Kosovo as game-like media spectacles, Harrison and Jewison's anxiety of an entropy of mediated violence through spectacularisation requires reconsideration. Ironically, a remake was mooted in 1999.

Michael Grant

I base my chapter on a consideration of Lucio Fulci's film *The Beyond* (1981). I contend that the film has many features in common with symbolist poetry, a mode of writing whose most brilliant avatar is Maurice Blanchot, and whose understanding of it can best be exemplified (in English at least) by reference to Eliot's *The Waste Land*.

I aim to show that like the symbolists, Fulci is attempting to explore that abyss, that interval, in which the horror of being, as such, the horror of material existence finds palpable realisation. In the same way that literature, as understood by Blanchot, is seen to be dedicated to the unthinkable uniqueness and singularity of things, so Fulci evokes a similar sense of exile, of utter hopelessness and abandonment in sound and image.

His film folds back on itself, in a sustained presentation that seeks to equate its own representation with hell itself, and the body of a living corpse to reveal an image of death, like the rotting cadaver of Lazarus, called forth not by the narrative but by cinema as such.

Hence, to say of *The Beyond* that it is a cult film is to say that it attaches to it a sense of the sacred, the awful. It is however, an intimation of the sacred that is perverse and fantastic. The film disengages itself from the world, not that it may transcend the world, since transcendence requires an access to meaning and the complexities of human motive. Rather, it does so in order to enter upon an interruption of time, a suspension of meaning. This is to reach to the threshold of true horror. Fulci's characters find themselves condemned to the suffocating and irredeemable presence of being itself. They enter 'the beyond' - lying beyond the grave, beyond the end and before the beginning, in an eternity of negation.

Biographical note: Michael Grant was born in 1940 and educated at Cambridge and Brandeis, where he studied English Literature. He is currently a Senior Lecturer in Film Studies at The University of Kent at Canterbury. Michael has edited *T.S. Eliot: The Critical Heritage* (Routledge, 1982) and written a monograph on David Cronenberg's *Dead Ringers* (Flicks Books, 1997). He has published extensively on modern poetry and horror cinema, and at the time of writing, his edited collection on *The Modern Fantastic: The Films of David Cronenberg* was forthcoming from Flicks Books.

Fulci's Waste Land: Cinema, Horror, and the Dreams of Modernism

Michael Grant

Horror as Modernism's Other

During the nineteenth and twentieth centuries art reached an awareness of itself that developed contemporaneously with the need for a new kind of criticism, one requiring a judgement not simply as to whether a given work is deficient in this or that respect but as to whether the work in question is art at all. From the beginning of the nineteenth century, with the onset of Romanticism, art began to make the matter of its own status central to what constituted it, and by so doing incorporated the problematic and ambiguous into its very essence. One need look no further than the titles of the early masterpieces of European horror cinema to see that works such as F.W. Murnau's *Nosferatu* (1922) and Carl Theodor Dreyer's *Vampyr* (1931) are also a products of the Romantic movement. Such texts also confront us with the question of their status: horror films were, and regularly still are, found to be offensive and trivial. Lacking the redemptive powers of art, they are thought especially worthy of censorship.

Condemned as trashily exploitative and sadistic, the films suffer as a consequence from mutilation, neglect and, what is worse, contempt. It is not to be denied that extreme violence, sexual degradation and grotesque forms of death are legion in the films of Dario Argento, David Cronenberg, Wes Craven, Tobe Hooper, Lucio Fulci, Ruggero Deodato, and many others. Yet I would argue that this is precisely the point: they are confronting us with death presented in especially offensive and unacceptable ways. It is the provoking of scandal and outrage that constitute the real significance of the horror film in our culture.

Language, Temporality and Ambiguity

Horror films have, on occasion at least, addressed themselves to the procedures and forms whereby they create what they create, and it is not too extravagant to suggest that films like *Vampyr*, Michael Powell's *Peeping Tom* (1960) and Lucio Fulci's *The Beyond* (which forms the focus of this chapter) exhibit an order of self-interrogation that has many features in common with the literature of modernism. These are features brought out by questions such as 'why write at all?' and 'how can the act of writing be justified?' Within modernism, literature becomes literature only as it becomes a question as to what counts as literature, and in order to show something of the significance of this degree of self-questioning, both for literature and cinema, I want to begin by considering what I have already pointed to as one of the abiding preoccupations of Romantic and modern writing, the ground of representation itself. To take a cinematic instance, the exploration of this issue is central to the project of *Vampyr*. Aporia and contradiction are fundamental to it, and Dreyer

accords them a particularly vivid and focused expression. The action of the film is situated ambiguously, in a world which is that neither of life nor of death. What happens in the film occurs elsewhere, in a place self-consciously created out of cinematic effects. For instance, Gray's first walk to the mill is both a narrative event and at the same time a disruption of the logical sequence of that narrative event. We are first presented with a disruption of the intelligibility of the relations between body and reflection, as Gray sees a figure, in reverse motion, reflected in the river, digging a grave. There is then a further fracturing of normal physical relations, when we see the corporal's shadow separate itself from his body. At the same time, the usual structure of narrative and temporal order is broken by a sudden, unmotivated irruption of music occurring when Gray enters the mill, an irruption which immediately seems to call forth the appearance of what look like cut-out figures, dancing or circling around each other. These different elements, combined with the sudden intrusion of the commanding voice of the vampire, compromise the meaning of the narrative at this point, rendering the presentation of events suspect. We cannot really be sure of what it is we are seeing. David Bordwell has argued that such a systematic dismantling of secure relations between the elements within the film extends to *Vampyr* as a whole.[1] The film aims to create a displacement of the presuppositions necessary to a stable spatio-temporal continuum.

This means that the narrative order of the film in its totality is not to be trusted. The status of what we are seeing has become undecidable, and as a result the temporal progression of the events we see has also become uncertain. The only order of time that we can trust is the time it takes for the film to be seen, the time it takes for the reels of film to pass through the projector and to cast an image on the screen and to bring up sound through the speakers. It is in this sense that *Vampyr* can be said to resemble music. The action that is represented and the process of representing that action have been collapsed into one, so that the time it takes the events we see to elapse and the time it takes to show us those events are one and the same. What *Vampyr* narrates, we might say, is the occurrence of the events that compose it, in the very instant that it is narrating the events themselves.

It is writing conceived of on the model of post-symbolist procedures that *Vampyr* most nearly answers to. It is when the events a poem narrates are the events that constitute its own unfolding that we are cast into what the French critic, Maurice Blanchot, has called a time before the world, before the beginning. In the symbolist poem, the work says what it says in the very gesture of saying what there is for it to say. The only happening in the poem is the happening of the poem itself: a world is described, and, in that same act of description or definition, created. Here, the act of creation turns back upon itself, becoming other than, and exterior to, itself. Hence it is possible neither to begin nor to end, since the words of the poem are already beyond themselves, elsewhere. As Eliot has it, in *Burnt Norton*:

> The end precedes the beginning,
> And the end and the beginning were always there
> Before the beginning and after the end.
> And all is always now.

We cannot begin, since the beginning is always already begun, and we cannot come to an end, since the end is always already completed, in a time before the beginning.

The Horror of Writing: T.S. Eliot's *The Waste Land*

To use Blanchot's idiom, such an effect betrays the work of the poem to worklessness (*désœuvrement*). By this he means that the poem is split from itself, in a movement of double negation that turns it towards the outside, the exterior, beyond language and concept, where, as he puts it, there is no

[1] *The Films of Carl-Theodor Dreyer* (Berkeley and Los Angeles: University of California, 1981), p. 103.

intimacy, no place to rest. The work says the nothing that is the condition of its simultaneous possibility and impossibility. An example of this effect is given below, from Eliot's *The Waste Land*:

> *What are the roots that clutch, what branches grow*
> *Out of this stony rubbish? Son of man,*
> *You cannot say, or guess, for you know only*
> *A heap of broken images . . .*

The poem is nothing other than what it constitutes itself as: a language of 'broken images'. The reader, caught within the language of the poem, unable to move beyond it, is, at the same time, exterior to it as it narrates the passage of its own negation:

> *A heap of broken images, where the sun beats,*
> *And the dead tree gives no shelter, the cricket no relief,*
> *And the dry stone no sound of water.*

Blanchot's prose, which often reads like a rhapsodic commentary on *The Waste Land*, says of this mode of writing: "The work declares being - and says choice, mastery, form - by announcing art which says the fatality of being, says passivity, and formless prolixity".[2]

At the conclusion of *Vampyr*, the mechanism driving the mill wheels that are drowning the doctor in flour finally stops, under its own volition and without visible cause. The doctor has been assimilated to the whiteness of the flour, a whiteness which is finally inseparable from a whiteness that has come to dominate the balance of light and shadow across the whole film. This fact is made evident in the penultimate sequence, when Gray and Gisèle move across the water into the light of the dawn sun. As they step out of their boat onto the river bank, they walk into, and are transfigured by, the intensifying rays of light streaming through the forest. Suffusing the mist rising around the branches, the light comes to acquire almost as palpable a material presence as the objects it illuminates. And at this juncture, we cut back to the mill. The whiteness of the flour has by this time so filled the projected image that there

[2] *The Space of Literature*, trans. Ann Smock (Lincoln, London: University of Nebraska Press, 1982), p. 244.

The Beyond

appears no discernible difference between it and the whiteness of the screen behind the image, and it is in this moment of assimilation of the image to its support that the movement of the mechanism comes to a halt. The seeming coincidence of the image and the screen behind it is doubled by the fact that the movement of the mill gears and that of the projector showing the film also appear to coincide. The two movements collapse into a single duration, as the teeth of the gears and the sprockets of the projector gears appear to mirror one another, in a concurrence that effectively links an action internal to the film with an action external to it. It is as though the film were being completed in a time that had already been superseded, inasmuch as it has been this same action, the action of the mechanisms of the projector, that began the film and that has continued to sustain it throughout the time of its showing.

The complex undertaking represented by Dreyer's kind of cinema is presented by Blanchot in relation to literature as something double. To see *Vampyr* in these terms is to say that the film exists as a movement through which whatever is imaged is abolished; and yet whatever is abolished is sustained, since the being of the thing is taken up into the being of the image. It is the experience of the interval or abyss of the meanwhile, and art - symbolist art like that of *Vampyr* - has as its aim the bringing about of the duration of it. The meanwhile of the film is never finished, and because it can

never end, we may see it as something shadowy, almost inhuman, monstrous, as a death doubling the impulse to live.

Lucio Fulci's Waste Land

If we are to accord this way of thinking its due weight and seriousness, then we must recognize that art of this kind has come upon states of mind and modes of experience that are accessible only by virtue of a specific employment of image and narrative, similar to that of post-symbolist poetry. And what this kind of experience gives onto is the true horror, the horror of the uncanny and the fantastic. It is the return of being in negation, the impossibility of death, the universality of existence even in its annihilation. It appears to us in the obsessions and insomnias of the night, and it is fear of being, not fear for being, fear of death. In the words of Levinas, "it is a density of the void, like a murmur of silence", and it is beyond contradiction.[3] It is the condition described by Eliot in *The Hollow Men*: "Shape without form, shade without colour,/Paralysed force, gesture without motion". And we find it also explored in Lucio Fulci's *The Beyond*.

Released by Fulvia Film (Rome) in 1981, the film takes up the motif of the gateway to hell from *The Sentinel* (Michael Winner, 1976) and living dead imagery based on George A. Romero's first two zombie films. The story opens in Louisiana, 1927. A posse, bearing torches, rifles and chains, is rowing across a lake towards an isolated hotel. Inside the hotel, Schweik, an artist, is completing an indistinct landscape, littered with grey shapes, perhaps corpses. The men burst into the hotel and seize him, the leader of the group accusing him of being a warlock. They beat him mercilessly across the face with a heavy chain. They then take him to the hotel's cellar, crucify him, and throw acid over his head, watching him as he dissolves in agony. At the same time, a young woman, Emily, is reading from the book of Eibon, which contains ancient prophecies concerning the seven sacred gateways into hell. Schweik is then walled up.

In 1981, Liza Merrill arrives from New York to claim the hotel, which she has inherited. On the way, Liza meets Emily, who now is blind. Emily takes Liza to the house where she lives, and warns her to leave the hotel immediately. Instead Liza decides on its renovation. At the same time, Martha, the hotel's Mrs Danvers-like housekeeper, guides Joe, a local plumber, towards the far end of the hotel's cellar, which is flooding, to find out where the water is coming from. He knocks down the wall entombing Schweik's body, and is killed by a hand that reaches out and seizes him.

Mary Ann, Joe's wife, goes to the hospital mortuary to prepare her husband for his funeral, when she falls, and lies unconscious at the foot of a cupboard, on which stands a large bottle of acid. The bottle tips forward, spilling its contents over her head, which dissolves into a sea of bloody foam. Later, Martin Avery dies in the town library. John McCabe, a doctor, investigates Emily. He goes to her house, only to find it in ruins. Here he discovers the book of Eibon and reads in it that the hotel stands on one of the seven gates to hell. In the hotel, Martha is cleaning the bathroom of Schweik's former room. She puts her hand into a bath of foul black water, and frees the plug. As the water drains away, Joe arises from the water, and drives Martha back, impaling her head on a large nail sticking out of the wall. Schweik appears before Emily, summoning her back to hell. She refuses to obey. Her guide dog tears out her throat.

Liza is set on by the dead in her hotel, but escapes with McCabe to the hospital, pursued by 'living' corpses from the morgue. They escape down to the basement, only to find that they are back in the cellar of the hotel. They pass through the holes in the walls, into a landscape that seems everywhere the same. It is the landscape of the painting Schweik completed at the time of his destruction, and it is the site of hell.

3 *Existence and Existents*, trans. Alphonso Lingis (The Hague, Boston: Martinus Nijhoff, 1978), pp. 63-64.

Beyond *The Beyond*: The Language of the Void

As this summary should indicate, the plot is anything but concisely organised. Elements are pulled in from many sources, and strung together in a series of set-pieces, involving various degrees of violence and bodily mutilation. Of these, the opening sequences are the most striking, as Schweik is crucified by the posse and dissolved in acid. The score, by Fabio Frizzi, dominates the sound track, carrying over to the reading by Emily from the book of Eibon. The same musical motif recurs throughout, especially at moments of violent death, such as Mary Ann's and Martha's. The music, rather than the narrative, is the cohesive force in the film, through its repetitious insistence drawing the disparate narrative events together, and emphasising pace and rhythm at the expense of motivation or psychological insight. The effect is of visuals and music seeming to cohere in a unified sound-image. This is brought home at the end of the film, when Schweik's painting has come to fill the screen, accompanied by the throbbing musical score. It is precisely at this point that Liza and McCabe are recognised as having become part of Schweik's landscape, which he completed as the film began, a painting which does not simply depict hell, but is it. The film's end is established at a point prior to its beginning, and the organisation of its temporal development identified with that of a painting internal to it. The role of music and rhythm in achieving this effect of reversal, whereby the end becomes the beginning, and the exterior the interior, is similar to the role of rhythm in *The Waste Land*, where, as we have seen, words impose themselves on us, disengaging themselves from reality, and (we may want to say) making us part of them. For Levinas, rhythm understood in these terms is what constitutes the duration of the interval. Words in poetry impose themselves on us without us assuming them:

"Or rather, our consenting to them is inverted into a participation. Their entry into us is one with our entry into them. Rhythm represents a unique situation where we cannot speak of consent, assumption, initiative or freedom, because the subject is caught up and carried away by it." [4]

Levinas is speaking here as we saw Blanchot do earlier. He believes that in poetry the subject enters into its own representation, so that the self exists no longer, having become an anonymous or impersonal shadow of what it formerly was. What this means becomes clear if we think of the way the reader is captured by the incantatory movement of Eliot's writing: "...you are the music/While the music lasts". Our consenting to the music, or the poetry, is inverted into a participation, in which initiative and freedom are lost.

The disruption of tenses in a symbolist poem disrupts and discredits retrospectively the whole tense sequence of the poem, so that the reader has nothing to fall back on except the duration the poem takes in the reading. The symbolist poem is "a falling movement on the hither side of time, into fate".[5] A disruption of comparable order takes place in *The Beyond*, but it does so at the level of the image, not the word, when image and what is imaged become one, as the film concentrates at the end on Schweik's painting. This echoes a point basic to Levinas' conception of art. For him, the most elementary procedure of art is to substitute an image for an object. And an image is not a concept. "A concept is the object grasped, the intelligible object. Already by action we maintain a living relationship with a real object; we grasp it, we conceive it. The image neutralizes this real relationship".[6] Like the Hegelian name, the image neutralises, annihilates, the object. The effect of Schweik's painting is to incorporate into the film the symbolist logic of the word, discrediting the narrative, and revealing its bondage to the inexorable duration of the interval. Seen in retrospect, the elaboration and spectacle of the film's many deaths reveal the film's fixity and subordination to a time impotent to go anywhere except interminably back to its beginning. A corpse rises from the foul water of the bath, in an obvious reminiscence of Clouzot's *Les Diaboliques* (1954), and Martha steps back before a horror she is unable to escape. She is

[4] *The Levinas Reader*, ed. By Sean Hand (Oxford: Blackwell, 1989), p. 132.

[5] *Existence and Existents*, p. 139.

[6] *The Levinas Reader*, p. 132.

held by the fact of its presence, by the fact that it is dead and yet before her: confronting it 'alive', she confronts a death that is not dead enough. For the viewer, this effect is reinforced by the Clouzot reference, in as much as the corpse seems summoned forth, not so much by the powers of hell or Schweik, as by the cinema itself. Death has become a sound-image, composed of elements we have seen or heard before, including the nails, the corpse rising from the black water, the music, the violation of the head, the moaning, as well as elements deriving from other films. These are the plastic elements which fix and immobilise the characters in time. The death we see is a death effected, not by motive or significant action, but by the image understood as Levinas and Blanchot understand it, as the site of a repetition, which the characters in the film and we, the viewers of the film, are equally impotent to resist. The housekeeper takes her place among the undead. Emily refuses the summons of her fate, and her death, her throat torn open by her guide dog, is the repetition of a similar episode in Dario Argento's *Suspiria* (1977).

Films of this type disengage us from the world, not in order to go beyond it, since this requires meaning, and the complexities of human action, but so that we may enter an interruption of time, similar to that effected in Eliot's poetry, where a quasi-eternal instant is created, aside from time, offering the horizon of a future which will never come. "Words, after speech, reach/Into the silence." In this realm, the priority of the concept is displaced, and we find ourselves submitted to fate. This is not the fate of rational law or universal necessity, but of a present, where "all is always now", constituted by the eternally suspended future of poetic rhythm and the image. Fate has no place in life. The fate of art is that of the statue, suspended in an immobile instant, where, according to Levinas, "the power of freedom congeals into impotence. And here too we should compare art with dreams: the instant of the statue is a nightmare".[7] The fate of art is also that of the narrative. The being of a character is immobilised in it, committing characters in novels and films alike to the infinite repetition of the same acts and experiences. Nothing in the narrative initiates life, and in *The Beyond* Fulci acknowledges the fact, immobilising death and forming it into a series. Death subordinate to repetition is impossible, and just as Liza and McCabe are fated to wander endlessly through the world of Schweik's hell so under Fulci's direction

[7] *The Levinas Reader*, p. 139.

The Beyond

freedom congeals into impotence. The characters of *The Beyond* are fated to a death that is always the same, suspended in the fixity of the film, not only because the film can be seen over and over, but because they each experience in their dying the nightmare of the interval. *The Beyond* does not reproduce time; it has its own time, a time of fixity. Time cannot shatter this fixity, despite the fact that cinema unrolls in time, since it is the fixity of the interval, and the interval stands aside from time. In *The Beyond*, the work is lost; going beyond itself it unites with its origin, establishing itself in impossibility. Fulci has created a cinema out of an image of writing. He has taken narrative beyond itself, as a condition of its existing, and it is only because the being of the characters can be doubled into the beyond that he finds their actions worth narrating at all.

Seen in this light, the film is nothing other than a catalogue of notations of its own aesthetic, and it exhibits them everywhere, in the blind yet seeing eyes of Emily, the appearance and disappearance of the hotel plans, the hotel itself, the undead, and, most significantly, Schweik's painting. The characters become elements of its plastic composition, in a transformation that defines the aesthetic undertaking of the whole film. Characters constantly die into the beyond constituted by their images, a doubling we first see in the death of Schweik himself, who returns from the dead, still in the atrocious condition in which he died. Like the Lazarus of Blanchot, he is not resurrected into the sunlight; he remains in the tomb, and of the tomb, and is evil, lost. Similarly with the hotel: putrescence and rot pervade it, and the dead dwell there. As with the 'old houses' in Argento's *Suspiria* and *Inferno* (1980), the hotel exists suspended in the empty place between life and death, inseparable from an image of itself that has disappeared, and ultimately no character is possessed of the power to escape it. The degradation of the world represented in Fulci's film is in effect a degradation marking the reversal by which reality is removed, and replaced by the shadow of the image. All darkens into the shadow of the beyond, and this peculiar death of the shadow serves in Fulci's hands to undo the narrative from within, inverting it into what is at once an image of death and a dead image. This view of the film is supported by the wording of the original Italian poster for the film: *...E Tu Vivrai Nel Terrore! L'Aldilà*. Reading this as '...And you shall live in terror! The Beyond', it points towards the notion of a future conditional on the past, a terror beyond, beyond the grave, beyond the end and before the beginning, in which you shall live. This is the threat that for Levinas appears in the approach of the interval; there can be no retreat from it, but the approach never ends.

Fulci's Waste Land

Liza and McCabe are lost in a place where to go forward is to go back, and where every beginning is simply a repeated end. "If all time is eternally present/All time is unredeemable": Eliot's words are an exact definition of Fulci's hell. And yet the film at its end pulls back, with a crane shot, away from the place of darkness, which the voice of Eibon tells us we are condemned forever to explore, into the painting, and finally away from that also. Here is the final ambiguity, that to dwell beyond, in the place outside, in the impossibility of the possible, is possible only at the cost of the impossible: to achieve this final ambiguity, for Fulci, as for a post-symbolist like Eliot, would be to achieve a condition of "complete simplicity/(Costing not less than everything)".

The consciousness induced by the horror film is therefore exterior to itself, and attenuated, incapable of mastery over its own negativity. In *Vampyr*, in the classic scene of Gray's dream, Gray sees himself being buried alive, while he is nonetheless dreaming elsewhere. It is as though my consciousness were present to me, but without me, lacking me. There is much in this that is similar to the state of consciousness that a symbolist poem like *The Waste Land* aims to induce. The central consciousness of the poem is that of Tiresias, an old man with wrinkled breasts, who has walked amongst the lowest of the dead, a prophet gazing, like Orpheus, into the night at what the night is concealing. So with *Vampyr*: the characters and figures called up are similarly spectral, their identities shifting and uncertain. Their existence is an existence coterminous with the existence of the sounds and images that create the film, and to participate in that existence, as a spectator of the film, is to participate in something neuter, as Tiresias is neuter, and the vampire, Marguerite Chopin. Gray's experience is like that of the narrator of Poe's *The Premature Burial*, who, though beyond death, is unable to die. Gray is caught up beyond himself, as we are with him. He is solicited by images from which he cannot escape, condemned to the empty interval of dying, of the impossibility of dying. In *Vampyr* and horror films like *The Beyond*, the dead are conscious of being dead, and so unable to die. They induce us to approach them, but in doing so we find ourselves as other, where what we hear is the echo of our own step, a step towards silence, towards the void.

Leon Hunt

The 'cult film' is always defined in relation to something else - an amorphous 'mainstream', contemporary cinema, one's indigenous national cinema (or Hollywood), or simply 'what everyone likes' - even if its cultishness often has more to do with its consumption than some inherent textual quality. Like many cult films, *Enter the Dragon* once inhabited the 'mainstream' (at least partly) - distributed by a Hollywood studio and one of the major Box Office hits of 1973-4. But not all of its 'cultishness' was bestowed in retrospect by loyal keepers of the flame after the early '70s 'Kung Fu Craze' fizzled out. The film's star, Bruce Lee, was already dead by the time of its release, already the subject of an elaborate mythology - fighter, philosopher, pin-up. Furthermore, like the more recent (Chan- and Woo-centred) Hong Kong cult, the film offered to curious westerners, limited exposure to cultural difference. The Lee cult is as strong as ever - check out the meticulous archaeology of his letters, interviews and essays, the video documentaries, his face (and body) on T-shirts and posters. Factions within Hong Kong fandom (that is, Western Hong Kong fandom) have carved out another shrine for Lee - as a site of authenticity ('real' kung fu, few camera tricks, a Bazinian insistence on the long take) in contrast to the wirework, under-cranking and special effects of '90s kung fu stars like Jet Li. Add to that the references in *Enter the Dragon* to blaxploitation, to Vietnam, to an earlier notion of Pulp Fiction (Sax Rohmer), the clothes, the hair, the music, and you have the kind of cult cool Tarantino can only dream of.

Biographical note: Leon Hunt is a Lecturer in Film and TV Studies at Brunel University. He is author of *British Low Culture: Safari Suits and Sexploitation* (Routledge 1998) and has written about Early Cinema, the Epic, Italian Horror and Martial Arts films. He has contributed to *You Tarzan: Masculinity, Movies and Men*, *Necronomicon*, *Framework* and *British Crime Cinema*.

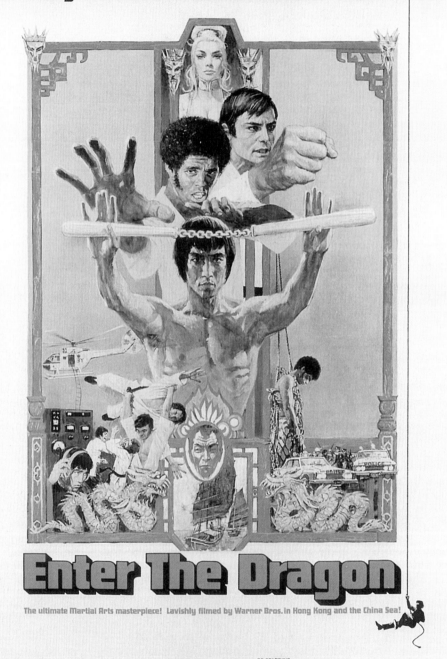

Han's Island Revisited: *Enter the Dragon* as Transnational Cult Film

Leon Hunt

"This 'unique' dragon (the Chinese, the spiritual, etc.) is not one of those Won Ton Kung Fu flicks from H.K. . . . (the title) 'Enter the Dragon' suggests the emergence (the entrance) of someone (a personality) that is of quality."
Bruce Lee [1]

Hong Kong in Action

For fans of 'Hong Kong action', 1998 was a key year. Jackie Chan, the biggest star in Asia, finally 'arrived' in Hollywood with the Top 10 hit *Rush Hour* (Brett Ratner, US 1998). Chow Yun Fat and Jet Li made Hollywood debuts in *The Replacement Killers* (Antoine Fuqua, US 1998) and *Lethal Weapon 4* (Richard Donner, US 1998), respectively; Michelle Yeoh had just beaten them to it as a 'Bond Girl' in *Tomorrow Never Dies* (Roger Spottiswoode, US/UK 1997). But for an older generation of fans, the restoration of Bruce Lee's *Enter the Dragon* (Robert Clouse, HK/US 1973) was the key event, and a reminder of an earlier 'crossover', from cult to mainstream, from East to West. While *The Replacement Killers* has been described as "a film which competently integrates the best levels of American and Hong Kong action cinema . . . an example of an original transnational film",[2] *Enter the Dragon* was arguably the first transnational Chinese-American action film.

Enter the Dragon takes place on an island - Han's Island was mooted as a title - an island, appropriately, of uncertain nationality. At one level, this seems like a reference to Hong Kong, given that Han's Island rests partly in British waters. But what Hong Kong and *Enter the Dragon* share is a similar sense of hybridity, of uncertain ownership and cultural affiliation. The film is most frequently damned as inauthentic, neither one thing nor the other - too cheap and tacky for Hollywood, too cynical and prepackaged for Hong Kong. According to Stephen Teo, its "Chineseness . . . does not integrate well with the Western sense of narrative decorum",[3] as though this hybridity was doomed from the start. Tony Rayns, meanwhile, represents the orthodox view that it attempts to "crossbreed a Sax Rohmer revival . . . with the most thoroughly discredited aspects of the James Bond ethic",[4] later concluding that it was "better forgotten".[5] *Enter the Dragon* has, of course, not been forgotten - it's a key reference point for kung fu/'China'/Hong Kong imprinting themselves on the western popular imaginary. Moreover, the gleeful hybridity of recent Hong Kong cinema - Kevin Costner's *The Bodyguard* (Mick Jackson, US 1992), remixed to accommodate Jet Li's kung fu skills, becomes *Bodyguard From Beijing* (Yuen Kwai, HK 1994), for example - does much to problematise these lurking implications of 'pure' national cinemas. Nevertheless, the film's enduring appeal seems a predominantly western (and Japanese) phenomenon. It was less successful in Hong Kong than early Lee films like *Fist of Fury* (Lo Wei, HK 1972) and *Way of the Dragon* (Bruce Lee, HK 1972). "Rarely,

1 John Little (ed), *Bruce Lee Library Volume 5: Letters of the Dragon* (Boston, Rutland, Vermont and Tokyo: Charles E. Tuttle Co., 1998) p. 181.

2 Tony Williams, 'Replacement Killers', *Asian Cult Cinema*, Issue 19 (April 1998), pp. 29-31 (p. 30).

3 Stephen Teo, *Hong Kong Cinema: The Extra Dimension* (London: BFI, 1997), p. 118.

4 Tony Rayns, '*Enter the Dragon* (Review)', *Monthly Film Bulletin*, Volume 41, Number 480 (January 1974), p. 6.

5 Tony Rayns, 'Bruce Lee: Narcissism and Nationalism' in *A Study of the Hong Kong Martial Arts Film*, 4th International Hong Kong Film Festival (Urban Council of Hong Kong, 1980), pp. 110-112 (p. 112).

6 Bey Logan, 'Enter the Dragon: What Really Happened Behind the Scenes', Martial Arts Legends Presents Bruce Lee (August 1998) 19-32 (p. 19).

7 Bey Logan, Hong Kong Action Cinema (London: Titan, 1995), p. 43.

8 Ackbar Abbas, Hong Kong: Culture and the Politics of Disappearance (Minneapolis and London: University of Minnesota Press, 1997), p. 25.

9 Abbas, p. 23.

10 S.N. Ko, 'Under Western Eyes', in Changes in Hong Kong Society Through Cinema, 12th Hong Kong International Film Festival (Urban Council of Hong Kong, 1988), pp. 64-7 (p. 64).

11 Ko, p. 66.

12 Mike Roote, Enter the Dragon (London: Tandem, 1973), p. 57.

13 Abbas, p. 4.

14 Abbas, pp.7-8.

15 Anne T. Ciecko, 'Transnational Action: John Woo, Hong Kong, Hollywood' in Transnational Chinese Cinemas: Identity, Nationhood, Gender, ed. Sheldon Hsiao-peng Lu (Honolulu: University of Hawaii Press, 1997) pp. 221-237 (p. 223).

16 Robert Clouse, The Making of Enter the Dragon (Burbank, California: Unique Publications, 1987), p. 43.

if ever," Bey Logan suggests, "has one film with one star loomed like such a colossus over a genre",[6] but he admits that the comparison is with other American Martial Arts films. Elsewhere, he acknowledges that Lee's long term influence on Hong Kong cinema was "negligible" and that the "big Chinese hits released the year after his death . . . look pretty much as they would had Bruce never returned to Hong Kong".[7] I do want to suggest, however, both that there's rather more 'Hong Kong cinema' in Enter than tends to be acknowledged and that, in any case, Western fans (who may also include diasporic Chinese) have some right to Bruce Lee's crossover film - Lee was himself a transnational, trans-Pacific. If Enter is heavily contested - breakthrough or sellout? - that's because Lee is, too.

What makes the film's Hong Kong-ness problematic is the slippery, shifting sense of what constitutes 'Hong Kong', not only as a colonial or post-colonial space, but also a marketable, international cinematic commodity. By the 1970s, Hong Kong itself was a comparative representational absence, not least from Hong Kong cinema. Ackbar Abbas has argued that prior to the emergence of the 'New Wave' (Tsui Hark, Ann Hui) in the late 1970s and the signing of the 1984 Joint Declaration returning Hong Kong to China, "stories about Hong Kong always turned into stories about somewhere else, as if Hong Kong culture were somehow not a subject".[8] It was impending reunification which enabled Hong Kong to see itself "with new eyes", discovering "itself as a subject"[9] - most critics operate on the implicit agreement that Shaw Brothers, Bruce Lee and Chang Cheh's Shaolin cycle barely belong to the same national cinema as John Woo, Tsui Hark and Wong Kar-Wai. Meanwhile, Western representations of the city traditionally presented a socio-geographically unspecific 'exotic' space akin to Sternberg's Shanghai or Morocco,[10] or, by the time of The World of Suzy Wong (Richard Quine, US/UK 1960), "an approximation of late 19th century Paris, a city of some seedy exoticism and dubious charm".[11] The novelisation of Enter the Dragon finds Williams (Jim Kelly) "digging the Suzie Wongs" and observing that "the miniskirt had caught up to Hong Kong".[12] Enter the Dragon adheres to the image of Hong Kong as a space of transit, "a doorway, a point in between"[13] - by implication, in between China and the West. Lee (Bruce Lee), Roper (John Saxon) and Williams pass through on their way to Han's island, Williams pausing to reconfigure it as a universalized ghetto ("the same all over the world"). Kung fu put Hong Kong cinema on the international market, but the genre itself seemed to signify an abstracted 'China' rather than the island itself.

Early '70s kung fu was Mandarin-language (in a predominantly Cantonese-speaking city), made by studios and talents largely transplanted from Shanghai and with visible influences (and technical expertise) from Japanese samurai films. Japan - often vilified in the '70s films - remains a key influence, only now the reference point is manga/anime rather than samurais and judo sagas. The 'new' Hong Kong action cinema, by contrast, was neon-lit, cosmopolitan, hi-tech and awesomely cool - predominantly, a cinema of hair gel and shades, not pigtails and nunchakus. Hong Kong cinema may have "found itself", but authenticity didn't come into it - according to Abbas, this new sensibility was "posited on the imminence of disappearance", a disappearance manifested in terms of ephemera, speed and abstraction.[14] Hybridity is just one expression of this - John Woo, for example, has described the gangster society of his films as "a hybrid of all the worlds of all the films I loved, an imaginary place recreated from the (American) gangster films I saw when I was young".[15] This suggests a type of transnational dreaming, a useful idea for rethinking Enter the Dragon. Admittedly, the film rests more on the West dreaming about the 'Orient', but Lee's presence and influence complicates the image-flow.

Director Robert Clouse rather notoriously claimed that he had to "kick the strut" out of Lee to make him palatable for international audiences, citing a gesture well known to fans of his Hong Kong films - "he slid his thumb across his nose like they used to do in American gangster movies of the '30s".[16]

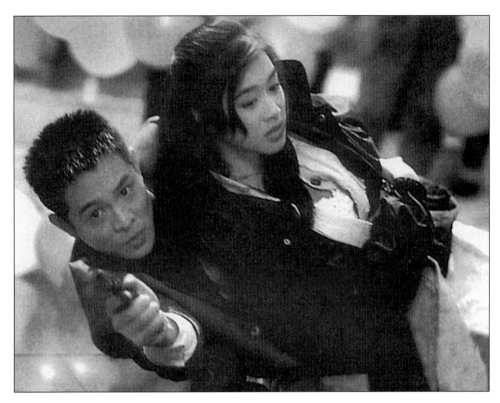

Bodyguard From
Beijing

Chow Yun Fat, too, seems to have been 'de-strutted' for *The Replacement Killers*. But when Clouse extracts his foot from his mouth - a style of kung fu much practiced by Western film-makers - he describes "the new Bruce Lee" as a "mosaic".[17] He has clothes, in particular, in mind - a combination of "beautiful silk Chinese suits" and ('70s fashions permitting) sharp western tailoring (shades of the debonair Chow). If this suggests a rather culturally polarised wardrobe, one might also mention the tight, black jump-suit Lee wears in the underground cavern scenes which suggests a less geographically overdetermined generic space.

Blurring the Boundaries of Cult Status

In Sheldon Hsiao-peng Lu's anthology *Transnational Chinese Cinemas*, transnationalism describes not only the way contemporary global capitalism operates, but the blurring of national cinematic boundaries through international markets, foreign investment and co-productions. Lu demonstrates that Chinese cinemas were transnational from the start - the first Chinese feature, *The Difficult Couple* (1913), was made by a US company based in China and there were abortive plans in the 1930s to build an 'Oriental Hollywood' in Shanghai. This scenario is now much more pronounced, both because of the tripartite terrain of 'Chinese cinema' (Mainland, Hong Kong, Taiwan) and because all three are part of the global market. In addition, Hong Kong and other émigrés are creating a "nascent Chinese American film . . . a transpacific, transnational Chinese film culture".[18] The book includes persuasive accounts of both John Woo and Jackie Chan as transnational Chinese figures,[19] but Lee is little more than a footnote, despite the fact that he anticipates both men. Like Chan, Lee was employed as a performer of action; like Woo, he was employed as an orchestrator of action - he choreographed (some might say directed) the fight scenes in *Enter the Dragon*. Like Chan (but unlike Woo), Lee brought other Chinese talent into his 'crossover' film - eagle-eyed aficionados like to spot Chan himself, Samo Hung, Yuen Biao, Yuen Wah (Lee's acrobatic stunt double) and Lam Ching-ying amongst *Enter*'s stunt team.

17 Clouse, p. 44.

18 Sheldon Hsiao-peng Lu, 'Historical Introduction: Chinese Cinemas (1896-1996) and Transnational Film Studies' in Lu (ed), pp. 1-31 (pp. 18-19).

19 Anne T.Ciecko, *op.cit.* and Steve Fore, 'Jackie Chan and the Cultural Dynamics of Global Entertainment' (pp. 239-262) in Lu (ed).

The film was a co-production between Warners' subsidiary Sequoia and Golden Harvest's Concorde (Lee and Raymond Chow), written and directed by Americans with a predominantly Chinese crew - it's Lee's input on script and direction which partially qualifies this distinction between primary (American) and secondary (Chinese) labour. Warner Brothers were the prime movers in the western incorporation of kung fu, and of Lee, who had already had a less than happy experience with them over what was to become *Kung Fu* (ABC 1972-5). More importantly, Warners had picked up Shaw Brothers' *King Boxer/Five Fingers of Death* (Cheng Chang-Ho, HK 1972) for distribution and had an unexpected hit with it (the film outgrossed the first two Lee films in Britain and the US). Clouse attributes this initiative to Warners' head of Asian distribution, Richard Ma, who had spotted an Orientalist fad in the making with Nixon's visit to China and the popularity of Chinese food.[20] *Enter*, it seems, was partly a way of squeezing Run Run Shaw out of any further deals, but there's also a sense of 'conquering' the genre just as martial arts had come to the West via American excursions into South-East Asia.

Even so, the signs of caution were visible - Rayns refers sniffily to "American 'stars' of the calibre of John Saxon",[21] and his equal billing with Lee gives us some sense of what Warners thought of their Chinese leading man. Nevertheless, Saxon is an interesting transnational figure in his own right, as fans of Italian exploitation would no doubt testify - a minor character actor at best in the US, Saxon has often shone for directors like Mario Bava, Dario Argento and Antonio Margheriti. Add a touch of blaxploitation in the irresistible figure of Jim Kelly ("I'll be too busy lookin' good!") and it's little wonder that *Enter* is one of the quintessential cult films. This second-guessing of different audiences now seems very modern and astute. Lalo Schifrin's score joins the trans-generic dots, deploying blaxploitation motifs (wah-wah guitar) alongside echoes of his own *Mission Impossible* score and the sort of 'Oriental' themes only found in the West. Hong Kong soundtracks did their 'sampling' rather more directly, mixing snatches of, say, Isaac Hayes' *Theme From Shaft* with selected Morricone or John Barry. Kung fu has remained central to the hip-hop soundscape, from Wu Tang Clan samples to the 'shapes' thrown on the dance floor.

Enter the Dragon was the most successful of Hong Kong's international co-productions, but it wasn't the only one. The '70s 'chop sockies' are often compared with spaghetti westerns - the baroque room Wang Yu rigs up to defeat *The Master of the Flying Guillotine* (Wang Yu, HK 1976) before depositing him in a ready-made coffin is especially reminiscent of an Italian Sabata film. However, Italian co-productions like *Blood Money* (Antonio Margheriti, HK/It 1974) did neither genre any favours. *The Man From Hong Kong* (Brian Trenchard-Smith and Wang Yu, HK/Australia 1975) anticipates kung fu's Eighties excursions into gritty urban thrillers and has impressive choreography by Samo Hung. *The Legend of the Seven Golden Vampires* (Roy Ward Baker, HK/GB 1974), a co-production between Shaw Brothers and Hammer Films, also has impressive choreographic credentials - Lau Kar Leung and Tang Chia - and provides a particularly illuminating comparison with *Enter the Dragon*.

Kitsch, Comics and Comparisons

Enter the Dragon has Vietnam at least partly on its mind - its two American heroes are vets, the narrative 'goal' is the securing of an island of uncertain territorial ownership and neither Saxon nor Kelly fully grasp the codes or agendas underlining the struggle. *The Legend of the Seven Golden Vampires* is more overtly colonialist. The film opens with a marvellous representation of two genres merging. Kah, High Priest of the Seven Golden Vampires, travels from China to Transylvania to seek the aid of Dracula in restoring the cult to its former glory. The Count is uncooperative by nature but tired of languishing in "this miserable place", and so he 'possesses' Kah's body and leaves for China. Thereafter, Kah speaks with Dracula's voice, but a flamboyant gesture is accompanied by an unmistakable 'swish' on the

[20] Clouse, p. 18.

[21] Rayns, 'Bruce Lee: Narcissism and Nationalism', p. 112.

soundtrack to represent these two genres inhabiting one body. Subsequently, however, the film is about two white Europeans - Dracula and Peter Cushing's Van Helsing - performing a kind of mythological colonization. We first meet Van Helsing as he delivers a lecture on ancient Chinese legends to a frankly sceptical audience at Chungking University. Naturally, the Prof knows better. As he travels into the cursed village of Ping Kwei, he experiences a "been here before feeling", an anticipation of what's around the next corner - in other words, for this colonizer of the Orient's imaginary, China's mysteries are already 'known'. Van Helsing teams up with Hsu Tien-an, his brothers and his sister (Shih Szu). "My brothers would die in your defence," Hsu Tien-an promises Van Helsing rather unwisely, because that's pretty much what transpires. Kung fu is explicitly played out as a spectacle for a (diegetic) white Western gaze - "It was the most fantastic display - I've never seen anything like it," Van Helsing tells Chiang rather condescendingly after one battle. *Enter the Dragon* seems to begin similarly - Lee 'performs' for the gaze of British emissary Braithwaite, who arrives at the Shaolin Temple to employ him. But at least Lee has his own agendas - when Braithwaite says that "we" would like him to attend Han's tournament, Lee replies sardonically, "We, Mr Braithwaite?"

Lee plays a (former?) Shaolin monk employed to take part in a martial arts tournament while gathering information on a heroin and prostitution ring on a secluded island - the island's mastermind is Mr Han (Shek Kin), a renegade Shaolin. Lee is one of three heroes, but the only one with clearly defined goals - revenge (Han is indirectly responsible for his sister's death), honour (less clear in the 'unrestored' version) and what is usually seen as a colonial/colonised policing of the 'Orient'. Roper (Saxon) is a gambler, a devil-may-care, white American smoothie - he arrives with dozens of suitcases, all of them presumably containing polo-neck sweaters. Williams's (Kelly's) hair puts the 'afro' into Afro-American - he's defined through Black Power and Hendrix posters, hassles with racist cops, an inexhaustible sexual appetite, plenty of 'strut' and most of the best lines. The tournament proceeds; Lee

Lethal Weapon 4

gathers evidence. In his first bout, he's pitted against his sister's killer, Oharra (Bob Wall, Lee's favourite punchbag), and takes the opportunity to humiliate and then kill him. Han mistakes Williams for the island prowler and kills him, using one of a selection of deadly artificial hands - he's rather more taken with Roper and offers him a job. As Roper seemingly wavers, Lee works his way through the island caverns and numerous guards before being captured. Roper refuses to fight Lee and they team up against more of Han's guards. Han tries out some more of his lethal hands - a bear claw and a hand of knives - but the wounds just make Lee more photogenic. Only a hall of mirrors delays Han's defeat and he's left impaled on a spear.

"Man, you come right out of a comic book!" Kelly says to Han - oh, how the reviewers jumped on that line! - and he's almost right. But, as most writers point out, Sax Rohmer and Ian Fleming got there first. At one level, it's almost as though the price of Lee embodying the Chinese Superman - he'd never been so invincible before - was a Yellow Peril villain. It's more likely, though, that the film had to work with some of the representations it already knew - representations which still had some mythic power. Rohmer's *Fu Manchu* novels had been reprinted by Pyramid books in the US in the 1960s, and their success was a factor in Harry Alan Towers' series of films starring Christopher Lee (1965-8). Marvel Comics had made a deal with Rohmer's estate to base a comic around the character, but were initially unable to find a suitable format. The kung fu 'craze' evidently provided the impetus for such a format, because in December 1973, *Special Marvel Edition* number 15 featured Fu Manchu's oedipally heroic son, Shang Chi, Master of Kung Fu. Shang Chi was a hit - by issue 17, the comic was retitled *Master of Kung Fu* and ran continuously until 1983. Its most immediate influences were Bond, *Nick Fury Agent of S.H.I.E.L.D.* and *Where Eagles Dare*, but by issue 31, *Enter the Dragon* was exerting a visible influence - island fortresses, international drug rackets, whirling nunchakus and a bare-chested, pouting hero. Like his TV counterpart, David Carradine's Kwai Chang Caine, Shang Chi was of mixed race - also a recurring device in American kung fu paperbacks - and portrayed as a lethal, philosophically-minded hippy (he later developed an alarming taste for Fleetwood Mac). Trained in seclusion - like an inverted Shaolin Temple - Shang Chi is initially his father's assassin. But Nayland Smith 'turns' him, and, like Lee, he defects to the British secret service.

Fu Manchu - pre-Republic, let alone pre-Mao - remains committed to restoring the Manchu (Quing) Dynasty, inhabiting an invisible, mobile 'China', a "'China' which no longer exists . . . except as a construct . . . carefully hidden inside an otherwise innocent office building".[22] The Manchus figure prominently in the kung fu genre - the Quing Dynasty, during which they ruled the Han Chinese, often figures as a way of addressing colonialism (or, more recently, reunification), with Shaolin heroes like Fong Sai Yuk cast as rebellious Ming patriots. But in the Western imaginary, Manchurian corruption formed half of a binary opposite in representing China - either incorrigible, decadent tyrants or passive, easily colonised, sheep (see Han's "refuse found in waterfront bars" in *Enter*). Such exotic villains had even colonised outer space in the form of Flash Gordon's Ming the Merciless (Manchu, Ming, Han - the dynastic signifiers are all too consistent).

Fu Manchu was already a nostalgic figure when he first appeared in 1913 - Nayland Smith first set eyes on him in 1911, the year Sun Yat Sen saw off the Quing Dynasty for good. What seems to be going on in the early '70s - against the backdrop of Nixon and Vietnam - is a renegotiation of what 'Chinese culture' signified in the west, a resetting of boundaries around who could be incorporated (martial artists, 'mystics') and who couldn't ('inscrutable' hardliners - i.e. communists). Western kung fu heroes were positioned between races, like Caine and Shang Chi, or between cultures, like Lee. But kung fu itself could easily inhabit the same cultural imaginary as the Yellow Peril - an excess of civilisation and culture, a decadent refinement of violence. Certainly they recombine in Jet Li's Wah Sing Ku in *Lethal Weapon 4*.

22 *Marvel Special Edition: Master of Kung Fu*, number 15 (December 1973) p. 32.

But Fu Manchu himself is something of an interracial paradox; on the one hand, "the yellow peril incarnate", "the cruel cunning of an entire Eastern race, accumulated in one giant intellect", but also "tall, lean and feline, high-shouldered, with a brow like Shakespeare and a face like Satan".[23] That's a potent set of signifiers - feminine, European, a fallen angel. Dr. No, too, is a fallen angel - named in negation of his father - and of more literal mixed race. Han, of course, has 'fallen' from the genre's key prelapsarian space, the Shaolin Temple - renegade 'White Eyebrow' monk Bai Mei, who aided the destruction of the temple, was a later mainstay of Shaolin-themed kung fu films. Shek Kin's voice was dubbed by actor Keye Luke, Kung Fu's blind father figure, Master Po, as though to underline the inverted Shaolin patriarch. Shek himself was a reminder of another generic father. Cantonese folk hero Wong Fei Hung was played by Kwan Tak-hing in 75 films between 1949 and 1970, with Shek often cast as the villain. Rayns parallels the series' run with Bruce Lee's days as a "punk . . . looking for fights",[24] as though there was always an Oedipal connection waiting to be made. But what's most striking about Han is that his Fleming-like taste for cats is overridden by his taste for Nietzschean epigrams. "We are unique, gentlemen", he tells his invited warriors, "in that we create ourselves . . . We forge our bodies in the fires of our will". Later, he holds forth to Roper on the inseparability of culture and strength - "it is strength that makes all other values possible . . . Who knows what delicate wonders have died out of the world for want of the will to survive?" This Will to Power doesn't seem to have been an accident. Writer Michael Allin apparently saw him as "a combination of Richard Nixon and director John Milius".[25]

Eastern West

Both the '70s and the '90s Hong Kong crossovers were preceded by dubbed exports. In the '70s, such exports constituted an entire cycle, but more recently, it was New Line's unexpected success with a dubbed, re-edited *Rumble in the Bronx* (Stanley Tong, HK 1995) which created a space once more for Chinese action stars in the US. Tony Rayns has likened the film to *Way of the Dragon* (Bruce Lee, HK 1972) - "naive Hong Kong boy travels abroad to visit relatives and tangles with local gang' - while noting that Jackie Chan's "stance is far more populist and far less Chinese-chauvinist than Lee's".[26] Chan, as both Rayns and Fore note, has for some time been an transnational figure - his characters and films favour international locales - and yet his blend of comedy and action took longer to catch on in the West than Lee's superheroic persona. Chan's low-key 'patriotism' implicitly authenticates him for Rayns as a modern Hong Kong star - someone who represents a more complex sense of belonging than simply being 'Chinese'. Yet *Enter's* lack of Chinese-patriotism is often taken as a sign of its inauthenticity, an 'emasculation' which represents "the West's antipathy towards Lee's nationalism".[27]

Two things happen to Lee's ethnic populism in the film. On the one hand, it is pushed down in the mix - he defends the Chinese workers against a gwailo bully on the junk to Han's island, but significantly without landing a punch ("the art of fighting without fighting"). But ethnic pride is displaced most visibly onto Williams - Hollywood had a generic model for representing black (male) pride, and Warners were shrewd in gauging the demographics of kung fu's Western audience. But as Lee's patronising reference to "Won Ton Kung Fu flicks" suggests, his sense of belonging, too, was contradictory. Even his fighting was "neither wholly foreign nor wholly Chinese . . . very international".[28] Lee bit, scratched and grappled, combined graceful traditional moves with western boxing and street fighting. His image as Super-Patriot rests largely on *Fist of Fury*'s Japan-bashing, although Abbas suggests that the film's anticolonialism was already slightly quaint, "as if Bruce Lee were fighting again in a new Boxer Rebellion through the medium of cinema, in much the same way that Hollywood refought the Vietnam War".[29] *Way of the Dragon* - Lee's most popular film in Hong Kong, but the last to reach the west (comedy again?) - softens this xenophobia. Lee beats the western heavies with "Chinese boxing",

23 Sax Rohmer, *The Mystery of Fu Manchu* (1913) in *The Fu Manchu Omnibus Volume 1* (London: Allison and Busby, 1995), p. 15.

24 Rayns, 'Bruce Lee: Narcissism and Nationalism', p. 110.

25 Lou Gaul, *The Fist That Shook the World: The Cinema of Bruce Lee* (Baltimore: Midnight Marquee Press, 1997), p. 131.

26 Tony Rayns, 'Rumble in the Bronx (Review)', *Sight and Sound*, Volume 7, number 7 (July 1997), p. 51.

27 Teo, p. 117.

28 Liu Shi, 'Ng See Yuen: An Interview' in *A Study of the Hong Kong Martial Arts Film*, 1-31 (p. 145)

29 Abbas, p. 30.

Enter The Dragon

but cautions his friends against dismissing "foreign fighting". It isn't Chinese boxing which defeats Chuck Norris in the Coliseum; rather, Lee's transnational Jeet Kune Do, a fighting style designed to transcend both 'style' and national-cultural tradition. Tang Lung (Lee) is "part bumpkin, part martial arts master-philosopher",[30] and never quite coheres into a unified character. Teo is as troubled by this inconsistency as he is by *Enter's* alleged co-opting. When he suggests that the bumpkin "is emphasised at the expense of Lee's national-ism",[31] he seems to be longing for a fusion of the latter with the fighter-philosopher. Instead, Tang's move from parochial bumpkin to master fighter is channeled through the international language of his fighting style.

Enter the Dragon doesn't exactly back off from Lee's 'philosophy', even if it finds it equally difficult to consistently square it with generic imperatives. The 'restored' version of the film - in fact, the version originally released in Hong Kong - makes this more apparent. The additional material is a pre-credits conversation between Lee and the head monk about martial arts technique. Even Teo acknowledges that the sequence provides "(Lee's) only chance to expound on the spiritual principles of kung fu".[32] In other words, there are issues around authorship here. Lee's fighting scenes are acknowledged prominently in the film's credits, and Rayns suggests grudgingly that they "come as near as anything could to save the day".[33] Lee's 'philosophical' input is a more complex commodity. In many ways, the Western 'kung fu craze' was bound up with commodifying two Others - violence and the 'Orient', fused together as mystical bodily harm. Hong Kong kung fu was much less 'philosophical' in the early '70s - it took directors like Lau Kar Leung and Samo Hung to later explore the principles of the art - much more unapologetically violent and revenge-driven. By contrast, Warners' *Kung Fu* was seen by more than one commentator as the '60s counterculture infiltrating the '70s mainstream, with its focus on "peace, love, the natural way, ecology, a raising of consciousness".[34]

30 Teo, p. 116.

31 Teo, p. 117.

32 Teo, p. 118.

33 Rayns, '*Enter the Dragon*', p. 6.

34 Richard Robinson, *Kung Fu: The Peaceful Way* (Manchester: Ensign, 1974), p. 28.

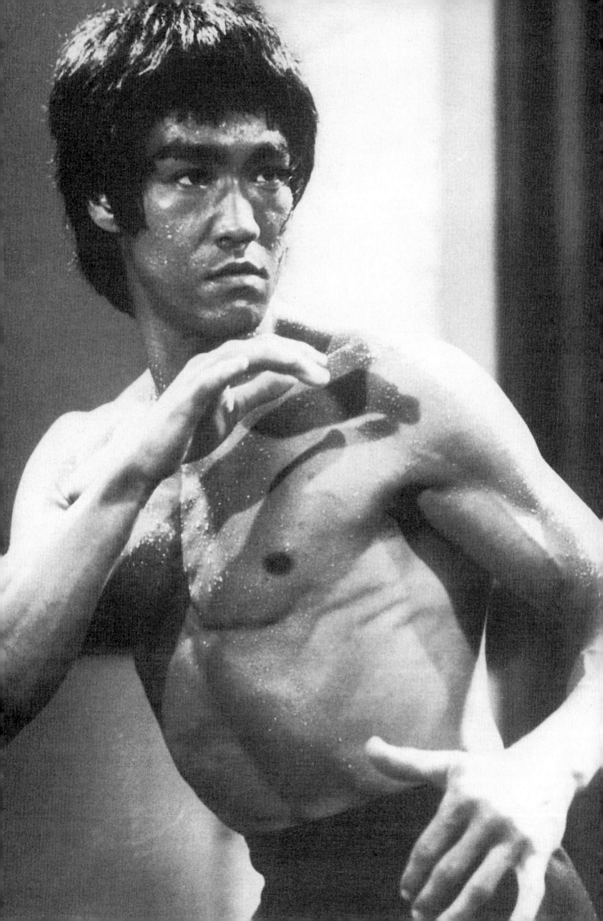

Han's Island Revisited

Enter does seem to have been conceived as more of a 'straight' action film - the 'monk' scene was felt to slow down the action and cut from the western print. Its restoration comes in the wake of a flood of books devoted to Lee's letters, essays, interviews and notebooks. The images of fluidity expounded by his character are familiar to anyone who's read such material: "When the opponent expands, I contract; and when he contracts, I expand. And when the time comes, I do not hit - (holds up his fist) it hits by itself."

I'm not trying to resurrect the auteur here, but authorship does complicate the idea of a western co-opting as well as suggesting that a more international production does seem to have opened a limited space for such material (even if it took twenty five years for the scene to find a Western audience). The scene has other implications, because it gives Lee a dual narrative function, falling as it does in between his opening duel with Samo Hung and his recruitment by Braithwaite. Lee first hears of Han through the head monk, and his mission to "restore the integrity of the Shaolin Temple" inscribes him into the Shaolin legends. But *Enter* is an odd Shaolin film - western representations seem to have fallen for the prelapsarian exoticism of the locale before Hong Kong cinema established its more elaborate myths in the films of Chang Cheh and Lau Kar Leung. Where is this Shaolin Temple supposed to be? China? Hong Kong? And Lee both belongs and doesn't belong there - his black gloves and trunks and '70s hairstyle contrast with the robes and shaven heads of the other monks. The spectacle offered in the opening fight is a mixture of (kick)boxing and grappling, interspersed with Peking Opera-style tumbling. Once again, Lee is a "mosaic", everywhere and nowhere, a mobile transnational signifier.

Lee's death made *Enter the Dragon* seem like a (flawed) culmination of the West's 1970s Eastern romance, rather than a transitional film, harbinger of a crossover which has only now arrived. *Rush Hour* makes for an interesting comparison - it refers explicitly to Hong Kong's postcolonialist status (even down to a villainous British governor), and embraces the Chinese-Afro-American bonding *Enter* didn't seem ready for. But make no mistake, its action scenes are Chan-lite, while *Enter* really did inject a new aesthetic into an American genre film. Watching the film with an audience recently was a revelation - the cavern fights were still impossibly thrilling, the audience gasped at the speed of the 'untelegraphed' punches meted out to Oharra and cheered the nunchaku scene usually missing from British prints. In addition, the new stereo soundtrack further amplified the sort of hyperbolic sound effects that could only emanate from a Hong Kong film. That this *"mosaic"* doesn't always hold together adds to rather than detracts from its continuing fascination. That it still retains its following suggests that it addressed its diverse audience rather better than tends to be acknowledged.

Jonathan L. Crane

Growing up in the Jersey suburbs across the river from New York City, I was painfully aware of cult films years before I was ever able to see one. In Times Square, alongside the porn arcades, theater marquees trumpeted forbidden titles. Here, Blaxploitation films, martial arts double bills and gore extravaganzas, triple features of macabre mayhem, were to be found but never seen. Instead, I went to the city, accompanied by extended family, to attend Radio City Spectaculars featuring the Rockettes and the high jinks of Disney favorites Dean Jones and Fred MacMurray. There was never a chance, no matter how desperate my hunger, that the family would elect to take in one of these proscribed aberrations.

I also knew that, in some distant remove, managing to see a cult film would surely entail a rejection of the values my family hoped to inculcate through our ritual viewing. As we made the pilgrimage to Radio City Music Hall for Christmas and Easter only, seeing good family movies in tribute to Our Lord's birth and resurrection, the connection between grievous rebellion and errant movie-going was sealed.

While other movie-goers with a taste for the wayward have had different formative experiences, the connection between cult films and the margins remains firm. Entertaining a cult film means, for at least an instant, turning your back on seemly or fitting cinema. The great virtue of all cult films is that they offer an alternative to the burden of mainstream viewing. Mainstream films, even the very best, are simply too familiar with the audience. They murmur to us with a reassuring voice that presumes to know our needs and desires better than it should. Too often, in what may be the worst moment of mainstream attendance, we surrender in agreement. Bringing relief, the cult film doesn't seem to have a clue to whom it is speaking. In failing to recognize us, the cult film provides a necessary reminder that identity, like a darting target, can be difficult to fix. Enchanted by some odd film, we may even become strangers to ourselves.

Biographical note: Jonathan Crane is an Assistant Professor in the Department of Communication Studies at The University of North Carolina in Charlotte. He is the author of *Terror and the Everyday Life* as well as numerous articles on popular culture and issues of genre.

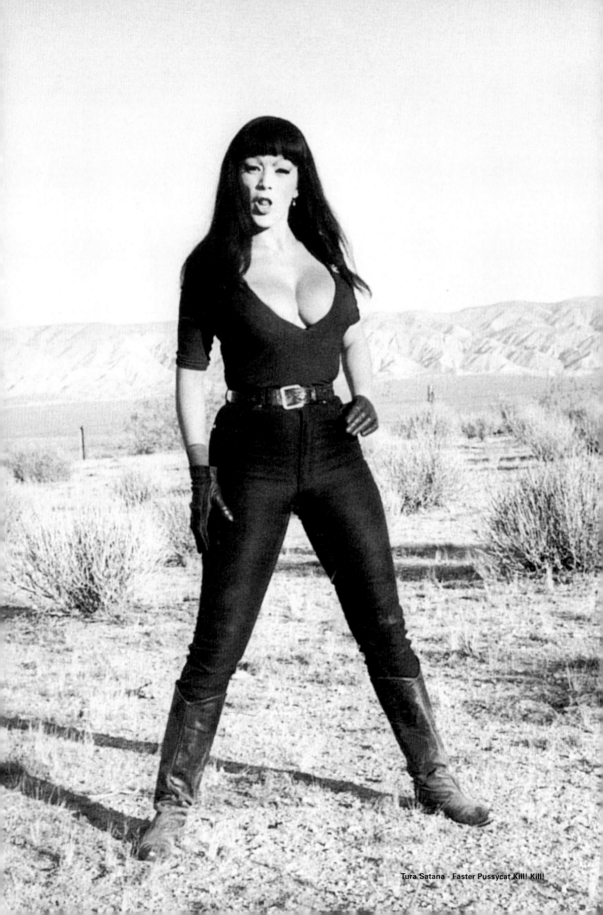

Tura Satana - Faster Pussycat Kill! Kill!

A Lust for Life:
The Cult Films of Russ Meyer

Jonathan L. Crane

Russ Meyer and the Roots of Porn

We arguably live in a time where the pornographic has run riot. For that considerable segment of the film-going public burdened by the rage to see all that the body has to offer, there are multiple forms of erotic gratification that can be consumed. Film, or more often video, now addresses with extraordinary particularity, all but the most *outré* or criminal desires. Aside from filmed murder or the debauching of minors, there is a glut of sexually explicit material which aims to satisfy any appetite. The unabated triumph of hardcore pornography began (at least in the United States) with the mainstream success of *Deep Throat* (1972). As a result of the film's impact, the downtown 'raincoat brigade' was supplanted by suburban middle-class, heterosexual couples.[1] The emergence of this new, vast and wholly respectable audience, in combination with the rapid introduction of home video, thrust every last bit of the flesh into the light. Infinite combinations of bodies, coming in all hues and sizes, were finally available for all who cared to indulge.

Ironically, the success of hardcore in America was an achievement predicated on the promise that nothing shall long remain unexposed. It was this promise which relegated its immediate predecessor, the softcore film, to the dustbin. Today (at least in the United States) it is the softcore film, the coy film, the film that acknowledges limits and exercises some sexual restraint, that has become for all but the most motivated viewer, impossible to see. While the term softcore is still in trade today, it is now typically used to refer to hardcore films that have had shots of erect penises, ejaculation, genital penetration and extended 'looks' at female genitalia excised. These films are hardcore 'lite'.

The only softcore film-maker whose work has not been totally elided by the hardcore onslaught is Russ Meyer. This chapter examines why interest in Meyer's work has survived, while the genre in which he made his name has been eroded. In part, the answer lies in the fact that, like any rogue film maker who fashions a lengthy career outside the mainstream, Meyer is an exceptionally skilled entrepreneur and indefatigable self-promoter. In addition, Meyer assiduously distributes his own videos and, now that lounge and surf music are once again in bona fide good taste, the ancillary soundtracks as well. In these unceasing efforts he may be the last independent director still doggedly employing the methods that made fortunes out of the less than stellar works of William Castle and the shoestring productions of Roger Corman and Samuel Z. Arkoff.

However, no matter how considerable Meyer's business acumen, no engaging promotional campaign can keep a body of films and their respective videos in circulation, year after year, for decades. Meyer may be a loveable shill with undeniable charm, but he is also the foremost representative of a

[1] Linda Williams, *Hard Core: Power, Pleasure and the 'Frenzy of the Visible'* (Berkeley: University of California, 1989), pp. 95-99.

unruly pleasures

89

2 David
McGillivray, *Doing
Rude Things: The
History of the
British Sex Film
1957-1981*
(London: Sun
Tavern Fields,
1992), p. 19.

3 David Chute,
'Wages of Sin, Part
I ', *Film Comment*,
Volume 22, Issue 4
(August 1986),
pp. 32-39, 42-48
(p. 45).

genre that for over thirty years defined what it was possible to say in daring representations of cinematic sexuality. The argument for Meyer is even stronger when we consider the fact that, while the genre he represents did play a formative role in enlarging the range of the permissible, it is also the case that it is largely composed of films that, "lack even the redeeming quality of being so bad they're good."[2] In spite of their undeniable value as historical curiosities, softcore films have, as a body of work, little to recommend them to most contemporary audiences. For all but the hardy specialist, the overwhelming majority of these films are painful to screen.

As a rule, the allure of many cult productions is proportional to the degree that the movie departs from the conventions of respectable film making. In sharp contrast, the softcore film is typically bereft of even the unintentional charms that knowing audiences find in the hapless enterprises of earnest but technically challenged film makers. An appeal to the serendipitous virtues of misguided auteurism cannot redeem the hack work evident in the usual softcore film. Softcore films found an audience because they were the first movies in generations to unsheathe the body outside of men's clubs and private screening rooms.[3]

At a time when the obscene did exist, when there were palpable limits to the permissible, thresholds for satisfaction were low for the initial films over the barricades. Quality, like clothing, was optional as long as the film managed to at least offer some scintilla of onanistic pleasure. In this important regard, Meyer's films depart the genre. They offer more than just instrumental relief. The films of Russ Meyer matter even when the genre does not.

All softcore films are blocked by legal prohibition from attaining the verisimilitude of the stag film. In trade for the real thing, the softcore film promises visual or narrative thrills unavailable in hardcore. With impossibly suggestive titles like *A Smell of Honey, A Taste of Brine!* (1966), *Take Off Your Clothes and Live* (1962) and *Merry Maids of the Gay Way* (1952) alongside captivating one-sheet blurbs, "Make Out . . . Suburban Style," the softcore film beckons viewers with exhilarating scenarios. Despite being hobbled by the

Vixen

law, their thrills offer more than the stark and unfettered realism of hardcore. Meyer's own titles follow suit. *Mudhoney* (1965), *Faster Pussycat, Kill! Kill!* (1966) and *Beneath the Valley of the Ultravixens* (1979) offer word associations so rich that the *cinéma vérité* of hardcore is threatened with becoming pedestrian.

The Meyer (Super) Woman

While tantalizing titles and hypnotic pull quotes share a common pedigree in the siren touts of conniving sideshow barkers, Meyer's films always deliver visions nowhere else to be seen. His entire corpus features voluptuously endowed superwomen that tower over the women and men displayed in competing hardcore features. Even in today's world of tightly focused, niche-market pornography, with films exclusively devoted to large-breasted women, Meyer's stars are unparalleled creatures.

The typical Meyer player: imagine Kate Moss grown to impossible dimensions in an X-rated Wonderland and then treble her size again to even marginally approximate the magnitude of women in a Meyer extravaganza! Along with their hyperbolic hourglass figures, blown well beyond the preposterous, the female stars of these concoctions are also gifted with matching gargantuan appetites for all liminal desires. Grotesque in size and demeanor, the Meyer heroine, who lives, loves, and dies hard, is a *femme fatale* in inflated Amazon's armour.

Those unfamiliar with Meyer's oversized starlets are almost certain to assume, with justification, that these films must represent the female form as the victim of some wild inflation of the flesh. Given how readily films fetishise the female form, morphing the body to fit market demand, it would be easy to conclude that Meyer's films merely embody male desire in the monstrous frame of an unrelenting giantess. The mammoth proportions of Meyer's actresses will, undoubtedly, be repugnant to some. Yet, a behemoth Lorelei may also be queerly inviting. As Barbara O'Dair notes, after a long weekend viewing Meyer videos:

"I imagined I'd have to overlook the usual sexist sentiments, the stuff that's so irritating in hard or soft X: the unceasing servicing of the men, fantasy perfection of the women. But I was surprised. His female stars Tura, Haji, Lorna, Vixen, among others are superwomen, outrageously endowed sex machines, voracious, insatiable. Few of us fit the proportions, so we're suitably distanced, but most of us can identify with the appetite."[4]

Following this line, Meyer's success is not built on telling the big lie. His iconography does not necessarily fuse the exaggerated with the essential. As O'Dair observes, these epic images are too implausible to function as the visual index for a new regime of female servitude. Instead, comic inflation gives free rein to sexual whimsy. In a manner analogous to the way King Kong and Godzilla engender pleasure, bringing welcome chaos and ruin to the social order, Meyer's fantastic matriarchs are the only beings not compromised by the chaffing bounds of social intercourse. As outsize Valkyries who conduct their subjects to a carnal heaven, Meyer's unstoppable Amazons afford an original revel in gendered excess.

For those who remain unconvinced that Meyer's representations carry no serious threat, his representations of mammoth women are more likely to be received as alien than normative in today's spartan climate of mandatory fitness. In the age of anorexia nervosa, how is Meyer to be indicted for authoring obligatory images no anxious woman could hope to match? Delivered with a very short sell-by date, sexual representations are acutely dependent for their charge on a whole host of time-sensitive variables. As much of the softcore genre demonstrates, and Meyer's work should not be excepted, the distance between the lubricious and the risible is exceedingly fine.

4 Barbara O'Dair, 'Tits and Sass', *Village Voice*, Volume 32, Issue 48 (1 December 1987), 57, 60 (p. 57). O'Dair's description is useful not only for what she makes of Meyer's titans; she also provides some insight as to why Meyer's films were consistently popular with heterosexual couples at a time when women were typically not part of the audience for such fare.

Even in the late sixties, when Meyer was hitting his commercial prime, critics wondered if his imagery was already archaic.[5] Regardless of whether or not his work continues to inflame the passions, Meyer's iconography is rooted in imagery that has long since seen its heyday. The director's striking (if passé) visual lexicon is founded on images that were in general circulation some fifty years past. Serving as a camera operator in the 166th Signal Corp - some of the footage he shot may be seen in *Patton* (1970) - Meyer learned his craft and came of age in the Second World War.[6]

Meyer's mammoth women are clear descendants of the bombshell girls, Betty Grable and Rita Hayworth, drafted to raise spirits during the great conflict. Meyer cheesecake, playing off these and later models, including Betty Page, Marilyn Monroe and Jayne Mansfield, is a superpowered extrapolation of the WWII pin-up. Red-blooded, All-American country gals, these fresh faced juggernauts are, as the old joke would have it, the farmer's daughter. Even those actresses who are clearly not 'All-American,' (either those with foreign accents or of differing ethnic origins), are in spirit proto-typical members of the Union. With an indomitable soul and a matching physique born from the same cultural wellspring that spit out Paul Bunyan, Calamity Jane, Pecos Bill and John Henry, these creatures could only be found on U.S. soil. Fit to pioneer the sexual frontier, the women in Meyer's films are embodied Americana cobbled together from new world fantasies suitable for a GI. In contrast, the highly educated and necessarily decadent urban-European women of the roughly contemporaneous *Story of O* (first published in 1954) represent the antithesis of the female Meyer archetype.

The 'Myth' of the Meyer Male

The men of Meyer's films are also cut from celebrated visual icons that were common currency for the allied generations that lived through the war. In Meyer's formative world, the companion physique to the titan woman is the square jawed and three squares a day working man. He has the jutting profile of Dick Tracy and the well-muscled physique of Li'l Abner. It is a blue-collar body bred for hard work and even rougher play. He is, to invoke the punning name of a philandering character in *Beneath the Valley of the Ultravixens*, Peterbuilt. (According to strict denotation, Peterbuilt is a model of semi-truck. The connotation with which Meyer uses the term will elude no one).

However, there is a crucial difference between the flesh of men and the bodies of women in a Meyer production. The body of a woman is a truthful and transparent signifier. Women are what they appear to be. Women with the awesome form of a titan will have all the powers, physical and mental, we would expect a mighty goddess to possess. Women of average dimensions are, to employ Meyer's iron lady vernacular, 'frails'. Contrastingly, the bodies of men, however well proportioned and muscularly defined, are not correlated with any set of innate virtues or intrinsic powers. You can never tell, simply by judging his cover, who is a real man. In failing to provide an immediate and credible index of masculine value, the unreliable flesh of men lies at the heart of one of the entwined narrative puzzles that run through most Meyer films.

In *Lorna* (1965) one of the main questions that compels interest in the film is: will a strapping husband, whose faults are compounded by a wayward yen for book learning, ever manage to satisfy his new spouse? As the audience and a forlorn Lorna wait on the inveterate reader to come to his senses, a murderous escaped prisoner will do what the husband cannot. *Beneath the Valley of the Ultravixens* hinges on the question of whether or not a prime specimen of U.S. male will abandon his perverse ways (an exclusive love for anal intercourse), and face a woman eye to eye when making love to her. Meyer's most unrelenting exploration of the uneasy relation between libido and male anatomy, *Good Morning and Goodbye* (1967), features a woeful male protagonist who is unmercifully lacerated for failing to do what should just come naturally.

[5] Vincent Canby, 'Screen: By Russ Meyer', *New York Times* (6 September 1969), p. 21.

[6] David K. Frasier, *Russ Meyer: The Life and Films* (Jefferson, North Carolina: McFarland, 1990), p. 2. This work, an extremely comprehensive annotated bibliography, also contains an excellent short biography and complete review of Meyer's corpus. It is indispensable for those interested in either Meyer's career or soft core film.

A Lust for Life

above: **Faster Pussycat Kill! Kill!** below: **Motorpsycho**

above: **Vixen** below: **Good Morning and Goodbye** opposite: **Supervixens**

Russ Meyer's
BOSOMANIA.

TOO MUCH...FOR ONE MOVIE!

Russ Meyer's
Super VIXENS

X

A Lust for Life

Those few men who do have a faithful penis are usually the most villainous males. As a result, these characters are clearly not without their own significant failings. Generally, working equipment is their only asset. In all other regards they are revealed as unpleasant sexual companions. Usually rapists, the men who can act are so full of rage and misplaced passion that they are unfit to share a bed. The problem with this variant of the Meyer male is that more often than not, despite visual evidence to the contrary, they cannot be trusted to perform as mother nature intended. In an unexpected reversal to porn's provision of reassuring male fantasies, the primary storyline for Meyer involves whether or not his males can find a way to become good partners and surmount their natural inclination to impotence and irresponsibility.

As part of this doubled plot line, the enigma of why men cannot do justice to their own physical appearance is complemented by the transparent incarnation of explosive desire in the titanic frames of bold females. Meyer's films generate tremendous narrative drive by posing two inseparable queries founded on this coupled opposition. His films ask what will women, who can be denied nothing, do with their absolute freedom and how will men elect to carry themselves in an environment defined by female action. In a reversal of John Berger's venerable dictum that, in the mirror world of artful images, "men act and women appear," Meyer creates films in which women, even naked women, act and men try to compose themselves.[7]

The favoured Meyer milieu, in which women do what they will and men hope to keep up appearances, is generally (except for his earliest films), a rural environment. In part this represents a cost-cutting decision, as it is cheaper and less trouble to shoot softcore films in the country. However, a rural setting also plays an important role in framing the question of pleasure in a Meyer film. The country, as represented by majestic groves of Douglas Firs, a lazy creek crawling to the Missouri River or prickly desert scrub is, first and foremost, not the city. If the city is the seat of sophistication, then Meyer country is home to white-trash yokels who care, unlike their refined, careering city brethren, to hang fire and chase earthly pleasures.[8]

Desire, The Country and Rural 'White Trash'

The yokel lives a wild life reflected by his (or more vibrantly her) immersion in the great outdoors. Living amidst nature, Meyer's North American savage is free to pursue an ideal, and idle, existence loosed from stifling convention and civilized *amour-propre*. In a peculiar backwoods amalgamation of Hugh Hefner's "Playboy Philosophy" and Rousseau's elevation of the noble brute, only the yokel, and not the city dweller, has the good sense to range after passion in the capacious embrace of the fallow hills. Of course, the Meyer yokel may go too far, and descend into irredeemable license. However, even in the grasp of lunatic lust it is better to crash and burn in the primeval wilds than to fade away in the enervating city.

Lest any of this read like an apology designed to redeem Meyer as a slumming intellectual, as there are few softcore films grounded in ribald Rousseau, it is important to note how mockingly Meyer packages these associations. In creating a rustic Eden, where anything is possible, Meyer's tongue never moves all that far from his cheek. Alongside voice over narration which parodies the stentorian voice of God heard most often in educational and industrial film, Meyer regularly employs two visual motifs which playfully celebrate the abundant freedoms available in the rural paradise of his lascivious hicks.

Firstly, his primary mode for linking wide open sexuality with nature is to film transcendently happy, ever smiling, nude women (occasionally trailed by grinning, naked men), capering across verdant copses, and splashing through crystal brooks. At once a parody of older stock visual sequences, desire is here signalled via long shots of women bounding along in ecstasy

7 John Berger, *Ways of Seeing* (London: Penguin, 1972), p. 47.

8 For a more extensive discussion of the symbiotic relation between pornography and white trash see Constance Penley, 'Crackers and Whackers: The White Trashing of Porn', in *White Trash: Race and Class in America*, ed. Matt Wray and Annalee Newitz (New York: Routledge, 1997), pp. 89-112.

and in genuine celebration of untrammelled freedom. As these shots are always artfully composed, the yokel in motion is, metaphorically, a wild mare or stallion who running free cannot be broken.

The other motif which reveals Meyer's call for a necessary departure from social convention is his typical depiction of sexual congress. As the paramount act of human intercourse, it remains the only engagement that allows human beings to realize their common humanity. Meyer inevitably links the inexhaustible satisfactions of frenetic copulation with the sublime beauty and fecundity of nature. Where hardcore has the seedy, poorly-lit motel suite as the room of its own, Meyer stakes a claim to all the vast, sun-dappled vistas of the great outdoors for his assignations. Here, volcanic bouts of intercourse are regularly presented with multiple and varied shots of the merry couple at it hammer and tongs, in a field of scattered boulders, wildly cavorting atop mountain pinnacles, and most tellingly, frolicking with abandon in the crotches of trees. While the fertility of nature has long played an important role as one of the significant tropes of the pastoral mythos, only a truly vulgar imagination would argue so bluntly that all the wide, natural world is a yielding mattress.

Meyer's fascination with sexual dynamos running roughshod over the American outback is furthered by the use of a series of important stylistic and visual traits. In particular, the director developed a characteristically furious editing style as well as an individual style of bold composition and a vivid palette absent from most softcore productions. While individually distinct, Meyer's trademark touches are tightly woven features that cannot be addressed apart from the subordinate role each plays in the grand scheme of the director's uncommon vision.

For instance, Meyer's palette gives his films the quality of an absorbing fever dream. Even Meyer's four black and white films, *Lorna* (1964), *Mudhoney* (1965) , *Motorpsycho* (1965), and *Faster Pussycat Kill! Kill!*, feature an impressive, if stark, palette. With blinding whites depicted alongside an extensive range of greys and blacks of deep ebony, these films are model exercises in tone. This effect is even more marked in the director's later colour productions. Here, searing reds, whites of creamiest ivory, the bluest blues (the skies under which his players tumble are some of the most beautiful to ever appear on film), and a thousand other brilliantly registered tones give these films an hallucinatory air. A legendary stickler when it came to colour correcting prints and video, Meyer managed, with very low budgets, and without ever shooting in Technicolor, to conjure up electric mirages that are the equal of any celebrated studio production. In league with other films noted for their use of colour, *Gone With The Wind* (1939), *The Wizard of Oz* (1939), or *The Umbrellas of Cherbourg* (1964), Meyer's piercing palette casts a rapturous spell.

Looking better, brighter and somehow truer than everyday shades, the hues and tones of Meyer's films, as with all notable colour compositions, compel belief. Anything that looks this good can't be entirely a mimetic creation. At the same time, these colours, so ravishingly vibrant, betray themselves. Bordering on the iridescent pigments of delirium, they cannot possibly be real. This tension, between exquisite materiality and appearing too good to be true, gives Meyer's erotic fantasies an extra charge that is not to be found in any other softcore film.

Equally, Meyer's editing works in concert with his colour work to further amplify the palpable physicality of his universe. Rejecting the use of zoom and pan methods, he has a marked preference for the stationary camera, characteristically building camera movement through cutting. He flits from set-up to set-up, via the edit, instead of remaining at a fixed vantage point and either tunnelling through or sweeping across the visual plane. The pan, a movement akin to simply turning one's head, and the zoom, a matter of just peering closer, are too closely allied with detached and slothful voyeurism to be of use

Beneath the Valley
of the Ultravixens

in the construction of Meyer's carnal adventures. In order to ensure maximum participation, Meyer navigates in, around, over, and through each scene by physically transporting the camera across any of an immense number of separate placements. In so doing, he creates viewers who are always, like the lovers and runners described above, on the move. If omniscience is the natural state toward which all cinema tends, then Meyer, though robust editing, creates an omniscient viewer who never transcends his or her own body. In Meyer's world, sexual revelation comes only to bodies in motion.

Movement in space is but one of the axes viewers travel. The audience is also positioned in time. Film tempo, the speed at which action or narrative is developed, is another creation of editing. And life in Meyer time, while always a sensual pleasure, is never a languorous experience; consequently, in keeping with the tempo at which violent erotic pleasures are enjoyed, he cuts at speed. As the pace of the libidinal plot quickens, editing and the pulse of the body converge. The vertiginous combination of movement in time with movement in space results in films that are felt as much as seen.

RUSS MEYER'S
BOSOMANIA

Longing...
Love...
Lust...
Life...

A
Woman...
Too
Much
For One
Man...

LORNA

Starring LORNA MAITLAND as Lorna • MARK BRADLEY as The Fugitive
JAMES RUCKER as Husband James • HAL HOPPER as Luther
DOC SCOTT as Jonah • ALTHEA CURRIER as Ruthie
JAMES GRIFFITH as The Fundamentalist • FRED OWENS as Grocer
FRANKLIN BOLGER as Customer • KEN PARKER as Fisherman
An Eve Meyer Production

A Lust for Life

Breakneck editing and supersaturated colour, common visual elements since the Sixties, do not just belong to Meyer. Without some final distinguishing feature, these community traits serve only to date him as one of many film makers active in the last half of the twentieth century. What saves Meyer from the taint of the commonplace is his attention to line and composition within the frame. Most every shot, from long to close-up, contains either strong sinuous curves, dramatic straight lines or both. The close attention to outline and shape is a way of establishing parallels between the natural world, the manufactured world and attractive bodies. Meyer's implacable devotion to outsize physique, in both women and men, and his pan-sexualization of the material world, ensures that the most tempting lines of the flesh, the double curve of a hip and the strong line of a jaw are echoed in the gentle bends of roads, the handsome cut of an outcrop and the taut steel of high-tension pylons. Shot after shot, he details the stalwart and curvaceous lines that the industrial object, natural wonder and human body share as one. All the world, as seen from this perspective, becomes appealing in a manner that only those in the throes of a totally undiscriminating sexual compulsion could understand. Here, everything is beautiful in its own salacious way.

By definition, the superior merits of a cult film must elude most film-goers and be appreciated by a coterie of dedicated aficionados. A film that is universally appreciated, whose virtues are obvious, is just a popular film. Softcore should be ready for cult status as the hardcore film has eclipsed it in popular regard. Unfortunately, a lack of public favour does not necessarily mean that softcore has the requisite hidden virtues worthy of cult reverence. Softcore, as a genre, is generally wretched. Not camp, not uproariously low brow, not splendidly inept, nor carnivalesque, most softcore is just plain awful. Void of secret charms, most American softcore films are unlikely to acquire cult status.

Meyer's work remains one key exception. As one of the sole softcore directors who has prevailed against hardcore and the limits of genre, his films bear watching. With an unmistakable visual style and a unique sensibility, this American Rabelais born out of the good war has created a body of engaging work that stands up to consistent review.

Mikita Brottman

This chapter grew out of an introduction to *Hollywood Hex*. This is a study of 'cursed movies', in which I investigated the kind of cult film that has become notorious and compelling in its role as inadvertent epitaph, as document on the subject of human mortality. These are films that have, in one way or another, resulted in death or destruction. Some are directly responsible for the accidental death of those involved in their creation; others have caused tragedy indirectly, by inspiring occult movements, serial killers, copycat crimes, psychotic behaviour in audiences, or bizarre and freakish coincidences. The theoretical framework I used in this chapter is influenced by Kenneth Anger's conceptualisation of film as an 'evil medium', and his belief in the dark, enigmatic connections between cinematic narratives and human catastrophe.

Biographical note: Mikita Brottman received her D. Phil in English language and literature from St. Hugh's College, Oxford, and is currently Visiting Assistant Professor in the Department of Comparative Literature at Indiana University. She is the author of *Offensive Films* (Greenwood, 1997); *Meat is Murder!: An Illustrated Guide to Cannibal Culture* (Creation, 1998) and *Hollywood Hex: A History of Cursed Films* (Creation, 1999). She has also published various book chapters and articles on horror films, psychoanalysis and true crime in such journals as *Cinefantastique*, *Trash Aesthetics*, *Film Quarterly*, *New Literary History*, *Continuum*, *Necronomicon*, *Studies in Popular Culture*, *PostScript* and *Headpress*.

Brando Lee - The Crow

Star Cults/Cult Stars: Cinema, Psychosis, Celebrity, Death

Mikita Brottman

"The dead have their magic"
David Thomson, *Beneath Mulholland* (1997)

What is a star? For some, the star is a mirror, a reflection in which the public studies and adjusts its own image of itself.[1] For others, the star is a direct or indirect projection of the needs, drives and dreams of American society.[2] In order to understand some of the complex connections between cinema, psychosis, celebrity and death, it is first important to consider the way in which dead stars can polarize and fix a wide range of human obsessions.

The growth of photography and the motion picture industry in the Twentieth Century has been coterminous with the cult of the celebrity personality. When specific actors and actresses suddenly became sought-after, valuable property, when the ticket-selling faces took on names, then the star system was born. Or, as Kenneth Anger puts it, "Cinemaland was cursed in its cradle by that fateful chimera, the 'Star'".[3] The cult of celebrity experienced such rapid and prodigious expansion that by the middle years of the current century, audiences were accustomed to being persuaded that they had special and privileged access to the off-screen, day-to-day lives of the 'stars'. In certain circumstances, fans found themselves encouraged by studio publicity mechanisms to attempt to erode the boundaries separating the individual ego from the personality of the celebrity, thereby allowing the fan to identify completely with the blessed life of the star. Writer Jay McInerney claims that it's an indication of a collapsed value system when the social order seems to be defined by our distance from these empty luminaries, or our connection to them, however vague, and when the highest rung on the 'celebrity ladder' is occupied by these people, who signify nothing.

As Richard Dyer points out, "stars have a privileged position in the definition of social roles and types, and this must have real consequences in terms of how people believe they can and should behave."[4] This privileged position is maintained in a variety of different ways. Primarily, it's maintained by the public relations industry that grows up alongside any successful celebrity. This industry allows us to amass, without any conscious effort on our part, a tremendous wealth of details concerning every aspect of the star's life and lifestyle. (From biographical accounts of their childhood by close friends or family members, to photographic archives recording their various hair styles and the history of outfits worn on various occasions, to graphic accounts of emotional intimacies and sexual preferences). It's also maintained by cinematic techniques like the close-up, a device which Bela Balazs describes as appearing to reveal "the hidden mainsprings of a life which we thought we already knew so well."[5]

[1] See, for example, Raymond Durgnat, *Films and Feelings*, (Cambridge: MIT press, 1971), pp. 137-8.

[2] See, for example, Alexander Walker, *Stardom*, (London: Joseph, 1970), p. xi.

[3] Kenneth Anger, *Hollywood Babylon* (London: Straight Arrow Books, 1975), p. 28.

[4] Richard Dyer, *Stars*, (London: BFI Publishing, 1979), p. 8.

[5] Bela Balazs, *Theory of the Film*, (New York: Ayer Company Publishers Ltd., 1972), p. 185.

opposite:
Greta Garbo

Orrin E. Klapp describes how one of the most significant features of the celebrity is to "maintain the image of the group superself",[6] something that's achieved through regulated depictions of the celebrity body. The body of every human being is considered to be revelatory. A person is considered to be one and the same as their facial gestures, physical appearance and bodily structure. This is true for every one of us, and takes on an enormously magnified level of significance for the celebrity whose bodily movements and physical gestures are constantly subject to intense and ongoing public scrutiny. To a far greater extent even than the rest of us, the celebrity not only has a body, they are their body. In this brief chapter, I want to suggest that dead celebrities are symptoms of a kind of cultural psychosis because they embody social values (mainly to do with the nature of the human body, and bodily death) that are, in one way or another, in serious crisis. I want to show how the 'cult' of the dead star refers centrally to these kinds of human and cultural crises.

Touched With Magic

Critics have often observed how celebrity personalities are 'constructed' by the entertainment industry. This 'personality construction' is so intrinsic to the 'star system', so taken for granted by film audiences, that it's sometimes very difficult to understand how far it goes, where it begins, and when (if ever) it ends. These constructions also include notions about what 'makes' a star, and how people 'become' stars, and are so deeply entrenched in the ideology of Western culture that they may perhaps be better described as myths.

One of these myths is the belief that stars become stars because they are 'touched with magic' in the form of 'great talent', 'a rare personality', 'an instantaneous connection with the public', 'an overabundance of charismatic on-screen charm' or 'the ability to make you care'.[7] Another myth is the idea that stars get 'discovered', as in the old story of the accidentally-spotted soda-fountain girl who was quickly elevated to stardom. This was a myth that, according to Daniel Boorstin, "soon took its place alongside the log-cabin-to-White-House legend as a leitmotif of American democratic folk-lore".[8] Other celebrity myths include the 'star plucked out of nowhere who becomes difficult and uncooperative', the 'big star who's declined into obscurity', the 'star who sacrificed everything on the altar of ambition', and the myth of 'Hollywood as destroyer'. Some of these myths change and develop over time. For example, it was once a popularly held belief that the role and performance of a star in a film revealed something about their personality, which was then 'corroborated' by stories in magazines, and so on.

In other words, the plot of a film was often regarded, at some level, as the working out of the actor/character's inherent nature. A good example of this is the 'character' of Greta Garbo, whose line "I want to be alone" in *Grand Hotel* in 1933 was a fictional line of dialogue, but one that was attributed again and again to the 'real' Garbo (who requested only that the press stop hounding her), and interpreted as the expression of an innate fundamental and 'metaphysical' personal desire.[9] Today, this myth has been replaced by the new myth of "contradictions-in-the-image", when that image is seen retroactively. For example, as Richard Dyer points out,[10] today's cult of Bogart tends to see him at odds with his contemporary image, more full of worldly wisdom perhaps. Equally, today's cult of Marilyn Monroe sees her as full of tragic consciousness, a quality so at odds with her movie roles that, to the modern viewer, the contradictions threaten almost to fragment the image altogether.

The Celebrity Death-Rattle

Most fascinating and compelling, of course, are the myths of destruction, of celebrity scandals, of Hollywood's 'dark side'. The glamour and the tinsel, the beautiful people and their daring love affairs are legendary for their sordid underbelly: the realm of greed, lust, jealousy and shame. As long as there is a celebrity elite living in an illusory world of sparkle and style, as

[6] Orrin E. Klapp, *Collective Search for Identity*, (New York: Holt, Rinehart & Winston, 1969), p. 219.

[7] Examples taken from Tichi Wilkerson & Marcia Borie, *The Hollywood Reporter--The Golden Years*, (New York: Coward-McCann, Inc., 1984), p. 181.

[8] Daniel Boorstin, *The Image: A Guide to Pseudo-Events in America*, (New York: Atheneum, 1980), p. 162.

[9] See Dyer, p. 176 and p.181 (footnote).

[10] Dyer, p. 71.

Marilyn Monroe

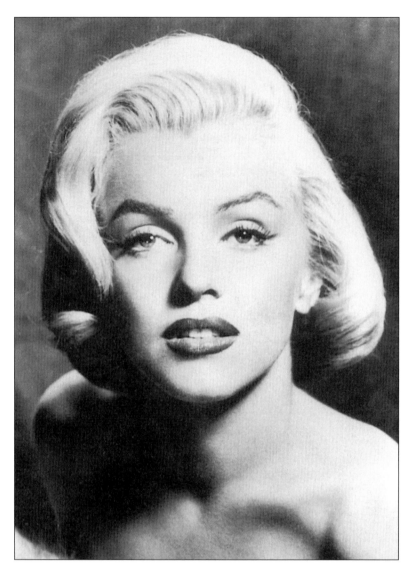

long as Hollywood fuels dreams of a glamorous, sexually-charged, thrill-packed universe, there will continue to be stories told of intolerable pressures, violence, and catastrophe.

The deaths of Montgomery Clift, James Dean, Marilyn Monroe, Judy Garland, Bruce and Brandon Lee as well as the premature retirement of Greta Garbo were far more significant, culturally and ideologically, than the films they made. Swayed by the spirit of *schadenfreude*, the press in Hollywood made enormous scandals out of Fatty Arbuckle's rape case, Ingrid Bergman's illegitimate child, the murder of Lana Turner's mafia boyfriend, Robert Mitchum's dope charge, Judy Garland's drunken breakdowns and Elizabeth Taylor's 'breaking up' of Debbie Reynolds' marriage to Eddie Fisher. It's no coincidence that the press in Hollywood invariably devote more space to Hollywood's top-name divorces and separations than they do the multitude of celebrity marriages witnessed every year.

Myths of Hollywood's 'dark side' generally tend to revolve around the legendary 'pressures' that every star must face: the criticism, the hypocrisy, the back stabbing, the extravagance, the dramas and scandals, the searching

inquisitions into their private lives, and the fabled rejection that follows the legendary adulation. The most fascinating aspects of celebrity lifestyles are not the lavish homes and priceless jewellery, but the personal anxieties and emotional tensions, the drunken collapses and nervous breakdowns that lead to distasteful and frenetic contests of luridness between the tabloids, constantly gleeful at the misfortunes of the rich and famous.

The most popular and enduring narrative of Hollywood's sordid underside is the story of the 'celebrity death-rattle': the star who finds it hard to face a future as a has-been. After all, once you've been right at the top, or so the story goes, there's nowhere to go but downhill. For some, the rupture between the outward glitter of Tinseltown and the daily reality of poverty and exploitation was reputedly hard to take. For others, the cruelty of studio 'ownership' was impossible to live with. For all, perhaps, to have one's physical body magnified on celluloid can be quite a terrifying thing, especially when that body beings to reveal middle-age paunches, disappearing or greying hair, and sagging facial tissues. Even the most beautiful front-line star, who once had no more to worry about than tell-tale signs of the previous night's hangover or cocaine binge, eventually comes face to face with their ageing image on screen, with its wrinkles, crow's feet and bags under the eyes, a sad tableau of second-hand flowers.

Fatty Arbuckle

Montgomery Clift

And then there is the story of the star whose decline is not merely physical, and whose hugely magnified body begins to manifest signs of psychological unease, insecurity or mental discomfort. To the gaze of the obsessive celluloid voyeur, the actor's thoughts imperceptibly turn into gestures. Tics, accidental twitches and gesticulations are quickly read as symptoms of mental obsessions: the physical enshrinements of psychic details. Consequently, to the celebrity, the performance that was once voluntary, and for the benefit of a real audience, can imperceptibly become involuntary, habitual, symptomatic and finally psychotic, and performed for the eyes of imagined spectators only.

Other paradigms of stars 'gone wrong' include the legend of what a celebrity once did in the obscurity of youth, when they needed the money. Consider, by way of example, the persistent rumour that in her younger days when she was a Schubert showgirl (and, they say, a sometime prostitute), Joan Crawford made a number of stag reels under her real name, Lucille LeSueur.[11] Rather more poignant, perhaps, is the story of the celebrity whose

[11] See, for example, Anger *Hollywood Babylon* (London: Straight Arrow Books, 1965), p. 28.

star has long-since faded, who dies alone, forgotten, their brief moment in the limelight reduced to a faded news-clipping from another age. Other celebrity has-beens, we learn, end up selling used cars, or working in a hot-dog van in the entrance to their former studios, or, like Frances Farmer, clerking at the Palace Hotel in San Francisco.

And just as the glittering surface of Tinseltown has its sacred places: Schwab's Drugstore, Grauman's Chinese Theatre, the corner of Sunset and Vine, so the Babylonesque side of Hollywood has its own special sites, too. The geomancy of this sordid underside derives its power from places equally full of magic, but black magic: Forest Lawn Cemetery, The Motion Picture Country Home, Cedars of Lebanon Hospital, The Betty Ford Clinic, Hollywood Memorial Park.

Gods Self-Slain On Their Own Strange Altars

This leads us inevitably to the cultic myths surrounding celebrity deaths. Of course, well-known figures have died in public since classical times and earlier; the extensive public mourning of royal and non-royal leaders has been witnessed since long before the rise of the mass media. As Dyer points out, however, 'stars' themselves, as a peculiarly characteristic feature of bourgeois theatre (and only subsequently cinema), did not emerge until the eighteenth century, with the popularity of such actors as Edward Garrick, Sarah Siddons and Edmund Kean.[12]

The contemporary public self that faces death, however, is considerably different from the selves of the past. Throughout most of the past, selfhood was considered to be more collectivist in orientation, as it still remains today in many non-Western cultures. To such societies, personal extinction did not hold the same terror it does today, because the ultimate social unit (the tribe, or clan) continued to survive, despite the deaths of its individual members. But with the increase of cultural individualism and the perceived relativity of value systems, the quest for specific identity and personal self-knowledge has become the primary source of meaning in most people's lives. As a result, the self becomes much more vulnerable to death, since death in modern societies takes away not only life, but that which gives life its value.

Consequently, part of the horror of the celebrity death, especially the public celebrity death (as in the car crash or assassination) is the sudden loss of revelatory power suffered by the star's body. That public body, once so expressive and so intensely scrutinized, is abruptly transformed into a limp marionette, the strings suddenly cut that once attached it to the complex and hidden mechanisms of media relations and industrial investment. And yet somehow, paradoxically, this detached puppet still purports to be the eminently notable celebrity its strings once so publicly animated. Little wonder, then, that the death of a celebrity (particularly if public, tragic, untimely, accidental or self-inflicted) should arouse such violent emotion, such voyeurism, such curiosity, such alarm.

With the arrival of the international celebrity came the public experience of the international celebrity death. In the age of motion pictures, death is, or has become, show business. The public relations industry that developed around dead celebrities such as James Dean and Marilyn Monroe functions as a pointed dialogic articulation of stories about the 'discovery', 'success' and 'pitiful downfall' of media celebrities.

Hollywood has always been a magnet for the erotic and violent. There are those who claim that our fascination with such cruel undoings derives from our cultural pruderies towards matters of sex and death. It has been argued that, just as sex is 'pornographic' when divorced from the human emotions of love and affection, so death becomes crudely absorbing when divorced from its 'natural' emotions of grief and mourning. In other words, despite our

12 Dyer, p. 102.

increasingly scarce contact with 'off-screen' deaths, 'celebrity' death does not generate moral reflections and ethical deliberations, but, instead, fills us with the galvanizing adrenaline rush of exquisite curiosity.

Significantly, it was no accident that the growth of the motion picture industry (and, more materially, the growth of the studio system) coincided with a sudden increase in the number of untimely deaths experienced. Writers such as Richard Schickel, in *His Picture in the Papers*, have described how "this phenomenon, this beginning of a new celebrity system, destroyed or crippled almost everyone caught up in it"[13] Whilst it is true to say that most of this new generation of celebrities passed quietly to oblivion on their day-beds in the Motion Picture Country Home, a not insubstantial proportion of others chose to end their not-so-glittering lives by their own hands, and in their own inimitable styles.

Innocently Spoken Words of Irony...

Cinema, psychosis, death and celebrity are all disturbingly entwined in the story of Florence Lawrence, the first film actress ever to receive billing, who became a great star for George Zukor. Lawrence was known only as the 'Biograph Girl' until Carl Laemmle attempted a publicity stunt which consisted of his planting a story in the St. Louis Post-Despatch to the effect that Lawrence had been killed by a trolley car in St. Louis. The following day, he planted a second story with an advertisement in the trade press, denouncing the earlier rumour as a vicious lie.

This event was the first occasion that a film star's name became known to the public, and perhaps the first example of the deliberate manufacture of a celebrity's image. Today, however, Lawrence lies buried in Hollywood Memorial Park in an unmarked grave, and would have passed into complete obscurity, were it not for the fact that she is commemorated in Kenneth Anger's *Hollywood Babylon* for her novel choice of suicide technique: she drank a cocktail of ant paste blended with cough mixture.

And so began the 'dead star' phenomenon, a complex series of events and circumstances that is crystallized in certain images and in certain films, many of which have subsequently attracted a cult audience. Such films are considered particularly fascinating in terms of the conjunctures and disjunctions they present between explicit plot, themes and attitudes, and implicit, perhaps inadvertent strategies, images and dialogues. In certain exemplary 'cursed' movies, two of which I will be examining in some detail, images and dialogue both reflect and illuminate all the issues surrounding the death of the human body. To this end, these films now function as inadvertent documentaries on the subject of human mortality. In such films as these, human obsessions and social formations intersect at the site of the celebrity death.

For stars who die shortly after or even before a film's release, the audience cannot help but subject the movie to microscopic scrutiny in a search for tell-tale betrayals of bad health, or signals of emotional meltdown. For those celebrities whose death comes some time later, it's still tempting to scrutinize these final movies for portents of the future tragedy, or innocently-spoken words of irony, regardless of what else might be happening on screen. Two cult 'cursed movies' rich in retroactive irony are Nicholas Ray's *Rebel Without a Cause* (1955), and John Huston's *The Misfits* (1960).

Rebel Without a Cause (director: Nicholas Ray, 1955)

Unique in the annals of Hollywood's 'cursed movies', *Rebel* managed to bring together a cluster of youngsters, all of whom burned out in a variety if different and tragic ways. And although each of them went on to make other films, *Rebel* stands as the epitaph for a generation in more ways than one.

[13] Richard Schickel, *His Picture in the Papers: A Speculation on Celebrity in America Based on the Life of Douglas Fairbank's Sr.*, (New York: Charterhouse, 1973), p. 27.

Joan Crawford
and Bette Davis

Most tragic of all, perhaps, was the death of James Dean during the very weekend the film went into national release. Dean, had been invited during the last month of his life to take part in a traffic safety commercial for the National Highways Committee. In his sequence, Dean is interviewed by Gig Young (another eventual suicide), who starts off by saying to him, "Jimmy, we probably have a great many young people watching us tonight, and, for their benefit, I'd like your opinion about fast driving on the highway. Do you think it's a good idea?" Dean looks directly at the camera, grins, and warns the film's teenaged viewers to "drive safely, because the next life you save may be mine."

During the completion of principal photography for his next film, *Giant* (1956), the wayward star was prohibited by director George Stevens from driving his racing model Porsche. Eight days later, Dean attended a gay party in Malibu, California. The party ended in a public fight between Dean and his male ex-lover, who accused him of dating women just for publicity. That night, the night of September 30th 1955, Dean was arrested on Highway 41 at Chalome, near Paso Robles. On the way to a sports car race in Salinas, the young actor was charged with driving his silver Porsche at 75mph in a 45mph zone. Two hours later, he smashed head-on into another vehicle, seriously injuring two other people, and was pronounced dead on arrival at Paso Robles hospital. Highway patrolmen who reconstructed the fatal crash showed that in order to get from where he was arrested to where he was killed, Dean would have had to be averaging 75mph.

After the star's death, his wrecked Porsche was used as a safe driving exhibit in a nationwide tour to discourage Dean's teenaged fans from similar feats of daredevil driving. The 'curse of James Dean's car' has gathered momentum over the years. Car designer George Barris eventually bought the

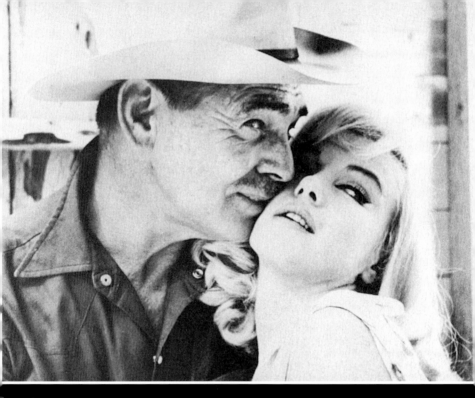

The Misfits

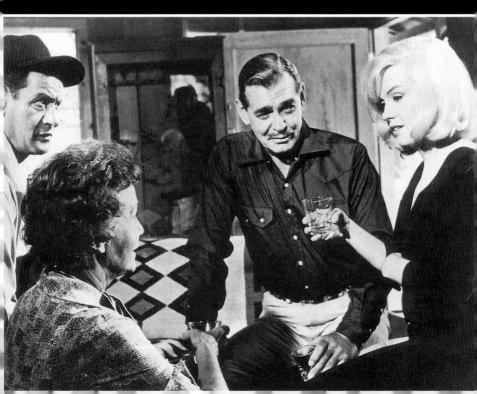

wreck of the Porsche to sell off some of the undamaged parts. When the car was delivered to his yard, it rolled off the back of the truck and broke a mechanic's legs. A Beverley Hills doctor, Troy McHenry, who also raced cars, bought the engine from Dean's Porsche, transferred it to another car, and was killed the first time he drove it. Another doctor who bought the transmission and put it in his own car was seriously injured in a crash, and a man in New York who bought two of the Porsche's tyres spent weeks in hospital after they both "mysteriously" blew out at the same time. A year later, the remaining shell of the car was being transported for a public road-safety exhibition in Salinas. The driver of the transporter was killed as the truck skidded and crashed. Dean's wrecked Porsche was stolen, and has never been seen since.

It's been noted on many occasions that Dean's auto wreck was the best career move he ever made. His death is often compared with the 'chicken run' scene in *Rebel*, in which Jim Stark (Dean) and Buzz are driving two stolen cars towards the edge of a cliff; the first one to jump out is branded a chicken. Jim rolls out at the last second, but Buzz's coat sleeve is caught in the door handle and he hurtles over the cliff to his death. In the aftermath comes Jim's anguished cry "a boy was killed!".

Dean's speech to an empty banquet hall in the 1956 release of *Giant* had to be later redubbed, after Dean's death, by his friend Nick Adams, another of the casualties of *Rebel*. Ironically, Adams was the next actor from the movie to die, an alcoholic, of a mysterious drug overdose in 1968. The death of Sal Mineo eight years later was equally untimely. Aged thirty-seven, Mineo, once known as the 'switchblade kid', was himself the victim of a fatal switchblade stabbing (with homosexual overtones, according to police) in the empty garage of his home just off Santa Monica Boulevard. Mineo managed to crawl up an adjacent set of steps before haemorrhaging to death in the middle of the street.

An equally ironic demise lay in store for Dean's glamorous young co-star, Natalie Wood. Suffering from a lifelong fear of water, Wood was discovered drowned in what many believe to be suspicious circumstances off California's Catalina Island. At the time of her death, she was three days from the end of work on *Brainstorm*, a film she was currently shooting with Christopher Walken and her husband, Robert Wagner. She was last spotted climbing into her yacht's small rowing boat and rowing herself out into the tide in the middle of the night. Some have claimed that her drowning was no accident, but a suicide resulting from the traumatic discovery of her husband being involved in homosexual activities with Walken.

Whatever the enigmatic circumstances behind her death, its resulting publicity dictated the deletion of a number of scenes from *Brainstorm* that had already been shot, but now appeared indelicate under the circumstances. These included a scene involving Wood in a motel swimming pool, and another in which an incidental character drowns. In fact, the scenes that Wood had yet to shoot on the movie were considered to be so crucial to the picture that MGM wanted to scrap the whole project and collect on their five million dollar insurance payment from Lloyds of London. Lloyds, however, refused to accede to MGM's requests, instead offering them three million dollars to finish the film without its leading actress. Consequently, production was shut down for two months while writer-director Douglas Trumbull reconstructed the picture's finale without the scenes that included Natalie Wood.

The Misfits (director: John Huston, 1960)

Both a critical and a commercial disaster, *The Misfits* now remains fascinating as a poignant and memorable swan-song for its two stars, Clark Gable and Marilyn Monroe. (Even though the film's behind-the-scenes activities are scarcely noticeable on-screen).

Rebel Without a Cause

Much like her co-star Montgomery Clift, Monroe both looked and acted forlorn during the shooting of the film, worn down by the combined effect of pills, alcohol, miscarriages and emotional breakdowns. Terribly insecure, she was constantly feuding with her director-playwright husband Arthur Miller. (He was the film's screen writer, and more than usually late and exasperating on set). Just like her on-screen character Roslyn, Monroe was currently negotiating divorce proceedings with her husband; their divorce was finalized in January 1961. Her performance in the film is fascinating, especially considering that for long stretches of time she was simply incapable of working. However, critics made a number of hurtful observations when the film was released, describing Monroe's performance as one of neurotic individuality that symbolized nothing. The following day, she was admitted to Manhattan's Payne Whitney clinic for psychiatric treatment. By August 1962, she was dead.

Clark Gable died even earlier than Monroe, in November 1960, not long after the film's completion. Virtually all members of the film's cast and crew found filming on location a nightmare in the brutal Nevada heat, but Gable, anxious to prove himself still a virile leading man, suffered more than the others. The ageing star insisted on performing most of his own stunts, with several re-takes. He was left bloodied, bruised and rope-burned by being dragged through the dust by a wild horse again and again. At one point, Gable's character Gaylord, a whisky-soaked has-been, consoles the tearful Monroe with the words "honey, we all gotta go sometime, reason or no reason. A man who's afraid to die is afraid to live". As the pair ride off into the sunset in Gable's pick-up truck (the last, poignant scene for both stars) Roslyn asks Gaylord how he finds his way back home in the dark. "Just head for that big star straight on", he tells her. "The highway's under it. It'll take us right home".

Star Cults/Cult Stars

On set, however, the relationship between the two stars was reportedly less placid. Gable was particularly affected by Monroe's unstable temperament, especially when she kept him waiting hour after hour in the blazing heat. When the picture was finally wrapped up, Gable was both physically and emotionally on the verge of collapse. A week after filming, Gable's wife Kay found him sitting by the bed, his face as white as a sheet as he complained of chest pains. It was the onset of a massive heart attack. Ten days later, on November 16th 1960, at 11pm, Gable collapsed and died in the Hollywood Presbyterian Hospital. His pregnant widow was one of many who believed that Monroe's tantrums on the set of *The Misfits* had contributed to Gable's death by forcing him to wait around for hours in the blistering sun.

Montgomery Clift's own emotional instability had led him to bond very closely with the equally unstable Monroe; their shared excesses and addictions contributed greatly to the film's neurotic atmosphere. Clift often appears wide-eyed in *The Misfits*, but intelligently managed to work his way through the picture. In his opening scene, Clift, playing the younger cowboy and rodeo rider, is shown talking on the telephone to his mother, whom he idolizes. He tells her that he's recovered from a rodeo accident, but that his face has been so badly scarred that she won't recognize him. Writer Robert Thom later accused Miller of being "ghoulish and cold-blooded" to have written this line, knowing full well that Clift was a mother's boy, and that his face had been smashed in a car accident during the making of *Raintree County*. Miller denied the accusations, claiming that, although he'd always thought of Clift as a prospect for the part, he didn't write the lines with him specifically in mind. Clift's last movie was a box-office failure entitled *The Defector*, a film which was critically shunned. The physically and psychologically devastated Clift died six years later, in 1966, of a heart attack brought on by a drug and alcohol overdose.

Cinema of Correspondences

Rebel Without a Cause and *The Misfits* are prime examples of movies that appeal to cult audiences. Such audiences are attracted not to any special aspects of the film itself, but to links between the film and events and circumstances outside of or subsequent to that film's production. Such movies are fascinating in their role as inadvertent celebrity epitaphs for those whose untimely demise the film either heralded, recorded, or (as in Gable's case, for example) set in motion. Audiences are constantly drawn to such films, compelled to search more and more deeply for further connections between filmic narratives and human catastrophe. These connections are not causal, but rather cryptic, enigmatic, and synchronicitous.

Such films are part of what Kenneth Anger calls the "cinema of correspondences". Anger regards film as the evocation of primal forces (demons, in fact). Once released, these can affect those involved with the film's production, as well as the film's audience, through a series of occult circuits connecting physical with spiritual dimensions of existence. To Anger, the point of cinematic images is to 'control' lives and occurrences; he regards film as a kind of black magic aimed at bringing the image and spectacle to life. To this end, in his two Babylon books he keeps a toll of what he describes as SS movies, and the even rarer SSS movies: that is, films involving two or three ultimately suicidal celebrities.

According to some primitive cultures, stories function as a natural conduit for dispelling the human evil and violence that might otherwise be directed against fellow members of society. In modern culture, many seem to believe the same thing, that art and narrative are expressions of man's higher impulses, and work as magical activities that have the power to sublimate or dispel negative energies and destructive feelings. To Anger, however, the opposite is true. He considers cinema to be "an evil medium", a "pure terrorist aesthetic".

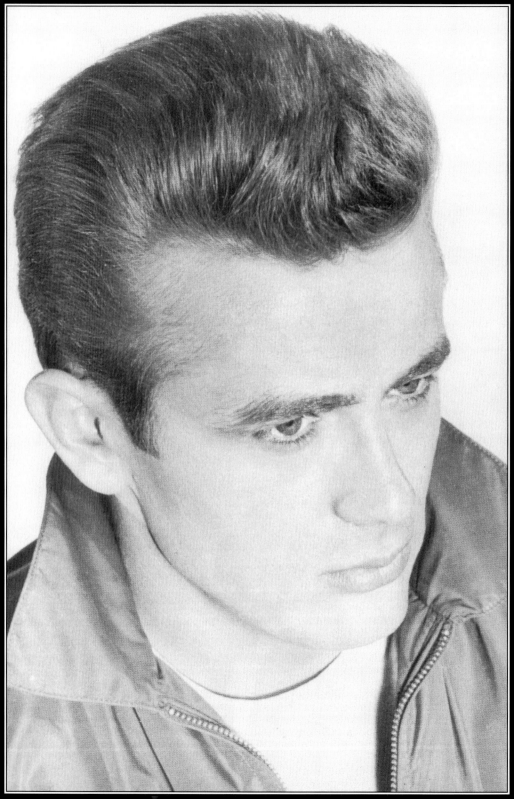

Star Cults/Cult Stars

Films like *Rebel Without a Cause* and *The Misfits* (and there are plenty of others) help to establish cults of dead celebrities because they appear to expose the seams and strata in the landscape of apparently 'random' events. Such films and their dead stars attract a cult following because they record a transcendental moment in cinema: that moment when a star is caught by the camera lens in a way that they themselves are unable to control. Such films are full of proleptic irony. In them, a transference of power takes place. And after this has happened, we mere mortals are no longer in obeisance to the star's celebrity status, because, of course, the star can never know what we know. Unaware of the irony of their roles in such movies, the stars are no longer in control. Hype, 'personality construction', the public relations industry and the entire apparatus that fabricates and maintains celebrity counts for nothing, once we have the stars, as we do in these 'cursed movies', not on their terms, but on ours.

Of course, any film that goes into release in controversial circumstances, especially after the death of its star or others involved in its production, will inevitably take on a whole different frame of reference to that of its original design. Every posthumous performance, every retrospective irony, by its very definition, signals the poignant underpinnings of the forthcoming catastrophe. To fully appreciate the law of synchronicity (that is, the meaning that can be revealed by an inadvertent encounter, hazard or casualty), it is necessary to put aside all rational logic of reasoning and concentrate instead on the chance events and sudden accidents that provide us with new ways of understanding.

opposite:
James Dean

Bill Osgerby

In contemporary parlance, the prefix 'cult' invariably carries connotations of the unusual and the bizarre. Epithets such as 'cult comic', 'cult tv' and 'cult film' usually denote cultural texts that are in some way unconventional, off-beat, perhaps even a little quirky. And, more often than not, they engender enthusiasm among audiences who are equally marked out by their (how shall we put this?) 'idiosyncrasies'.

Audiences for 'cult' texts are not, of course, entirely composed of spotty, anorak-wearing fan-boys who do not get out much and have trouble getting girl-friends. Nonetheless, 'cult' texts cast a fascination that can border on the fanatical and the obsessive. 'Cult' phenomena possess this allure through the virtue of being especially malleable cultural forms - in the imaginations of their audiences they are creatively worked, transformed and adapted to an infinite range of cultural interests and meanings.

There are, however, other facets to 'cult' texts which mark them out as intriguing cultural forms. Many 'cult' phenomena are adept at articulating and condensing the themes, issues, questions and concerns of their historical moment. This is not, of course, to say that they are straightforward and unproblematic 'reflections' of their historical context. Rather than being the simple embodiment or expression of a broader social climate, 'cult' texts are the outcome of complex relationships of production, circulation and consumption. Nevertheless, while they do not mirror wider beliefs and attitudes in any simple, linear fashion, they remain interesting for the ways in which they elaborate specific explanations and interpretations of the world. The changes and developments in the Gerry Anderson universe, then, do not crudely 'reflect' the sensibilities and social attitudes of Sixties Britain. Rather, programmes such as *Thunderbirds*, (as well as its related cinema spin-offs) along with other works such as *Captain Scarlet* and *UFO* actively explained and interpreted the way in which the world was to be perceived and understood. And this is why they are of historical significance.

Biographical note: Bill Osgerby is a writer and cultural historian, and a Senior Lecturer in Cultural Studies at the University of North London. He has published widely on the subjects of youth culture, the media and post-war British and American social history. His survey of modern British youth culture: *Youth in Britain Since 1945* was published by Blackwell in 1998. He has never quite got over his infatuation with Lady Penelope.

TV21 & JOE 90

NEW SERIES No. 7 8th NOVEMBER, 1969 EVERY WEDNESDAY PRICE 8d

MINE-BLAST ON THE OCEAN BED!
SEE THUNDERBIRDS INSIDE!

CORGI
MODEL CLUB
PAGE 19 NEWS

"Stand-By For Action!":
Gerry Anderson, Supermarionation and the 'White Heat' of Sixties Modernity

Bill Osgerby

"We are redefining and we are restating our socialism in terms of the scientific revolution... the Britain that is going to be forged in the white heat of this revolution will be no place for restrictive practices or outdated methods on either side of the industry."
Harold Wilson, speech to the Labour Party Conference, 1st October 1963.

"Thunderbirds Are Go!"
Voice-over to opening sequence of *Thunderbirds*, ITC, 1965.

'Call For International Rescue!'

During the mid-1960s the British people had occasion for confidence and optimism. In the not too distant future they were set to live in a much safer, fundamentally more secure world. This sense of assurance would be indebted, (at least in fictional terms), to the fearless endeavours of a clandestine team of Good Samaritans known only as International Rescue. With all manner of hi-tech wizardry at their disposal, International Rescue could be trusted to triumph over even the most threatening of dangers, the most hazardous of perils.

Operating from an island base somewhere in the Pacific, this team of intrepid trouble-shooters had at their command an array of space-age vehicles including the Thunderbirds - capable of dealing with all manner of apocalyptic calamities. There was, it seemed, no crisis that could not be assuaged through International Rescue's ingenious enlistment of the forces of science and technology.

Premiered on ITV in 1965, the children's science fiction puppet show *Thunderbirds* was the flagship of Gerry Anderson's Century 21 Productions. Originally founded as AP Productions in 1957, Century 21 already had a string of successful sci-fi marionette creations to its name, yet *Thunderbirds* far surpassed its predecessors in terms of both its commercial success and its cultural resonance.[1]

Each episode of *Thunderbirds* saw International Rescue undertake a rescue mission of unbelievable heroism. The daredevil team was headed by ex-astronaut and philanthropic millionaire Jeff Tracy, his five sons (Scott, Virgil, Alan, Gordon and John - all named after the first American astronauts) piloting their amazing Thunderbirds to avert all manner of cliff-hanging disasters. On hand to help out in the stickiest situations were 'Brains', the

1 Full accounts of Gerry Anderson's work can be found in the following: Sylvia Anderson, *Yes, M'Lady: A Personal Memoir* (London: Smith Gryphon, 1991), Simon Archer, *Gerry Anderson's FAB Facts: Behind the Scenes of TV's Famous Adventures in the 21st Century* (London: Harper Collins, 1993) and Simon Archer and Stan Nicholls, *Gerry Anderson: The Authorised Biography* (London: Orbit, 1998).

stuttering and bespectacled scientific genius who had invented International Rescue's fabulous vehicles, and the glamorous, aristocratic secret agent Lady Penelope - always accompanied by Parker, her rough-diamond cockney chauffeur (and reformed safe-cracker).

The format of *Thunderbirds* was simple, yet the thirty-two episode series enjoyed phenomenal success. The series proved to be by far the most popular of Anderson's sci-fi puppet creations in terms of its original ratings, merchandising and overall audience-appeal. Syndicated throughout America and sold to sixty-five other countries, the success of *Thunderbirds* saw the value of Anderson's Century 21 empire soar to around £7 million by 1967, a success that ensured the launch of two full-length Thunderbird feature-films, *Thunderbirds Are Go* (1966) and *Thunderbird Six* (1968) - the first time a British television production company had ventured into the field of film-making.

The launch of two *Thunderbirds* feature films bore testimony to the significant changes taking place in the British film industry. Facing a serious decline in post-war cinema attendance, film-makers hunted for new avenues of audience-appeal. One strategy was to court more specialised markets - evidenced, for example, by a plethora of horror-films geared to younger cinema-goers.

An alternative tactic was to bring successful television programmes to the big screen. With much of the pre-production work already completed, and with a proven track-record of popular appeal, established TV series seemed to offer a short-cut to commercial cinema success. The two *Thunderbirds* movies were in the vanguard of this trend and were followed by a host of attempts to

adapt popular British television series for film release. For instance, the success of the television series *Dr. Who* also spawned two film releases during this period - *Dr. Who and the Daleks* (1965) and *Daleks: Invasion Earth 2150 AD* (1966). With an ability to appeal to a spectrum of generational audiences, situation-comedies were also bankable and the late 1960s and early 1970s saw the release of film versions of such TV favourites such as *Till Death Us Do Part* (1968), *Please Sir!* (1971), *Dad's Army* (1971) and *On the Buses* (1971). The *Thunderbirds* movies also sought a cross-generational audience, the TV show having proved popular with many adults. This success, however, did not transfer easily to the cinema.

While Gerry Anderson's science fiction puppet series were an enormous hit on television, cinema box-office receipts for both features were disappointing. The amazing stunts and special effects of Century 21 shows made for sensational television, but in the medium of film it was hard to beat Hollywood's mastery of the dazzling and the spectacular. Moreover, screened in the home, it was possible for a child-oriented TV series such as *Thunderbirds* to win-over viewers from a wide-range of different age-groups. This task was more challenging at the cinema where, especially during the 1960s, audiences had become more deeply segregated along generational lines. The films *Thunderbirds Are Go* and *Thunderbird Six* were certainly popular among children, but they failed to match the cross-generational appeal achieved by the earlier TV series.

The same difficulties befell Century 21's later venture into the realm of live-action cinema. With the release of *Doppelganger* (a.k.a. *Journey to the Far Side of the Sun*) in 1969, Anderson courted an adult science fiction audience. Yet, once again, cinema success eluded him. Deploying many of the production techniques that were familiar features of Century 21's television puppet shows, *Doppelganger* found it difficult to establish cachet with adult cinema audiences and (despite being nominated for an Academy Award for Special Effects) it performed poorly at the box-office.

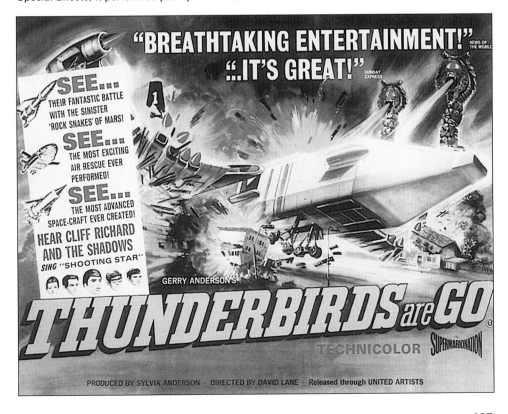

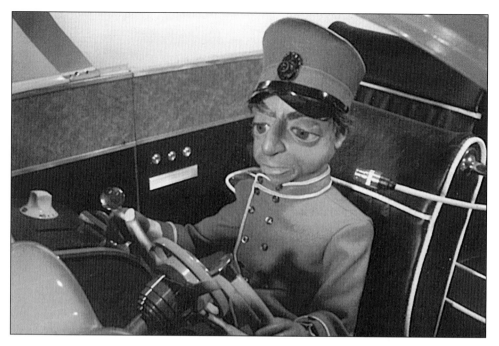

Despite the relative commercial failure of these films, *Thunderbirds* retains an important niche in popular cultural history. Not only have both the films and TV series become objects of cult fascination, but they exemplify the era's fascination with science and push-button gadgetry. International Rescue's array of sleek-lined machines and hi-tech gizmos captured a mid-Sixties *Zeitgeist* in which cutting-edge technology appeared as a talisman of forward-looking modernity. International Rescue's ability to save the day through their cool-headed operation of machines encapsulated the period's confidence in science as a panacea that seemed to promise virtually limitless economic growth and social progress.

Throughout the Sixties successive British governments believed in an intrinsic connection between scientific advancement and economic prosperity. The 1964 General Election, in particular, saw science emerge as a political rallying cry, with Harold Wilson's celebrated reference to the 'white heat' of the scientific revolution as the road to a 'New Britain'. Wilson's speech envisioned a nation where traditional class conflicts could be set aside in favour of a consensus in which all sides 'pulled together' in the 'national interest'.

While the cultural purchase of *Thunderbirds* is partly explained by its adept mobilisation of the Sixties discourses of modernisation and progress, this cannot fully account for the development of the programme and the related films. As Tony Bennett argues, cultural forms should not be reduced to a simple embodiment or expression of their social determinations. Rather, attention must be drawn to the complex ways in which cultural phenomena are intrinsically embedded in their social context and actively contribute to the shaping of social relations.[2] The task of analysis, then, is not simply one of deciphering the ways that cultural texts express their conditioning relations, but demands broader recognition of the nexus of economic, technological and institutional relationships that regulate their production.[3] Accounting for the emergence of Gerry Anderson's sci-fi marionette series and films, therefore, requires attention to their articulation of a wide range of cultural preoccupations during the 1960s. They also point to the ways in which they were shaped by developments in the realm of media organisation, production and finance during the period.

2 Tony Bennett (ed), *Popular Fiction: Technology, Ideology, Production, Reading* (London: Routledge, 1990), pp. 3-5.

3 For further elaboration on the complex relation between cultural texts and their conditions of production see Tony Bennett and Janet Woollacott, *Bond and Beyond: The Political Career of a Popular Hero* (London: Macmillan, 1987), pp. 16-20. Further evidence of the link between film and its conditions of production are given in Stephen Heath, *Questions of Cinema* (London: Macmillan, 1981), pp. 226-227.

"Stand-By For Action!"

'Anything Can Happen in the Next Half Hour!'

The success of Gerry Anderson's puppet creations during the Sixties was indicative of fundamental change in the ideological underpinnings and economic imperatives of British television. In 1955, the BBC's monopoly of television broadcasting was breached by a Conservative government which aspired to 'Set the People Free' (as their election slogan put it), dismantling many economic controls and reviving the notion of 'consumer choice' in a free market. A token of this commitment was the launch of a second, commercially-based, television channel.[4] Financed through the sale of advertising, the economic survival of commercial television rested on its ability to attract large audiences. Hence their schedules laid an accent squarely on entertainment - an approach that starkly contrasted with the BBC's mandarin traditions of 'public service' paternalism.

In this new approach to programming Lew Grade stood as one of ITV's major trailblazers. Flamboyant and charismatic, Grade emerged as one of the most powerful men in commercial television through his ownership of the Independent Television Company (ITC), a leading TV production company, and his major stake in Associated Television (ATV - one of the first commercial broadcasting franchises). Despite high start-up costs, ATV soon found its financial feet and by 1957 was turning a healthy profit. This success was due, in large part, to the style of programming initiated by Grade. Proclaiming "I am not here to educate the public. I am here to entertain them".[5] Grade's schedules were weighted towards light entertainment, the media tycoon happily taking credit for changing "the whole complexion of television" through his introduction of programmes traditionally disdained by the BBC - soap operas, game shows, comedies, adventure series and American imports.[6] A shrewd judge of public taste, Grade was willing to bankroll any project he felt had potential for popular success. It was, then, with this in mind that he was attracted to the work of Gerry Anderson.

Working on a shoestring budget, Anderson's company had cut its teeth on fantasy children's puppet shows such as *The Adventures of Twizzle* (1957) and *Torchy the Battery Boy* (1958). It was, however, in the Western-based series *Four Feather Falls* (1960) that Anderson and his colleagues began to

[4] For concise and well elaborated accounts of the development of commercial television in Britain and the responses it elicited, see Andrew Crisell, *An Introductory History of British Broadcasting* (London: Routledge 1997), pp. 83-106. On the sensationalistic aspects of commercial television see also Kevin Williams, *Get Me A Murder a Day!: Mass Communications in Britain* (London: Edward Arnold, 1998): pp. 158-170).

[5] Cited in Archer and Nicholls, p. 48.

[6] Lew Grade, *Still Dancing: My Story* (London: Fontana, 1988), p. 196.

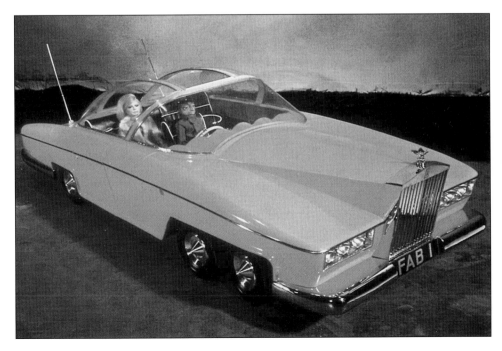

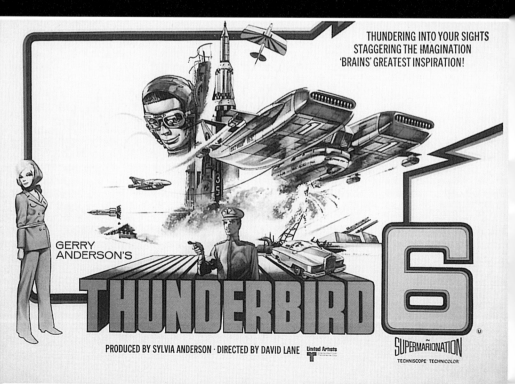

perfect the techniques of 'supermarionation' - the production style that would later become the trademark of Century 21 Productions. Eschewing the glove puppets typically used in children's series of the period, Anderson's team opted for the greater realism offered by string marionettes. The illusion of reality was further boosted through the puppets' finely-sculpted features, the use of highly detailed miniature sets and props and the development of electronic 'lip-synching' - a mechanism that allowed the marionette's lower-lip to operate in synchronisation with pre-recorded vocals. Despite the success of these early shows, a blow came when Granada Television, who had financed *Four Feather Falls*, showed no interest in a further Anderson production. It was with some relief, then, that in 1961 Anderson (by now working in close partnership with his wife, Sylvia) accepted backing from Grade for the creation of a new series - *Supercar*.

Piloted by the valiant Mike Mercury, Supercar was a futuristic vehicle capable of travelling on land, underwater and through the air. A more ambitious and costly programme than its predecessors, Grade was nevertheless prepared to invest in *Supercar* because he believed the series would not only be popular in Britain but also had potential to be marketed internationally. Aimed squarely at an American market, *Supercar* proved an enormous Stateside success. Screened in the autumn of 1962, the first eight episodes grossed $750,000 and prompted a quick follow-up from the Grade-Anderson partnership. Late 1962 saw the arrival of *Fireball XL5*, a twenty-first century rocket-ship flown by Colonel Steve Zodiac and fellow members of the World Space Patrol, all fearlessly pledged to the defence of the galaxy.

Thunderbirds, too, was carefully tailored to an American market. With *Thunderbirds*, Anderson's intention was to "make it appear to be an American picture which happened to be made in England", the characters of Lady Penelope and Parker being included to play up to American perceptions of the British class system.[7] Indeed, as Anderson later recalled, during the 1960s success in the American market became imperative - "Everything we did in the company was an endeavour to sell to America. Even our scripts were typed on American quarto sized paper, and we used US spelling. Anything to overcome the terrible resistance at the time to British programmes."[8]

The success of Anderson's 'supermarionation' creations can therefore only be understood when viewed in the context of the wider transformation of British media production during the late 1950s and 1960s. As market forces increasingly penetrated the television industry, commercial moguls like Grade looked for programmes which - like *Thunderbirds* - could guarantee to deliver large audiences to advertisers. Moreover, the degree to which projects such as the *Thunderbirds* series and films were geared to international sales was a benchmark of incipient trends towards the globalization of the finance, production and marketing of popular cultural texts - trends which would ultimately dominate the political economy of media production.

'F.A.B!'

Developments in the structure and organisation of media industries, then, go some way toward accounting for the success of projects such as *Thunderbirds*. Yet economic contingencies alone cannot account for the style and success of the supermarionation phenomenon. To fully grasp why the Century 21 productions attained such a cultural purchase we also have to look toward changes in social, economic and political life during the late 1950s and 1960s.

It was initially more by necessity than design that Gerry Anderson sallied into the world of technology-based adventure. While Anderson's team had mastered most of their marionette skills in their earlier series, getting their puppets to 'walk' in a convincing manner still posed a problem. Hence the concept of *Supercar* arose as a solution - the scripting of most of the show's

7 Cited in Archer and Nicholls, p. 91.

8 Archer and Nicholls, p. 67.

action in and around a vehicle allowing for forms of rapid movement and action that could maintain the illusion of reality. However, the launch of *Fireball XL5* in 1962 saw the arrival of a supermarionation series more consciously and comprehensively immersed in the world of futuristic technology and science fiction. The move was, at least partly, an attempt to connect with contemporary cultural and ideological concerns.

The late 1950s and early 1960s saw the super-powers jockeying for position in the space race. In 1957 a shiver was sent through the American national psyche as the Soviet Union stole an early lead, putting into orbit the first artificial satellite, Sputnik 1. In 1961 the Soviets achieved another coup, with the first manned space mission - Vostok 1, piloted by cosmonaut Yuri Gagarin. Within a matter of weeks President Kennedy responded with the inauguration of the Apollo programme designed to land a man on the moon and return him safely to the earth "before the decade is out" and the following year saw John Glenn become the first American to orbit the planet.

In Kennedy's 'New Frontier' rhetoric, space exploration and scientific knowledge became ideologically charged. As John Hellmann argues, the space programme was promoted as an embodiment of the wider challenges facing America during the 1960s.[9] It became a metaphor for the new era of social harmony and economic prosperity that could be won if only the American people could muster sufficient courage and commitment. Kennedy's mobilisation of the 'mythologies' of scientific knowledge was powerful, but not unprecedented. A 'cult of science' had held sway in America since 1945, with scientific progress "seen as the key to American greatness and the main source of economic and industrial expansion."[10]

To use Elaine Tyler May's phrase, this was "the era of the expert" in which science and technology seemed to infuse every aspect of public and private life.[11] Standing as supreme icons of modernity and progress, science and technology became cultural tropes endemic to American society during the 1960s - from the space-age designs of domestic furniture to the themes of TV sit-coms, dramas and adventure series. In such a context it was hardly surprising that the reassuring confidence of sci-fi supermarionation shows such as *Fireball XL5* and *Thunderbirds* should receive such a warm reception.

In Britain, too, Century 21 productions struck a chord with a popular imagination fired by advances in science and technology. After the Second World War the vital importance of scientific development to Britain's economic growth and sense of national prestige became common political currency. Throughout the 1950s and early 1960s governments sought to preserve Britain's faltering status as a global power by promoting the country as a world-leader in advanced technology. The election of Harold Wilson's Labour government in 1964 was a high-water mark to the British state's embrace of science as a totem of economic prosperity.

The implementation of the recommendations of the Robins Report (1963) saw training and education enhanced through the expansion of higher education, while a Ministry of Technology was established as an avenue through which the government could encourage economic efficiency and the use of advanced technology in industry. By the mid-Sixties, therefore, it looked as though Britain was set to equip itself as a modern industrial nation.

As in the United States, there were powerful ideological dimensions to British visions of scientific progress and modernity during the 1960s. According to the persuasive model of post-war political history forwarded by Stuart Hall and his colleagues,[12] British governments after 1945 had secured popular consent through mobilising the ideologies of social and political consensus. Full employment and rising living standards allowed for a mythology of 'classlessness' in which the pace of economic growth was presented as steadily ameliorating social divisions and neutralizing traditional

[9] John Hellmann, *The Kennedy Obsession: The American Myth of JFK* (New York: Columbia University Press, 1997), p. 121.

[10] Andrew Jamison and Ron Eyerman, *Seeds of the Sixties* (Berkeley: University of California Press, 1995), p. 15.

[11] Elaine Tyler May, *Homeward Bound: American Families in the Cold War Era* (New York: Basic Books, 1989), p. 26.

[12] See in particular Stuart Hall, Tony Jefferson, John Clarke and Brian Roberts, *Policing the Crisis: Mugging, the State and Law and Order* (London: Macmillan, 1978). Also useful is Stuart Hall and Martin Jacques (eds) *The Politics of Thatcherism* (London: Lawrence and Wishart, 1983).

class conflicts. By the beginning of the 1960s, however, significant cracks were appearing in the confident rhetoric of consensus and progress.

Growing economic strife and industrial unrest combined with political scandals and foreign policy disasters to bring about a crisis of national identity and an erosion of the articulating principles through which political hegemony had been secured. As a consequence the early Sixties saw an attempt to construct a new basis for social and political hegemony - a task undertaken most obviously by Wilson's Labour administration. In Wilsonian terms economic growth was still realisable, yet could only be won through a combination of short-term 'belt-tightening', the subordination of sectional demands to the 'national good' and the harnessing of the potential of 'the scientific revolution'.

As Bennett and Woollacott argue, periods of change in the ideological articulations through which hegemony is secured often coincide with periods of generic innovation and adaptation within the field of popular fiction. In these terms, popular fictions act "as a touchstone for the entire field of ideological representations, sounding out where, ideologically speaking, 'the people' have moved to and piloting the ideological adjustments which ... will be able to stitch 'the people' back into a newly constituted place within a restructured hegemony."[13] The 'supermarionation' productions of the mid-Sixties can be read in exactly this way. *Thunderbirds*, especially, embodied Wilson's 'ideology of corporatism' in which Britain was set to be revitalised through the alliance of capital and labour and the command of 'white-hot' technology.

[13] Bennett and Woollacott, p. 282.

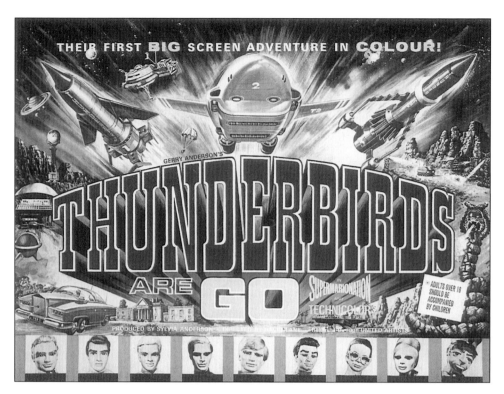

From their opening sequences, the 'supermarionation' series (and especially the *Thunderbirds* films) made it clear they were dealing with a no-nonsense world where the forces of dynamic vigour could be trusted to get the job done. An intense sense of dramatic energy was generated through fast-cut action sequences, sharp camera angles, exciting music (composed by Barry Gray) and shouted action lines - "Stand-by For Action!", "Thunderbirds Are Go!". The central ingredients to each production, meanwhile, were the stylishly designed machines equipped with all manner of nifty gadgets. In *Thunderbirds*, for example, it was always the brightly coloured, smooth contoured vehicles that were the stars of the show - especially Thunderbird One (a racy rocket-ship capable of speeds of up to 7,000 miles per hour) and Thunderbird Two (a pea-green freighter able to carry a selection of 'pods' stocked full of awesome equipment). This arsenal of breathtaking machinery, combined with International Rescue's staggering technical know-how, meant there was virtually nothing beyond the capabilities of the Tracy brothers and their confederates. The series' dazzling production techniques and spectacular special effects also inspired wonder at the potential of technology. Audiences of both children and adults were captivated by the sense of realism created through Century 21's attention to the details of puppets, sets and vehicles, their impressive photographic and design tricks and sensational pyrotechnics.

The vogue for acronyms in Sixties government and science was also echoed in the world of 'supermarionation'. The shows were peppered with distinctive code-words and call-signs ('F.A.B.', 'S.I.G') together with an array of special organisation names (W.A.S.P., W.N., I.R., B.I.S.H.O.P.). Indeed, the recurring theme of a pan-global organisation working in the service of mankind encapsulated both the sixties climate of détente and the contemporary ideological discourses of modernity and meritocratic classlessness. As Bennett and Woollacott observe of James Bond's Sixties incarnations, characters such as Steve Zodiac, Troy Tempest and Scott Tracy were "heroes of modernisation".[14] Members of organisations that were the model of well-oiled proficiency, these 'men' recognised no loyalties of class, earning their status simply through their virtues of expertise and ability. The Century 21

[14] Bennett and Woollacott, pp. 20-1.

universe, then, condensed contemporary ideologies that held Britain was escaping the archaic constraints of class-bound traditionalism, moving instead into a bold, new age of meritocracy and professionalism.

Lady Penelope Creighton-Ward was the obvious exception. A blue-blooded archetype of the landed nobility, International Rescue's London Agent was an embodiment of the aristocratic amateur rather than the meritocratic professional. Nevertheless, in combining her sexy glamour with a thirst for action, Lady Penelope (family motto: 'Elegance, Charm and Deadly Danger') can be seen as a Sixties 'pop feminist' whose sex-appeal, like that of her peers Emma Peel and Modesty Blaise, was complemented by her strength, courage and technical skills. Lady Penelope, then, was liberated from the constraints of family, marriage and domesticity and stood as an emblem of 'Swinging Sixties' femininity.

In its jaunty cheer and camp humour *Thunderbirds* also captured the essence of the Sixties pop sensibility. The film *Thunderbirds Are Go!*, for example, includes a sequence in which Lady Penelope (resplendent in sequins and gold lamé) visits 'The Swinging Star' - a glitzy night-club orbiting the earth - and is serenaded by none other than marionette versions of Cliff Richard and the Shadows. Developing trends in youth culture also surfaced in *Thunderbirds* - with touches such as a pirate radio station in outer space and various members of the 'cast' wearing mini skirts and even the occasional kaftan. In the Tracy household, meanwhile, expressions like 'groovy' and 'fab' were not unknown. International Rescue's gadgets and gimmickry also had decidedly 'pop' connotations. It can be argued that the Sixties notion of the 'gadget' marked a radical break with previous conceptions of an awesome and hulking modern technology. In the pop aesthetic of the 'gadget', technology had become a miniaturised and individualised consumer product - precise, functional and emblematic of stylish cool. There were even marked elements of camp to International Rescue's hi-tech gadgetry. For example, for the launch of Thunderbird Three Alan Tracy would travel from the family lounge to the vehicle's launch-pad on a motorised settee, while Lady Penelope's shocking-pink Rolls-Royce (registration number: FAB 1) stood equal to Mary Quant or Carnaby Street as a symbol of sixties pop kitsch.

'This Is the Voice of the Mysterons ...'

Century 21's supermarionation television series and films, therefore, were texts that expressed contemporary themes of modernity, progress and optimism, exemplifying an era in which Britain seemed to have the chance of a new way forward. It was something of a shock for the production crew when Lew Grade decided to pull the plug on *Thunderbirds*. Gerry Anderson had fully expected a further season to be commissioned and was taken aback when Grade told him that an entirely new show would be more saleable. Though Grade's decision was entirely business-driven, it was also culturally prescient. By the late sixties *Thunderbirds*' brand of pop joviality was beginning to lose step with wider patterns of social relation. These were beginning to exhibit features decidedly more confrontational and paranoiac than those at the beginning of the decade.

First screened in 1967, *Captain Scarlet and the Mysterons* was Century 21's ambitious follow-up to *Thunderbirds*. The series featured all the familiar supermarionation trademarks - finely detailed puppets and sets, an array of amazing vehicles and a catalogue of spectacular stunts and special effects. Yet the tone of the programme was very different to its predecessors. Gone were the campy hi-jinx, instead *Captain Scarlet* played it straight. Indeed, the series had an atmosphere that was positively dark and threatening - personified in the spectral aura of Captain Black.

Set in the year 2068, the premise of the show was that the Mysterons, the mysterious and unseen inhabitants of Mars, were waging a war of attrition

against humankind. Their city accidentally destroyed by an exploration mission from earth, the Martians were intent on revenge. Using their power to recreate any object or person that had been destroyed, the Mysterons launched a campaign of sabotage and assassination against earth - with former earth-agent Captain Black acting as their deadly emissary. Defending the earth was the obligatory world security organisation (in this case S.P.E.C.T.R.U.M.) and their trump card, Captain Scarlet - "one man fate has made indestructible".

The future envisioned in *Captain Scarlet*, therefore, was less secure and more vulnerable than that anticipated in *Fireball XL5*, *Stingray* or *Thunderbirds*. Each episode saw Captain Scarlet foil one of the Mysterons' murderous schemes, yet the Martians were never ultimately defeated. Without a sense of narrative closure, *Captain Scarlet* left the world in a state of profound uncertainty. In this respect the series can be seen as constituent to the wider social and political anxieties that characterised the late Sixties.

Both in Britain and America the stability and confidence that had marked out the beginning of the 1960s was, by the end of the decade, disintegrating. In the United States the structural limitations of the 'New Frontier's' liberal optimism was starkly revealed by growing social fragmentation, urban disorder and the bloody quagmire of the Vietnam War. In Britain, too, the

'expansive hegemony' of the Fifties and early Sixties was in tatters ten years later. As the deep-seated weaknesses of the British economy became glaringly apparent, the late Sixties and Seventies saw Britain beset by social, political and industrial discord. In both countries these moments of 'hegemonic crisis' saw the rise of more abrasive, confrontational forms of political state. The ideologies of affluence and prosperous growth had proved untenable and in their place arose more repressive and coercive forms of social relation in which consent was won through the discourse of 'law and order' and calls for concerted action against a host of subversive 'enemies within'.

Characterised by an atmosphere of unease and ambiguity, the Century 21 productions of the late Sixties and Seventies dramatised at a symbolic level the wider sense of crisis and the collapse of social and political certainties. 'Supermarionation' shows such as *Joe 90* (1969) and *The Secret Service* (1969) sought to resurrect the earlier spirit of pop exuberance, but were lack-lustre failures in viewer ratings. More successful were Anderson's live-action projects - all of which continued the serious themes of anxiety and mistrust that had surfaced in *Captain Scarlet and the Mysterons*.

Following the completion of *Captain Scarlet*, Anderson was drawn towards the challenge of a live-action movie. In *Doppelganger* there featured the same kind of model vehicles for which Century 21 was famous, though this time the lead was taken by actors. The tale of two astronauts travelling to a planet apparently the mirror-image of earth, *Doppelganger* was a study in apprehension and disconcerting ambiguity - a stark contrast to the up-beat confidence of the earlier *Thunderbirds* films. This sense of unease and uncertainty was also intrinsic to the two Anderson live-action television series of the 1970s. Set in 1980, *UFO* (1969-70) was based around the activities of S.H.A.D.O, a secret military organisation struggling against sinister alien invaders intent on abducting humans for unknown purposes on their mysterious home planet. *Space 1999* (1975-6), meanwhile, followed the adventures of the personnel of Moonbase Alpha, marooned in the infinity of a space-time warp after a freak nuclear accident blasts the moon out of its earth-orbit. Moonbase Alpha's endless drift through the expanse of space reiterated the sense of unresolved questions and open-ended narratives that had featured in *Captain Scarlet* and *U.F.O.* This motif, moreover, captured the themes of confusion, instability and doubt which, by the beginning of the 1970s, were displacing the faith in the 'scientific revolution' and were coming to define cultural life in the age of late modernity.

In recent years the term 'cult' has been applied to an array of media texts. However, appellations such as 'cult film' and 'cult television programme' are often used glibly, few commentators troubling to interrogate the charac-teristics and qualities that distinguish a 'cult' cultural form. Those texts to which 'cult' status is awarded are often those that inspire particular devotion among sections of their audience, individuals creating a 'fan identity' through their consumption and production of an (often elaborate) world of fanzines and memorabilia. The Century 21 productions clearly fit into this category - evidenced by the international network of devout 'supermarionation' fan-clubs and enthusiasts. Another dimension, however, also exists to the 'cult' film or TV programme. Such cultural phenomena are also distinguished by their ability to encapsulate important shifts in the social and political concerns of a particular historical moment. In this respect the Century 21 universe is, again, exemplary - Gerry Anderson's creations owing at least part of their enduring appeal to the way they articulated the rise and fall of Sixties ideologies of prosperity, growth, and rational progress.

Victor Sage

Cult is clearly a semantic vortex. I am assuming throughout this essay that cult is what is sometimes called the 'defining other' of taboo. The attempt by pressure groups to ban Cronenberg's *Crash* in the UK converted a director working in an established popular tradition (gothic horror), into a cult director, just at the point when he was making a nod to a literary source of the 1970s. This is the way I see the irony (and the boredom) of the film's reception: its 'moment' is a titanic-sized iceberg, most of which lies below the surface of postmodern orthodoxy. I am aware that one could argue the case the other way round: that Cronenberg was a cult (meaning 'minority', even 'elite') director already, who was plunged into the mainstream by being 'banned'. But for me the term 'cult' is not simply a socio-economic label that implies the mechanism of supply and demand; it is also the sign of an alteration in the chemistry of expectation.

Biographical note: Victor Sage is Reader in English Literature in the School of English and American Studies and Chair of Graduate Studies there. He is the author of two novels, *Black Shawl* (Secker, 1995) and *A Mirror For Larks* (Secker, 1993), and a collection of short stories, *Dividing Lines* (Chatto, 1984). He has published a number of books and articles on the Gothic, including *Horror Fiction in the Protestant Tradition* (1988) and *The Gothick Novel: A Casebook* (1991). With Allan Lloyd-Smith, he has co-edited a recent interdisciplinary collection of essays, *Modern Gothic: A Reader* (Manchester UP, 1997).

BEING TERRIFIED IS JUST THE BEGINNING!

DAVID CRONENBERG'S

SHIVERS

starring PAUL HAMPTON · LYNN LOWRY · ALAN MIGICOVSKY
SUSAN PETRIE and BARBARA STEELE as BETTS
directed by DAVID CRONENBERG produced by IVAN REITMAN

The Gothic, the Body, and the Failed Homeopathy Argument

Victor Sage

My starting point is the argument of Jean Baudrillard in *The Transparency of Evil* (1990, trans. 1993)[1] about the state of contemporary culture. On the face of it, this book seems an absolute blueprint for the Modern Gothic. Baudrillard represents contemporary Western culture (which means the late Eighties, but it's the broadest implications of his diagnosis which seem its most significant contribution) as having exorcized its Other and having co-opted Evil into the 'transparency' of consensus. We are left alone with ourselves: instead of a horrific confrontation with the opacity of the Other, he argues, we are left with the 'Hell of the Same': the viral and the virtual go hand in hand, they reflect the fact that we have exhausted all means of self-transcendence - aesthetic, sexual, political, religious - and have substituted an inertial and endless proliferation of ourselves.

He puts it in a way that has an instant resonance with the Gothic tradition of the Double: Ours is rather like the situation of the man who has lost his shadow: either he has become transparent, and the light passes right through him or, alternatively, he is lit from all angles, overexposed and defenceless against all sources of light. We are similarly exposed on all sides to the glare of technology, image and information, without any way of refracting their rays; and we are doomed in consequence to a whitewash - whitewashed social relations, whitewashed bodies, whitewashed memory - in short to a complete aseptic whitewash. Violence is whitewashed, history is whitewashed, all as part of a vast enterprise of cosmetic surgery at whose completion, nothing will be left but a society for whom, all violence, all negativity, are strictly forbidden.[2]

Traditionally the Gothic novel has thrived on the confrontation, often horrific, between the Self and the monstrous Double, the representation of the Other which is banned whether by Enlightenment theory, or by Protestant Christianity. The confrontation with the Other is a powerful motif in Hoffmann's tales. At times an explicit parody of Enlightenment thought, it became part of modern consciousness through Freud's re-reading of Hoffmann as 'uncanny'. As Terry Castle and Helene Cixous have forcefully (and quite differently) argued, it recuperated in a paradoxical fashion the Enlightenment taboo on the Irrational.[3]

Equally, From Walpole to Ann Radcliffe and Mary Shelley's *Frankenstein*, the narratives of the Gothic are often shaped by the threat of a profane Resurrection of the Body, an explicit taboo reinforced in the Christian (Protestant) credo, which recommits itself during the Nineteenth century (i.e: after Hume's sceptical challenge in the mid-Eighteenth century) to a pre-emptively spiritualised interpretation of the Pauline doctrine of the Resurrection of the Body.

1 Jean Baudrillard, *The Transparency of Evil; Essays on Extreme Phenomena*, trans. James Benedict, (London: Verso, 1993). All susequent quotations from this edition.

2 Baudrillard, *Transparency*, pp. 44-5.

3 T. Castle, in eds., L. Brown and F. Nussbaum, *The New Eighteenth Century;Theory, Politics, English Literature* (London and New York: Methuen), pp. 237-53; and H. Cixous, 'Fiction and Its Phantoms: A reading of Freud's *Das Unheimliche* (The 'Uncanny')', *New Literary History*, 7.3 (Spring 1976), pp. 525-48.

Baudrillard's argument represents this tradition of horror with ironic nostalgia. Those were the days. Evil was the limit of ourselves: the subject relied on these heroic confrontations with the Other to define itself. But in the post-revolutionary period since the 1960s, we (whoever 'we' finally includes...) have carried out, he argues, a relentless assault on all the oppositional aspects of the Other, with results as banal as they are horrifying. And something has happened to representation, and in particular the Representation of the Body, in the process:

"The uninterrupted production of positivity has a terrifying consequence. Whereas negativity engenders crisis and critique, hyperbolic positivity for its part engenders catastrophe, for it is incapable of distilling crisis and criticism in homeopathic doses. Any structure that hunts down, expels or exorcizes its negative elements risks a catastrophe caused by a thoroughgoing backlash, just as any organism that hunts down and eliminates its germs, bacteria, parasites or other biological antagonists risks metastasis and cancer - in other words, it is threatened by the voracious positivity of its own cells, or, in the viral context, by the prospect of being devoured by its own - now unemployed - antibodies."[4]

4 Baudrillard, *Transparency of Evil*, p. 106.

This looks like a map of the Contemporary Gothic - the various metamorphic forms of the Resurrected, Undead Body which roam our screens are a taboo virtualised; 'biomorphic horror' (Ballard's phrase) is, from this point of view, a failed homeopathy, locked into repetition, cloning its own images, unable to provide critique. Biomorphic horror as cultural symptom.

The Gothic, The Body, and the Failed Homeopathy Argument

Cronenberg's *Shivers*:
Narrative 'Incoherence' and the Resurrection of the Body

But let's take the question down to a more manageable level. Does this cultural argument really cash out? Does it provide us with an analytic framework, as it appears to, for the interpretation of contemporary Gothic ? Take the films of David Cronenberg, for example, which are obsessed with the representation of the body. I am particularly concerned here with two works which seem to me on the face of it to exemplify Baudrillard's thesis. Cronenberg's first feature, *Shivers* (1975), and the recent *Crash* (1996), based on Ballard's novel of 1973.

The opening of *Shivers*, in a comic and grotesque fashion, represents a version of Baudrillard's 'backlash'. Located on the outskirts of Montreal, the movie opens in a parody of a promo film, with the glibly lyrical script, and artificially hushed, oddly clipped pronunciation of the speaker set at odds. The advertisement is for a new luxury apartment building, a concept model, the 'Starliner', which exploits the architectural connection between a building and a ship. The apartment block, the only one situated on 'Starliner Island', overlooking the St. Lawrence seaway, boasts of total 'self-sufficiency', even down to dental and medical clinics. The inhabitants are on a perpetual cruise. "Cruise the stars", the voice croons, as we follow a couple up to the glass and pre-stressed concrete entrance.

This is a world which seeks to banish Evil or the Other in all its forms. It is also a form of late Capitalism; we are informed brusquely that 'Starliner Enterprises' is a part of 'STARCO', a division of 'General Structures Incorporated'. The camera, still in promo mode, is in the back seat of the blonde couple's car as the narrative opens. They turn out to be called 'Mr and Mrs Sweden'. The security guard is a bespectacled wimp who is reading a novel. When questioned by 'Mrs Sweden' about the gun in his holster, he confesses that he's "never had it out", that it's an "advertising gimmick". The 'Swedens' are then greeted (and named - was it really 'Sweben' and he didn't hear it right ?) by the unctuous Real Estate manager of the building, Mr Merrick, who is also the owner of the promo film's voice, and taken to his office.

It is at this point that we get a glimpse of what is going on inside the building, in apartment 1511. We cut to a scene of violent sexual intensity, a sadomasochistic rape, which is either theatrically acted out, or really performed, at this stage it is difficult to tell: a girl, Annabel, is attempting to bar her apartment door against someone on the other side. A man in senior middle-age, grim business-like intention written all over his be-whiskered features, bursts open the door against her feeble attempts to bar it, and faces the young woman who is dressed in schoolgirl clothes. The soundtrack moves into a rapid blipping or popping noise, which parodies electronically a raised heartbeat.

The blip is over, and we are restored almost immediately to Mr Merrick who is trying to sell the Swedens an apartment. The counterpoint has been established, the opacity of Evil has apparently entered a world of transparent surfaces, to use Baudrillard's terminology.

However, the ambiguity of the viewer's positioning is crucial to how we ultimately interpret this contrast, and this, I believe, makes it difficult to see whether we can map Baudrillard's argument onto Cronenberg's movie or not. At this point, I want to invoke a methodological point about the positioning of the viewer in this scene. It is crucial to our understanding of the action on screen whether we are watching a deliberately concocted fantasy between the protagonists, or a real scene of rape. The movie's construction makes it impossible for us to tell. All we know is the stark contrast between this *kind* of behaviour and the antiseptic claims of the publicity-driven opening. The indeterminacy means that our response is necessarily fragmented, and at least doubled.

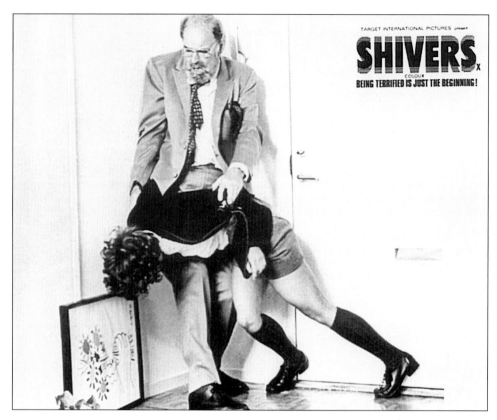

At this point, let me invoke by contrast Susan Wolstenholme's argument about the asymmetry between point of view in Gothic Novels and Films:

"All Gothic fiction might be said to employ a kind of sado-masochism.... In Gothic novels, perspective is vaguer, more diffused through different 'eyes' - the narrator's own and those of various characters - and thus offers various vantage points to the narrating voice, diffuse, de-centred, moving. Although many of the films that have been the object of a feminist inquiry achieve a kind of coherence through the presence of a seeing eye (a coherence that patches over the incoherence suggested by the disruptive female body the same film may fetishize), these novels are more obviously incoherent. I mean this incoherence less as a negative aesthetic trait than as a distinctive feature that reveals the double, even duplicitous, position of the author, and that offers that position to the reader."[5]

The opening scenes of Cronenberg's *Shivers* seem to me a case where the 'incoherence' of the Gothic Novel's narrative technique - accurately described here as 'diffuse, de-centred, moving' - is directly relevant to the viewer's narrative positioning in the case of the Cronenberg film. I don't want to gloss over the difficulty of the argument about fetishism and the sado-masochism of our visual responses and will return to that in a moment, but it seems to me that the case of Cronenberg suggests that the 'coherence' of the seeing eye is not axiomatic; it is precisely the 'patching over' process which is parodied here.

[5] Susan Wolstenholme, *Gothic (Re)Visions*, (Albany: State University of New York Press, 1993), p. 11.

The encounter between the girl and the man, or Annabel and Professor Emile Hobbes, as we later learn, reveals a gulf between appearance and reality. The Professor has indeed, in the past, had the kind of erotic relations with Annabel that the scene suggests, and the ambiguity of the viewer's position is created by the play with the point of view of conventional pornography. But to

The Gothic, The Body, and the Failed Homeopathy Argument

the horror of the viewer, he pursues her, strangles her, and then proceeds briskly to cut up the corpse on the dining room table and pour acid into the stomach cavity. Steam rises. In an almost laughably horrible sequence, we then see him turn the scalpel on himself and then hear him crash to the floor off-camera, with all the heavy conventionality of a radio play. The contrast between this and the promo sequence in which it is apparently embedded is so extreme that it tends to produce laughter in the audience, despite the presence of horror and disturbance.

Experimenting with organic prosthetics, Professor Hobbes has introduced a parasite into Annabel's body, and it is this which he seeks to destroy, at the expense of the unfortunate host. This level of 'explanation', which alters what we see, plays alongside the conventional expectations of the porn film sequence. The ridiculously penis-like parasite, which is meant to replace failing human organs, we learn later, has unfortunate side effects, among them violent, indiscriminate, and uncontrollable sexual urges. Annabel has already spread it on the bridge, the poop-deck, and in the cabins of 'Starliner', and the Ship of Fools is already on its way across the Ocean of its maiden cruise. The narrative pattern - increasingly comic and grotesque, as well as violent and horrific - is the revelation of this progressive invasion by the parasite of the whole of 'Starliner'.

To come back to the opening scene between Annabel and the Professor, we have at least two narrative codes being played with; the promo film and the porno film. After that, we have the slasher or 'splatter' genre, if we simply take the extreme male brutality offered to the figure of Annabel, a response which is, to a disturbingly large extent, framed and even undermined by the explanation given retrospectively by the Professor's assistant, Dr. Lynberg.

The ambiguity created by this play of framed genre-signals, intersected by a specific plot, can be illustrated in the difficulty the viewer has in interpreting the sequence of actions which lead up to the strangling. Annabel begins by trying to prevent the Professor from entering the room; then, when

he persists and advances towards her, she runs across to the sofa and lies back on it, putting out an uncertain hand towards him as if trying to gauge what it is that he wants. He hesitates, and she appears to decide that he is playing, and moves towards him. He then seizes her round the throat. The strangling sequence which follows involves an insistent shot of her short skirt riding up and exposing her white lace underpants, and even of her upper thighs beginning to arch and thrust against his leg with apparent excitement - or is it pain? So much so that he is distracted and removes the leg, or is it merely to get a better grip on her throat?

Susan Wolstenholme's coherent all-seeing eye here is the classic collusive positioning of the viewer of sadomasochistic pornography in which all pretensions to narrative, flimsy as they were, have suddenly become a pretext for the insistent shots of underwear and (from the narrative point of view, irrelevantly) straining thighs, eroticizing the act of strangling. But this coherence is disturbed on another level: against it (a set of expectations, not of the medium, however, as Wolstenholme has it, but of the genre) we have to set the explanation contained in the film's plot. In this context, why is Annabel straining towards him in this 'erotic' fashion, even as he seeks to strangle her? Is it because she fatally misinterprets the signals of his behaviour and thinks that he is only playing a 'game'? Or do these actions merely signify that the parasite is acting within her body and causing her, without wanting it (we have seen from the beginning that she appears to distrust him and doesn't want him to enter the room), to behave in an erotic fashion? The answers to these questions are not easy and depend ultimately on how much we are willing to allow these relatively fleeting signals to dramatize fully a misunderstanding between the points of view of its protagonists. But they make a difference: there is pathos in the former, amusement of a disturbingly detached kind in the latter.

This ambiguity about the role of 'explanation', which problematizes what we see, is a hallmark of Gothic fiction from Ann Radcliffe onwards. Characteristically, the technique fragments the reader's response by separating explanation from event, exorcizing the effectiveness of various explanations by including them explicitly in a rhetoric of 'explanation' that

Night of the Living Dead

The Gothic, The Body, and the Failed Homeopathy Argument

Night of the
Living Dead

parodies the explanatory act and plays on our nerves. The explanations, of course, never 'explain' anything, because we see that they are meant to explain it *away*. The most explicit traditional example of the technique in the literary Gothic is Sheridan LeFanu, who wrote in the 1870s to his publisher in defence of the redundancy of one of his stories, that he included both natural and supernatural explanations of the events in the story, and left the reader to accept whichever one he chose. But the important thing here is that the technique leaves room for allegory, which is a mode Cronenberg, as many of his Gothic novelist forebears, likes to work in.

Shivers makes two very specific allusions to Romero's *Night of the Living Dead* (1968); first, when Dr. St. Luke and Nurse Forsyth are exploring a set of ever narrower passages in the bowels of the 'Starliner', the walls of which are made of timber slats. Suddenly, arms are thrust through the slats on all sides, just as the arms of the dead are pushed through the barricades over the doors and windows of the deserted house in Romero's film. In both cases, this moment is informed by the encounter with the Body which has been denied, but the tone is different. In Romero, it is genuinely repugnant, as the inhabitants, terrified of the touch of the dead, begin blindly to chop at the grasping limbs; but in Cronenberg, it is a joke, leading to a chaotic and comic sexual orgy.

The second occurs at the end of the film. Dr. St. Luke manages to escape from 'Starliner' and mounts the shallow crest of a terraced, ornamental lawn. We see him stop, turn round and begin to run back towards us, as virtually the whole cast of the film rises above the crest; all of them hosts to the parasite, like the moment in *Zulu* (1964) or *Butch Cassidy and the Sundance Kid* (1969) when we realise how impossibly numerous the Other is. In Romero, newly risen from their graves, these dionysiac hordes come out of the darkness towards the house, moving like sleepwalkers with outstretched hands, and there is a moment when we realise that they are impossibly many. In *Shivers* too, the hordes of the parasite-ridden move towards the glass-surrounded

annexe in which St. Luke (the name suggests a failed saviour) vainly hopes to shelter himself, the only Apollonian left in this particular Dionysiac world. And very Baudrillardian is the fact that the McGuffin, the retrospective 'explanation' offered in Romero's film of the mass Resurrection of the Body, *Night of the Living Dead*, is that of a virus coming from a crashed space rocket.

So, Romero's virus and Cronenberg's parasite, linked by allusion, both create a kind of Resurrection of the Body, and, thematically, they both explore the Hell of the Same. But unlike Baudrillard's version of the transparency of evil, in which 'we' are all passively trapped, both films contain critiques of the society in which they find themselves, and in the case of *Shivers*, this means a grotesque parody of the Utopian, Le-Corbusier-like Ship of Fools, which seeks to live prosthetically, without the body. The prosthesis in this case goes absurdly wrong and resurrects, in the form of a voracious collective sexuality, the Body it was meant to exorcize.

Crash: the Survival of Imaginary Perversion

Baudrillard also appears to give us a thematic conspectus for the relation between Cronenberg's recent (cult, partly-banned) *Crash* and Ballard's *The Atrocity Exhibition* of 1970, from which the narrative of his 1973 novel *Crash* was selected and extended, and Cronenberg's film elaborated. But again I'm going to argue that it is only at a thematic level that Baudrillard seems to map. *The Atrocity Exhibition* anticipates much of Baudrillard's argument by 25 years, but there is a whole other dimension of *Crash* (the book and the movie), that remains unrepresented by Baudrillard's argument.

The Atrocity Exhibition takes the form of an encyclopaedia of conceits about postwar history and politics from Hiroshima to Vietnam, about psycho-history and psychopathology, art, sex, technology, and particularly science - hard science, not just computer science. Its fifteen sections form a romance of documentation, its narrative conveyed in a style of paragraphing which plays between encyclopaedia entries (each paragraph in the entire book is headed in bold type) and the kind of 'objectivist' poetic style of the immediate postwar French novel of Robbe-Grillet. There are also lurches into recycled surrealist motifs from painting and drama (DuChamp, Ernst, Dali). We don't know therefore whether we should be reading in a linear fashion and connecting up paragraphs, or whether the relation between them is random and we always have to start again. It's a strange mixture of the two, which wrong-foots the reader all the time: conventional linear narrative does not survive this process of defamiliarization. People die before and after they are dead. Death is conceptual.

On the other hand, there is an implicit reference to the horrific facts of postwar history and popular culture and the postwar archive in the whole presentation of the book, which makes us feel that the line between fiction and fact has broken down. 'Elizabeth Taylor', for example, is reported as dead at one point like Marilyn Monroe, JFK, and Albert Camus. These deaths are 'notional', even the ones that have happened. The fragmented plot takes place half-in and half-out-of the minds of a number of bomber and helicopter pilots from the major scenes of postwar catastrophe who are trying to 'recreate' what are referred to as 'alternate' histories.

The format is a parody of scientific report or learned argument, its images posing, and acting, as examples. At the same time, trashy and popular, full of deadpan jokes, not 'high' and experimental like the French novel at all. The solipsism which is the post-Sartrean thematic context of the latter is nowhere to be seen, though traces of it remain in Cronenberg's film. Ballard's world is madly collective, madly 'social' - i.e. it is a world of analogy in which everything is an analogy for everything else. Freud is turned inside out and grafted on to Euclid: any historical event therefore has an unconscious, a latent and a manifest content, visible in its geometry: Karen Novotny's body is a

The Gothic, The Body, and the Failed Homeopathy Argument

Crash

'modulus' (the term drawn from Le Corbusier). The fantasy-identifications of paranoid-schizophrenics with public figures (Jacqueline Kennedy, Ronald Reagan) are codified into 'experiments', like Ralph Nader's road-safety accident recreations. Some of these are much more extreme and dislocated - jokes in wonderfully horrible bad taste - than anything contained in *Crash* - either Ballard's novel or Cronenberg's narrative selection. For example, Cronenberg retains the rear-end crash as an explicitly sexual joke about sodomy; but one cannot think of the following embroidery of this conceit in the narrative decorum of his film. "Subjects were required to construct the optimum auto-disaster victim by placing a replica of Reagan's head on the retouched photographs of crash fatalities. In 82 per cent of cases massive rear end collisions were selected with a preference for expressed faecal matter and rectal haemorrhages."[6]

The 'subjects' here are not young and beautiful - as Cronenberg's are, but paretic - i.e. in the terminal stages of tertiary syphilis. The point about Ballard's *Crash* is that it acts out one tiny biographical strand of *The Atrocity Exhibition*'s programme - the providing of the reader with an encyclopaedia of postwar history - as a catalogue of 'imaginary perversions'. The genre of both books and of Cronenberg's movie is mock-utopian, mock apocalyptic ('autogeddon'). I stress the 'imaginary', which in the rhetoric of the 1973 novel becomes a persistent source of metaphor, of the counter-factual. Baudrillard wrote about this novel in 1991, but his version of it is of a limp, post-Lacanian banality, without fetishism and without desire, and, spectacularly, without humour:

"The Accident, like death, is no longer of the order of the neurotic, of the repressed, of the residual, or of the transgressive; it is the initiator of a new manner of *non-perverted* pleasure (contrary to what the author himself says in his introduction when he speaks of a new perverse logic, one must resist the *moral* temptation of reading *Crash* as perversion), a strategic reorganization of life beyond the perspective of death. Death, wounds, mutilations are no longer

6 J.G. Ballard,
*The Atrocity
Exhibition*
(London: Jonathan
Cape, 1970),
p. 149.

unruly pleasures **147**

1996 CANNES WINNER

special jury prize for
originality, daring and **audacity**

a film by david cronenberg

CRASH

ROBERT LANTOS and JEREMY THOMAS PRESENT IN ASSOCIATION WITH FINE LINE FEATURES AN ALLIANCE COMMUNICATIONS PRODUCTION A DAVID CRONENBERG FILM

JAMES SPADER HOLLY HUNTER ELIAS KOTEAS "CRASH" DEBORAH KARA UNGER AND ROSANNA ARQUETTE MUSIC HOWARD SHORE COSTUME DENISE CRONENBERG EDITOR RONALD SANDERS PRODUCTION CAROL SPIER

CINEMATOGRAPHY PETER SUSCHITZKY CO-PRODUCERS ANDRAS HAMORI AND CHRIS AUTY EXECUTIVE STEPHANE REICHEL LINE MARILYN STONEHOUSE PRODUCED JEREMY THOMAS AND ROBERT LANTOS WRITTEN DAVID CRONENBERG

The Gothic, The Body, and the Failed Homeopathy Argument

metaphors for castration - it's exactly the reverse, or even more than the reverse. Only fetishist metaphors are perversion: seduction by the model, by the interposed fetish, by the medium of language. Here, death and sex are read straight from the body, without fantasy, without metaphor, without phraseology..."[7]

'Perversion', of course, is not a *moral* motive in Ballard - it is an aesthetic one. Baudrillard's quotations from the novel manage to get rid of the impact of Ballard's prose, the suppressed giggle of excitement, concealed under a po-faced listing of terms; the absurdly nautical word 'binnacle', for example, a term which describes projecting bits of dashboard instrument housing, which no one ever uses except in automobile brochures, is repeated in the novel at every opportunity. Metaphors abound, because the premise of Ballard's narrative is the 'imaginary perverse'. Baudrillard's quotations from the novel are all out of context; his first - the death of the minor actress (pages 189-90) - for example, occurs as fantasy in the mind of the narrator 'Ballard' - that's part of its joke. But Baudrillard reads it off literal-mindedly as socio-pathology, as dead symptom of a general postmodern 'style' in which "mutilations are *no longer* metaphors for castration..." (my emphasis). This is a purely theoretical fantasy about Ballard's writing, which is actually an encyclopaedia of jokes about a new application of imagined drives: narcissism, fetishism, coprophagia, sado-masochism, etc, etc. The point is to imagine the logic, the state of desire in which this perversion has taken place. Take Ballard's first act of sex with Helen Remington for example (the name ludicrously out-of-date, combines an old typewriter with the face that launched a thousand ships).

"Seizing me with her body in this arbour of glass, metal and vinyl, Helen moved her hand inside my shirt, feeling for my nipples. I took her fingers and placed them around my penis. Through the rear-view mirror I saw a water-board maintenance truck approaching. It moved past in a roar of dust and diesel exhaust that drummed against the doors of my car. This surge of excitement drew the first semen to my penis. Ten minutes later, when the truck returned, the vibrating windows brought on my orgasm."[8]

The point about this passage is that it is a logical set piece: counter-factual, mock-erotic: we know this from the phrase 'arbour of glass' (a narcissistic contradiction) which recycles a thousand such seduction scenes in arbours from Renaissance poetry to Victorian pornography's summer houses, a genre which itself is expert in spreading sexual anatomy, metaphorically, into an environment. The idea of a 'water-board maintenance truck' actually being a material and motive part of protagonist Ballard's desire in an erotic encounter is at first sight so improbable - read the deliberate realism of the dull descriptive phrase out, and you almost burst out laughing - that we are challenged to imagine the state of mind in which such excitement would be possible. The verve of the writing is a triumph: it is the metaphorical logic of imaginary perversion, an imaginary taboo broken, not a reflection of a historically new state of affairs:

"This small space was crowded with angular control surfaces and rounded sections of human bodies interacting in familiar junctions, like the first act of homosexual intercourse inside an Apollo capsule."[9]

There may indeed by now be an 'alternate sociology' of the space capsule which has become banal - amongst astronauts - but the excitement of desire is in the analogy, (the 'first act', not the ten thousandth), for the erotic encounter of 'Ballard' and Helen Remington in their 'arbour'.

Baudrillard sees what he wants to here, removing the difference between the reader's point of view and the protagonist's, removing metaphor and replacing it with metonymy, and converting analogy into reflection, rendering the impact of Ballard's carefully-organised writing as passive and symptomatic. Baudrillard quotes the laboratory car-crash from the novel, without noticing that it is riddled with anthropomorphic fiction: the

7 J. Baudrillard, "Ballard's Crash", *Science Fiction Studies*, Vol 18 (1991), p. 314. I'm grateful to Jayne Morgan for calling my attention to this piece.

8 J.G. Ballard, *Crash*, (London: Jonathan Cape, 1973), p. 80.

9 Ballard, *Crash*, p. 80.

unruly pleasures

mannequins are referred to *as if* they were real. A bizarre poetry of metaphor is made out of this; the figures are perversely animated, the language hyperbolic, laced with mock-heroic exaggeration, full of an incongruous mixture of comedy and desire:

"The mannequin, Elvis, lifted himself from his seat, his ungainly body at last blessed by the grace of the slow-motion camera. Like the most brilliant of all stunt men, he stood on his pedals, legs and arms fully stretched. His head was raised with its chin forwards in a pose of almost aristocratic disdain."[10]

And so on. 'Ballard' here has just begun to see what Vaughan sees, and Vaughan has just come in his trousers at the sight. The theological allusion in the first sentence is to the counter-gravitational 'grace' of Kleist's puppets which is compared to the 'slow-motion camera'. The perverse anthropo-morphic fiction is pursued and energised by allusion and metaphor and embedded analogy, alternate logics to the functional. Baudrillard fantasises this passage back into a 'hyper-functionalism', which gets rid of the clear distinction between fiction and reality (which is clearly signalled, within it, in order to be playfully inverted):

"In *Crash*, there is neither fiction nor reality - a kind of hyper-reality has abolished both."[11]

For all its almost-fatal aestheticism, Cronenberg's movie has faithfully translated the perverse logic of the novel into visual form: it too is a solemn, witty, reversed-premise *bildungsroman* that uses the format of pornography. The main story is the encounter between 'James Ballard' and Catherine, both of them already beginning to experiment in perverse and prosthetic erotics, and the violently bisexual car-crash addict Vaughan, who shows them how much further the erotics of the car crash can go.

[10] Ballard, *Crash*, p. 126.

[11] Baudrillard, 'Ballard's *Crash*', p. 319.

There are two quite distinct sexual codes: the languid bourgeois eroticism of James and Catherine at home contrasts with the brutal and dispassionate (in the visual context, very 1950s) lust seen in the briskly animal encounters between James and the other victim of their crash, Helen Remington, in the car where her husband - to add to the spice - was killed. Suddenly, we feel James has discovered a whole new world of sexual perversion. The car, not as mere site, but erotic instrument. And he proceeds to introduce Catherine to it, who has already, independently, made a mild beginning for herself with an aircraft engine cowling.

In this simpler logic, fucking equals crashing and the ultimate orgasm - the little death - is Death. The compromise, which retains consciousness and therefore enjoyment, is extreme mutilation. In Cronenberg's film, Vaughan - already mutilated - can't wait, and drives off the road, over the rail on to a tour-bus. James and Catherine's murmured joke after their climactic prang is "Maybe next time..." which ranges precisely from the comfortable bourgeois desire for absolute sexual bliss, to its reverse - absolute mutilation. In a comic parody of the main plot, Vaughan's girlfriend, Gabrielle, so badly mutilated she can hardly walk, reduces a car salesman to sexually-aroused jelly, a scene which is expanded from one short deadpan passage of the novel:

"She provoked a young salesman on the Mercedes stand to ask her to inspect a white sports car, relishing his embarrassment when he helped her shackled legs into the front seat. Vaughan whistled in admiration at this."[12]

Unlike the novel, the film ends with James performing consolatory anal intercourse on a doll-like Catherine, still in her post-accident position, as she masturbates against the blunt knife-edge of the car's window frame; Catherine, whom he has clouted off the road in Vaughan's old car and who is, unfortunately for both of them, unhurt.

The premise of sexual initiation is consistently reversed, and the pornographic story told the wrong way round in Cronenberg's film; and there is some ingeniously represented 'biomorphic horror'. Cronenberg creates what in Ballard is 'abstraction', meaning the process of conversion of objects and bodies into conceptual analogy. This is achieved by the use of extreme stylization within a skeletally linear narrative frame: he relies (to marvellous effect, it should be said) on statuesque pacing, whispered dialogue, derelict musical cadences, and the alienated way the camera dwells on aspects of the (posed) body. After Vaughan has violently fucked Catherine during the cycle of a car wash sequence, James and Catherine are lying together on the bed at home. Ballard's inverted logic is brought out more clearly in the movie than in his own novel in this scene. Her bruised and torn body is posed very carefully to resemble a corpse, the raised pubis and hip-bones and the impossibly concave belly mocking the conventions of the ideal (magazine-created) live body to give a perfect, ghoulish form to the erotic code. This is rigorous logical reversal by stylization, a visual pun, which translates the 'analogy' and mimicry of *The Atrocity Exhibition* into other, more naturalistic conventions. But these conventions are less naturalistic than Ballard's own *Crash* at this point, which relies on the voyeurism of 'Ballard', the protagonist, 'mimetizing' with the head of his penis the wounds of her raped and torn body. Cronenberg by contrast hands the paradox straight to the viewer by means of an enigmatic tableau.[13]

Nor, finally, at the level of representation, is Ballard's mimetic quest (an obsessive part of the rhetoric of *The Atrocity Exhibition*, but not of his *Crash*) equivalent to Baudrillard's famous 'simulation'. Ballard's term hovers between replication and miniaturization; but it contains no whiff of nostalgia for the notion of an 'original', as Baudrillard's notion of the 'perfect crime' of simulation does, however ironically. We've hidden the Body, i.e. the Original. For Ballard and Cronenberg their appropriation of gothic style requires no concept of an Original.

12 Ballard, *Crash*, p. 174.

13 Cf. Ballard, *Crash*, p. 166.

The Gothic, The Body, and the Failed Homeopathy Argument

For Ballard in the late Sixties and early Seventies, real Twentieth Century history is an imaginary perversion, the horrific invention of the Other; for Baudrillard, in the late Eighties, it is post-Hegelian loss, the loss of the Other, and of all means of self-negation and self-transcendence (which apparently includes orgasm). Cronenberg, in the late Nineties, who has his own visceral Gothic obsessions with the human body, stomach cavities, etc, is interested, too, in the *biography* of imaginary perversion, but not in a Fall from Grace.

Of course, there are some obvious points of symmetry between Baudrillard the critic, on the one hand, and Ballard and Cronenberg, the artists, on the other - otherwise, the critic's argument would not be so seductive. Ballard is concerned indeed to explore loss of affect (he invented the phrase, after all, in *The Atrocity Exhibition*), and with replication, and prosthetics, but as a way of representing the horrors of history, not simply or primarily the prison of technology. He, like Vonnegut or early Heller, is concerned with ways of representing the unrepresentable limits of mass human insanity. But Baudrillard replays Benjamin's loss of aura as a way of describing 'our' post-evolutionary banalizing of the image, 'our' descent into irreversible metonymy. For Ballard and Cronenberg, and their 'autogeddon', there is no shadow of an absent 'authenticity' in their horror, and they prove it to us by the energy of their metaphors, not Baudrillard's effetely banal, post-metaphorical, metonymies, for the state of the Other.

Elena Gorfinkel

The cult film poses a problem for film classification and for conventional understandings of genre, as its qualities cannot be divined in advance as properties of the text itself. Rather, the cult film's numerous constitutions emerge from the set of relationships between itself and its audience and between the text and its social context. One commonly thinks of cult film as a bastion of oppositional taste, as it becomes a site for aberrant readings as much as it is produced by such aberrant readings. Certainly, one can look at the characteristics of a variety of cult films to excavate the qualities that pre-destine it for cult status. These include an oppositional relationship to dominant modes of film practice (low budget, b-movies, exploitation and sexploitation, art films, independent film), as well as a thematic excess, a stylization or parodic stance that defies genre at the same time that it may represent the outer limits (and therefore exemplariness) of a specific genre.

But the cult film, produced as it is from a dense network of relationships with its audience, is also constituted by a certain mode of spectator recognition and expansion of textual meanings. The pleasures of cult cinema emerge from this recognition and are intensified in repetition. Cult cinema often has a fascination with the transgressive, and its pleasure emerges in the breaking of social prohibitions - this break includes the rupture of generic conventions and narrative codes, as well as a break with what constitutes a normative film spectator. In this sense, the cult audience offers the institution of the cinema a reconsideration of what spectatorship and film viewing have come to mean. Cult film's mode of address, at times constructed in retrospect, engages with an intensity of affective and interactive participation. In effect it revises the presumptions of audience passivity and narrative immersion in illusionistic fictional structures. The discourses of cult cinema's fan culture have certainly taught film studies a lesson about the complexities of reception and the social, historical localities of filmic pleasure.

Biographical note: Elena Gorfinkel is a PhD student in the Department of Cinema Studies at New York University.

The Body as Apparatus:
Chesty Morgan Takes on
the Academy

Elena Gorfinkel

"The simple gesture of directing a camera toward a woman has become the equivalent of a terrorist act."[1]

"Let me tell you something. All movies are exploitation movies."[2]

Exploitation: No Place For a Woman?

Written in 1981, Mary Ann Doane's articulation of the difficulties of a feminist film practice in light of the 'impossibility' of representing the female body, can serve as an interesting point of departure for a discussion of exploitation film, particularly in the work of director Doris Wishman, author of the second epigraph above. In the male-dominated world of American exploitation film of the 1960s and 1970s, Wishman was a formidable auteur, producing underground films and cult classics such as *Hideout in the Sun* (1960), *Nude on The Moon* (1962), *The Sex Perils of Paulette* (1965), *Bad Girls Go To Hell* (1965), *Keyholes Are for Peeping* (1972), *Deadly Weapons* (1974), *The Amazing Transplant* (1970), and *Let Me Die A Woman* (1978). Wishman's 'female signature' and attention to the gendered and sexed body can be read within a mode of production and set of genres which appear explicitly overdetermined by their content. Most importantly Wishman's importance extends into the larger scope of American film history, as she is considered the "most prolific woman director of the sound era,"[3] having made twenty four feature films in a span of 18 years. Wishman's status in the realm of cult reception depends on her singularity, as one of the few women working in exploitation and in the particularity of her filmic style. Her work has undergone a period of re-discovery and revival in the last ten years, compounding the appreciation of her films which had already been activated in underground film circles.[4] All of these retrospectives and revivals attest to the renewed public interest in Wishman's work and a climate of historical endearment towards previously 'bad' cultural objects such as exploitation film.

Doris Wishman contributed significantly to the prevalent 'cycles' of sexploitation film of the period: the 'nudist camp' film, the 'roughie,' the 'kinky,' the 'splatter' film, and even 'pseudo-documentary.'[5] Wishman has become a cult icon, representative of the 1960s and 1970s heyday of sexploitation filmmaking, in which the exploitation strategies of previous decades - dependent on the 'square up' and some form of pedagogic or documentary pretense - succumbed to a more blatant display and narrativization of sexuality and nude female bodies. In concert with the weakening of the Production Code and numerous legal decisions ruling nudity as not in and of itself obscene, sexploitation directors were able to capitalize on the American movie-going public's sexual curiosities.

[1] Mary Ann Doane, 'Woman's Stake: Filming the Female Body,' *Feminism and Film Theory*, ed., Constance Penley, (New York: Routledge, 1988), p. 216.

[2] Doris Wishman, quoted in programme notes, 1998 New York Underground Film Festival, p. 23.

[3] Michael Bowen, 'Embodiment and Realization: The Many Film-Bodies of Doris Wishman.' *Wide Angle*. vol.19, no. 3 (July 1997) p. 65.

[4] Beginning with a retrospective of her film work in 1994 by Harvard University's Film Archive, Wishman has also been featured as the guest of honour at the New York Underground Film Festival in 1998, and has made guest appearances on national television and radio.

[5] See Bowen; and Eithne Johnson and Eric Schaefer, 'Soft Core/Hard Gore: Snuff as a Crisis in Meaning.' *Journal of Film & Video*. vol 25, 2-3. Summer-Fall 1993, pp. 40-57.

Not surprisingly, exploitation and sexploitation films are considered primary fodder for the 'object choice' of cult audiences' affection, as the low budget mode of production and lurid subject matter allow for a range of reading practices across texts and cycles. Although not every sexploitation film necessarily becomes a full-fledged cult phenomenon - in the vein of the prototypical *Rocky Horror Picture Show* - the ephemerality and eccentricity of the genre as a whole allows it to be positioned entirely within the purview of cult acceptance. Cult film has often been discussed in terms of a logic of excess,[6] in which the intentionality of authorship and narrative requirement comes into conflict with the strategies of execution and the primarily budgetary limitations placed on them. The emergent 'trash aesthetic,' ascertained by a cult audience in concert with the sexploitation film's hard sell and direct address, represents a counter-cultural sensibility, a flouting of the classed basis of structures of taste.

Yet the genre simultaneously depends on the epistemological weight of sexuality, and cinema's capacity to 'document' the sexed body within a newly public sphere of relatively unrestricted exhibition. The historicity of sexuality is another cult attraction to sexploitation as a genre, as historical limits are also read into the dramas of sexual practice so often banally recounted as the backdrop of such generic attractions - the liberatory drama of the nudist camp, the flight of the errant, 'nymphomaniac' wife from an inept and unsatisfying husband, the fall of an innocent into a 'den of depravity' involving same-sex relationships, bohemianism and violence, the submission of simpering men to sadistic female dominatrixes, the re-circulated sexual economies of female prisons, and the underground exchange in white slaves. These are some of the sexual scripts of the sexploitation period, and they supply the speculative excesses that animate cult film viewership.

Perhaps feminist film theory's reticence to deal with exploitation films emerges in response to these blatant 'scriptings' of hegemonic, white male fantasy. But certainly, exploitation films are not *reducible* to their narrative arcs, as questions of aesthetics, reception, context, intertextual and extratextual meanings are in some sense constitutive of their spectatorial and affective experience. The cult attachment to Wishman, I would argue, circulates around two thematics that involve a recognition of 'excess', one being her recognizable film style, and the second being her virtuosity in manipulating the classic 'gimmick' which constitutes the draw of exploitation.

[6] On cult's relation to excess, see Jeffrey Sconce, 'Trashing the Academy: Taste, Excess, and an Emerging Politics of Cinematic Style.' *Screen.* 36:4, (Winter 1995). pp.371-393; Gaylyn Studlar, 'Midnight S/Excess: Cult Configurations of Femininity and the Perverse,' *Journal of Popular Film & Television*, vol.17, no.1, (1989): pp. 2-14; and J.P. Telotte, 'Beyond All Reason: The Nature of Cult,' *The Cult Film Experience: Beyond All Reason.* ed. J.P Telotte. (Austin: University of Texas Press, 1991), pp. 5-17.

Wishman's exploitation aesthetic relies in two of her films on the 'excesses' of a specific female body, that of stripper Chesty Morgan. Along with *Bad Girls Go To Hell*, and in terms of video purchases, Wishman's most acclaimed and recognizable films involve Morgan as star. *Deadly Weapons* (1971) and *Double Agent 73* (1974) both employ Chesty's hyperbolic bust measurement as the exploitation gimmick and mode of address. In the former film, Chesty Morgan's character seeks revenge on her lover's death by smothering his killers with her breasts. In the latter film, her breasts are photographic weapons. Wishman's role within film history, largely neglected by feminist film theory, requires a reconsideration of her films, their place within genre and their mode of production; both as products of a woman author, and as sites for reworking theoretical presumptions.

Consequently, I would like to consider Wishman's film *Double Agent 73*, which utilizes the female body as 'prop,' as it can offer feminist film theory an alternative route for theorizing the feminine in relation to spectatorial pleasure. In light of an analysis of this film, Doane's statement at the beginning of this essay requires a number of questions posed to it: whose terrorism? what is the terrorism in service of? and whom does this terrorism address? Wishman not only directs a camera toward the body of her star Chesty Morgan, but directs a camera 'inside' her star, via the plot device of a camera implanted in the breast of the spy. The two gestures are co-extensive,

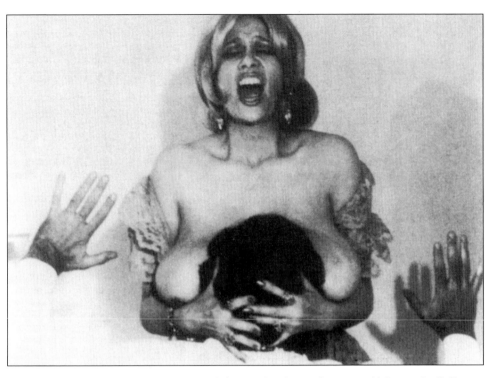

Deadly Weapons

the interiorized camera facilitates and reinforces the cinematic gaze, which fixes on the 'excessive' body of Morgan with the knowledge of what it 'contains.'

While the invasion of bodies by foreign elements, be they alien or technological, is largely the domain of science fiction, *Double Agent 73* remains an exploitation spin on a spy thriller. Nonetheless, the gimmick of the implanted camera in the breast of its well-endowed star, Chesty Morgan, is significant as it plays with the traditions of the female body as a site of inscription, using the logic of entry into the bodily interior to install an imaging technology. The camera, as photographic device, inverts the logic and meanings of medical imaging technologies which aim to diagnose via an inspection of hidden, invisible organs. The camera itself becomes an organ in its seamless assimilation into the body and breast of Morgan. The interiority of the body is employed to investigate and taxonomize the outer world. Chesty Morgan's body becomes the empirical site of experience, as the installation of mechanical memory, via photography, records events, faces and scenes.

Therefore, such an exploitation premise, which invites the traditional voyeuristic, patriarchal spectatorship, also has immense ramifications for the body as a photographic mechanism, not merely a surface for the inscription of the phallocratic order, but as a technology which itself inscribes, records and performs an epistemology of its 'victims.' The problematics and complexities of such a deployment of the female body - as reproductive instrument, as photographic apparatus - seems to re-enact, yet trouble, the division explored by psychoanalytic feminist film theory, which posits the woman outside of discourse, outside of language, given access to it only through a mimetic function. Doane comments on Parveen Adams' negotiation of the difference between the girl and the boy in relation to the phallus in Lacanian theory as follows:

"For it is clear that what is being suggested is that the boy's body provides an access to the processes of representation while the girl's body does not. From this perspective, a certain slippage can then take place, by means of which the

unruly pleasures **159**

female body becomes an absolute tabula rasa of sort: anything and everything can be written on it. Or, more accurately, perhaps, the male body comes fully equipped with a binary opposition - penis/no penis, presence/absence, phonemic opposition - while the female body is constituted as 'noise,' an undifferentiated presence which always threatens to disrupt representation."[7]

The antagonisms set up between the female body and the field of representation imply the gendering of representation in favour of the male; *Double Agent 73* pressures this presumption into a confrontation between the 'undifferentiated presence' of Chesty Morgan in the object of her breasts, and the invisible camera, which is signified by the *exposure*, in both senses of the term, of the breasts against her assailants and victims. The terrorism is doubled, collapsing the gaze with its object. Photography becomes a trope by extension, included as technological antecedent as well as self-reflexive foil to cinema itself. The photographic act is set in dialogue, within the diegesis and conceptually, with the cinematic mechanism.

The reconfigured body of the woman, subject to the intersecting discourses of exploitation cinema, apparatus theory (Baudry), psychoanalysis and feminist film theory, offers an alternative within this "heterocosm,"[8] a re-theorization of image making, of the represented female body and of its spectatorial audience. Therefore, the terrorism of representing the female body in *Double Agent 73* can be reassessed within the context of a discussion of masochistic cinematic spectatorship, as a body that terrorizes the spectator, within the masochistic contract of the "pleasure of unpleasure."[9]

Firstly, however, the viewing structures and presumptions of exploitation cinema need to be explored as the groundwork for an analysis of Wishman's film. In the oppositions set between mainstream Hollywood cinema and the woman's avant garde, feminist film theory has neglected addressing the potentialities of an exploitation cinema, whose gimmicks, contrived narratives and low budget productions disavow the standards of taste. Yet, just as the genre of pornography has proven crucial for an understanding of the figuration of 'the woman' within representational modes, epistemological structures and cinematic discourses, so too exploitation, particularly in its lack of accountability to the traditions and conventions of Hollywood cinema and to the 'pretensions' of an art cinema, provides different ways to theorize 'woman as image' outside of narrow determinisms. This position outside of accepted aesthetic and taste hierarchies also structures exploitation film's appeal for a cult audience. Pam Cook, writing about female directors in exploitation, and following Noel Burch's argument about films made before 1919, remarks that:

"Instead of inferior products which fail to conform to the classic ideal, these films can be seen as evidence of what might have been, offering alternatives to the representational system that became dominant, and opening up the possibility of saying something different."[10]

The idea of "saying something different" is compounded, in the case of Wishman, by the relative rarity of women filmmakers working in this mode of production. Although Wishman was not the only woman directing sexploitation, her female colleagues were few and far between, none matching her output and longevity in the field. Stephanie Rothman, worked with Roger Corman and made films in the 1970s, titles which include *Terminal Island* and *Working Girls*. Barbara Peeters was an actress in Corman's ventures, who then shifted to directing a number of features. Other women filmmakers, such as Roberta Findlay, and Hildegarde Esper, worked as part of husband and wife teams (although Findlay continued as a prolific exploitation/porn director after her husband's death in 1977). Precisely because of this scarcity, the work of women directors in exploitation film needs to be explored for its oppositional or differential enunciation of the genre's consistent concerns with sexuality and female bodies.

[7] Doane, p. 221.

[8] This term is used by Gaylyn Studlar in her discussion of the "masochistic heterocosm" of Joseph von Sternberg's films with Marlene Dietrich, *In the Realm of Pleasure: Von Sternberg, Dietrich, and the Masochistic Aesthetic*, (New York: Columbia University Press, 1988), pp.85-108. I will return to a discussion of this term, in relation to the plot devices of exploitation film, later in this essay.

[9] Ibid, p. 192.

[10] Pam Cook, 'The Art of Exploitation, or How to Get Into the Movies,' *Monthly Film Bulletin*, Vol.52, No.623, (December 1985), p. 367.

The Body as Apparatus

The Photographing Breast: The Female 'Gimmick' of *Double Agent 73*

Exploitation films' aggressive marketing strategies, their use of sexualized and violent themes to sell the film to distributors and audiences, is indelibly linked to its mode of address, and the ways its spectatorship is constructed. Paul Watson comments on the genre of exploitation as an economic one:

"Exploitation cinema is a convenient category in which aesthetic and formal considerations are organized with capital investment/assets so as to ensure that their economic potential will be utilized to maximum effect." [11]

Doris Wishman, a proud proponent of the 'gimmick,' utilized the image of her star, stripper Chesty Morgan, and her large breast size, 73 inches, as the basis of promotional strategy. The gendered presupposition, which literalizes the representational economy of women as objects of exchange, is destabilized. Wishman's re-duplication of the 'attraction' - by providing a premise in which Morgan, as Double Agent 73, is a spy who has a camera implanted in her breast as a way to identify the leader of a heroin smuggling ring - acknowledges the fetishistic aspects of cinematic spectatorship.[12] The fetish of the breast is displaced from the breast itself to the fact of the presence of the camera and the photographic process. But the question is, what sort of fetish? I contend the dominance of a masochistic one, as theorized by Gaylyn Studlar, in which, rather than the penis, the source of fetishism is in primary identification with the Pre-Oedipal mother's body.[13]

Every revelation of Chesty's breasts is a simultaneous acknowledgment of the masochistic spectator, a knowledge enacted by the reflective function of the *invisible* camera, signified by the eminent *visibility* of the breasts. Subsequently, there are actually three modes of referentiality to the woman 'being seen' and 'seeing': in the structure of exploitation cinema which presumes a sensational object, in the appearance of Morgan's body itself - a perceived 'excess' which 'calls attention to itself' - and in the knowledge of the fictional device, the presence of the camera, which redoubles the look of the audience.

Exploitation's identity as a genre, which by economic necessity operates on a logic of attraction and the spectacular, is dependent on the desire of the audience, a desire that must be produced before any films are actually shown, through marketing and promotion. Pam Cook notes that, "much of the pleasure - and success - of exploitation films derives from the way they play on audience expectations of authorship and genre."[14] This manipulation of expectations is crucial to a feminist reading of Wishman's films, in that the institutional production of desire and acknowledgment of that production denaturalizes certain processes of gendered spectatorship.

Paul Watson terms this the "foreknowledge of spectacle," in which "the promotional drama itself provides a cultural text that invariably exceeds and outlives the movie it prefigures."[15] In the same sense, the gimmick of Morgan's body and optic breast, as an idea, as a *theoretical* object, has great potency as a springboard for feminism's adjudication of sexual difference. The implicit critique of representation in *Double Agent 73* is inextricable from, is contingent on, Chesty Morgan's *oversignifying* body. Doane's call to consider the female body outside of divisive debates on essentialism is useful here; she incisively states:

"Both positions (essentialist and anti-essentialist) deny the necessity of posing a complex relation between the body and the psychic/signifying process, of using the body, in effect as a 'prop.' For Kristeva is right - the positing of a body is a condition of discursive practices. . . the stake does not simply concern an isolated image of the body. The attempt to 'lean' on the body in order to formulate the woman's different relation to speech, to language, clarifies the fact that what is at stake is, rather, the syntax which constitutes the female body as a term."[16]

[11] Paul Watson, 'There's No Accounting For Taste: Exploitation Cinema and the Limits of Film Theory,' *Trash Aesthetics:Popular Culture and its Audience*, (London: Pluto Press, 1997), p. 75.

[12] Both Paul Watson (p.74) and Eric Schaefer, (*Bold! Daring! Shocking! True! A History of Exploitation Films 1919-1959*. Durham: Duke University Press, 1999, pp. 77-82,) have discussed the usefulness of Tom Gunning's 'cinema of attractions' model of early cinema in thinking about exploitation's impulsion to 'show' and its constitutive address to the viewer.

[13] Studlar, p. 42.

[14] Cook, p. 367.

[15] Watson, p. 79,

[16] Doane, p. 226.

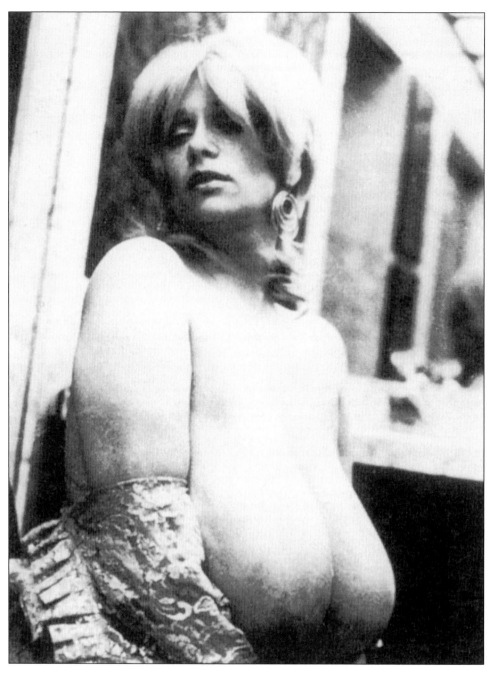

Doane stresses the importance of a syntax, which creates the body as a term within discourse and representation, in favor of focalization on a single image. Wishman's elaboration, in *Double Agent 73*, on the question of representation as an insertion into the female body, in effect, creates a largely masochistic syntax. Although Wishman's place within a male dominated field proscribes limitations on her films' structural and generic organization, *Double Agent 73*, in its dizzying and insistent hand held close-up shots, in dulling focus on Morgan's cleavage as subjective landscape - analogic to the facial close-up - provides a syntax which interrogates and threatens the spectatorial pleasure which it presumes to simultaneously appease. Morgan's body *as* apparatus, as

screen, defines the parameters of the film's syntax. Wishman's film stages a conflict between Doane's position in which woman's acquisition of language is unclearly demarcated, and Studlar, who questions the validity of such a mystification.[17] *Double Agent 73* subsequently asks whether access to representation constitutes access to language.

I would like to look more closely at the syntactical patterns through which Chesty Morgan's body, as Jane/Double Agent 73, is presented to the spectator. Her excessive corporeality, marked by the size of her breasts, is a source for obsessive fixation by Wishman's camera. This excess is sanctioned by it, conditional to the masochistic context. The use of the close up is obligatory, serving as a punctuation of the film text, functioning to bring the spectator into a close relation with Jane's body. The close-up is not reserved for Jane's body alone, but fixates on hands, phones, feet and surfaces, seemingly a synaesthetic perception of tactility. The close-up on objects is considered the epitome and distillation of Wishman's trademark style, the banality of its focus in some sense becoming a complication of conventional understandings of fetishism and its operation.

The close-up is most striking when Jane's face is conflated or set in an associational relay with her breasts. The breasts attain a state of faciality, becoming subjectified through their visibility and the absent presence of the camera. In the hospital scene, Jane is lying down, having just gone through the surgery which has implanted the camera; a fast cut to a close-up of her exhausted face which is heavily daubed with makeup, cuts again, to focus in on her post-operative, braless, sagging breasts, on which a small bandage appears. This synecdochal relationship between the breasts and the face (and of the breast and the body) has a number of implications. Within film criticism, the close-up has a history of phenomenological and epistemological articulations. The facial close-up, for a classic theorist such as Jean Epstein, was a prime example of *photogenie*, which has been interpreted by contemporary theorists such as Paul Willemen as a 'lost object.' Willemen writes:

"Photogenie, then refers to the unspeakable within the relation of looking and operates though the activation of a fantasy in the viewer which he or she refuses to verbalize. In this sense, it requires a viewer's complicity in refusing - as if refusal were sufficient to obliterate it - the fall into symbolic signification (language) and the corresponding privileging of a nostalgia for the pre-symbolic when 'communication' was possible without language in a process of symbiosis with the mother. A trace of this nostalgia for the psychotic existence of pre-oedipal childhood (that is for utopia) can be read from the way in which the term 'soul' is mobilized in these writings: the souls of the cinema and of the viewer are supposed to be able to 'fuse' in a wordless interaction when divested of the inevitable material encumbrances inherent in any process of signification."[18]

Willemen's remarks are suggestive, despite his avoidance of the fact that the close-up is most often 'embodied' by a woman's face. The effect of regression to the pre-oedipal and the fusion of viewer and screen resemble the theorization of the 'dream screen', as taken up by Gaylyn Studlar, in which the cinematic apparatus produces a 'cine-subject' that submits to the uncontrollable images on screen.

But, returning to the close-up and the effect of 'reality' it induces, it is necessary to note Doane's analysis of the close-up; she comments that the face which appears as pure surface also belies a depth, and refers to Roland Barthes 'reading' of Garbo's face:

"Garbo still belongs to that moment in cinema. . . when one literally lost oneself in a human image as one would in a philtre, when the face represented a kind of absolute state of the flesh, which could neither be reached nor renounced."[19]

17 Studlar, p. 32.

18 Paul Willemen, 'Photogenie and Epstein,' *Looks and Frictions: Essays in Cultural Studies and Film Theory*, (Bloomington: Indiana University Press, 1994), p. 129.

19 Roland Barthes, quoted in Doane, 'Veiling Over Desire: Close-Ups of the Woman,' *Femmes Fatales: Feminism, Film Theory Psychoanalysis*, (New York: Routledge, 1991), p. 47.

The conjunction of perception at the site of the flesh and the repetition of Willemen's observation of an impulse towards fusion returns us to the dialogic relation set up between Morgan's face and breasts. The face as a site for the emotive and the performance of subjectivity enacts a series of exchanges with the breast. Getting 'lost' in the face of the close-up seems literalized by the enormity and the absolute presence of Chesty's breasts, and subsequently getting lost in the breasts is diffused. If anything, the breasts, implanted with the camera, further complicate the slippages between depth and surface that the facial close-up invokes.

If Doane's statements that "the face, more than any other bodily part, is *for* the other. . . mute without the other's reading," is applied to Morgan's face, where does that leave her breasts? The subjectification of Morgan's breasts through close-ups that ally them with the face, and the focus on Morgan's breasts in reaction shots at moments of tension, seem to imply an unrecipro-cated gaze, the body looking, activated by the knowledge of the interiorized camera. The implication is that the breast cannot be read because it is looking. The breast is usually not read at all. The camera's assumption of a close-up, of closeness and proximity to the female body - as a way to access the body and appease the exploitation spectator - is too close for the spectator, it removes the 'objectivity' of distance. For the closeness of the breast as representational technology implies its identification of the diegetic victim and the cinematic spectator. Morgan's body is not the object of an investigative epistemology, rather the breast is gathering evidence, and the look at the breasts is an inquiry into that invisible process. In this way the breast *collects* the look.

Thus, the status of Morgan's screen image as surface comes into question, as the materiality of her body and the aesthetic of close-ups forces a closeness onto the cinematic spectator which does not allow the spectator any agency in distance or objectification. The two cameras have performed it within the text for the spectator, presumptive of the desire for a 'fusion' with the 'ultimate flesh' of the female image, a flesh which even exceeds the face. Furthermore, it seems that such 'closeness,' denied by Doane as an untenable position for feminist film theory to assume, is a source of potency and imposition in *Double Agent 73*. In *Masquerade Reconsidered*, Doane writes that:

"To embrace and affirm the definition of femininity as closeness, immediacy, or proximity-to-self is to accept one's disempowerment in the cultural arena, to accept the idea that women are outside of language. To investigate this matter as an idea, with a certain cultural effectivity, is another matter altogether."[20]

Morgan's body, in its closeness and enforced proximity to the spectator is such an idea, and furthermore a *tactic*; not a positing of essence or a definition of femininity in a fixed position. The close-up, which imposes this closeness, is a representational strategy, in league with Studlar's delineation of masochistic spectatorship, which attempts to reclaim a fusion, a symbiosis with the abundant mother of the oral phase.[21] Morgan, as maternal imago, manipulates the spectator, particularly via her fetishized implant, the invisible camera which can be seen as a disavowal of the Father and of sexual difference via the attribution of a 'phallic fetish' to the mother, "the child's attempt to create the mother as the ideal hermaphroditic parent."[22]

But what of this fusion? How do the notions of *photogenie*, the 'dream screen' and masochism coalesce at the site/sight of Chesty Morgan's photographing body? I would argue that Morgan's body, as a proto-cinematic mechanism, induces in her spectators/victims the effect of the apparatus, as instated by Jean Louis Baudry, in his essay *The Apparatus*, Baudry writes, "the cinematic apparatus brings about a state of artificial regression."[23] Studlar elaborates on Baudry's model of cinematic experience, to promote the rendering of cinematic spectatorship as having masochistic qualities that challenge gendered viewing positions. The re-deployment of the 'dream

[20] Doane, 'Masquerade Reconsidered,' *Femmes Fatales*, p. 37.

[21] Studlar, p. 43.

[22] Ibid., p. 40.

[23] Jean Louis Baudry, 'The Apparatus: Metapsychological Approaches to the Impression of Reality in the Cinema,' *Film Theory and Criticism* , ed., Gerald Mast, Marshall Cohen, Leo Braudy, (New York: Oxford University Press, 1992), p. 703.

screen,' as a regression to 'oral phase pleasures,' aligns to the contractual structures by which the spectator submits to the film image. The originary site for desire is located at the state of unity with the mother's breast:

"The imaginary visual fusion with the cinematic dream screen results in a loss of ego boundaries analogous to the child's presleep fusion with the breast. . . the spectatorial position duplicates the infant's passive, dependent position. The viewer like the masochist and the dreamer, adopts the 'formless body image of the infant' and the feeling of animistic omnipotence that accompanies the infant's sense of oneness with the mother. . . The dream screen offers bliss but threatens obliteration of self as separate entity."[24]

Therefore Morgan can be seen simultaneously as 'dream screen' for the actual audience, for the narrative victims, and for the audience identifying through the point of view of the victims. In a number of places in the film, Morgan's breasts are rendered as surfaces through superimposition of other images onto her body. The first instance is when the surgery is being allegorically performed; the image of surgical implements and their tray, is placed directly over her breasts, as her boss's voice indicates the specifics of the procedure. The overlay of sound and image is incredibly suggestive, in the relation between the 'dream screen' and the speculative 'hermaphroditic' status which the implanted camera affords for Morgan. The boss is also implicated as a masochistic spectator, the child who tries to create the mother as 'hermaphroditic parent.' The conflict between symbiosis and separation is staged through the boss as well; the camera in her breast simultaneously necessitates separation, via the assignment, and symbiosis, through the time ultimatum and her necessary return before the camera explodes.

Consequently, Morgan's body and breasts are complicated by the 'installation' of the camera in her body; on this level, she cannot be seen as a screen, a surface for projection, but must be acknowledged as a projective technology that necessitates its own surface. Perhaps this is why the violence of her assaults is figured specifically in the loss of consciousness and even death for the victims. Morgan enacts the 'punishing mother' and the danger of separation. The imposition of a self, through the identifying practice of the photograph, brings Morgan's body close to her victims and then necessitates the fatal separation. Death is signified through both symbiosis with and separation from Morgan's maternal breasts.

Pressing Up Against the Pre-Oedipal

Double Agent 73 and the seeing body at its center, literalizes the fishing joke put upon Jacques Lacan, and recounted in his Four Fundamental Concepts of Psychoanalysis. Young Lacan, out on a fishing expedition, is hailed by one of the crew on his boat, who is pointing to an indistinguishable object in the water, "You see that? You see that can? Well it doesn't see you." Lacan concludes the opposite, that the sparkling reflection of the can did indeed see him, and that from its perspective, "I, at that moment. . . .looked like nothing on earth. In short I was rather out of place in the picture."[25] The othered object is given the privilege of excluding and subjectifying Lacan only when the fact of his being sighted and seen is in question. Once the can can see, it must see the subject in order to put his existence and coherence into question. Similarly, the body of Morgan is figured as the object that has been infused with vision, given the power to dispel the epistemological certainty of the spectating self.

It is also important to note the specific choice by Wishman to use the device of the photographic camera rather than that of the film camera, as the object to be incorporated into the star's body, and despite the obvious thematic analogy between photography and cinema. The temporal fixity of photography, it's noted relation to death, photography as mortification, is most eloquently evoked by Roland Barthes, in Camera Lucida:

[24] Studlar, pp. 186-187.

[25] Jacques Lacan, The Four Fundamental Concepts of Psychoanalysis, (London:Hogarth, 1977), pp. 95-96.

"Each time I am (or let myself be) photographed, I invariably suffer from a sensation of inauthenticity, sometimes of imposture (comparable to certain nightmares.) In terms of image-repertoire, the Photograph (the one I intend), represents that very subtle moment when, to tell the truth, I am neither a subject nor object, but a subject who feels he is becoming an object: I then experience a micro-version of death (of parenthesis): I am truly becoming a specter."[26]

Barthes' parenthetical admission of complicity, the 'letting myself,' indicates the contractual masochism of becoming the photographic subject.

The term 'victim' takes on an ironic self-designating tone within the context of a cinematic spectatorship that is masochistic; as Studlar indicates, "the cinematic dream screen defines the spectator through looking, just as the infant is defined by the mother's look."[27] The 'owner' of the look, in Studlar's transposition from cinema to the oral phase, moves from the spectator's look to the mother's look; their relation is not one of gender hierarchy but of mutual dependence, reciprocity tempered by the pleasurable punishment of the child/spectator.

Formally, Jane's assault of suspects operates within a consistent pattern of shots, in which the confrontation of the male subject with her corporeality effects a regressive move from the Oedipal to the pre-Oedipal. The initial implantation of the camera is contingent on Morgan's sexual and bodily difference, both marked by her huge breasts; the implanted camera will work dependent on the seduction, Morgan "using her own body as a disguise,"[28] the premise of the Double Agent designation. A spy negotiates through modes of invisibility; yet here Morgan's role of spy depends on her being 'seen' as sexed body, the seen objects, her breasts, luring her victim into a passive position in which she can trigger the camera. The camera passes as a woman, wearing the veil of her body in order to justify its function. Morgan passes as a 'conventional' film actress. The Oedipal and the Pre-Oedipal become coextensive.

The Pre-Oedipal regression allows a forgetting of Morgan's sexual difference in favour of her image as an abundant, punishing mother. The passive position taken by her diegetic victims always involves a blurring of vision as if in a hallucination or a falling into sleep; Jane drugs her victims through the application of poison or smoke. At these points we see Jane through the point of view of the victims. *Double Agent 73* visualizes this condition of the masochistic spectator through formal devices which employ close-ups and zoom-ins, which assail the viewer with images of Jane's breasts as disembodied, floating forms, taking up the entire screen. In other scenes, however, where Morgan is not in terrorizing photographic mode, the zoom in on the breasts attempts to prescribe their stability and faciality. In these instances the breasts appear unmoored, given an agency that seems to evade the frame itself. The references to fusion with the image all imply a location in the pre-oedipal, sexually undifferentiated position of infant nursing.

[26] Roland Barthes, *Camera Lucida*, (New York: Hill & Wang, 1981), pp. 13-14.

[27] Ibid., p. 188.

[28] Michele Montrealy, quoted in Doane, 'Film and the Masquerade,' *Femmes Fatales*, p. 26.

When Morgan, standing with her breasts exposed, is ready to photograph her subjects, the cinematic audience sees her from below, as she looks down imperiously on the spectator. She lifts the left, activated breast to shoot; as the sound of the flash goes off, we see not a flash emanating from her direction, but a flash of the film itself, which registers the event with a blanking of the film screen, for a moment obliterating all vision. The responsive quality of the framing cinema to the narrativized invisible camera in Morgan's breast seems to acknowledge the assaultive power of such a technology and its threat to cinematic representation itself. The point at which the victim, our point of view shot, loses consciousness or dies, is the point at which the actual spectator is assailed and the framing apparatus that contains the narrative renders a fissure.

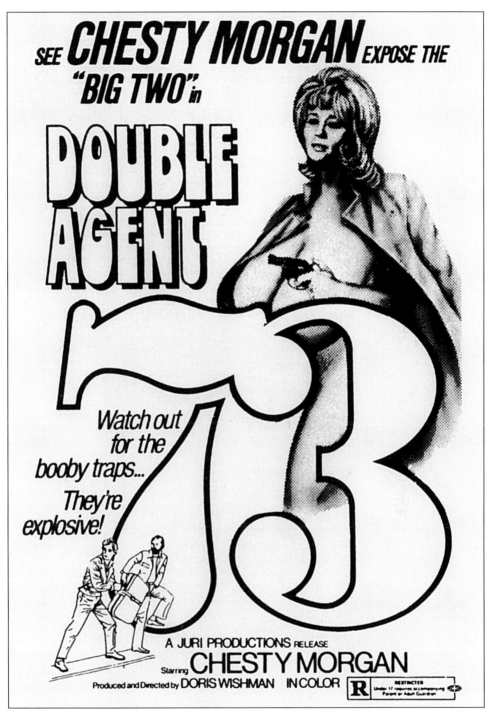

SEE *CHESTY MORGAN* EXPOSE THE "BIG TWO" in **DOUBLE AGENT 73**

Watch out for the booby traps... They're explosive!

A JURI PRODUCTIONS RELEASE
Starring **CHESTY MORGAN**
Produced and Directed by DORIS WISHMAN IN COLOR

The collapse of the female body onto the cinematic apparatus can only be sustained for a limited time. Jane must finish her mission before the camera explodes. According to Michael Bowen, the factor of a time bomb within the body, marks Wishman's films as indicative of a sense of "somatic betrayal."[29] Yet within the reading I am working through here, the explosive device - in this case a gimmick which narrativizes and dramatizes the camera - can be seen as a precautionary measure employed by the boss, who can't allow Morgan's

29 Bowen, pp. 79-81.

excessive body to incorporate the photographic technology. Or rather, he can't allow the camera to replace him. As a reproductive device, the camera threatens to eliminate the child/ spectator who has fantasized the 'hermaphroditic parent.'

In *Double Agent 73,* how the *reproductive* mechanism serves in relation to the oral mother's body is ambivalent. The hermaphroditic element complicates the one-on-one relationship of the mother with the child, as well as the presumed role of sexual difference at the sight/site of the breasts. If the phallus is attributable to the camera inside the spy's breast, what of the penis? Feminist theory's contestation over the split of the phallus from the penis in Lacanian psychoanalysis is crucial here, as it exposes the ambivalence between phallic power and the attribution of embodiment. The instability of the phallus discussed by Mary Ann Doane, as referential to the figure of the masculine, explains the cohabitation of the camera as tool of phallic inscription and the breast, the screen on which the inscription occurs. However, if the phallus, the camera, must be veiled, what of the veil itself? It would seem that, following the logic of Doane's argument in 'Veiling Over Desire,' Wishman's film indicates that woman is not the "substrate of representation,"[30] but quite the opposite, in that *representation is the substrate of woman.* If the veil is not a concealment of the female body, but the body itself, rendering itself more than visible, and gesturing to the photographic phallic fetish, the fetish of representation that resides within, then Wishman is orchestrating a radical critique of gendered spectatorship and the cinematic apparatus. The body has no essence beyond the ministrations of technology and epistemology upon it and through it.

The coalescence of two misplaced fetishes, Morgan acquires the potency of the metaphorically intersexed. The role of sexual difference in the production of the hermaphroditic within the pre-oedipal needs to be questioned further, for it seems to reach an impasse at the locus of Morgan's body in relation to the child/spectator who desires union. The removal of the camera would imply that within conventional social codes, the camera is marked as masculine, gendered male by historical use, and must be wrested from possible usurpation. Also, what underlies this is the question of whether gender can characterize the reproductive mechanism. Can an essential gender identity be posited for the photographic (and cinematic) apparatus? Yet if the "phallus is a fraud" and "can only take up its place by indicating the precariousness of any identity assumed by the subject" as Jacqueline Rose states, Wishman's film underscores this failure of the camera/phallus.[31] Desire for the phallus which lies beyond Morgan's flesh, renders the transparency of power and subjection through spectatorship, a desire for the reproductive which uneasily settles on the hermaphroditic, beyond gender but ambiguously sexed. Wavering between the Pre-Oedipal and the Oedipal, between the hermaphroditic mother and the uncertainty of having the phallus, the spectator of *Double Agent 73* registers the instability of pleasure around the site of sexual difference. It would seem that producing the hermaphroditic parent is a belated process of regression, in which castration anxiety is effaced by the return to the undifferentiation of the hermaphroditic parent, the *mother with a difference*, a place where nothing seems lost. Desire and fetishization of the representational device seems patently naive, a dependence on fixity which is truly fictional, and according to Barthes, on the threshold of death. As Michael Bowen insightfully comments on this film, "fetishization no longer kills its objects, it now often kills its consumers."[32] Yet the feminizing of the phallus and the reproductive mechanism points to interesting questions regarding power, technology and their definitive 'essences.'

In conclusion, the exploitation gimmick, in conjuncture with this bodily technology - embodied by Jane/Double Agent 73/Chesty Morgan - produces a heterocosm, which aligns itself with a reading of the text as masochistic in form. Studlar deploys the heterocosm as an emblematic space for the masochistic aesthetic of Joseph von Sternberg's films. She quotes Harry Berger, Jr. on the heterocosmic painting: "The imaginary world is both disjunctive and

30 Doane, 'Veiling Over Desire,' *Femme Fatales,* p. 73.

31 Jacqueline Rose, "Introduction II," *Feminine Sexuality: Jacques Lacan and the Ecole Freudienne,* ed., Juliet Mitchell & Jacqueline Rose, trans. Jacqueline Rose, (New York: Norton, 1982), p. 40.

32 Bowen, p. 82.

The Body as Apparatus

hypothetical. It is not real life but art or artifice. . . a new and very different world created by the mind." Furthermore, Studlar claims that "verisimilitude is not the goal of the masochistic heterocosm."[33]

In *Double Agent 73*, the heterocosm is a condition of possibility engendered by the conventions of exploitation cinema, furthered by the reconfiguration of Morgan's body. Her body, already hyperbolic in its appearance, her corporeality defined by the size of her breasts, and their ascription to a function which refracts the gaze, positions her in a place marked as fantastical and imaginary. Morgan is not 'representative'; the specific materiality of her body counters both her ability to stand in for 'all women' and to be idealized as perfect object. Although she 'symbolizes' the pre-oedipal maternal figure, it is not a universal motherhood but a specific version of mother that is deployed strategically.

Yet the heterocosm has its limits as an explanatory engine which contains the strategies of the film, and it can be critiqued as an unremittingly utopian space sealed from historical representation. However, the heterocosm can also be reconfigured historically as the space of this film's, and more broadly, exploitation film's, reception, the space of cult film's affective investment. Morgan's body, in its specific banal and 'excessive' embodiment, serves not only to maintain but to dispel the masochistic heterocosm; though not 'representative' of the 'average woman,' her body becomes a representational technology, its materiality and multiple functions, "convey(ing) more than it intends." As an instantiation of the real, her body both precedes and follows representation.[34] While the heterocosm violently disavows 'reality,' and the excessive real of the oversignifying returns us to materiality, both allow a space for a theoretical working out, a place to negotiate the conditions and technologies of representation and potentialities of the female body.

Finally, the mention of strategies returns us to the notion of terrorism, which in the epigraph by Mary Ann Doane, is used to point to a certain crisis in the representation of woman and of woman as representation for feminist filmmakers. Terrorism, which implies danger more than reciprocity or contractual play, also explicitly references it as a violence addressed inevitably towards women. In light of the 'aggressive' images of women so popular in exploitation, the question of "terrorism's" address becomes important. Doris Wishman's filming of the female body can be said to 'terrorize,' particularly within structures of masochistic spectatorship, but also within the largely patriarchal codes of exploitation films, in their generic conventions and sexed topologies. *Double Agent 73* thus complicates the position of women both in front of and behind the camera, and within the cinematic space itself. Doane herself comes to the conclusion that women cannot remain *unrepresentable*.

[33] Studlar, pp. 91-93.

[34] Peggy Phelan, *Unmarked: The politics of Performance*, (New York & London: Routledge, 1996), p. 2.

Julian Hoxter

It is clear to me that at the heart of any serious discussion about the nature of cult there must lie some account of the relationship between the fan and her/his object of fandom. Even at a common-sense level of discussion, the use of the word cult at least implies a closer affiliation between the two than in other instances of audience attachment. The reasons for this closeness are complex and in one obvious sense as varied as the range of cult objects - a range which must itself be defined at least in part according to the level of attachment between fan/object and not according to precise generic or narrational criteria. In this way the discussion that follows is less concerned with offering a reading of a cult film than it is with exploring the idea of cult through fans own responses to such a film.

What accounts of cult cinema by genre do offer, however, is the possibility of useful comparison between fan accounts of their favoured genre. In other words, the ability better to compare like-with-like. How then do cult fans display their attachment and what is the basis for such a comparison? What I have attempted to do in the chapter which follows is to think between the generic and the experiential frames, using a grid from post-Kleinian psychoanalysis, in order to make some observations about the function of cult as it is expressed by fans of *The Exorcist*. In doing so, the question I am asking is not so much what are the criteria for the inclusion of an object (in this case a particular horror film) under the rubric of cult, but what do cult fans get from such an attachment to an object; what, in the broadest sense of the term, is there to be learned from the cult film experience?

Biographical note: Julian Hoxter is Senior Lecturer and Course Leader in the Media Arts Faculty at Southampton Institute. He combines ongoing film production work with research interests in Kleinian and post-Kleinian psycho-analysis, and in popular American film and culture. Previous publications have focused on the horror film and Dennis Hopper's career.

WILLIAM PETER BLATTY'S

THE EXORCIST

Directed by WILLIAM FRIEDKIN

ELLEN BURSTYN · MAX VON SYDOW · LEE J. COBB
KITTY WINN · JACK MacGOWRAN JASON MILLER as Father Karras
LINDA BLAIR as Regan · Produced by WILLIAM PETER BLATTY
Executive Producer NOEL MARSHALL · Screenplay by WILLIAM PETER BLATTY based on his novel
From Warner Bros. 🆆 A Warner Communications Company

Taking Possession:
Cult Learning in *The Exorcist*

Julian Hoxter

One of my students recently asked me out of the blue why *The Exorcist* wasn't scary anymore. I have to say that the question took me aback in that I had taken it for granted that *The Exorcist* was still *very* scary - by reputation at least. (Indeed the question, which I think underlies that of my student, of whether it is *The Exorcist* or its *reputation* which is really cult is an interesting one.) I have always believed that the film's banned video status in Britain elevated *The Exorcist*'s reputation to 'cult' status for the new generation of young fans experiencing for the first time the uncomfortable pleasures it promised via poor quality video copies with bad sound.

In any event, very soon after that conversation, the film was given its 25th Anniversary cinema release and was subsequently granted a video certificate by the BBFC. The coincidence - which, of course, it was not - of these three events gave me pause to reflect once again on the complex relationship between fear, pleasure and fandom which is unique to the horror film.

It is a commonplace to suggest that tastes, and thus fears, constantly shift and that the story of a little girl possessed by a demon might have a resonance in the cultural milieu of the early 1970s that, perhaps, it lacks today. Vivian Sobchack has argued persuasively that a number of films dealing in various ways with childhood, such as *2001: A Space Odyssey* and *Rosemary's Baby*, keyed into a particular sensitivity around the status of the child and the family operating in the *Zeitgeist* of 1968 America.[1] By 1973, the year of *The Exorcist*'s theatrical release, America's cultural insecurity was, if anything, even greater. Certainly the popular press in this country treated the recent re-release of *The Exorcist* with far less outrage or even concern than they had previously. In 1973, the moral panic was as good as written in. Not so, apparently, in 1998. Of course, historical distance and, to a certain extent, reputation can be argued to have assisted in the process of normalisation undergone by the film in as much as they have helped generations of viewers to prepare for the experience of seeing the film.

If all this suggests that *The Exorcist* has become *just another horror film* then this chapter is merely chronicling the death of a cult. If that is so, then it was instructive in researching Internet horror sites designed by, and largely for, adolescent fans to come across pleas like this: "Some of you may be turned off by this movie because it was made in the 70s. Don't let that fool you. It is a truly terrifying movie."

If, on the other hand, *The Exorcist* still retains its power to terrify despite the acceptability granted by its hugely successful re-release on UK video and DVD, then its cult status can be said to be due for another critical visit. Incidentally, I have concentrated my research around Internet fan sites because they allow for a more direct, personal and prompt communication between fans than, for example, the letters pages of genre magazines or fanzines.

1 Vivian Sobchack 'Child/Alien/ Father:Patriarchal Crisis and Generic Exchange' in *Close Encounters: Film, Feminism, and Science Fiction*, ed. by Constance Penley; Elizabeth Lyon; Lynn Spigel & Janet Bergstrom (Minneapolis: University of Minnesota Press, 1991).

Whatever else it may be about, participation in a fan cult must signify a very particular communication, a closeness, an attachment even, between the fan and the object of fandom. The pleasurably anticipated and oft repeated encounter between the horror fan and the potentially troubling content of the horror film suggests a particularly powerful set of needs and expectations of the one to and from the other.

Recreational Terror

Isabel Christina Pinedo, herself a horror fan, elegantly equates the apparently contradictory pleasures of horror fandom to dream processes:

"Much as dreams displace and condense repressed thoughts and feelings, so horror films introduce monstrous elements to disguise the quotidian terrors of everyday life. Much as dreams are unconscious attempts to express conflicts and resolve tensions, so horror films allow the audience to express and thus, to some extent, master feelings too threatening to articulate consciously. The horror film is the equivalent of the cultural nightmare, processing material that is simultaneously attractive and repellent, displayed and obfuscated, desired and repressed. Just as Freud regards dreams, even distressing ones as wish fulfilments of repressed desires, so I regard the horror film as an amalgam of desire and inhibition, fascination and fear."[2]

For Pinedo the horror film undertakes important, even healthy, cultural and psychological *work* for its audience. For this work to be successful the horror film must operate within boundaries. It must offer not real, but rather *recreational* terror:

"Recreational terror is the context in which viewers submit to tension and fear provoked by body horror, a highly conventionalized spectacle of violence in which controlled loss substitutes for the loss of control that people who come to these films are already experiencing. Or as Wes Craven put it when asked about why people go to horror films: 'I don't think people like to be scared. I think people are scared or have been scared.'"[3]

Pinedo is more concerned with arguing for a positive position for women's pleasure as horror spectators and fans than she is with the broader communication between fan and film in terms of human development. However, it is precisely in these terms that the nature of cult spectatorship, and, in particular, that of the cult following of *The Exorcist* and similar films needs to be understood. If for no other reason, this is so because it is on the basis of concerns over social and developmental harm (in particular harm to potential child viewers) that the film was banned on video for so long.

It is with this in mind that my own investigation into Internet fan sites has concentrated, in as much as this is possible to ascertain given the structure of the object of enquiry, on young, male (mainly British), adolescent fans of *The Exorcist*. These fans communicate with one another and interrogate the established sources of information regarding the film. In doing so they circulate and also consume particular types of information as a kind of personal/collective property. Fan websites present this information in largely standardised formats which are personalised by the individual fan primarily through the interpolation of autobiographical example and personal 'statements of faith'.

In researching this chapter, I have visited ('hit') approximately thirty sites dedicated to, or at least foregrounding *The Exorcist,* and upwards of seventy other more general horror-themed sites. Between these sites, clear patterns emerge in terms of strategies of display (in relation to the user interface produced by hypertext markup language), hierarchies of information and approaches to self inscription by the fans themselves. What interested me in particular was the *educational* tone taken by many of the sites. This is made manifest in two main contexts: firstly, by the way in which information is

[2] Isobel Christina Pinedo, *Recreational Terror: Women and the Pleasures of Horror Film Viewing* (Albany: State University of New York Press, 1997), p. 40.

[3] Pinedo, p. 66.

Taking Possession

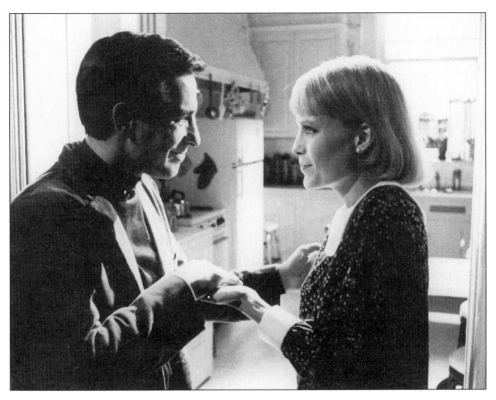

Rosemary's Baby

presented in terms of the structure of the interface itself (this is true of any website) and, secondly, of course through the content of the pages itself.

Fan sites tend to follow the pattern of existing software and database hierarchies by presenting information by rigid category accessed through a mouse driven menu. This serves to parcel out the content rather like chapters in a book. The principal difference is that one frequently has to wait for connections before one is able to move freely from one section to another. Although most menus allow free choice in terms of category - one can visit parts of the site in any order - in my experience, this repeated deferral while the user waits for connection can have the curious effect of hyperbolising the expectation of satisfaction from the new page. In other words, the very process of deferral and delay inherent in navigating any website leads *oneself* to become deferential to the controlling structure. It is, after all, either that or the off button.

In terms of content, the typical fan website is helpful and friendly in its tone, but it is helpful in the way of a 'sage advisor'. There is a pedagogic quality to the presentation of information. The site provides a service that has to do with pleasure certainly, but that service is offered on certain terms (sometimes even requiring the user to login to the site's 'guest book' before access will be granted) and with the understanding that the visitor is there to be informed: to learn something. There is, in this way a kind of double play with the notion of fandom. All fans are equal and welcome, but this is *my* site, *my* contents (even if, as is often the case, every other site has many of the same entries) and I'm teaching you *my* way.

Cult Learning

What, then, do *we* learn from all this cult learning? What do the fans learn about one another, about their objects of fandom, their cult objects and what does this tell us about the social and developmental functions of cult?

Paul Davis is a young British fan of *The Exorcist*. Like many similar film fans he has set up a website on the Internet which is full of information about the film and the personalities involved in its production. Paul's site has links to other similar sites and is connected to a formal grouping - or mini database - of such sites: 'The Exorcist Ring', which enables interested users to follow a 'trail' of websites all of which espouse an interest in that film. Like many other websites, Paul's goes to considerable lengths to justify its content in terms of factual accuracy and faithfulness to the 'project' of, and to the accepted field of fan knowledge surrounding the film. To this end, his site includes interview material, reviews and his own historical/journalistic article which combines an autobiographical account of his interest in the film with 'behind the scenes' information, rumours from the shoot and around the theatrical release of the film in the US and the UK. At the time of writing this article, Paul's site had recently been updated and his introduction to the improved version included the following statement:

"I hope that this new, updated site is just as successful as the last, it was incredibly popular and raked in over a thousand visitors in the little time it was available, but I feel now that my commitment to the film has been well recognised by those who visited other *'Exorcist'* sites and e-mailed me regularly and this site is the tribute I've always wanted."[4]

In as much as his statement sets up the notion of *commitment* to the cult object as a pre-requisite for 'authentic' fandom, Paul is not very different from fans in general. Indeed Paul fits very neatly into J.P. Telotte's account of cult fans motivated by a desire for a particular kind of comforting, interpolated (what we might come to think of as projective), encounter with their chosen text/s.

Under Telotte's grid *The Exorcist* falls between his categories of 'classic cult' and 'midnight movie'. In terms of production values it is the former while thematically and, I would submit, 'experientially' it has been colonised by fans and also exhibitors in the latter context subsequent to its initial release. Telotte puts it like this:

[4] Paul Davis, 'The One Hope, The Only Hope, The Exorcist' at: http://lavender.fort unecity.com/birds/ 275/articles.htm (1999).

Taking Possession

"Sourced in the Hollywood studio system, the classical work is typically marked by a large budget, a big name cast, technical expertise, and a measure of original and conventional success - all of which signify a cinematic status quo and quickly mark it off from the 'outsider' cinema of a *Putney Swope* (1969), *Pink Flamingos* (1972), or *Eraserhead* (1976)."[5]

Of course, as we know, *The Exorcist* also has a very particular place in British film culture due to its long term status as a formerly banned video. This holds if we accept Telotte's argument in as far as he submits that cult films (which he further splits into the categories of 'classic cult' and 'midnight movies') go a long way towards defining their audience by evoking:

". . . a kind of subcultural desire, a desire not simply for difference, but for an identifiable and even common difference, in effect for a safe difference that is, ultimately, nearly not difference at all... In common, [cult films] offer a kind of loving understanding that acknowledges our own sense of difference or alienation, even as it mates us to other, similarly 'different' types in the audience or the films themselves."[6]

The notion of such a supportive interaction is distinctly at odds with the surface *subject matter* of many - if not most - of the films which typically come under the rubric of cult. To allow for such a positive engagement with *The Exorcist*, historically a film which has come to define extremes in audience reaction in terms of alienation and shock, would seem to present immediate problems (indeed if *The Exorcist* does enable such a reading it would surely go a long way towards validating the assertion on its own). For Paul Davis, however, it is exactly this history, this accretion of extremeness to the text of the film, which engages him with his cult object. His contribution to the 'fan script' page of another fan website: *Bavard's Exorcist Tribute* includes what for *Exorcist* fans is an almost talismanic statement (written of course before the BBFC's recent decision):

"It is the inexplicable power that *The Exorcist* contains which is still the considered factor by the BBFC. Can the film still have a lasting affect on unsuspecting viewers. It can... if you're weak minded."[7]

Paul is a fan who, by his own account, has seen the film on video many times and yet the experience of watching it in a cinema during its recent theatrical 25th Anniversary re-release was a shock: "For me as someone who has seen the film fifty to sixty times on a TV screen and know [sic] what is going to happen, witnessing *The Exorcist* on the big screen was [a] horrifying experience from which I don't think I'll ever recover."[8] The importance of the constitution of cult status as in part based upon repeated viewing of the colonised text/s has not been lost on critics.

Bruce Kawin notes that common sense definitions of cult focus either upon: ". . . any picture that is seen repeatedly by a devoted audience," or ". . . a deviant or radically different picture, embraced by a deviant audience."[9] Like Telotte's, Kawin's thesis rests upon the idea of two types of cult film. To paraphrase: Kawin offers the categories of the inadvertent cult film - films which become cult without challenging their audience or redefining its values such as *Casablanca* (1942) - and the programmatic cult film - films with cult status 'designed in' which often set about violating their audiences' shared values, like *The Texas Chainsaw Massacre 2* (1986).

The effect of this repeated desire for a return to the 'mother text' is, for Bruce Kawin at least, indicative of a similar expectation of, and pleasure in, a kind of imagined reciprocity between text and fan to that outlined by Telotte:

"These are films with which we, as solitary or united members of the audience, feel we have a relationship. In the case of oldies like *Casablanca*, it is because we have enjoyed and allowed ourselves to feel open to them for so long; in the case of oddities like *Eraserhead* or *Liquid Sky*, it is perhaps because

5 J.P. Telotte (ed.), *The Cult Film Experience: Beyond All Reason*, (Austin: University of Texas Press, 1991), p. 10.

6 Telotte, p. 11.

7 www.geocities. com/Hollywood/ Set/6537/ fanscript.html

8 Davis, http://lavender. fortunecity.com/ birds/275/articles. html

9 Bruce Kawin, 'After Midnight' in *The Cult Film Experience: Beyond All Reason*, ed. J.P.Telotte (Austin: University of Texas Press, 1991), p. 18.

we made them hits, or perhaps because we found there the mirrors for which we were searching, the mirrorings of our buried concerns, our true self-images, and the outrageous projections of nightmare, of rebellion, or of style: a vision that, if not literally ours, still clicked with or spoke to ours."[10]

For horror fans like Paul Davis, however, their desired communications with their favoured genre films often involve a very specific kind of expectation. Hardcore horror fan discourse on the Internet and in the pages of fanzines is suffused with comparative and contestatory statements about the relative affective power of the films. A brief review for *A Nightmare on Elm Street 3* (1987) in the *Slashers Haven* website enthuses: "a great Freddy movie. Lots of cool deaths." Another site reviews *The Exorcist*, valorising the cardinal connection between fear and authenticity for the horror fan: "Whether or not you're a religious person or not [sic] this movie will really hit you... If you want a true scare, watch *The Exorcist*." With a certain amused relish, the rules for 'The Exorcist Ring' state that its sites are not for children, while paradoxically, if obliquely, playing into Billy Graham's oft repeated reification of the film as manifestly evil: "Certain horror films contain EVIL material and we don't want to warp their minds!" (How this particular rule is policed, however, the site does not reveal). Part of being a horror film fan is, then, an investment in an implicit game of 'dare' with one's own fear and disgust and that of one's contemporaries.

Whatever else it may involve in terms of male ambivalence towards the female image elucidated and debated in the critical trajectory from Mulvey, the pleasure many horror fans (no matter their gender) take in genre spectatorship has much to do with a process of self-testing. Pinedo thinks of it in terms of mastery: "It is a test of our mettle to survive the ordeal..."[11] It is a kind of game which British readers in particular might recognise by association (and at the risk of flippancy) as something like the adolescent 'Vindaloo test'. Only instead of the object being to prove who can eat the hottest curry without adverse effects, here the fan competes to colonise - and by extension naturalise (digest) - the hottest horror.

Following this alimentary line of thinking in at least two senses, *Dr. Schwa's Exorcist Page* offers a challenge: "Calling this film 'the scariest film ever' does it no favours, if you go to see it expecting to be sitting in a pool of your own feces [sic] by the end you will not enjoy the film. Just let all your expectations go, let yourself believe, feel every hair stand on end, and enjoy the best film ever made."[12] We have already seen that for Paul Davis *The Exorcist* is the 'Phal' of horror films and he chides the potentially "weak minded" audience member for whom this film may be too much.

Possessing meets Possession

The impression one gets from reading fan discourse is that of the centrality of ownership or perhaps more appositely, of possession and control of knowledge about the cult object which speaks to a sense of insecurity and anxiety regarding the status of the fan before his object. In normal circumstances, the fan can only ever aspire to becoming, at most, a post facto addition to the cultural meaning of the film. I would submit that it is this implicit anxiety which does much to circumscribe the accepted field of popular knowledge and understanding surrounding a film. Fan sites endlessly re-write from this finite base of factual knowledge, and they do so from the first person. In structural terms, fans' film websites are functionally almost identical with pages for journalistic reviews and criticism, background information (the *sine qua non* of 'authentic' fandom which is presumably intended to signify in yet another sense the grail of 'insider' status), star biographies, images and film stills, video and sound-clips and links to similar sites alongside the ubiquitous 'position paper' of the individual writer. Paul Davis, for example, praises Mark Kermode's championing of *The Exorcist* but then rapidly intervenes: "Kermode has been researching the movie's history ever since its release when he was

10 Kawin, p. 20.

11 Pinedo, p. 50.

12 www.btinternet.com/~Schwa/reviews.htm

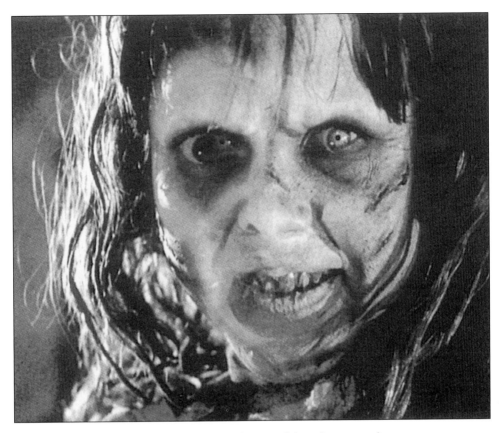

eleven years-old, but I feel now that it's time for an opinion of someone from the 'younger generation'."[13] Paul's writing of the canonised backstory is typical in that although the information he lays out is not new, it is presented with a kind of journalistic immediacy and familiarity that, intentionally or otherwise, has the effect of signifying mine:

"On August 20th 1949, a 21 year-old student called William Peter Blatty, came across a newspaper article in the Washington Post at Georgetown University. The article was a brief outline about a so-called case of demonic possession that was taking place in nearby Mount Rainer, MD . . ."[14]

The acquisition of fan knowledge is about learning, certainly, but its display in websites often reads like the kind of learning Margot Waddell describes as the "...greedy gathering-of-facts-and-information"[15] which, for her, signifies an overwhelming need for security (to satisfy deep yearnings through self justification to a replacement object). Waddell cites a pattern of academic, intellectual or knowledge-based achievement of this sort in adolescent patients, whose motivations have very little to do with the 'learning as understanding' and 'for development' that Bion offers as a basis for the structuring of the personality in his theory of thinking in *Learning From Experience,* and everything to do with a kind of intellectual consumption as defence.[16] Waddell's patient Simon, for example, who presented with typical, if rather extreme adolescent anxieties surrounding his own identity, played out just such a tendency:

"This intellectuality was of a greedy-incorporation-of-facts-and-skills sort, one which had a distinctly oral quality of wanting to gobble up, to swallow down and later to regurgitate... knowledge and experiences rather than to digest them psychically and to metabolise them."[17]

13 Davis, http://lavender.fort unecity.com/birds/ 275/articles.htm

14 Davis, http://lavender.fort unecity.com/birds/ 275/articles.htm

15 Margot Waddell, *Inside Lives: Psychoanalysis and the Growth of the Personality* (London: Duckworth, 1997), p. 109.

16 Wilfred R. Bion, *Learning From Experience,* London: Karnac, 1991 (1962).

17 Waddell, p.144.

This is not to suggest for one moment that ordinary film fans - even horror fans - are in some way 'disturbed'. It is rather that in the kind of informational acquisitiveness, in the reification of facts as facts that their websites present, we can ascribe a certain eloquence to the self-regulation of the field of enquiry of cult. No better illustration could be found than the message board of *Dr. Schwa's Exorcist Page* which has one discussion thread, title: 'Obscure Information Wanted'!

Learning here is about consensus and the display of learning. It is also about the security to be enjoyed in that consensus and from that display. And yet in the world of the cult itself, this kind of learning forms the basis for a potentially powerful and, within its limits, empowering communication. From one fan to another, it is a communication which is fundamentally understood, appreciated and returned in kind. The security offered by such communications is exemplified by comments such as this one found on a website message board: "I watched the movie last week. It is the scariest thing that I have ever seen. I am having trouble sleeping."[18] Not only do fans feel safe enough to admit some of their own frailties to one another, but it would not be stretching a point to suggest that the person who posted that message anticipated gaining something in the way of comfort from the offering. This kind of reaction, this kind of fear is clearly accepted into the virtual space of the ring and understood, and with that understanding comes a kind of transformation. It is in a curious way an example of a sort of group containment in which the fans propagate their own security, contributing to one another's sites and circulating the canonised knowledge within the 'ring'.

The Pleasure and Containment of Horror

The idea of containment, a particular instance of projective identification identified and explored in the work of Wilfred Bion, is a central tenet of post-Kleinian psychoanalysis. It links to the development of thinking, of learning and thus of the personality, through the relative eloquence of early communication between an infant and its good parental object. The good parent is able to engage with the child's pre-verbal expression of fears, anxieties and unpleasure in such a way that the child is helped to ameliorate overpowering feelings and gradually to learn to control and to understand them. A similar communication occurs between the analyst and the analysand in the session.

[18] Erock1979@ aol.com

Taking Possession

In 'Attacks on Linking', Bion outlines the interaction in which the patient projects into the analyst's mind those parts of himself which are in need of treatment, and "...if they were allowed to repose there long enough they would undergo modification by my psyche and could then be safely introjected."[19] The relationship between container (the responsive parent/analyst) and contained (the unbearable projections) is a subtle one, although Waddell finds an apt analogue in J.M. Barrie's description of Mrs. Darling in *Peter Pan*:

"Mrs Darling first heard of Peter when she was tidying up her children's minds. It is the nightly custom of every good mother after her children are asleep to rummage in their minds and put things straight for the next morning, repacking into their proper places the many articles that have wandered during the day."[20]

In Barrie's fantasy, Mrs. Darling performs a function for her sleeping children not unlike that of dream. It is, however, in the implication that she is able to undertake a restorative function through a projective communication that Waddell's example is apposite to containment:

"According to this way of seeing things, the mother becomes the 'container', and the baby's fragmentary impulses and emotions, the 'contained'... The container/contained relationship constitutes Bion's model for the thinking of thoughts, a model for processing emotional experience which, insofar as it is repeatedly reproduced in the infinite flux of life thereafter, makes a fundamental contribution to the structuring of the personality."[21]

The infant's/patient's ego is "...built up through introjection of an object that can contain and understand his experience..."[22] This object 'pasteurises' traumatic material which subsequently becomes safe to take inside once again. (Bion uses the abstracted notation '&' for container and '%' for contained.) Pinedo thinks her account of recreational terror through a not dissimilar, if 'common sense', understanding of containment. For Pinedo, as for Paul Davis, pleasure in horror spectatorship is predicated in part on taking comfort in the fictive basis of the viewing experience: "A film promises a contained experience. What makes it tolerable for the monster to persist... is the containment of the menace within the temporal and spatial frame of the film."[23] Noël Carroll, for his part, acknowledges the same principle in his exploration of the paradox of being "...art-horrified."[24]

To express this in Kleinian terms, one would suggest that the fan imbues the film with the function of a kind of knowing container and the spectator's fear is projected with the expectation of a moderated return, enabling the spectator successfully to introject and safely to enjoy the film-as-fiction.

Love, Hate and Knowledge

The Exorcist, of course, has attained a reputation based precisely upon the premise that it breaks the boundaries of Pinedo's 'recreational terror'. In this common sense iteration at least, it is a film about the uncontainable which has attained a very particular cultural status as 'the film which cannot be contained'. Indeed at the level of narrative, problems of containment also underlie the central plot and thematic concerns of the film.

The still everyone remembers from *The Exorcist* is the image of Father Merrin arriving outside the MacNeil house in Georgetown, staring up the unnaturally bright beam of light from Regan's window which, in turn, throws his own gaunt figure into an ominous silhouette. In this one image, the central dilemma of the film's narrative as well as of its cult-ural and political status in this country as, to paraphrase James Ferman, a wonderful film for adults that threatens to do actual harm to potential underage video viewers, is also thrown into stark relief.[25]

19 Wilfred R. Bion, 'Attacks on Linking' (1959) in *Second Thoughts* (New York: Aronson, 1967), p. 103.

20 Waddell, p. 32.

21 Waddell, p. 32.

22 R.D. Hinshelwood, *A Dictionary of Kleinian Thought* (London: Free Association Books, 1991), p. 248.

23 Pinedo, p. 41.

24 Noël Carroll, *The Philosophy of Horror or Paradoxes of the Heart* (New York: Routledge, 1990), p. 59.

25 'James Ferman,'The Exorcist' and the BBFC' in *Sight and Sound* Volume 8, Issue 7 (July 1998), p. 10.

In the film it is this powerful projection which signifies an evil which the MacNeil house - for which read the family, specifically Regan's mother, and subsequently both the medical and Catholic professions as therapist/abusers - initially do not understand and subsequently cannot contain. The connection formed in this image between the unseen Regan and her would-be exorcist also prefigures a complex and ultimately fatal transference for the priest which has, as we know, been echoed in terms of trauma by the recorded reactions of many cinemagoers subsequent to the film's release.

From somewhere within her inner world, Regan writes her desperate need for projective identification onto the surface of her own body: 'HELP ME'. Father Karras, however, cannot pasteurise the devil for Regan (or, indeed, for the viewer) without killing himself: 'TAKE ME'. For Regan, Karras and the other characters in the film, the resulting destruction signifies, in Bion's terms, that the link Regan-Karras has been unsatisfactory, or 'parasitic', a situation which ". . . occurs when the object produced by &% destroys both & and %".[26] Karras, the intended container (&), is dead and the demon 'Pazuzu', Regan's overwhelming projection (%), along with him. Regan survives, but as a victim - this, after all, is a central 'problem' of the film. So clear, indeed, is Regan's status as victim in *The Exorcist* that the film's sequel: *Exorcist II: The Heretic* is premised explicitly upon an exploration of her victimhood through narratives of psychoanalysis and pseudo-medical experimentation. We are given no evidence to suggest that she has learned - that she has anything to learn - from her experience. Regan is, in Gianna Williams' terms, the unwilling receptacle for violent projections which she cannot keep out.[27]

For the fan who has successfully sat through the film, the subsequent communication offered by cult sanctuaries like 'The Exorcist Ring' would suggest the availability of a more constructive, 'symbiotic' link (where & and % are mutually beneficial) which the fan can use to work through any anxieties the experience of spectatorship has brought up. The fan is able to set out and discuss his feelings and thoughts, potentially a positive development in his powers of expression. And yet, finally, one is forced to question the depth and significance of this communication. There is a very obvious and immediate limit or block here. Cult websites are interested in knowledge certainly but, as we have seen, not really of the sort which leads to greater understanding. In Bion's terms once again, if fans are in some way looking to establish a meaningful human connection, a 'K' link - the *connaître* to factual knowledge's *savoir* - *The Exorcist* sites surely do not offer it.

[26] Joan Symington & Neville Symington, *The Clinical Thinking of Wilfred Bion* (London: Routledge, 1996), p. 56.

[27] Gianna Williams, *Internal Landscapes and Foreign Bodies: Eating Disorders and Other Pathologies* (London: Duckworth, 1997).

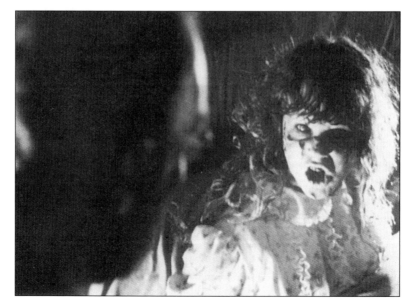

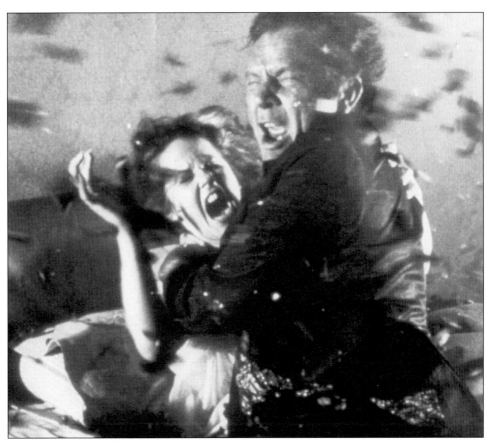

The 'K' link is a central element in Bion's account, comprising one of three links at the heart of human communication, L, H & K (Love, Hate & Knowledge) along with their negatives, -L, -H & -K:

Exorcist 2:
The Heretic

Bion (1962) started to investigate the vicissitudes of the containing relationship by describing the quality of the link between the containing mind and the contents put into it. Thus mother at times will love her child, hate him or find herself trying to understand how he is experiencing, feeling and thinking. For purposes of the development of thought, the K-link is the most important. Mother's linking with the infant in this way develops the capacity of the child through the introjection of the K-linking object.[28]

To suggest that such a K-link is not offered in these instances of fan discourse, of course, does not necessarily imply that it cannot be found. One gets the impression, however, that despite the openness of message boards, it is almost as if fan websites are designed specifically to avoid or sideline just this kind of communication. Joan and Neville Symington paint a particularly bleak picture of this kind of emotional link in -K in an example from the session:

"A patient may try to extract facts from the analyst or theories to explain his symptoms, rather than risking an emotional engagement with the analyst. The process of getting to know involves pain, frustration and loneliness. Obtaining a piece of knowledge about a person does not involve these states, in fact it is like cannibalism, taking something and avoiding emotional involvement."[29]

The language of the example they cite from Bion, while instructive, is even more extreme:

[28] Hinshelwood, p. 461.

[29] Symington and Symington, p. 28.

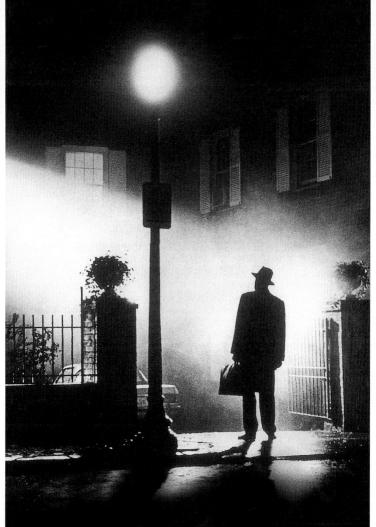

"The greatest movie ever made"

MARK KERMODE, RADIO 1

WILLIAM PETER BLATTY'S

THE EXORCIST

Directed by William Friedkin

"25 years on The Exorcist is still terrifying" - THE TELEGRAPH

"Go and be scared, 10/10" - LOADED

Taking Possession

"He bashes in [the woman's] skull. God! It's like rock. He treats it like eggshell. He's sucking - this is cannibalism! He sucks out the brain . . . The darkness deepened. The skull-crushing and sucking object is overwhelmed by depression and the failing supply of nutriment from the dead & and the failure to restore it to life."[30]

It is, then, doubtful whether Internet fan networks currently function as truly receptive containers which can understand and return and therefore strengthen the fan's (infant's) own capacity to contain. However, that is not to suggest that they perform no useful purpose. On the contrary, they clearly work at the level of providing basic comfort and security simply through the recognition of commonality of experience. Similarly some of the message board contributions from fans who have really been frightened imply that for them the Internet can also work as a receptacle for the outpouring of undigestible experience. For others, including Paul Davis, there is some help to be had in 'working through' (making digestible) by thinking - writing - out their experiences. The relative success of this activity for individual fans is difficult to assess because it cannot be judged purely on the surface level of verbal articulateness. Emotional communications may, of course, be quite genuine and positive even if simply or inexpertly expressed.

For some fans, knowledge gathering and display has a more directly defensive or evasive purpose if it becomes merely an airing of their knowledge without actually furthering their capacity to understand/contain the horror. The violent antipathy that some horror fans display, in the letters pages of fanzines for example, towards overtly academic investigations of their cult objects - which explicitly break the boundaries of the accepted range of fan knowledge and, by implication at least, call into question the basis of their fan affiliations - is testament at least in part to this kind of evasion. Of course, evasions or defences of this kind are not necessarily merely negative responses. Those who use an accumulation of knowledge to evade the emotional experience of *The Exorcist* may in their own right be taking possession of the film in making it their own area of expertise. Of course it goes without saying that this is vastly preferable to the unspoken other that is violent 'acting out'!

If the insular world of Internet web rings does not actually 'pasteurise the Devil' for fans of *The Exorcist* it may, at least, provide a safe forum in which, amongst the cannibalistic evasions that characterise cult learning, the possibility of containment can be found.

[30] Symington and Symington, p. 28.

unruly pleasures

I.Q. Hunter

Who decides what counts as a cult film? Is cultism a personal or shared experience? This chapter sets out to describe the viewing practices of one fan of *Showgirls* (1995), a fan (myself) who happens to be an academic. Whereas most cult films are marginal or overlooked movies with vociferous support from devotees of the 'different' and transgressive, *Showgirls* largely attracted either disdain or camp mockery as a pathetically 'bad' movie. It was a modest hit a few years ago among gay American audiences, who ironised its clichés and bizarre excesses, but no community of fans has ever emerged to celebrate the film's merits.

That I actually like and admire the film, then, to the point of being a one-person non-ironic cult audience, raises some interesting questions. Is this fandom a sad example of misplaced enthusiasm and poor interpretive skills? How does such active and perverse reading reflect the fan's needs and private fantasies? Who in a period of cultural relativism has the authority to decide whether a fan's taste for and interpretation of a film are 'wrong'? And how many people do you need to make a cult?

A good deal of recent academic criticism endorses a 'hermeneutic of suspicion', reading movies to find in them evidence of bad faith and ideological complicity. But film studies, for some of us, is mostly a continuation of fandom (not politics) by other means.

This chapter therefore muddles any distinction between fan and academic, enthusiastic partisan and severe enforcer of political rectitude. It defines the film cultist as a sort of consumer-age aesthete, who insistently asks, as Walter Pater did, "What is this song or picture, this engaging personality presented in life or in a book to *me*?" As a cultist, I am less concerned with whether my interpretation of *Showgirls* is 'right' than with the solipsistic pleasures of being fascinated, aroused and uncritically interpellated by this remarkable trash film.

Biographical note: I.Q. Hunter is a Senior Lecturer in Media Studies at De Montfort University, Leicester. He is the co-editor of the *Film/Fiction Annual* (Pluto) and Routledge's *Popular British Cinema* series, for which he has edited *British Science Fiction Cinema* (1999).

Beaver Las Vegas!
A Fan-Boy's Defence of
Showgirls

I.Q. Hunter

"Andrew Sarris once began an interview with a sustained defence in intellectual depth of his auteur theory, and concluded by confessing that what really kept him coming to the cinema was its girls. Here is the beginning of wisdom."
Raymond Durgnat[1]

'The Worst Hollywood Film Ever Made'

Showgirls (1995), Paul Verhoeven's lap-dance musical, is that rare object in cultural life: a film universally derided as 'bad'. *No one* seems to like it. At a time of alleged cultural relativism and collapsing standards of aesthetic judgement *Showgirls* has emerged as a welcome gold standard of poor taste and world-class incompetence.

From the start, critical reaction to the film was numbingly hostile. According to *Halliwell's Film and Video Guide*, only one of the 14 leading British critics and two out of 34 critics in Chicago, New York and Los Angeles ventured so much as a good word for it.[2] The rest teetered on hysterical loathing. Mocking the film's brashness, overblown dialogue and the acting deficiencies of its young star Elizabeth Berkley, critics deplored above all Verhoeven's hypocrisy in exploiting the very sleaze and voyeurism that his film purported to expose. Gina Gershon alone escaped general censure, if only because her arch performance as Cristal, an omnisexual dancer, appeared to send up everything around her. Not surprisingly, despite being the most hyped film of the year, *Showgirls* was a commercial disaster. Costing $40 million it took no more than $25 million in domestic theatres, and although video sales and overseas revenue meant that it eventually turned a profit, it was still the second most costly write-off of 1995.[3]

Since the film was released, few, even among hardcore aficionados of trash, have bothered to come to its defense. An exception was the director Quentin Tarantino. "The thing that's great about *Showgirls*", he enthused, "and I mean great with a capital great, is that only one other time in the last 20 years has a major studio made a full-on, gigantic, big-budget exploitation movie [*Mandingo* (1975)]. *Showgirls* is the *Mandingo* of the '90s."[4]

But even as an exploitation film *Showgirls* came dreadfully unstuck. It not only missed but also alienated its core audience of overheated hetero-sexual males. Seeming to address only straight men probably didn't help its chances. (That *Showgirls* is a campy musical suggests that an address to gay audiences, or at least a space for gay appropriation, was built into it as a possibility. This ambiguity wasn't stressed in the promotional material.) Other

1 Raymond Durgnat, *Durgnat on Film* (London: Faber and Faber, 1976), p. 179.

2 Leslie Halliwell, *Halliwell's Film & Video Guide 1997 Edition*, updated 12th edition, ed. John Walker (London: Harper Collins, 1996), p. 678.

3 Anne Thompson, 'Is Bigger Better? The 21st Annual "Grosses Gloss"', *Film Comment* March–April 1996, pp. 60-64 (p. 63).

4 Mim Udovitch, 'What Do You Mean, You Liked *Showgirls*? Tarantino & Juliette', *Premiere* UK Edition June 1996, pp. 56-61 (p. 60).

single-mindedly male-orientated films of the period such as *Striptease* (1996) and *Barb Wire* (1996), whose appeal rested on the exposure of celebrity silicone, also flopped badly in spite of aggressive publicity campaigns. Like *Showgirls* they were too tame to attract the porn trade, but neither romantic nor arty enough to break into the couples market for erotica.

Showgirls did, however, very briefly attract a cult following. In 1996 gays in New York and LA set up special *Rocky Horror Picture Show*-style screenings to celebrate it as "the camp classic of the decade".[5] Emboldened by this 'resurrection', as Verhoeven called it, and eager to re-launch the film by any means, MGM/UA edited the video release version to emphasise what the reviewers had managed to overlook: the deliberate tone of mocking self-parody inspired by the tastelessness of its setting. As such *Showgirls* was redesignated as a pre-fabricated cult film, an exercise in heterosexual camp like *Repo Man* (1984) and *Mars Attacks!* (1996), whose in-jokes, rarefied irony and fondling delight in kitsch nourish cult viewing. What is so unsettling about *Showgirls* is that lines like "I've a problem with pussy", "It must be strange not to have people come on you" and "The show goes on" are not bracketed off as inappropriate or deliberately funny comic effects.

As with *Blue Velvet* (1986) the audience doesn't immediately know whether to laugh at or with the film. Should we, as most people ended up doing, regard its zingy clichés as evidence of naivety and bad writing or should we instead give Verhoeven the benefit of the doubt and conclude that they are integral to a meticulous spoof? Either way, the original negative critical judgement has become the definitive one, which the ironic 'so bad it's good' interpretations confirm rather than subvert. When a character in *Scream 2* (1998) is asked to name his favourite scary movie and smugly replies "*Showgirls*, definitely", he acknowledges not only industry lore but a truth universally recognised. *Showgirls* is *Plan Nine from Las Vegas*.

So why do I like the film? How could I be so wrong? Five years after it slunked off the screen, trying to defend *Showgirls* might seem either perverse or uninterestingly weird. But film criticism has always 'advanced' by the aggressive re-evaluation of 'bad' movies. What passes for a canon is little

5 http://www. filmzone.com/ Showgirls/shinfo. html/ 06/02/97.

more than a quirky makeshift record of the enthusiasms of cultists, auteurist romantics and off-duty academics (categories at best blurred and over-lapping). In this spirit, through an account of one fan's subjective discursive practices, I offer an interpretative defence of *Showgirls*, vaguely hoping thereby to re-appropriate a much-loved film from its camp detractors. At the very least it's a chance for scornful readers to find out what it's like passion-ately to admire the worst Hollywood film ever made.

A Sort of Interpretation

Briefly, it goes something like this: *Showgirls* is a coherent, self-reflexive and stylistically dynamic send up of consumerism, Hollywood and the mechanics of the star system. Incidentally, I don't just mean that the film is 'interestingly' symptomatic of its period, whose discourses it happens to articulate more openly than most other texts. Nor do I claim that it is politically transgressive (the standard line nowadays for revisionist appropriations). *Showgirls* strikes me as being very far from progressive. It is an anti-humanist, even dehumanising, film and like all exploitation movies entirely in love with its debased subject matter.

My interpretation is necessarily a very partial one, leaving out much that many critics would consider central to the film. I should say more about its sardonic plagiarism of other movies, such as Busby Berkeley musicals, *All About Eve* (1950), *The Lonely Lady* (1983), Verhoeven's own *Keetje Tippel* (1975) and the contribution of the screenwriter Joe Eszterhas, who seems to have taken the film more seriously than Verhoeven ever did. I'd also like to explore how *Showgirls* represents Las Vegas in comparison with the numerous other recent films set there, such as *Bugsy* (1991), *Casino* (1995), *Leaving Las Vegas* (1995) and *Mars Attacks!* (1997). Two key aspects of the film, its relation to erotic thrillers and its depiction of predatory lesbians, are covered elsewhere in an excellent discussion by Yvonne Tasker.[6] I'll restrict myself, then, to a couple of ideas and move swiftly on to the main theme of this chapter, which is how the film works as the object of private cult fandom.

What is striking about *Showgirls* is not so much its sexual content as the possibilities for sexual display that it does *not* exploit. There are no romantic sex scenes, no soft lights, soft focus and jazz music. There are no extraneous sequences in showers, no female masturbation or lesbian scenes; in short none of the staple turn-ons of softcore porn. The film records public perfor-mances with sexual content (lap-dances, the stage show) rather than a succession of private sexual encounters. The forceful sweeping Steadicam presents sharp-edged action movie images of bodies in movement and hard at work.

Besides a rape, the only sex scene - between Nomi (Berkley) and Zack (Kyle MacLachlan), her boss - is presented as a very obviously simulated performance, with much flailing about in a swimming pool. There are no intimate close-ups of the female body like the conversation piece pussy-shot of Sharon Stone in Verhoeven's *Basic Instinct* (1992). The emphasis is strictly on breasts, augmented or otherwise. The emotional implications of sex and the subtleties of sexual pleasure are unimportant. What matters is sex as performance, sex as work, sex as commodity and commercial transaction. Instead of adventurous, intimate explorations of 'sexuality', the film distributes quantities of choreographed flesh, nude 'stuff', across the widescreen.

This matter of fact crudity of exposure (landscaping by nudity, if you like) is matched by the dialogue's hyperbolic obscenity. From mere exclama-tions ("Fuck! Fuck! Fuck!") to scatological jokes ("What do you call the useless piece of skin around a twat? A woman!"), the film boorishly insists on a vulgar anti-romantic 'realism' that identifies sex with the body. Yet for all its shamelessness the film frustratingly declines to offer any release into authentic inner emotions. Far from being distinctive to character, sex in the

6 Yvonne Tasker, *Working Girls: Gender and Sexuality in Popular Cinema* (London and New York: Routledge, 1998), pp. 156–157.

film is a means by which bodies manipulate other bodies on their way to meeting career goals. As Claire Monk remarked in her criticism of the film: "the message we gain [is that] valuing the authentic self over the commodified self and of erotic self-expression over commodified sexual display is to be despised."[7]

Sexuality as Consumption: The 'Performance' of Desire In *Showgirls*

Nomi, with her multiply punning name ('No me', 'No! *Me!*') highlights the film's existential ethic in her solitary and narcissistic trajectory towards gleeful self-abasement. The film suggests that under consumerism, there are no authentic identities but merely a series of performances. Throughout the film names are exchanged (at the Cheetah lap-dancing club everyone has a fantasy pseudonym). In the film's logic, bodies that are shaped to conform to standardised ideals matter more than 'real' selves. At the Stardust club the performers are interchangeable, functions of the corporate necessity to keep the show going. In this environment anyone could be the next 'Goddess'.

The film deliberately eliminates psychological depth by reliance on stereotypes and by ambiguity of motivation. Who is exploiting whom when Nomi performs sex with Zack? Who knows whether her orgasm is real or cunningly faked? The acting is so exaggerated and histrionic that we get little sense of true emotion or uncalculated response. In keeping with this functional thinness of characterisation, the film outrageously foregrounds its own glaring artificiality, from the numerous absurd coincidences (Nomi meets the same guy when she arrives in and leaves the city: she's Marilyn, he's Elvis) to the joltingly crude dialogue. Above all it revels in Las Vegas's abolition of nature, the perfect setting in which to define the self as an empty denatured signifier.

The overriding theme of the film is sex as the performance of power, sex as a route to advancement within a corporate system founded on exploitation. Buying and selling is the business of Las Vegas, and no relationship in the film is uncontaminated by commerce. Nomi moves from prostitute to lap-dancer and then to showgirl, not to exorcise personal trauma or as means to self-

[7] Monk, *Sight & Sound* Volume 6, Issue 1 (January 1996), pp. 51-52.

expression but in order more perfectly to achieve independence through self-commodification. She wants to become a complete material girl. Although she resists actual prostitution in the course of the film (in the back story she is a crack-addicted call girl in New York), it is made clear that little real difference exists between the apparently discrete 'levels' of her career.

What becomes noticeable throughout, is the relentlessness with which the film works through its metaphor of capitalism as prostitution. This motif is cinematically familiar in productions as diverse as *Vivre Sa Vie* (1963), *American Gigolo* (1980) and even *Pretty Woman* (1990), which normalised prostitution as a career move. In Verhoeven's film the theme is used systematically to emphasise that, as one character says, "Someday you're going to have to sell it". People are just exploitable flesh, whores in all but name. No less than *Casino*, in which Las Vegas symbolises America's economic history from gangsterism to Disneyfication, no less even than Pasolini's *Salò* (1975), *Showgirls* is about how a totalising system of exploitation can be made to work.

This exploitation is of course inescapably gendered, so the film tries to universalise from the specific oppression of woman. The aim is misanthropy rather than misogyny: as one critic said, "Reality, for Verhoeven, is that most people are nasty shits".[8] The men are entirely unsympathetic, their expressions of power ranging from harassment at auditions to its logical conclusion in rape. The women, who are only marginally less vile, have power only so long as they are willing to be objects of consumption. Their complicity in exploitation is not only useful to them but also essential to their fantasies of self-creation. Specifically, complicity alone enables them to maximise consumption. The only hint of escape from *huis clos* is the friendship between Nomi and her housemate Molly. But even this transcendent interracial sisterhood is ambiguous; at best it is a way of sticking together to work the system more effectively.

The metaphor of prostitution is crude and cartoonish, as befits the reductive cynicism of an exploitation film. Far from stirring itself to denounce capitalist consumerism, the film merely lays bare how it functions in a "life-mostly-sucks, people-are-mostly-shitheads" kinds of way.[9] That America, let alone Las Vegas, is about consumerism; that sex is power; that we are all commodified now - these gems of T-shirt philosophy do not require scandalised exposure. They are common knowledge, as obvious to us in life as they are to the showgirls (Cristal, for example, doesn't resent Nomi sabotaging her career, rather seeing it as the way of things). Hard-bitten Gumpisms of cynical postmodern reason are spat out all through the film: "Life sucks", "Shit happens". But the revelation of basic economic instincts can offer nothing new about human nature and social reality. The naked truth is on the surface: the system has nothing to hide because it is complete, perfect, and impregnable.[10]

Nomi's experiences are therefore a fable of that most open of secrets: the dark side of the American Dream. She leaves Las Vegas at the end of the film, disgusted by the city's values and having, she says, gambled and won herself. But she is heading off for Los Angeles - in other words, for Hollywood, where the same system of exploitation is played out on a larger budget. *Showgirls* itself - and this is the film's sickest joke - only proves the point. Remorselessly exposing its actresses' bodies, it blurs the distinction between sexual performance in sleazy strip-clubs and bidding for stardom in Hollywood movies. Berkley, churning eagerly over MacLachlan's crotch, is just one more hungry wanna-be lap-dancing her way to the big time.

Showgirls mocks distinctions between good/bad, authentic/inauthentic, art/trash, those aesthetic and ethical ideas trashed by the logic of consumption. Although judgements about aesthetics and talent are made throughout the film, it is unclear how seriously we should take them. Nomi's skill as a dancer is much discussed, but she employs it in an apparently

[8] Larissa MacFarquhar, 'Start the Lava!', *Premiere* US Edition October 1995, pp. 78–84 (p. 82).

[9] MacFarquhar, pp. 80.

[10] *Showgirls'* bitter celebration of the 'End of History', the simultaneous triumphs of capitalism and trash culture, links it to 'Dumb White Guy' movies like *Bill & Ted's Excellent Adventure* (1988), *Forrest Gump* (1994) and *Beavis and Butthead Do America* (1996). See I.Q. Hunter, 'Capitalism Most Triumphant: Bill & Ted's Excellent History Lesson' in *Pulping Fictions: Consuming Culture Across the Literature/Media Divide* (London: Pluto, 1996), pp. 111–124.

全世界を挑発！

「トータル・リコール」「氷の微笑」の
ポール・バーホーベンが放つ、灼熱の映画（ショー）

SHOWGIRLS
ショーガール

'96年正月ロードショー決定！

worthless context. At the sex club, James's dance routine, which is meant to be arty self-expression but looks suspiciously like pretentious nonsense, is booed off stage. Should we applaud the audience's good taste or condemn it as stifling 'genuine' artistry? Nomi is commended for her good taste when she buys a Versace dress (she pronounces it 'Ver-saze'). Yet Versace is the Verhoeven of high-fashion, an ironic *pasticheur* of trash for whom unembarrassed *bad* taste is a mark of true style. In *Showgirls* trash is indistinguishable from art; stripping from dancing; self-expression from pretentiousness; low-budget filth from expensive porn; Vegas from Hollywood; Hollywood from America. It's all grist for the mill of exploitation, the closed unbeatable system of consumer capitalism.

Memo From Boysville

"The only thing I could imagine with regard to *Showgirls* is that part of the audience will go home in a state of excitement and, thinking of the film, make love or masturbate. That's not so bad."
Paul Verhoeven[11]

To me as a fan of *Showgirls*, for whom it is *the* key cult film, a legitimate, correct and persuasive interpretation of its meaning is not especially important. I can imagine that people might be cautiously intrigued by my brief interpretation of the film without caring to revise their appalled opinion of it. 'OK,' they might respond, 'the film is a satire, but it's not a very good one. You're right about its intentions - but it botched them.' Still, why I like the film has little bearing on whether I get the meaning of it right *in public*, although as an academic I am obliged (i.e. paid) to pretend that this matters very much indeed.

So what does it mean to be a fan or cultist of *Showgirls*? Being a fan of a canonical cult text like *Star Trek* seems relatively straightforward, at least if fannishness is identified with its more spectacular and productive manifestations. 'Trekkies' watch *Star Trek* 'obsessively'. Fandom is still widely perceived as 'sad' and inappropriate enthusiasm: populated by those who turn up at SF Cons with phasers and pointy ears, and identify with a supportive community of like-minded enthusiasts who also 'get' the point of *Star Trek*. Trekkies, though, are an unusually active and self-conscious species of fan. Most cult viewing is considerably less public, organised and socially useful. For many of us it is a private, even hermetic, activity enjoyed at home in front of the video recorder. As Steve Chibnall notes, "video transformed films from collective experiences to privatised commodities which may be used (like any others) in the process of individual identity formation and communication."[12]

By Star Trek standards I'm not a proper fan at all; at any rate not an especially flamboyant, productive or sociable one. A description of what I actually do as a cult viewer would, I suspect, bore ethnographers of oddball tastes in movies. They'd be more interested in the dissident gay cultists at midnight screenings who performed along with the film, called out favourite lines ("You *are* a whore, darlin'!") and imitated the Busby Berkeley dance routines. Unfortunately, I can't claim to appropriate the film on behalf of subversive reading practices. Indeed by trying to reclaim *Showgirls* for myself, in the po-faced belief that it is really a good film, I risk seeming to want to 'straighten out' the camp interpretation and dismiss gay fans as delinquent misreaders.

Academia as Fandom: The Cult Movie and 'Rhetorical Performance'

What I do as a cult-fan is this. I watch *Showgirls* on video, mostly by myself, and remind myself why I like it. Every time I see the film my interpretation is mysteriously reaffirmed. Fast-forwarding to keynote scenes: the 'Goddess' number, sex in the pool, the 'Ver-saze' dress. In such scenes I am diverted, amused and interpellated by the tone of heterosexual camp. Today as

11 Rob van Scheers, *Paul Verhoeven*, trans. Aletta Stevens (London: Faber and Faber, 1997), p. 271.

12 Steve Chibnall, 'Double Exposures: Observations on The Flesh and Blood Show', in *Trash Aesthetics: Popular Culture and Its Audiences*, ed. by Deborah Cartmell, I.Q. Hunter, Heidi Kaye and Imelda Whelehan (London: Pluto, 1997), pp. 84–102 (p. 88).

13 Lisa A. Lewis,
'Introduction', in
*The Adoring
Audience: Fan
Culture and
Popular Media*, ed.
By Lewis (London:
Routledge, 1992),
pp. 1–6 (p. 2). See
also Joli Jensen,
'Fandom as
Pathology: The
Consequences of
Characterisation'
in Lewis, pp. 9-29.

14 David
Thomson, *A
Biographical
Dictionary of Film*,
revised and
enlarged edition
(London: André
Deutsch, 1994),
p. 771.

15 On
Verhoeven's irony
and outsider's
sensibility see R.J.
Ellis, '"Are You a
Fucking Mutant?":
Total Recall's
Fantastic
Hesitations',
*Foundation: The
Review of Science
Fiction* Number 65
(Autumn 1995), pp.
81–97; and I.Q.
Hunter, 'From SF
to Sci-Fi: Paul
Verhoeven's
Starship Troopers',
in Writing and
Cinema, ed. by
Jonathan Bignell
(London:
Longman, 1999).

I write, the clippings file on my desk bulges inches thick with newspaper and internet reports, press packs, interviews with the cast (Berkley gauche and nervous, Gershon breezily unembarrassed), and off-prints on Verhoeven. I trawl the Net again for *Showgirls* links (the official and fan sites closed years ago; now you mostly get Las Vegas porn). Lurking in public I talk about the film, bore my friends with opinions about it, use it as a sign (or warning) of my unreliability in matters of aesthetic value. Now and then I lecture on its merits to disbelieving students (an activity which, if critical orthodoxy is any guide, uniquely couples sexual harassment with time wasting). And, of course, vacillating between fandom and academia, I turn out chapters like this.

In other words, my sedentary behaviour as a cultist isn't that much different from my usual life of academic research. I watch the film, go on about it, collect secondary material, and now and then jot down a few ideas. The only significant difference between *Showgirls* and the other films I research is that I rarely come across anyone who agrees with me about it - which only spurs on my mission to explain. In fact, the distinction between being a fan, an idiosyncratic partisan of texts and readings, and being a 'serious' academic is not always very clear. Joli Jensen has pointed out that academic research has much in common with fandom: *we* produce articles and attend conferences, *they* write slash-fiction and go to conventions, but a "system of bias... debases fans and elevates scholars even though they engage in virtually the same kinds of activities".[13] That's why it's hard for me to distinguish between the cultural production of this chapter on *Showgirls* and the sort of thing I might write for a fanzine. At most, they're just two kinds of rhetorical performance, which seek access to nominally different but equally valid interpretative communities.

Since I'm interested in Verhoeven generally: ("he has his followers, alas", David Thomson remarked),[14] liking *Showgirls* gears smoothly into an overall fondness for the director's work. What I like most about his films is that their facetious sarcasm and excess seem to speak directly to me. The elitist thrill of secretly shared irony, of exclusive access to double coding, encourages my belief that, like Sirk's admirers in the 1970s, I comprehend his films in ways unavailable to ordinary punters.[15] This empowers me to construct around Verhoeven a personalised but sociologically explicable cult as 'my favourite director'.

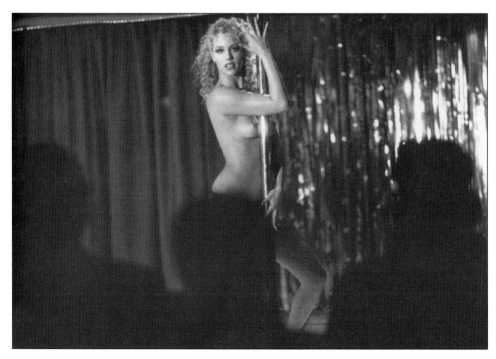

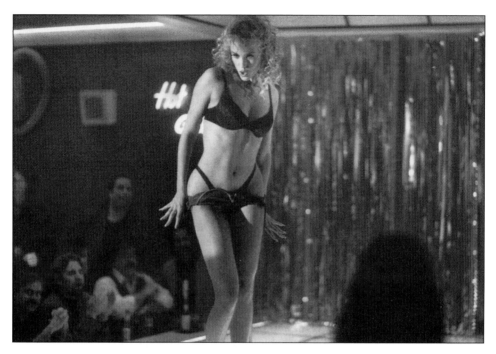

For this fan, therefore, the point of identification in *Showgirls* was not with any of the characters but rather with the director himself: the unapologetic 'bad-boy' of flash-trash cinema, the intellectual Dutchman who frolics among the clichés of Hollywood blockbusters. A bewitched tourist in American excess, Verhoeven embodies an ideal of aroused, vicarious but wholly optional cultural slumming. Since I am captivated not only by Hollywood movies but also by the easy cultural capital I can make by 'seeing through' them, I recognise in Verhoeven my own (European?) ambivalence towards disreputable material which I both love and am culturally obliged to rise above.

This kind of postmodern irony can be seen as the 'habitus', the last refuge, of middle-class white male intellectuals.[16] It helps to explain why I might invest so heavily in (and be so wrong about) a 'bad' film like *Showgirls*. For as Chibnall writes, "Paracinema ['bad' cinema] has provided opportunities for (predominantly) young straight white male academics to reclaim marginalised areas of cinema's history and to resist the dominant paradigms of film theory which have tended to problematise and pathologise male heterosexual pleasure in the text."[17] A perverse liking for an 'obviously' bad film is a strategy for carving out some interpretative space and ensuring distanciation from an earlier generation of academics. Liking *Showgirls* is a special kind of cultural capital by which I signify both an independence of taste ('It's *my* film. No one else understands it') and my identification with the growing number of academic connoisseurs of trash cinema.[18] Although few of them have much time for *Showgirls*, they certainly understand the sensibility that led to my over-investment in the film.

Of course, describing the socio-cultural background of my taste for *Showgirls* neither undercuts not legitimises my opinion of the film. To know *why* I read it in certain ways is not a prescription for how anyone, including myself, *should* read or judge it. Naturally, it dismays me to think that my interpretation of *Showgirls* is merely symptomatic of my position in the academic field. Rather than being an engaged, active and freethinking cultist, I am cruelly re-described as a case study in cultural negotiation. Exhibit One: the postmodern white male academic.

[16] See Scott Lash, *The Sociology of Postmodernism* (London: Routledge, 1990).

[17] Chibnall, pp. 88.

[18] On the subcultural utility of a taste for bad films, see Jeffrey Sconce, 'Trashing the Academy: Taste, Excess and the Emerging Politics of Cinematic Style', *Screen* Volume 36, Issue 4 (Winter 1995), pp. 371–393.

On the other hand if movies are really nothing else than discourses knitted together by History, and if my skills of understanding and evaluation are merely functions of my social position and store of cultural capital, then I might as well relax into being a fan-boy and a one-man cult audience. What else can I do? Society, history and habitus have rigidly shaped my tastes and sensibility, even down to my fondness for a trashy sex film. Liking *Showgirls* is the pathological response of a dubious social type.

The philosopher Richard Rorty offers an account of interpretation that might be relevant here in two ways. First, he suggests how we can get beyond the 'genetic fallacy': confusing the merits of an interpretation or value judgement with the psychological or social factors that gave rise to it. Second, his pragmatist take on interpretation enables us to resolve a few of the tensions between academic work and cult fandom, between reading as a contribution to knowledge and reading as a private act of self-creation.

Rorty invites us to give up trying to discover the right as opposed to the most useful personal framework for interpreting texts. We should forget about processing texts through the grid of theory in the belief that we will uncover their true objective meaning:

"One learns to 'deconstruct texts' in the same way in which one learns to detect sexual imagery, or bourgeois ideology, or seven types of ambiguity in texts; it is like learning how to ride a bicycle or play the flute. Some people have a knack for it, and others will always be rather clumsy at it." [19]

Proving that a text is merely a disguised ideological formation is a trick, a nifty party-piece, simply another way of putting it to work. Rorty wants to blur the difference between interpreting a text (i.e. like an academic) and playfully using it (i.e. like a cult fan) as a resource for idiosyncratic negotiations of cultural space. We should "just distinguish between uses by different people for different purposes".[20] He has a thoroughly laid back approach to interpretation:

"I should think that a text just has whatever coherence it happened to acquire during the last roll of the hermeneutic wheel, just as a lump of clay only has whatever coherence it happened to pick up at the last turn of the potter's wheel ... Its coherence is no more than the fact that somebody has found something interesting to say about a group of marks or noises which relates them to some of the other things we are interested in talking about ... As we move from relatively uncontroversial literary history and literary criticism, what we say must have some reasonably systematic inferential connections with what we or others have previously said – with previous descriptions of these same marks. But there is no point at which we can draw a line between what we are talking about and what we are saying about it, except by reference to some particular purpose, some particular intention which we happen, at the moment, to have."[21]

What is appealing about this is the element of romantic voluntarism, the assumption that we choose to read texts in whatever ways suit our own purpose. Rorty takes the standard post-structuralist notion of the open text and pushes it to its limit, towards an irresponsible free-for-all aestheticism. Critics otherwise sympathetic to talk of open texts and active readers might still prefer to cling on to some notion of interpretative authority. Rather than privileging specific hermeneutic strategies, they may wish to invest that authority in the discourse of certain types of readers (expert and productive fans, for example, or those who speak from the experience of oppression). Rorty, however, recommends only that we strive for and value criticism that is:

"...the result of an encounter with an author, character, plot, stanza, line or archaic torso which has made a difference to the critic's conception of who she is, what she is good for, what she wants to do with herself: an encounter which has rearranged her priorities and purposes."[22]

[19] Richard Rorty, *Contingency, Irony and Solidarity* (Cambridge: Cambridge University Press, 1989), p. 134.

[20] Richard Rorty, 'The Pragmatist's Progress', in Umberto Eco with Richard Rorty, Jonathan Culler and Christine Brooke-Rose, *Interpretation and Over Interpretation*, ed. by Stefan Collin (Cambridge: Cambridge University Press, 1992), pp. 89–108 (p. 106).

[21] Rorty, 'The Pragmatist's Progress', pp. 97–98.

[22] Rorty, 'The Pragmatist's Progress', p. 107.

Beaver Las Vegas!

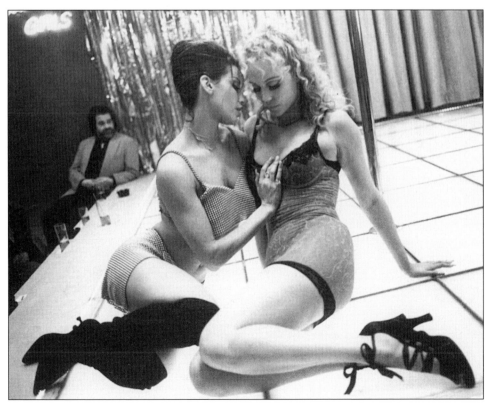

Beaver Las Vegas!

That critic's (or fan's) vivid description of such an encounter may in turn inspire other readers (or fans) to yet more vivid descriptions of their encounters with beloved and life-changing texts.

There are problems with Rorty's non-theory of interpretation. If you read with the narcissistic monomania he describes, then it is hard to see how any text could ever succeed in challenging you and altering your self-image. An honest encounter with texts and authors whose purposes are radically different from your own would be impossible by definition. Rather as paranoid Leftist critics manage to find traces of ideology in every text they read, so free-wheeling Rortyians find yet another excuse to ventilate their private obsessions, and the result is potentially as boring as other peoples' recounted dreams. Nevertheless, it is not hard to see in Rorty's defence of "'unmethodical interpretation' of the sort that one occasionally wants to call 'inspired'" an aestheticist manifesto for cult reading. This type of activity discards for good the line between academic interpretation and the unruly pleasures of fan activity.[23] Interpretation under this description is a series of quirky, unpredictable, self-pleasuring experiments in disguised autobiography. *Legitimate* interpretation is simply what you can get away with in public: the rare experiments for which other fans and critics happen to find a use.

For me, as an unmethodical (if not very inspired) fan, *Showgirls* has been an invaluable cultural resource. As I thought, talked and wrote about it I worked through whatever obsessed me at the time: the double life of the academic fan; the sexual thrills of consumer culture; the inevitable triumph of capitalism; the agreeable way that irony legitimises an addiction to trash culture; and so on. It was a means of revising what Rorty calls one's 'final vocabulary': "the words in which we tell, sometimes prospectively and sometimes retrospectively, the story of our lives".[24] Verhoeven's bitter, sexy, uncaring, stupidly ambiguous film lent itself perfectly to my intellectual fantasies and aesthetic needs. Now that this chapter is done and *Showgirls* is finally out of my system, I hope other fans and critics will be able to salvage something useful from my strange interlude in Vegas. Above all I hope they'll be inspired to look again at *Showgirls* and then, goaded by the error of my interpretation, start beavering away on their own.

23 Rorty, 'The Pragmatist's Progress', p. 107.

24 Rorty, *Contingency, Irony and Solidarity*, p. 73.

Julian Petley

Mention cult films to the uninitiated and it's a fair bet that someone will think you're talking about *occult* films. But before you scoff at their cinematic illiteracy and cringe at their lack of subcultural credibility it's perhaps worth remembering that among the OED's definitions of the adjective "occult" are "kept secret", "esoteric", "recondite", and "beyond the range of ordinary knowledge". Now, don't all of these evoke just that aura which gathers around cult-film and its all-important initiates?

Why all-important? Because cult films cannot be produced to order, however hard companies such as Troma may try. In a very real sense, and usually in blissful ignorance of fancy academic theories about the 'active audience' and 'semiotic democracy', it is audiences themselves which create cult movies. This may be in the complete appropriation of a mainstream work such as *Mommie Dearest*, the discovery and canonisation of a one-time obscurity like *Carnival of Souls*, or in the diligent and devoted excavation of an entire *'oeuvre maudite'* such as that of Jess Franco. But, whatever the object of their adulation, cult movie fans are remarkably like members of secret societies, with their rites, gatherings, esoteric texts and air of exclusivity. Furthermore, they are often viewed with the same hostility and suspicion by the wider world, as fans of cult horror movies, and especially those who experienced the 'video nasty' panic at first hand, know to their cost.

Biographical note: Julian Petley works on the Communications and Media Studies degree in the Department of Human Sciences at Brunel University teaching "about media freedom and regulation, as well as more general issues of media policy". He has defended horror films and attacked censorship in the *Guardian*, the *Independent*, *Sight and Sound*, *New Statesman*, *Index on Censorship*, the *Aurum Encyclopaedia of Horror*, the *BFI Companion to Horror*, and elsewhere. He writes: "As a direct response to the ludicrous outcry over horror videos which followed the murder of James Bulger, Martin Barker and I edited *Ill Effects: the Media Violence Debate*, and we're now preparing a substantially revised and enlarged second edition."

'Snuffed Out': Nightmares in a Trading Standards Officer's Brain

Julian Petley

The Manson Cult

Of all the myths generated by controversies about horror films, and especially about 'video nasties' in the UK, that of the 'snuff' movie is the most persistent and hardest to dispel. As Brian McNair argues, it has come "to take on the character of a 'moral panic' around which public outrage and political action is periodically organised".[1] A fully-fledged 'urban legend', it is now routinely invoked to justify not simply the censorship activities of the British Board of Film Classification but also, much more ominously, regular raids by police and trading standards officers on the homes of horror video collectors. The myth originally had two, closely related, sources: the activities of Charles Manson and his 'family', and the movie *Snuff*, which was made in Argentina in 1971 as *Slaughter*, but never released under that title. Both of these sources are analysed in detail in the indispensable *Killing for Culture* by David Kerekes and David Slater[2], and both Linda Williams[3] and Avedon Carol[4] have undertaken useful discussions of the latter. However, given the extraordinary mythology still surrounding the film, it is absolutely vital to establish here the bedrock of hard fact at the core of this story.

Snuff Out

In his 1971 book *The Family*,[5] Ed Sanders suggested that Manson and his followers might have filmed the killing of Sharon Tate and their other victims. These alleged visual records of people being 'snuffed out' were never actually found, and gradually acquired mythical status as a ghoulish grail for 'snuff' hunters. Meanwhile, the Manson cult inspired several low-budget exploitation movies, including *Slaughter*, which was made on the cheap in Argentina by the husband and wife sexploitation team of Michael and Roberta Findlay. An unreleasable mess, it sat on the shelves of Alan Shackleton's sexploitation outfit, Monarch Releasing, until 1975, when rumours (fuelled by the FBI) began to circulate that 'snuff' movies were being imported from South America.

These, allegedly, were hardcore sex films featuring prostitutes who were actually murdered on screen as the climax to the 'entertainment'. Alternatively they were records of the torture and murder of political prisoners of the oppressive regimes in Chile and Argentina. The opportunistic Shackleton now saw his chance to put the crude, home-movie look of *Slaughter* to good use. He hired hardcore director Carter Stevens to shoot a new, four-minute ending which was tacked on to *Slaughter*'s 78 minutes. The original film ends with the murder of a heavily pregnant woman; in the new ending this fictional scene is followed by what purports to be a cut-away to the set on which the scene has just been filmed. Apparently turned on by what they have witnessed, the director and a production assistant begin to have sex

[1] Brian McNair, *Mediated Sex: Pornography and Postmodern Culture* (London: Edward Arnold, 1996), p. 74.

[2] David Kerekes and David Slater, *Killing for Culture: an Illustrated History of the Death Film from Mondo to Snuff* (London: Creation Books, 1995).

[3] Linda Williams, *Hardcore* (London: Pandora, 1991).

[4] Avedon Carol, 'Snuff: Believing the Worst', in *Bad Girls and Dirty Pictures: the Challenge to Reclaim Feminism*, ed. Alison Assiter and Avedon Carol (London: Pluto, 1993).

[5] Ed Sanders, *The Family: The Manson Group and Its Aftermath* (New York: New American Library, 1989).

on the bed on which the 'murder' has just been committed. However, the director suddenly turns insanely violent and begins to slice up and then disembowel the unfortunate girl. The whole thing is captured by the cameraman of the fictional film, the allegedly real, non-fictional footage being brought to an abrupt end (complete with blank leader tape) only by his film running out. *Slaughter* was then stripped of its original opening credits (thereby heightening the impression of something illicit and nefarious) and the complete movie was released as *Snuff* in 1975.

Sensationalist and tacky the ending of *Snuff* may be, but one wonders if any of those who have expressed outrage over it have actually seen it, as it's almost inconceivable that anybody, even a cinematic illiterate, could actually believe that the scene is in any sense 'real'. The cast are barely able to contain their laughter, the 'director's' performance is hysterically over the top, and the special effects are tacky in the extreme: the 'disembowelling' consists of animal guts being pulled out of an all-too-obvious human dummy. Furthermore, the 'murder' is filmed in classical 'Hollywood' style, complete with alternating point-of-view shots and so on, which would have meant that the unfortunate 'victim' would have had to have remained in place throughout the course of various successive camera set-ups!

On the other hand, Shackleton milked the public's gullibility (not to mention voyeurism and prurience) for all it was worth. Before the film opened in New York, posters appeared advertising *Snuff*; the art-work consisting of a cut-up picture, oozing blood, of a naked woman, with a text promising "The film that could only be made in South America - where life is CHEAP!", "the *Bloodiest* thing that *ever* happened in front of a camera" and "the picture they said could NEVER be shown". The cinema was picketed by women's groups, leaflets condemning the film were distributed, and scuffles took place outside the cinema. The furore made the pages of the *New York Times*, and there was a strong suggestion that some of the 'protestors' had been hired by Shackleton himself; after all, as he put it: "pickets sell tickets". Indeed, the film took over $66,000 in its first week at the National. As *Variety* grudgingly admitted in its review of *Snuff*: "the Monarch head deserves notice for bringing life, such as it is, back into promotion."[6] But perhaps the most astute comment on the scam came from the *New York Times* film critic Richard Eder who wrote that: "there is a patch of anti-matter on Times Square into which not only public decency disappears, but reality as well. Everything about the film is suspect: the contents, the promotion and possibly even some of the protest that is conducted every evening outside the box office."[7]

Of course, had the film *really* depicted the murder of an actual person, one staged purely for the purpose of filming it, then all sorts of legal recourse would have been open to the authorities. Even the wily Shackleton was forced to admit that if the film depicted real murder "I'd be in jail in two minutes . . . I'd be a damn fool to admit it". Alternatively, however, "If it isn't real I'd be a damn fool to admit it."[8] Manhattan D.A. Robert Morgenthau then launched a two-month investigation into *Snuff*, during which the actress who plays the 'murdered' girl was traced and interviewed by the police. Morgenthau was reported in *Screen International*, as having concluded that the 'murder' was "nothing more than conventional trick photography" and that "there is no basis for a criminal prosecution."[9] In Las Vegas, reported *Variety*, the city authorities demanded that all advertising for the film carried the disclaimer that the purported murder was a "theatrical enactment rather than a real murder."[10] Similarly, in Indianapolis, District Attorney James Kelley forced the cinema showing *Snuff* to run a disclaimer stating "this is a theatrical production. No-one was harmed in this production."[11] In other words, as the *New York Times* put it: "nobody gets *vérité* killed."[12]

However, this careful legal deconstruction of Shackleton's scam did nothing to stop the 'snuff' myth from growing apace; as Kerekes and Slater note:

[6] *Variety*, 25 February, 1976.

[7] Kerekes and Slater, p. 21.

[8] *Variety*, 17 December 1975.

[9] *Screen International*, 20 March 1976.

[10] *Variety*, 25 February 1976.

[11] Peter Birge and Janet Maslin, 'Getting Snuffed in Boston', *Film Comment*, May/June 1976, p. 35.

[12] *New York Times*, 27 February 1976.

'Snuffed Out'

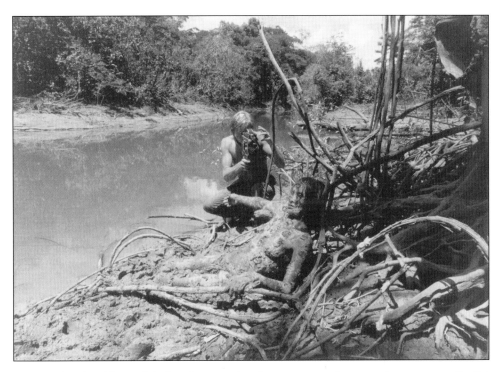

Cannibal
Holocaust

"What Shackleton did when he tagged an impromptu ending onto the Findlays' *Slaughter* was validate a myth, and the rumour that had been snuff films suddenly developed an identity: even if their existence had yet to be proven, this is what they looked like." [13]

Soon the notion of the 'snuff' movie was working its way into actual cinematic narratives, typically in the form of apparently 'documentary' episodes inserted into the fictional story. Of course, this was by no means the first time that films had presented what purported to be 'real live death' for the purposes of entertainment. The tradition is, in fact, as old as the cinema itself, but its most significant expression, in the context of 'snuff' movies, is undoubtedly the vast, sprawling *Mondo*-related cycle sparked off by Gualtiero Jacopetti's *Mondo Cane* (A Dog's Life, 1962) and which took on renewed life with the release of the *Faces of Death* series, starting in 1981.

Stranger than Fact

Among the wholly fictional feature films deliberately to make cinematic play with 'snuff'-like elements are the full version of Joe D'Amato's *Emanuelle in America* (1976), and Ruggero Deodato's *Cannibal Holocaust* (1980), both of which did so with such 'documentary' verisimilitude that their directors were actually forced to prove that they had not set up real killings for the camera. However, this did not stop David Hebditch and Nick Anning claiming that:

"there has (sic) been a number of unsubstantiated rumours that documentary footage exists showing real brutalities and atrocities . . . There are strong grounds for believing that some very brief sequences of this extremely gruesome material were incorporated into a scene in one of the films in the unending *Emmanuelle* series." [14]

Even if none contain the sleaze quotient of the hardcore version of *Emanuelle in America* or the shockingly visceral power of *Cannibal Holocaust*, various other films have utilised 'snuff' elements, even if only, in some cases, as a mere plot device. These include Victor Janos' *Last House on Dead End*

[13] Kerekes and Slater, p. 23.

[14] David Hebditch and Nick Anning, *Porn Gold: Inside the Pornography Business* (London: Faber and Faber, 1988), p. 23.

unruly pleasures

LAURA GEMSER LA VERA EMANUELLE

HA FOTOGRAFATO PER VOI

BORDELLI PER SOLE DONNE • LE SCHIAVE DEL PIACERE • SNUFF: FILMS SADO MASOCHISTI
L'AMORE PRIMITIVO DI UNA TRIBU IN UN ISOLA DEI CARAIBI • COME SI DIVERTONO I RICCHI
E I NOBILI • L'AMORE SENTIMENTALE E SESSUALE NATO TRA UNA DONNA E UN CAVALLO

FIDA
INTERNATIONAL FILMS presenta

EMANUELLE in AMERICA

LAURA GEMSER in EMANUELLE IN AMERICA

con GABRIELE TINTI • ROGER BROWNE • RICCARDO SALVINO

MARIA PIERA REGOLI • MATILDE DELL'AGLIO • STEFANIA NOCILLI

e con la partecipazione straordinaria di **PAOLA SENATORE** · musiche di **NICO FIDENCO** · una produzione **NEW FILM PRODUCTION** · regia di **JOE D'AMATO**

COLORE DELLA TECHNOSPES

Anno di Edizione 1977

SELESTAMPA Roma

'Snuffed Out'

Street (1977), Paul Schrader's Hardcore (1978), David Cronenberg's Videodrome (1982), Larry Cohen's Special Effects (1982), Jörg Buttgereit's Der Todesking (1989), John McNaughton's Henry: Portrait of a Serial Killer (released 1989), Wings Hauser's The Art of Dying (1991), the remarkable snuff-satire C'est arrive pres de chez vous (Man Bites Dog, 1992) by Remy Belvaux, Andre Bonzel and Benoit Poelvoorde, Mute Witness (dir. Anthony Waller, 1995), Alejandro Amenabar's Tesis (Thesis, 1995) and Joel Schumacher's 8mm (1999). On television, 'snuff' crops up in programmes as varied as the 1987 Miami Vice segment 'Death and the Lady' and the 1994 Yorkshire Television vehicle for comedians Hale and Pace, the three-part A Pinch of Snuff. In literature, meanwhile, one finds reference to 'snuff' in latterday hardboiled works such as Bret Easton Ellis' Less than Zero, Dennis Cooper's Frisk and Jerk, James Cohen's Through a Lens Darkly, Robert Campbell's In La-La Land We Trust, Andrew Vachss' Flood and Blossom, and Yaron Svoray's Gods of Death. However, it was not simply in various forms of fiction that 'snuff' became something of a fixture in the wake of Snuff itself. In spite of the careful exposure of the film as a crude, opportunistic fake, and notwithstanding the complete absence of any proof of the actual existence of 'snuff' movies, many commentators carried on as if such films were now simply an established fact of modern life. There were several conduits through which 'snuff' now began to enter contemporary history.

Firstly, there were the anti-pornography feminists. As early as 1977, critics such as Gloria Steinem were claiming that women were actually being tortured and killed during the making of snuff movies for an underground market. Laura Lederer's Take Back the Night: Women in Pornography contains a 1980 interview with a pseudonymous former nude model who claimed to have heard about snuff films whilst working in the sex industry. Andrea Dworkin's 1981 book Pornography: Men Possessing Women makes a link between organised crime and 'snuff' films, and in 1985 the author told the Meese Commission that one could buy a snuff movie in Los Angeles for $3000 or arrange a private screening for $250. She also startled the assembled worthies by alleging that in the Vietnam war women were filmed being killed then "skull-fucked".[15] Sarah Daniels' 1984 play Masterpieces, which was performed at the Royal Court Theatre in London, features a character who clearly believes that the final scene in Snuff is real. Unfortunately this belief is not confined to the fiction itself; in a preface to the published script, theatre director Dusty Rhodes is quoted to the effect that "Snuff is a film which first appeared in the States in 1976, so called because the actresses were actually mutilated and murdered in front of the camera - 'snuffed out'. Many 'snuff' films have been made since then."[16] Jane Caputi's The Age of Sex Crime also takes the 'snuff' myth at face value. Susan G. Cole in Pornography and the Sex Crisis defies all logic and reason by stating that "there is no evidence that snuff films do not exist",[17] an argument which could equally well be used in defence of the existence of Father Christmas or UFOs. Equally unruffled by the stubborn absence of any real evidence are Tim Tate in Child Pornography and Catherine MacKinnon in Only Words.

A second source of the rumours, speculation and gossip which have fed the 'snuff' mythology are the books about 'true crime' which have enjoyed an increasing popularity from the 1980s onwards. Those which mention 'snuff' movies include Robert Graysmith's Zodiac, Maury Terry's account of the David Berkowitz killings The Ultimate Evil, Gordon Thomas' Enslaved, and Georgina Lloyd Jones' Murders Unspeakable which contains a chapter entitled 'The Snuff Movie Murder'. It has also been claimed in some accounts that the serial killers Henry Lee Lucas and Ottis Toole made 'snuff' movies of their exploits, a claim to which the film Henry: Portrait of a Serial Killer actually gives some credence.

A third, and crucial, source of the 'snuff' mythology lies in the work of Christian fundamentalists, first of all in North America[18] and then in Britain.[19] Here stories of 'snuff' become increasingly and inextricably bound up with

15 Bill Thompson, Softcore (London: Cassell, 1994), p. 195.

16 Sarah Daniels, Masterpieces (London: Methuen, 1986), preface.

17 Kerekes and Slater, p. 244.

18 Jeffrey S Victor, Satanic Panic: the Creation of a Contemporary Legend (Chicago and La Sale: Open Court, 1993).

19 J.S. La Fontaine, Speak of the Devil: Tales of Satanic Abuse in Contemporary England (Cambridge: Cambridge University Press, 1998) & Fortean Times, No. 57 (Spring 1991), contains a number of articles on 'satanic abuse' Sun, January 1976.

stories about 'satanic abuse'. Important cinematic precursors here were, of course, William Friedkin's *The Exorcist* (1973), Richard Donner's *The Omen* (1976) and the whole ensuing cycle of 'demonic possession' movies. Equally significant was Lawrence Pazder's 1980 book *Michelle Remembers*, allegedly the true story of a Canadian girl who, through psychotherapy, 'recovers' buried memories of familial sexual abuse. In May 1985 in the USA, the popular *20/20* current affairs slot aired a programme entitled 'The Devil Worshippers', which helped to swell a veritable flood of books on contemporary satanism. Many of these alleged that 'satanic' child abuse was taking place, much of it filmed, and some of it involving infanticide. British and American examples of such works include Winkie Pratnet's *Devil Take the Youngest,* Ted Schwarz and Duane Empey's *Satanism,* Arthur Lyon's *Satan Wants You,* Carlson and Larue's *Satanism in America,* Pat Pulling's *The Devil's Web*, Jerry Johnson's *The Edge of Evil*, Tim Tate's *Children for the Devil*, Andrew Boyd's *Blasphemous Rumours*, Linda Blood's *The New Satanists,* Michael Newton's *Raising Hell* and Lauren Stratford's *Satan's Underground.*

Those of the above which mention 'snuff' movies do so in an entirely uncritical fashion; those which avoid the topic nonetheless helped to contribute to a climate of credulity and hysteria in which rational enquiry was largely abandoned by a worrying number of authorities and commentators. In Britain, matters reached something of a nadir when Channel 4 broadcast a programme by Andrew Boyd in its *Dispatches* slot on 19 February 1992. This was entitled 'Beyond Belief' (which sums up its contents in a nutshell) and contained film of what was alleged to be 'Satanic ritual' and an interview with a survivor of such practices. However, in an intriguing pre-echo of the instances of documentary fakery that came to bedevil the channel later in the decade, the 'Satanic' film turned out to be excerpts from a piece of perfor-mance art, *First Transmission,* by Thee Temple Ov Psychick Youth, which contained images of entirely consensual sado-masochistic practices. Meanwhile the 'survivor' turned out to have been through the clutches of a fundamentalist 'healing and deliverance' centre in which she was told that she was possessed by demons. None of this, however, stopped Scotland Yard's Obscene Publications Squad raiding the house of the performance artist Genesis P-Orridge, the leader of the Temple, and, in a search for 'snuff'-related material, seizing a huge lorryload of extremely valuable archival material. At the time he was out of the country, enjoying a holiday in Thailand with his wife and two children. Terrified that, in the wake of the ludicrous and irresponsible scare whipped up by Boyd he might lose his children if he and his family returned to Britain, he fled with them to the States - permanently.

Finally, no discussion of the 'snuff' movie myth, and in particular of the part which it plays in the legitimation of censorship, and worse, would be complete without an account of the role played in it by the credulous and sensation-hungry British press, which, of course, has a long history of demanding stricter film and video censorship.

Headlines and Video Tapes

In January 1976, whilst papers like *Variety* and the *New York Times* were busy investigating and exploding the *Snuff* scam, in Britain the inimitable *Sun* was doing its utmost to perpetuate the mythology in an article headed 'Would They Dare Make a Movie of a Real Murder?' Although this does suggest that *Snuff* itself is a hoax, it carefully leaves the door open for other 'snuff' stories by stating that "police in New York and California are convinced that at least one real "snuff" movie exists. And they have spent months trying to track it down". It also quotes Detective Sergeant Joseph Horman of the Organised Crime Control Department to the effect that "I don't believe that many of these films exist. We haven't been able so far to get a copy of a genuine one. But, on information from extremely reliable underworld sources, I am convinced that such films do exist. And that a person is actually murdered in them."[20] An unidentified source, who has apparently seen a 'snuff' movie, helpfully adds

[20] *Sun,* 27 March 1983.

'Snuffed Out'

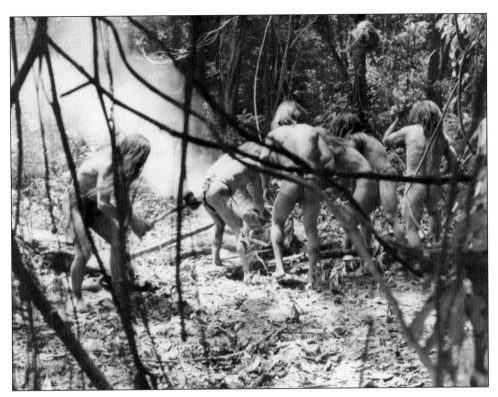

Cannibal
Holocaust

that "it's real all right . . . It's grisly. Terrible. Too real for the thing to be faked." Inevitably *Snuff* came to the fore during the 'video nasty' affair of the early 1980s. In spite of the *Sunday Times* having several times revealed *Snuff* to be a hoax, the *Sunday Mirror* ran an article entitled 'The Vilest Video of Them All on Sale in Britain'.[21] This called *Snuff* "the most hideous horror movie ever" and claimed that "American cinema audiences were sickened by claims that some scenes were from the real sex-murder of an unsuspecting actress staged before the cameras". A dealer is quoted as saying that "my customers didn't have the stomach for it. They didn't mind horror but that film was over the top. It is sick." It should perhaps be added that the British distributors of the video of *Snuff* didn't exactly help matters by advertising it with the words: 'the actors and actresses who dedicated their lives to making this film were never seen or heard from again'.

With the passing in 1984 of the Video Recordings Act, the panic about 'snuff' movies subsided, but the death of a number of children in Britain at the hands of paedophiles would soon ignite it again.

On 22 April 1990 the *Sunday Correspondent* ran a lengthy feature entitled 'Where Have All the Children Gone?' This examined the phenomenon of missing children in America and focused in particular on two men who allegedly intended to kidnap a boy and then sell videos of him being molested, tortured and killed. This "case of the pornographic snuff film plot"[22] provided the authorities, according to the article, with the "opportunity to unearth the existence of a long-rumoured but never proven ring of murderous pornographers producing 'snuff' films for private distribution". Unfortunately for the author the opportunity turned out, as usual, to be a barren one.

In Britain, ever since the death of fourteen year old Jason Swift during a paedophile orgy in Hackney in 1985, there had been persistent rumours that this sexually motivated murder, and others like it, had been filmed for circulation on video amongst paedophile groups. These rumours received

21 *Sunday Mirror,*
22 April 1990.

22 *Sunday
Correspondent,*
22 April 1990.

unruly pleasures **211**

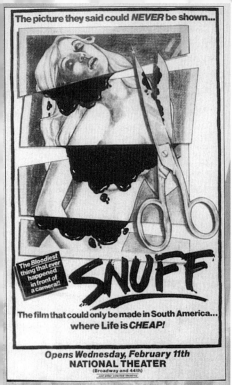

The picture they said could NEVER be shown...

The Bloodiest thing that ever happened in front of a camera!!

SNUFF

The film that could only be made in South America... where Life is *CHEAP!*

Opens Wednesday, February 11th
NATIONAL THEATER
(Broadway and 44th)
and other selected theatres

ANTHROPOPHAGOUS
THE BEAST
WATCH IT IF YOU DARE!

a film by JOE D'AMATO
starring GEORGE EASTMAN and
TISA FARROW
Running time 1 hr. and 30 mins. approx. Colour.

FACES OF DEATH

Prepare yourself for the ultimate experience.
This video cassette will change your attitude
to life.

Executive Producer: William B. James
Producer: Rosilyn T. Scott
Director: Conan Le Cilaire

TRUE LIFE HORROR
Colour - AVP 601

◀ **MODERN FILMS** ▶
VIDEO

CANNIBAL TERROR

WITH
SILVIA SOLAR · STAN HAMILTON
BURT ALTMAN · PAMELA STANFORD
OLIVIER MATHOT AND GERARD LEMAIRE

93 minutes Colour

V.H.S.

'Snuffed Out'

their first major coverage in the British press at the end of July 1990; this marked a major escalation of the 'snuff' myth in Britain. Predictably, the broadsheet press was more critical and less credulous and sensational than the tabloids but, equally predictably, no paper had the courage to be entirely sceptical about the whole affair, know by police as Operation Orchid.

For instance, *The Daily Star* were in no doubt about the existence of paedophile 'snuff' movies. A headline from this era says it all: '10 Kids Die on Videos: Porn Beasts Film Torture of Innocent', whilst *The Sun* stated that "detectives are convinced a snuff movie was made of 14-year-old Jason Swift's harrowing murder - but it has never been found". Elsewhere, under a still from *Snuff* (which is at least acknowledged to be a fake) we are assured that: "in Britain today, videos showing actual killings are changing hands for thousands of pounds. They feature the agonising last moments of young boys who have been snared by sex monsters."

The broadsheet coverage manages the difficult feat of simultaneously casting doubt on and feeding the myth. Thus the *Independent* ran an article under the headline 'Detectives Appeal for Evidence over 'Snuff' Videos'. This admits that police officers investigating the alleged existence of paedophile 'snuff' movies "are aware that after months of inquiries, there is still need for firm evidence to support largely anecdotal reports of such films" but then becomes increasingly speculative and equivocal. Thus: "some early 'snuff' movies in the United States have turned out to be hoaxes; genuine ones are said to mainly stem from the Far East and South America and to be expensive and rare". And again: "detectives have not seized a 'snuff' movie during Operation Orchid, although they have reports - some after interviews with convicted paedophiles and abused young men - that sexual activities were filmed. It is unclear whether the deaths followed the activities, which happened to be filmed, or whether murder were (sic) committed for the films."[23] A third option (i.e: neither) is conveniently ignored. David Waddington, then Home Secretary, is quoted as saying that "it is a shocking thing that these [videos] should come to light" (even though they hadn't!), and the article concludes by sitting firmly on the fence: "professionals working in the field said yesterday that they have heard reports of 'snuff' videos, but have never seen them in this country. Ray Wyre, director of the Gracewell Clinic in Birmingham, said it was difficult to tell genuine films, although he has little doubt they exist. He added: 'with the development of video, there is no doubt that there are men weird, bizarre and evil enough to make them.'"[24]

The same day's *Guardian* concentrates more on Scotland Yard drawing up a register of paedophiles, but it too cannot resist devoting the greater part of its coverage to the issue of 'snuff', and doing so in the same equivocal fashion as the *Independent*. Thus whilst it admits that Detective Superintendent Michael Hames, head of Scotland Yard's child pornography unit, had said that no 'snuff' movies had yet been discovered, and had indeed warned that concentration on this issue could distract attention from the question of child abuse itself, it also quotes Hames as stating that "in America, the FBI went undercover to a meeting of people invited to watch a snuff movie with a view to buying a copy, and the fee to attend the showing was $10,000". We are not, however, informed of the outcome. Tim Tate (see above) opines that "*Snuff* is alleged by paedophiles to be the first of a genre of child sex and torture films" (although children do not feature in it, let alone in a sexual context), Ray Wyre argues that "when video replaced film, everybody could hire a camera, and the arrival of the snuff movie in Britain become almost inevitable, because there are always people willing to pay". As Diana Core, "director of a national organisation promoting the safety of children", asserts: "we have known for about a couple of years that these films were being imported into the country. The majority were made in America, but now they are being made here."[25] The idea that such films, even if they existed, could be available for sale or rent at the local video shop, in Britain or in any other country, is, of course, simply too absurd to warrant serious discussion.

23 *Independent*, 28 July 1990.

24 *Guardian*, 28 July 1990.

25 *Star*, 8 May 1992.

unruly pleasures

Demons

What is clearly happening in these press reports, and in many similar ones, is that two completely different kinds of films (namely entirely fictional ones like *Cannibal Holocaust* and 'shockumentaries' such as *Faces of Death*) are being conflated and confused with one another, and the whole unsavoury stew is then being spiced with references to the entirely mythical 'snuff' movie. The clear effect of all this grotesquely ill-informed and profoundly hypocritical nonsense has been not simply to demonise an entire area of contemporary horror film-making but also to legitimate extraordinarily authoritarian and oppressive measures on the part of the police, trading standards officers, Crown Prosecution Services and the courts to try to stop such horror movies circulating in Britain.

Thus, for example, in May 1992 police and trading standards officers, both of which groups one would have thought had better use for their limited resources, launched raids across Britain on the homes of video collectors, many of whom, denied commercial access to many horror films by the depredations of the 1984 Video Recordings Act, were reduced to swapping second-hand copies amongst themselves. Inevitably, the over-zealous officials found nothing more terrible than classic 'nasties' such as *Cannibal Holocaust*, *Driller Killer* and the like; freeze-framing the TV coverage of the raids one also discovers video boxes of such 'illegal' fare as *Blue Velvet*, *Wild at Heart*, *Assault on Precinct 13*, *The Thing*, and *Night of the Living Dead*.

However, rather than report these raids as the actions of latterday thought-police, the disturbing eruption of Orwell's fictional *1984* into the real 1992, and a totally unacceptable invasion of the privacy of various understandably terrified film fans, both the press and the broadcasters slavered in drooling complicity with the authorities, falling over themselves to legitimate this shamefully authoritarian exercise by repeatedly invoking the spectre of the 'snuff' movie. Thus, under the heading 'Snuffed Out: Cops Swoop to Seize 3000 Sick Killer Videos', and accompanied by a still from Joe D'Amato's legendarily preposterous *Anthropophagous* (1980), the *Star*, 8 May

Anthropophagous

'Snuffed Out'

Snuff

1992, states that "the haul includes several 'snuff' movies, in which actual murders are filmed" and reminds us how it "revealed two years ago how schoolboy Jason Swift's horrific slaughter was captured on film by paedophile perverts."[26] Except, of course, it actually *failed* to reveal any such thing.

Similarly, the *Evening Standard*, under the headline "'Snuff' Films Seized in Porn Raid', alleges that,

"Among the films were some which appeared to be "snuff" movies in which an unsuspecting participant is murdered in front of the cameras. The killings are believed to have been carried out abroad. Others show real torture, mutilation and cannibalism and sex."[27]

Meanwhile the *Express* states that:

"a nationwide network selling snuff videos of torture, mutilation and cannibalism has been smashed in a massive undercover operation . . . Campaigners against child abuse warn that "snuff" movies - where the victims are killed or 'snuffed out' during filming - are a growing menace."[28]

An incoherent quote from Liverpool's chief trading standards officer, Peter Mawdsley, simply adds to the confusion: "snuff films have been around for some time and I am not aware of anybody finding any evidence to date that these films do involve actual murders". In which case, of course, they're not 'snuff' movies at all!

One has by now come to expect nothing other than this hysterical, ill-informed, authoritarian drivel from Britain's newspapers, tabloid and broadsheet alike, when it comes to stories about horror videos. What is so depressing, however, is the way in which the broadcasters unerringly trail along in the wake of the press-set agenda. That this is the case can be clearly illustrated by an episode of the BBC2 series *The Rip Off Merchants* which was broadcast on 31 August 1994, set in Liverpool, and contained an item about a follow-up to the 1992 raids. Over images of the video boxes of *Cannibal Terror*, *Faces of Death*, *Snuff* and *Nekromantik*, the portentous commentary intones that trading standards officers have "infiltrated a national network of dealers

26 *Star,* 8 May 1992.

27 *Evening Standard,* 8 May 1992.

28 *The Daily Express,* 8 May 1992.

unruly pleasures

in uncensored films". Later, in a passage that could have been lifted straight from the pages of a newspaper, we are told that the seized tapes "portray scenes of mutilation, torture, disembowelment and even animal killings."[29] Much more interestingly, however, in a scene in which the intrepid officers are briefed prior to the raid, the viewer who refuses to be fooled by the item's ludicrously sensational and melodramatic mise-en-scène is offered, no doubt quite unintentionally, the clearest indication that what is in fact being planned here is an outrageous invasion of civil liberties, as the leader of the raid states that they will not be looking only for videos but also "his correspondence with other dealers, his contacts, orders, any diaries he's kept, or notebooks regarding payments, recorded delivery slips, magazines . . ."[30] (In other raids, victims have told me, their savings accounts books have been taken and photocopied, and their bank accounts investigated). Inevitably, of course, the 'dealer' turns out to be a young, disoriented horror fan, but, nothing daunted, the BBC team resolutely stick to their threadbare, second-hand agenda and totally fail to grasp the much more serious issues that are staring them straight in the face. The item ends on a note of complete bathos with an asinine reporter gasping "what *kind* of people *watch* these films?"[31] One is left wondering what kind of people make these programmes.

Children and Cannibals

On 6 April 1993 the *Independent* reported that trading standards officers had "seized copies of a snuff movie at a children's fair in Birmingham"[32], and the *Mail* worked itself into a frenzy over "snuff films on sale with Peter Pan at children's comic fair". Dr Mike Hilburn, chairman of Birmingham Trading Standards Committee, stated that one movie "contained absolutely disgusting scenes of a man being hacked to death, decapitated and disembowelled. I have never seen anything like this before, and I have no doubt that the scenes were genuine."[33] Predictably, the 'snuff' movie turned out to be *Cannibal Holocaust*, whilst the event was not a children's fair but a comic collectors' mart.

In February 1994, trading standards officers infiltrated another underground network of video dealers (as they would doubtless have put it) and raided homes in twenty towns and cities. In fact, the horror fans (which is all they were) were easy enough to find, since all the officers had to do was to look through the small ads in horror fanzines and pick out any unwise enough to be offering to swap or sell horror videos: a clear-cut case of entrapment, one would have thought. On 11 February the *Mirror* reported that amongst the haul was "the first 'snuff' video found in this country - an apparently genuine film of a woman being raped and beaten to death. It was apparently shot abroad."[34] Similarly the *Guardian* quoted Jim Potts, Lancashire's chief trading standards officer, to the effect that: "My own opinion is that, sad to say, these videos show genuine killings . . . It is clearly not acting and some of the scenes would not be possible if they were real. We suspect that they come from North or South America where missing persons are more of a way of life." Interestingly, when Potts was challenged over these remarks, he flatly denied ever making them.[35] As a consequence of the raids, John Gullidge, the Exeter-based editor of *Samhain*, one of the fanzines in which the ads appeared, found himself under investigation by his local trading standards officers and publicly dragged through the mire by his local paper, the *Express and Echo*.

On 13 January 1995 a variation of the Operation Orchid story re-appeared in the *Mirror* under the headline '7 Boys Killed in Snuff Horror'. This alleged that:

"detectives are investigating claims that a child-sex ring has murdered seven boys and disposed of their bodies with the help of a crooked undertaker. 'Snuff' movies are said to have been made of some killings with a home-movie camera. It is claimed that the paedophile ring murdered the youths, all Liverpool rent boys, aged 12 to 16, between 1989 and 1992."[36]

[29] *The Rip Off Merchants*, BBC2, 31 August 1994.

[30] *The Rip Off Merchants*.

[31] *The Rip Off Merchants*.

[32] *Independent*, 6 April 1993.

[33] *Independent*, 6 April 1993.

[34] *Mirror*, 11 February 1994.

[35] John Martin, *The Seduction of the Gullible: the Curious History of the British "Video Nasties" Phenomenon* (Nottingham: Procrustes Press, 1997), p. 260.

[36] *Mirror*, 13 January 1995.

'Snuffed Out'

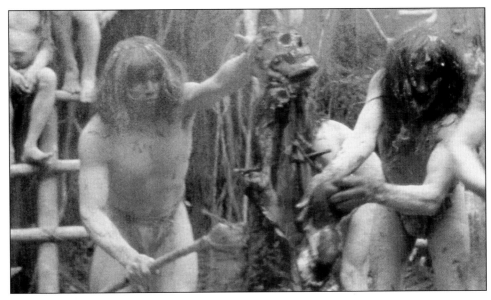

Cannibal
Holocaust

The story was also covered by the *Guardian* and *Independent* but, like its predecessors, vanished without trace. Another variant appeared in the *Star* on 21 May 1995; the story, headed 'Snuffed Out by Evil Perverts', ran:

"A child sex ring murdered tragic bike boy Daniel Handley, police revealed last night. They fear he was snatched . . . abused in gay orgies and brutally murdered. The nine year old's agonising ordeal may also have been filmed by the evil monsters in a 'snuff' video."[37]

And when pornographic videos were found at the Broadmoor maximum security hospital in 1997, the *Mirror*, 17 February, couldn't resist bringing in 'snuff':

"Sex-and-kill 'snuff' movies were among the hardcore porn hoard discovered at Broadmoor . . . child sex offenders and killers are copying the smuggled videos using their own recorders. Staff are now probing an alleged ring dealing in child porn."[38]

And, not to be outdone, the *Sun*, 7 April 1997, under the headline 'Cops Hunt British Snuff Movie Fiend', reported that:

"*A British sex pervert was being hunted last night over the suspected murders of up to five young boys for 'snuff' movies. The fiend and his pals allegedly filmed the youngsters as they killed them during paedophile orgies in Holland.*"[39]

Undoubtedly one reason why the press repeatedly insists on trying to make this link between 'snuff' movies (which are entirely mythical) and paedophile activity (which, unfortunately, is all too real) is because certain police officers clearly believe that it exists. Thus the victim of a police raid on his video collection wrote to me that "after long arguments with a vice squad officer about myths concerning 'video nasties' and 'snuff' movies he went on to say that if he hadn't caught me in time I would have moved on to child porn". Another correspondent related how, during a raid, the police had found a pair of child's mittens and seemed distinctly unwilling to believe that these were a memento of the collector's childhood. Whilst being driven to the police station an officer asked him if he had ever been sexually abused, and "seemed genuinely to think that these films, in his words, "lead on" to child pornography".

37 *Star,* 21 May 1995.

38 *Mirror,* 17 February 1997.

39 *Sun,* 17 April 1997.

unruly pleasures

Bestialisch bis aufs Blut gequält

American cannibale

'Snuffed Out'

opposite:
**German poster for
Snuff**

The story of 'snuff' in Britain clearly demonstrates how the constant peddling of a myth has succeeded not only in legitimating excessive censorship but also in criminalising those who collect horror videos and even tarnishing them with the taint of paedophilia. It could also be argued that the 'snuff' movie myth, like equally mythical stories of 'Satanic' abuse, has succeeded only in distracting the police in their search for child abusers. Nor is it only the civil liberties of horror movie collectors which have been trampled underfoot in the censorious stampede provoked and legitimated by stories about 'snuff' movies.

In November 1987, in 'Operation Spanner', police raided and arrested a number of men who occasionally met together to take part in entirely consensual sado-masochistic practices, some of which were filmed on video and distributed among the group members. Interfering with the Royal Mail, the police stumbled across four of these videos in Bolton and immediately jumped to the conclusion that they had at last discovered a 'snuff' movie ring. Indeed, during raids on group members' houses, the police dug up their gardens searching for dead bodies! This was, of course, a time of growing panic about 'Satanic' abuse and paedophile-produced 'snuff' movies, which helps to explain why the police felt justified in wasting £500,000 of scarce public resources on pursuing a chimera. Perhaps, also, it was because they had already spent so much money on the case that they refused to drop it once they realised, inevitably, that it had nothing remotely to do with 'snuff' movies. Even though all the acts filmed had been purely consensual, the police charged the men with conspiracy to corrupt public morals, subsequently changed to charges under the Offences Against the Person Act. Unbelievably, these charges were actually upheld in December 1990 and all subsequent appeals failed, thus dangerously widening the definition of assault under English law, and rendering peoples' private, domestic activities yet more subject to official surveillance, harassment and intrusion. This also marked the start of increasing official intolerance of any material or activity with sado-masochistic overtones - witness police action against the body-modification book *Modern Primitives* (1989) - which also features the unfortunate Genesis P-Orridge previously mentioned - local council bans on the Jim Rose Circus Show and the Sex Maniacs Ball, police raids on S-M clubs and private S-M parties, and so on. As Bill Thompson correctly concludes:

"If the £500,000 Spanner investigation had initially begun as a means to prove that Satanic snuff movies really existed, it quickly became an excuse to attack sexual diversity in general and S&M sex in particular."[40]

As Kerekes and Slater conclude: "Snuff as a commercial commodity is a fascinating, but illogical, concept. It reads well in crime fiction and, from the journalistic angle, it's one of the all-time great moral panics to feed the people. Snuff is a malleable and terrifying supposition. Snuff has the power to cloud the mind. It can nudge the most asinine assumption and unlikely scenario into a best-selling book or damning TV documentary. It can provoke women all over the world to fight for a cause and keep them fighting no matter that they're levelling punches at their own shadows. Even the word itself is a threat."[41] This threat has been remorselessly exploited not only by pro-censorship campaigners but also, in Britain at least, by those who wish to criminalise whole swathes of private activities of which they themselves disapprove, be it watching horror videos or engaging in entirely consensual sado-masochistic sexual practices.

[40] Bill Thompson, *Sadomasochism* (London: Cassell, 1994), p. 255.

[41] Kerekes and Slater, p. 245.

Jonathan Rayner

Cults seem to accrue around specific, singular media texts, films and franchises at an increasing rate. The recognition of greater numbers of cultist candidates underlines a trend towards audience ownership of textual forms and meanings. The appeal and significance of the cult film may, however, be construed as not only different but unrelated to each other. The former resides in the identification of an individual text by a group aspiring to exclusive or elite status. The latter is discernible in a cult's enunciation of mythological or archetypal materials. Vladimir Propp's paradigmatic analysis of the character types, actions and interpretations of folk tales, Carl Jung's tracing of cultural archetypes, Joseph Campbell's cataloguing of consistent narratives, and their articulation in the *Star Wars* films of George Lucas and *Mad Max* films of George Miller, point to pervasive narrative structures and ubiquitous characterisations underlying popular storytelling throughout human history. In contrast to the implication of commonality and compatibility between superficially varying cultural texts, the emphasis within cult consumption is on the assertion of difference. The distinctive text (and the self-defining audience of devotees) are elevated on the grounds of their exclusivity. The cult presupposes and positions a *cognoscenti*. Yet such texts and groups rarely remain sacrosanct. The limited following of an unsuccessful 1982 film has evolved into prevailing admiration for a landmark generic and auteurist text, the universal acceptance of a film at first universally criticised: *Blade Runner*. To the dismay of aficionados, the *X Files* cult transferred to the cinema with the intention of gaining a wider and previously unconverted audience. The cult's exclusivity belies the common mythological basis which inspires its popularity and underpins its significance. Additionally, the postmodern phenomena of cultural and textual allusion, amalgamation, parody and pastiche equate with the ubiquitous mythological structures of narrative and characterisation, one simply being a more recent expression of the other. The myth, like the cult, is built on reference, recognition and reiteration, suggesting exclusivity but relying on ubiquity. The postmodern film viewer's acquaintance with intertextual quotation and reflexivity, and the cult's appropriation of enduring texts and motifs represent different but parallel engagements with the sources of prevalent mythology.

Biographical note: Jonathan Rayner lectures in Film Studies at Sheffield Hallam University. He has taught Film History at the University of Portsmouth, English and Media Studies at the North East Wales Institute of Higher Education, and Film Studies at the University of Sheffield (Division of Adult and Continuing Education). His publications include *The Films of Peter Weir* (Cassell, 1998), *Cinema Journeys of the Man Alone: The New Zealand and American Films of Geoff Murphy* (Kakapo, 1999), and *Contemporary Australian Cinema* (Manchester University Press, forthcoming 2000).

The Cult Film, Roger Corman and *The Cars That Ate Paris*

Jonathan Rayner

The Cult of the Open Road

Cult status is assumed by or suggested for examples of the road movie, the biker film and the horror genre, in which the youth audience, the popular visual idiom and the exploitative material converge to telling and seductive effect. The libertarian, anti-authoritarian and controversial materials found in these three forms are concentrated in several interrelated and hybridised films appearing between the mid-sixties to the mid-seventies. Roger Corman's horror films and biker movies of the 1960s appear as influential sources for the black comedic, anti-authoritarian horror films, categorised as 'Gothic', produced in Australia in the 1970s and '80s. These in turn exerted an influence on contemporary American horror and science fiction films. The connections to be traced between American exploitation and Australian Gothic films reveal common textual features alongside varying aesthetic influences and commercial or ideological motivations. The inspiration derived from American exploitation films, which is discernible in Australian films centred on car culture, reflects the utilisation of conventional forms in differing commercial and cultural contexts.

Peter Weir's debut feature *The Cars That Ate Paris* (1974) draws upon the conventions and iconography of numerous genres and forms of film in the construction of its Gothic narrative. The film initiates the discussion of the centrality and lethality of the car within contemporary Australian culture, but couches its social commentary in the format of the horror film. The deification of the car is explored further in the *Mad Max* trilogy (George Miller, 1979, 1982, 1985), but Weir's film provides some inspiration for later Gothic treatments in its exposure of the Australian predilection for and reliance on cars. *The Cars That Ate Paris* develops several themes and preoccupations evident in Weir's earlier short and independent films. The cult following for *Homesdale* (1971), a black comedic allegorical tale of authoritarianism, did not prevent the film's inclusion on the school curriculum in Australia.[1] The hero's arrival in a secluded, secretive and dangerous rural township follows the pattern of Australian Gothic antecedents such as *Wake in Fright* (Ted Kotcheff, 1971), which like *Cars* owes a structural and thematic debt to the Hollywood Western.

The experiences of Arthur Waldo in the wake of the car accident which strands him in Paris illustrate the varied generic sources for Weir's film. Once he has recovered from the injuries sustained in the accident, Arthur leaves the town hospital to attend the funeral of his brother who died in the crash. The assembled townsfolk stand around the hearse, motionless and expressionless, as Arthur is met by the Mayor of Paris. The dehumanised provincial population resembles that seen in science fiction and horror films such as *Invasion of the Body Snatchers* (Don Siegel, 1956: Philip Kaufman, 1978) and *The Stepford Wives* (Bryan Forbes, 1974). The disconcerting position of the outsider is exacerbated by the uncanny restraint of the local conformist community, whether burdened by secrecy or literally replaced by androids or aliens.

1 Andrew Pike and Ross Cooper, *Australian Film 1900-1977*, (Melbourne: Oxford University Press, 1980), p. 331.

The combination of horror and science fiction motifs has been apparent within the film from the credit sequence. As Arthur and his brother drive along rural roads, they pass evidence of societal breakdown and encroaching anarchy. Petrol is rationed, employment is scarce, and newspaper headlines broadcast a 'currency crisis' and 'opposition to new laws'. They are puzzled by the sight of three men manhandling a dead cow into the boot of a car, unaware that the exploitation of 'accidents', either real or manufactured, forms the basis of Paris' economy in the present social turmoil. This futuristic scenario, an extrapolation of the world wide fuel shortages experienced in the 1970s, is also developed further in the *Mad Max* films. However, where Miller's films combine science fiction with the road and biker films, Weir's fantasy co-opts elements of the horror genre in its Gothic commentary.

Ominous musical cues in the vein of the horror film appear at the moment when Arthur's car turns off the main highway onto the hill road to Paris. The subsequent shock of the crash at night is succeeded by an idyllic view of the town in daylight, emphasising from the outset the horror of incongruity, juxtaposing normalcy and barbarism, which Weir's film essays. This musical motif accompanies subsequent sequences showing the mobilisation of the townsfolk when the next 'accident' is prepared. While the images of the brightly lit town and hospital contrast with the preceding sequence, the tone of horror is re-established by the behaviour of the Doctor, who conducts cruel psychological tests on Arthur before releasing him. He asks Arthur to describe what he sees in a series of black and white photographs. After a 'chair', a 'dog' and a house', Arthur is shown a picture of a 'car'. A later picture shows a car damaged in a collision, and Arthur hesitates before saying "smash". The doctor replies, almost as a correction, "accident". Subsequent pictures of a 'table', a 'cat' and a 'pen' are followed by an image showing a dead body in a wrecked car, which causes Arthur to close his eyes before conceding "accident". The last pictures of harmless objects are displayed at a quickening pace until the last picture, suddenly in colour, shows a corpse in bloodied car wreckage. Arthur is unable to speak and hides his face in his hands as the Doctor's stern voice declares, "accident".

The Doctor's psychological manipulation of Arthur, the inconvenient survivor, contrasts with his surgical experimentation on the injured victims of earlier crashes. These unfortunates have been reduced to vegetables ('veggies') by the Doctor's nightmarish treatments. They are left to wander the wards of the hospital and are shepherded, in fancy dress, to the Paris Pioneers' Ball at the film's climax. Their physical and mental degeneration, and their spiritless motion recall those of the expanding zombie population in *Dawn of the Dead* and *Day of the Dead* (George A. Romero, 1979, 1985). As the victims and representatives of a cannibalistic car culture, the choric veggies appear as an understated but pertinent element in Weir's contemporary polemic. The manipulation of accidents is present in the black comedy of *Homesdale*, in the case of a man who murdered his wives by faking road crashes. The institutionalisation of such violence in *Cars*, in the reliance of Paris' barter economy on the vehicles, belongings and bodies of their victims, illustrates the criticism of consumerism and car culture embodied in Weir's film.

Following his accident (and because of the Doctor's tests) Arthur finds himself incapable of driving, and therefore unable to leave the town. As an unwilling inhabitant of Paris, he observes its devotion to the car from outside but gradually becomes assimilated into its automobile-based existence. He discovers the truth behind the fatal crashes, but he cannot escape to tell the authorities, and hypocritically the people of Paris do not want to harm him without provocation. The compromise is for Arthur to join the community. In order to integrate (and silence) him, the Mayor offers him a home within his own family as his adopted son. The Mayor's family epitomises the town's absorption of the spoils of the accidents: his wife sports a 'second-hand' fur coat and the household is already augmented by 'second-hand children', in twin daughters orphaned in an earlier crash.

The Cult Film, Roger Corman and The Cars That Ate Paris

In accepting the Mayor's hospitality, Arthur is pressured into colluding in the town's secret, but he is also forced to accept a job which places him on the front line in Paris' civil conflict. While the older generation maintain a hypocritical status quo, in subsisting on an immoral, twilight economy and planning for an idealised but unattainable Paris of the future, the younger generation have adopted the car religion wholeheartedly and unequivocally. Where the town feeds off the car-casses of the crashes, the youth of Paris build their own fantastic, fetishised vehicles from the wrecks. They race and perform stunts on the town's roads to the irritation of the Mayor, who seeks to rein in the car mania which he and the town's circumstances have engendered. The crucial incident is the killing of the Reverend Mulray by Charlie the village idiot. The killing of the vicar and the wrecking of his car are condemned by the Mayor, but in fact Charlie's desire to acquire his own vehicle merely conforms to the town's doctrine. Charlie's violent action is a reminder of the car's tribal and totemic value, especially within the environs of Paris. Like the sharing of a kill after a tribal hunt, Charlie accuses the town bigwigs of keeping the "best bits" of the car wrecks for themselves. He poses possessively next to his personal trophy, the remains of Mulray's Mini.

The Metallic Monsters of Paris

As tension grows between the generations, the cars become increasingly violent and anthropomorphised. When Arthur tries vainly to leave in his brother's repaired car, he finds himself observed and his way blocked by several monstrous customised vehicles. The concealment of the drivers behind the cars' fins, grills and spikes and the equation of their revving engines with the roars of animals lends them an autonomous and menacing animation. In response to the town council's sanctions against the youths' antics, a car rams the Mayor's home, and in retaliation he orders one car burned in the town's high street. His henchman Max carries out the public execution, but later warns that "the Cars are upset over the burning". When the cars mass on the hills and wreak revenge by razing the town at the film's

climax, the transformation is completed by the cries of wild beasts overwhelming the engine noise on the soundtrack. The iconic silver VW Beetle encrusted with metal spikes, which leads the attack on the town (and has since become identified with the film because of its use in its promotion at Cannes), seems to have no driver at all. Its deification, through its clinical appearance and apparent invincibility, sees it enshrined as the ultimate car symbol and weapon produced by the town. It is a magnification and mythologisation not only of the car and car culture but also of the surgical instruments, associated with Paris' parasitic and cannibalistic existence, used on his patients by the Doctor.

The similarity between the menace of the cars and the threat posed to the frontier town by the Indian in the classical Western highlights another area of generic debt within Weir's film. Soon after Arthur's arrival, the parents and young children of the town are seen huddled in the local church while outside the cars race around the town. A council meeting is similarly interrupted by the noise of the youths' vehicles in the main street. However, where in the Western the outlaws or Indians represent an external or alien force which must be faced and overcome in the establishment of civilisation, in Cars the menace is homegrown and inseparable from the town's lifestyle. Despite evidence of the Western inheritance in the image of the beleaguered townsfolk, the youths' equation with their cars reflects their sincere adoption of the doctrines of their elders. The car circulates as an economic and totemic symbol, customised and idolised as an expression of personality and power. The anthropomorphism of the vehicles, and their place within the building, subsistence and destruction of the town, is indicative of the car's privileged place within Western consumerism. The equation of the car with death is also evident in the truck wreck, resembling a death's head, whose headlights and mirrors are used to cause the crashes on the road leading into town, and in the rows of wrecks seen on the nearby hillsides. These are bleached white like tombstones, and their similarity to corpses is heightened by an accompanying buzz of flies on the soundtrack.

Arthur becomes embroiled in the conflict between Paris' generations when he becomes the Mayor's adoptive son and the town 'parking officer'. In this capacity, he is tasked with controlling the lawlessness of the younger generation, "cleaning up the town" and "making it a decent place for people to park". The bathetic parallel to the duty of the Western hero is obvious in this role, and is made explicit in the confrontations which ensue between Arthur and the drivers of the cars. Arthur's incapacity as a hero is indicative of the emasculation and disempowerment of male protagonists within the Australian Gothic. (The diminutive actor Terry Camilleri who plays Arthur also appears as the timid and ineffectual prowler in The Night of the Prowler [Jim Sharman, 1978]). In Australian Gothic thrillers of the 1970s and '80s, the hero's action is frequently undermined by weakness, misapprehension or failure. The repercussions of heroic fallibility for narrative progression and closure reflect the consistent subversion of generic and narrative conventions in films of the Australian revival. These are particularly noteworthy in Arthur's case.

When Arthur attempts to enforce the law, the disagreement becomes a parody of the gunfighter's stand-off in the generic Western. Handicapped by his phobia about driving, which inspires mockery akin to the cowardice of the cowboy too yellow to draw, Arthur is powerless in the face of the youths. His opponents are cast as Western outlaws, and this association is heightened by their iconic costuming. In the confrontation with Arthur, Darryl and the other youths assume the hats, neckerchieves and dustcoats of the villains in 1960s 'spaghetti' Westerns. This allusion is reinforced by the appearance of a harmonica motif, reminiscent of the soundtrack of Once Upon a Time in the West (Sergio Leone, 1968), during the stand-off. In the absence of any credible authority embodied by Arthur, the confrontation is ended by the intervention of the local police officer, Sergeant Cotter.

The Cult Film, Roger Corman and The Cars That Ate Paris

During the cars' climactic night assault on the town, Arthur seeks to escape, but finds himself cornered by Darryl in a garage with the Mayor's car. Under the Mayor's orders he gets into the driving seat and starts to fight back. In this sequence, jump-cuts exaggerate the violence of his repeated ramming, reversing and ramming again until Darryl and his car are dead. Instead of taking the mayor to safety, Arthur smiles beatifically at being able to drive once again. However, though his earlier phobia about cars undermined his heroism and masculinity, regaining the courage to drive does not equate with the resumption of heroic, redemptive activity. Arthur proves his manhood in a protracted but opprobrious act of violence which, unlike the moral intervention of the Western hero in films like *High Noon* (Fred Zinnemann, 1952) and *Shane* (George Stevens, 1953), does nothing to cure the town's ills. Arthur is not confined to Paris by the requirement to fulfil a heroic role, but by his physical inability to move on. The Western hero departs from civilisation and returns to the wilderness once a moral, often retributive and always violent task has been completed. It is this immobility and entrapment which leads to his gradual assimilation into the community and culture of Paris. When he leaves, it is as a lone killer in a stolen car, not as the saviour of a corrupt but renewed society. The subversive adoption of Western motifs in *Cars* serves to highlight the immorality of the town and the inadequacy of the anti-hero. The hypocrisy of the town's leaders and the collusion of the local population give rise to internecine and self-destructive conflict, with the institutionalisation of violence incarnated and enacted by the youths' outlandish cars. Paris can only be cleansed by utter annihilation, and as such *Cars* follows the lead of such 'revisionist' Westerns as *High Plains Drifter* (Clint Eastwood, 1972), which draws on the same iconography (such as Sergio Leone's *Dollar* trilogy [1964-1966]) as Weir's film. Instead of the gravitas of the heroic nomad, Arthur exhibits the guilt and self-reproach of the outsider. In this respect, he seems closer in characterisation to the civilised Easterner (such as Ransom Stoddard in *The Man Who Shot Liberty Valance* [John Ford, 1962]) who is educated and transformed by experience at the lawless frontier.

From Paris to Corman

Cars subversion of the Western runs parallel to its polemicisation of the horror genre in the fashioning of a social critique. The construction of two conspicuous montage sequences, which reveal the day-to-day workings of the town, display the film's technical and ideological debt to European art cinema of the preceding decade. However, the content, colouration and editing of the images in the first montage are also derived from the horror idiom of exploitational and drive-in movies of the same period. In the first sequence, the prelude to and aftermath of a car crash at night are shown. Arthur sits up in bed, disturbed by nightmarish shouts in the hospital. Cuts show the bandaged heads of veggies blurred and framed in the frosted glass of a door. Although the scene changes to the street and the woods outside, the cries of the brain-damaged veggies continue to echo on the soundtrack, and accompany the appearance of signal lamps among the trees. The horror theme music, heard at the time of the brothers' crash, returns as the tempo quickens. A warning bell sounds in the town pub, and the men leave immediately to participate in the hunt. A point of view shot, equating with the perspective of the doomed driver, shows the hill road in darkness. The horror music reaches a peak when lights blind the driver, making him scream and lose control of his vehicle.

In the following scenes the Doctor, in his operating theatre, checks his surgical instruments and beckons benignly to someone out of frame. While an unidentified voice screams in pain and terror, shots of Arthur sitting up in bed are intercut with those of a nurse and an orderly manhandling the injured driver into the operating theatre. The analogy to the cow in the credit sequence is furthered by shots of a damaged white Jaguar being pushed through the town, and then dismantled by the citizens of Paris. The removal of its fixtures and fittings is juxtaposed with the patient being tied down, to the accompaniment of pumping mechanical sounds. The nurse removes the driver's watch

unruly pleasures

and shoes, the Mayor requisitions the car radio and Charlie claims its crest, and women dressed like the *tricoteuses* of revolutionary France (another instance of institutionalised violence) divide the spoils.

The generic horror elements of this sequence contrast with the harmless, homespun atmosphere of the second montage. This begins with a mobile crane being manoeuvred towards a car wreck. A man works on a detached white car bonnet, a child is seen sitting in a large tyre and a smiling grandmother polishes a chrome hubcap as she sits on an open porch. A notice, asking for tyres to "swap for food, clothing, milk, petrol and oil" is seen in close-up. In the local hardware store, a man brings in a paper parcel of clothes and shoes to barter for food. These leisurely scenes of deranged domesticity jar against shots of a maimed gravedigger carrying a bundle of white crosses, the customised cars crashing into each other, the Mayor admiring his model of the Paris of the future, and scavengers picking over a heap of scrap parts. The sequence concludes with Charlie staggering towards the camera while carrying the large white bonnet on his head, transformed into a bizarre, inhuman shape by his burden.

The innocuous images and dreamy music of the second sequence contrast with the juxtaposition of violent, debased dismemberment of people and vehicles shown in the first. In both cases the intentionally dark humour depends on the viewer's connection of Paris' literal murder and consumption with the unacknowledged cannibalism at the heart of Western capitalism. This complicity has been established by the pre-credit sequence. In a visual style deliberately evocative of advertising, we see a fashionable and photogenic '70s couple driving through the countryside in a white convertible, buying antiques and enjoying Coca-Cola and Alpine brand cigarettes. The product names are shown in close-up just before a tire blows out, the male driver loses control, and the car careers off the road and overturns. This dumb-show epitomises and summarises the combination of horror film, art film and social satire attempted in Weir's film. Paris' moral myopia and economic pragmatism allegorise the pursuits of consumerism, war, crime and materialism within a hybridised, generic film format. A model for these ideological and stylistic aspects of Weir's film can be found in *Weekend* (Jean-Luc Godard, 1967). The influence of Godard's polemical films of the 1960s is also discernible in *Michael*, Weir's contribution to the Commonwealth Film Unit's portmanteau feature *Three to Go* (1971). In Godard's film, voice-overs and talking heads deliver political tracts directly to the camera, titles bear ideological slogans, and abbreviated shots of the slaughter and butchery of a pig are connected by association with the greed of middle-class consumption.

The montage sequences in Weir's film deliver a comparable message without the use of dialogue, depending instead on the juxtaposition of images, music and concepts to produce the desired ideological effect after the fashion of Soviet formalist filmmaking. Yet the narrative content of the first montage sequence, its nightmarish assault on the viewer through identification with the driver-victim, and its features of colouration and editing, are strongly reminiscent of Roger Corman's horror films of the 1960s, particularly the cycle of Edgar Allan Poe adaptations beginning with *The Fall of the House of Usher* (1960). In Corman's adaptation, the family house not only embodies but enacts the evil of the depraved family, matching the anthropomorphism of the cars in Weir's film. The vivid colouration and appearance of blood through both films also evince common symbolic and horrific uses:

2 David Pirie, 'Roger Corman's Descent Into the Maelstrom', in Paul Willemen, David Pirie, David Will and Lynda Myles, *Roger Corman*, (Cambridge: Edinburgh Film Festival '70, 1970), p. 52.

"Usher [Vincent Price] is wearing a crimson, felted jacket, which matches deep-red curtains, and a red-bound armchair and table-top. The room itself, a fairly large baroque apartment, contains a grotesque painting suffused in red, that is Usher's work. The overwhelming effect of the whole is that of blood and guilt. Against it Winthrop's blue coat is mild and innocent. The room also foreshadows the ending of the film, in which there is a positive eruption of red, as Madeline, trailing blood and wearing a white funeral dress deeply stained in it, wrestles first with Philip, and then with Usher, in a kind of frenetic, but deadly, sexual embrace."[2]

The Cult Film, Roger Corman and The Cars That Ate Paris

Weekend

Other similarites between the Corman-Poe films and Weir's Gothic horror films emerge in aspects of treatment and characterisation. The black humour based on violence and deviance which characterises *Cars* arises from the juxtaposition of the mundane and the horrific, the everyday and the fantastic. Given the traumatic circumstances of his entry into the nightmarish environment of Paris, it is unsurprising that the unremarkable Arthur is unable or unwilling to intervene meaningfully or heroically to alter the town's condition. His initial association with ordinary tasks and relationships (seeking work with his brother) is mirrored in his immersion in Paris' inverted construction of ordinary town and family life (absorption in a family composed of perpetrators and victims of the crashes, and employment as a traffic warden in a town filled with deadly cars). Arthur's ineffectuality, and that of other examples of the hero in Australian Gothic, chimes with Corman's construction of a fantastic, reflexive diegesis in which the nominal hero appears impotent and ridiculous:

"While Price's ludicrous excesses can create a bond with the audience in which both share the joke, the humour which revolves around the more conventional heroes seems to be almost entirely at the heroes' expense. While Price can play both knowing understatement and knowing excess to comic effect, the humour of the heroes is almost entirely produced out of the mundane inappropriateness of their reactions."[3]

In spite of the art film technique and political stance of *Cars*, the narrative and aesthetic features it derives from the horror genre reflect its popular basis. In this respect it epitomises the Gothic sensibility, which was prevalent in the early years of the Australian filmmaking revival:

"They are in fact art films coming up into the feature category from the underground of experimental filmmaking, and from the sense of the marvellous in cartoon art, horror comics, and matinee serials...'Normality' - of the Australian suburban and small town strain - is the hunting ground for Gothic comic hyperboles and motifs: the mix master; the front yard; the car,

[3] Mark Jancovich, *Rational Fears: American Horror in the 1950s*, (Manchester: Manchester University Press, 1996), pp. 282-3.

In the year 2000 hit and run driving is no longer a crime. It's the NATIONAL SPORT!

DAVID CARRADINE

DEATH RACE 2000

DAVID CARRADINE "DEATH RACE 2000" SIMONE GRIFFETH AND SYLVESTER STALLONE
ROBERT THOM AND CHARLES B. GRIFFITH · IB MELCHIOR · ROGER CORMAN · PAUL BARTEL focus film distributors

and the car crash; and the other things that litter the landscape of contained insanity. The normal is revealed as having a stubborn bias towards the perverse, the grotesque, the malevolent."[4]

Later Gothic films, especially the *Mad Max* trilogy, mythologise the car further rather than extend the criticism of its fetishisation initiated in Weir's film. The unalloyed generic heritage of the *Mad Max* films provides the key to their commercial success abroad, particularly in America, as compared with *Cars.* The energetic updating of the Western, and its combination with science fiction in the *Mad Max* films, dynamises the Gothic sensibility through stress on exploitational elements such as the customised cars and costumes. Criticism of the car culture may still be discernible, but is submerged in an ecstasy of vehicular speed and violent death. In comparison, Weir's first feature was not a box office hit, despite considerable critical acclaim. While it built on the cult elements of *Homesdale*, the diversity of *Cars'* aesthetic and generic sources made it difficult to market:

"Reactions at the Sydney and Melbourne Film Festivals in June [1974] were vigorously divided, prefiguring the critical acclaim and commercial failure that occurred when the film opened...Attempts were made to salvage the film commercially by changing distributors...and by changing the advertising campaign from horror movie to art film (in Canberra during the 'Australia 75' arts festival) but neither succeeded."[5]

Hit and Run as a National Sport: *Death Race 2000*

If it failed to spawn a cult of its own, *Cars* can be attributed with the inspiration of related and comparable cult films. Its own sources in American exploitation were reinvigorated by the unrestrained approach to fantasy narrative and generic hybridity which the Australian Gothic displayed. A circle was completed by *Cars'* effect upon the Roger Corman production *Death Race 2000* (Paul Bartel, 1975).

[4] Susan Dermody and Elizabeth Jacka, *The Screening of Australia Vol.II: Anatomy of a National Cinema*, (Sydney: Currency Press, 1988), p. 51.

[5] Pike and Cooper (1980), p. 354.

The Cult Film, Roger Corman and The Cars That Ate Paris

Corman's own biker and counter-culture movies of the 1960s are discernible influences on examples of Australian Gothic. Drawing on the antecedent of *The Wild One* (Laslo Benedek, 1953), Corman's *The Wild Angels* (1966) achieved notoriety for its violent and sexual content. The arrival of a biker gang in a parochial rural town is the catalyst for social and generational confrontation in both cases, as ageing conservativism and the counter-current of youth clash on the quiet main streets. The violence of the reactionary forces (disproportionate to the threat posed by the gangs) which is established in *The Wild One* recurs in the diegeses of Corman's film and the later, more famous *Easy Rider* (Dennis Hopper, 1969). The portrayal of social upheaval which these films contain grows in radicalism from the comparatively subdued resistance of Johnny (Marlon Brando) in Benedek's film to the alienation and nihilism of the gang members in Corman's. In comparison, the characters of Hopper's film appear almost as blank slates, upon whom their varied and escalating experiences leave little impression. The inevitability of their victimisation to death negates the putative freedom of travel associated with the road movie. *Easy Rider*'s inversion of the Western (eastward travel from California to Louisiana, towards a declining and retrenching society) underlines the impetus for social change embodied by the road movie in this era:

"Common to most of these films is that they are about escape, from the claustrophobia of petit-bourgeois life, from corruption and injustice and from an intolerant 'normality'...road movies served as sources of easy identification between dissidents on and off the screen."[6]

The impossibility of escape for the heroes of *The Wild Angels* runs counter to the the road movie's symbolic freedom, and this reflects the extent of contemporary social upheaval. The repressive powers of the establishment, embodied in the older generations of the parochial towns forming the biker film's backdrop, preview the anti-authoritarian stance and the institutionalisation of violence seen in Gothic examples such as *The Cars That Ate Paris*. In Weir's film and comparable representations of the rural backwater (*Shame* [Steve Jodrell, 1987], *Deadly* [Esben Storm, 1990] and *Wake in Fright*), the establishment structures and the family groups of respected figures are the perpetrators of violence. In *Cars* the only uniformed representative of law and order is Sergeant Cotter, whose jacket, hat and boots echo the costuming of Johnny in *The Wild One*. The same iconic clothing adorns the (undercover) female lawyer in *Shame*, to the opposite effect. Where in Jodrell's film the stereotype of the biker is doubly undermined by her gender and her profession, and provides an ironic commentary on her role as bringer of justice, in *Cars* the true nature of the town's lifestyle is indicated by the criminal-biker associations of the town's police.

As well as building on generic antecedents in its amalgam of horror, road movie and science fiction, Corman's *Death Race 2000* draws direct and uncredited inspiration from Weir's film. In the course of fruitless attempts to release *Cars* in the States through Corman's New World Company, Paul Bartel was approached by Corman to direct *Death Race 2000*:

"Corman first came to him with the idea of the cars themselves, and the rest of the plot was built around them. Bartel himself never saw *The Cars That Ate Paris*, although he was aware that a print of the film was in Corman's office."[7]

As completed, *Death Race 2000* evinces the low-budget, exploitational and tongue-in-cheek characteristics of many other Corman productions (within the Poe cycle, *The Raven* [1963] had also fallen into self-parody). It defuses the violence of the future 'sport' of hit-and-run driving through the racial and sexual caricatures of the drivers, punning dialogue, and media satire in the road race's coverage. Like the more portentous vision of sporting violence as a form of social control seen in *Rollerball* (Norman Jewison, 1975), *Death Race 2000* imagines a future society as a logical extension of contemporary moral

6 Ron Eyerman and Orvar Lofgren, 'Romancing the Road: Road Movies and Images of Mobility', in *Theory, Culture and Society*, vol.12 no.1 (1995), pp. 53-79, (p. 62).

7 David Stratton, *The Last New Wave: The Australian Film Revival*, (London: Angus and Robertson, 1980), p. 64.

Death Race 2000

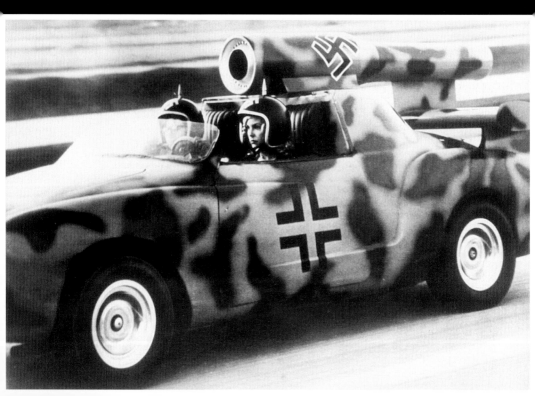

and consumerist trends. Ironically but comically, the underground moral minority opposed to the race can only stop its progress by resorting to violence themselves: again characters whose age and appearance stress their establishment credentials are seen as perpetrators of violent acts. The institutionalisation of violence as sport in *Rollerball* and *Death Race 2000* is comparable to Paris' resort to killing for survival, but the setting of these narratives in a comparatively distant future eliminates the immediate, allegorical relevance found in *Cars*. Instead, the unabashed populism of violence in Bartel's and Jewison's films represents a crucial distinguishing factor in their commercial reception and subsequent cult status in comparison with Weir's.

The elevation of Corman's production of *Death Race 2000* to cult status rests at least partly on its parodic stance towards fantasy, commentary and violence. This emphasis arose from a disagreement between Bartel's desire to turn the film into a straight comedy and Corman's commitment to an innovative horror film. In interview Corman maintained:

"I told Bob Thom, who'd written *Bloody Mama* for me (which was a serious picture with comedy, insofar as these films can be serious), that what I wanted was something along the lines of *Dr. Strangelove*: a serious comedy about violence. To me, *Death Race* was about gladiator fights in ancient Rome or boxing today - the need the public has to experience vicarious thrills. I wanted to treat it with humor but what Paul Bartell [sic] and Chuck Griffith wanted to do was make it a silly comedy. A farce comedy. I wanted it to be a smart comedy."[8]

In this aspiration, *Death Race 2000* was intended to emerge as a clearer development of Corman's earlier, violent, road-based and counter-culture movies, *The Wild Angels* and *The Trip*, which resembled "animated colour supplements fused with myth and archetype".[9] *Death Race 2000* disarms its satire and violence in comedy, just as *Cars* submerged its populism and exploitational potential in art film technique and intention. The true offspring of both films, achieving a powerful synthesis of myth, archetype, generic forms and popular appeal, is *Mad Max*. Where in *The Wild Angels* death registers as defeat, and the inability to accept it as delusion, the nomad gang's collection of the Nightrider's coffin from the train station in an outback town stands as a focal point for their confrontation with society and the law. The death of the individual biker is an event from which the gang draw an infernal energy, and from which escalating atrocities ensue. As a low-budget, controversial and exploitational picture, merging Australian and American materials and sensationalism with social observation, *Mad Max* may be the film *Cars* could have been, and Roger Corman wanted to make.

[8] Mark Thomas McGee, *Roger Corman - The Best of the Cheap Acts*, (London: McFarland, 1988), p. 80.

[9] Lynda Myles, 'Two Colour Supplement Movies', in Willemen, Pirie, Will and Myles (1970), p. 81.

Xavier Mendik and Graeme Harper

Defining a contemporary film as 'cult cinema' acknowledges that, regardless of the stance of the film critic, much of the work has already been done by the cine-literate film-maker and the active audience. To define a movie as cult is to recognise its seams and its scenes so that, whatever the genre of the production, these works allow gratification and give pleasure in specific elements rather than adherence to the experience of the narrative whole. By applying the theories and ideas of the Marquis de Sade it is possible to show that such contemporary cult film has not only ethnographic identities (or audience positions) but textual identities (or forms). In particular, contemporary film audiences are drawn to be both 'outside' film and 'within' it, both audience and participants. By using the work of Sade our investigation of such 'cultifying' of a film like *From Dusk Till Dawn* leads to a new way of discussing contemporary film and film-making.

Biographical note: Xavier Mendik is co-editor of *Unscene Film: New Directions in Screen Criticism* and co-director of Film Forum: the British film events network. His research interests centre on the application of psychoanalysis to cult, horror and exploitation cinema. He has published widely on this area in books such as *Ethics and the Subject* (Rodopi), *Harvey Keitel: Movie Top Ten* (Creation), *Necronomicon Books 1-3* (Creation/Noir Press), *Christopher Walken: Movie Top Ten* (Creation) and *The Modern Fantastic: The Films of David Cronenberg* (Flicks Books). He is writing a book on Joe D'Amato for Creation Books and has completed a book on Dario Argento's *Tenebrae* for Flicks Books. His credits extend to broadcasting, conference organising and film consultancy in the area of cult cinema.

Biographical note: Graeme Harper is co-editor of *Unscene Film: New Directions in Screen Criticism* and co-director of Film Forum: the British film events network. His books include *Swallowing Film* (Q), *Black Cat, Green Field* (Transworld) and the forthcoming *Captive and Free* (Cassell). His critical and creative work has appeared in journals in Europe, the USA, Canada and Australia in such places as *CineAction, Southerly, Ariel, Sight and Sound, ABR*, the *Dalhousie Review* and *Outrider, and in a number of edited collections*. He has been an organiser of the annual "Cult Fiction Festival".

The Chaotic Text and the Sadean Audience: Narrative Transgressions of a Contemporary Cult Film

Xavier Mendik and Graeme Harper

"She was placed like an actor in a theatre, and the audience in their niches found themselves situated as if observing a spectacle in an amphitheatre . . . At the back of each niche was a little door leading to an adjoining closet which was to be used at times when . . . one preferred not to execute before everyone for whose execution one has summoned that subject."[1]

Tarantino's Turn to Sade

One might be mistaken for presuming that the above quotation is taken from the dance routine featured in Robert Rodriguez's cult hybrid film *From Dusk Till Dawn* (1996). Here, a pair of gangsters named the Gecko brothers and their hostages hide out in a sleazy strip-joint named 'The Titty Twister'. During the scene, this group (along with the roadhouse rogues who make up the locale's regular audience) are treated to an erotic dance routine performed by the nightclub entertainer Satanico Pandemonium. Satanico's dance signals that both the assembled cast *and* the film's audience are about to be co-opted into a new, transgressive rhetorical structure.

As Satanico dances, she and Rodriguez's trucker bar-dogs transform into vampires, and in so doing the structure of the narrative suddenly and dramatically alters from tough heist/road drama to offbeat horror comedy. In the ensuing mayhem, Quentin Tarantino (delightfully playing the psychotic Richie Gecko) is bitten and eventually killed (as are the rest of the now *formerly* human cast). The film's frenetic finale finds his brother Seth Gecko (George Clooney) along with former hostage, Kate (Juliette Lewis), left bewildered in the blood, pus and dust. They briefly (and implausibly) ponder the possibility of teen/mighty-jawed sex before Clooney floors it off down the road in a silver Porsche.

There are currently two ways of defining and 'dealing' with the curious concoction that is *From Dusk Till Dawn*. The first (and least useful) is that of downright dismissal. Countless critics have read the film's sudden and unmotivated generic shift as a new low in talentless film making, deriding the movie's structure as merely two gratuitous stories bolted uneasily together. For instance, in her review of the film, Lizzie Franke rejected the film as "pure juvenilia that should have remained true to its origins . . . Stretched to a big budgeted feature film, with its Vampire stand-off second half going on for an eternity, it tests the viewer's patience."[2] While it is easy to dismiss the film's popularity with young 'thrill-seeking audiences' (whom we will define via the term 'Film Avids'), such renunciation leaves unexplained why the disruptive moment of the text's generic shift remains the crux of its cult appeal.

[1] Marquis de Sade, *120 Days of Sodom and Other Writings*, ed. by Austryn Wainhouse and Richard Seaver, (New York: Grove Press, 1966), p.237.

[2] Lizzy Francke, 'From Dusk Till Dawn,' *Sight and Sound*, (June 1996), p. 42.

A second and more fruitful way of understanding *From Dusk Till Dawn*'s convoluted operations has been to label them as 'postmodern'. This may seem rather obvious, given the film's intertextual media-smarts, its cross-generic structure, its self-referential nature, and its simple disregard for historical and cultural parameters. A Tex-Mex Drive-In Movie, then, with a good line in Peter Cushing (*Legend of the Seven Golden Vampires* [1974]), a touch of the 70s B-grader, Blaxploitation definitely, CGI indebted to contemporary body horror, and the first half of its plotline oscillating between tough thriller and parodic CNN News update.

While the film's curious construction results not only from its convergence of popular post-classical generic types, its 'postmodern' status is also assured by the presence of such iconic contemporary cinematic figures as Quentin Tarantino in its production. As Paul A. Woods has noted "Hollywood helped to shape the sensibility of a movie maker who loves to celebrate the medium's cheap thrills and glamour, validating it with a knowing referential context."[3] Yet, while no one can deny the postmodern label does some of our interpretative work, it is premature to stop the analysis of *From Dusk Till Dawn* there.

In our opening quotation we used a passage which draws on several of the key features which critics usually employ to define postmodern cinema. However, this quotation, with its references to "spectacle", "niche" viewing pleasure and "amphitheatre" thrills comes not from any postmodern volume, but from the Marquis de Sade's *The 120 Days of Sodom*. It refers to a point in the story's convoluted structure where a trio of whores begin to narrate a series of stories which radically alter the flow of the implied author's established narrative. As is usual in Sade's work, this textual digression is accompanied by the description of excessive physiological acts of violence, torture and obscene bodily transformations.

We intend to use to Sade's writing as a basis to consider *From Dusk Till Dawn*'s duel bodily/narrative permutations as well as its ambivalent construction of morality (as represented in the figure of Richie Gecko). By drawing on Sade, we also aim to offer some comments on the possible motivations and gratifications that turned this into a 'cult' film for its young, spectacle bound audience. This last point remains important because the consideration of Sade's work as it applies to the realm of spectatorship is almost completely undeveloped in contemporary film criticism. Yet, Sade's theories and experiments are paradigms of active rather than passive creation and reception. Here, the text's audience is both enticed into its celebrations of evil and perversity before being shocked, misled or violently forced to reflect on their gratifications from the narrative proceedings.

Richie Takes a Tumble: The Moment of the Grand 'Switch'

In Sade's novel *The 120 Days of Sodom*, the narratives that the whore trio detail are significant not merely for their sudden evoking of textual/bodily change, but also because they are organised in the manner of a theatrical production. This is important in that it demands the direct involvement of the assembled libertines. Each of the whores' narratives is presented to a captive (indeed *captivated)* audience which in turn opens up the possibility of further narratives, further stories, each of which draws the viewers and listeners further into the web of the text. For instance, Timo Airaksinen has pointed out that the construction of such reflexive and staged dialogues between narrator and audience are central to the vignettes that dominate *The 120 Days of Sodom, Justine* and Sade's other works. Here:

"....the key task is to create variety by translating the creatures of the imagination into the language of reality by means of stage productions. The standard etiquette is set aside momentarily, the workers erect a stage and direct a play, the masters join their victims and slaves and create something new."[4]

3 Paul A. Woods, *King Pulp: The Wild World of Quentin Tarantino*, (London: Plexus Press, 1996), p. 8.

4 Timo Airaksinen, *The Philosophy of the Marquis de Sade*, (London: Routledge, 1995), p. 128.

The Chaotic Text and the Sadean Audience

From Dusk Till Dawn likewise follows this Sadean ideal, by presenting the vampiric chaos that follows Satanico's dance to *two* stunned and captivated audiences: the fictional truckers of 'The Titty Twister' as well the film's bemused and yet captivated spectators. By overloading both depicted and viewing audiences with such 'difficult', linear and non-traditional information, the film reproduces the Sadean ideal of intellectual and moral ambiguity through the narrated act.

Indeed, the film's preoccupation with acts of aggression and sexual excess is also emblematic of Sade's depiction of physiological liberation through radical and violent alterations in self and identity. Fundamental to this is the mode of presentation and reception of such acts undertaken by an informed audience. Spectatorship, then, based on a social imperative to increase both individual and communal knowledge *insatiably* (a phenomenon as familiar in the changing social contracts of Sade's eighteenth century 'Age of Revolution' as in our own revolution in 'information technologies').

Central to such audience acceptance of *From Dusk Till Dawn*'s convoluted narrative is the presence of such iconic contemporary cinematic figures as Quentin Tarantino in the film's production. This further enhances the film's complex network of intertextual 'storytelling' references, to other films and genres both inside and beyond the Tarantino camp. In the same way that Sade's libertines are characters who are suddenly created, even more violently replaced, only to reappear in someone else's meanderings and recollections, Tarantino has continually created a series of characters which relate endlessly to his own productions, e.g: Mr. White in *Reservoir Dogs* (1992) links us to *True Romance* (1993); Vince Vega in *Pulp Fiction* (1994) and Vic 'Mr. Blonde' Vega in *Reservoir Dogs* are family and so on and on.

Tarantino's 'street cred' clearly relies on such self-referentiality. His work is a celebration of the thrills and glamour of contemporary film, backed by a

'knowing' context which he actively shares with his attuned film audience. Of course, a cinematic dialectic is a performative aesthetic: it always requires agreement between act and audience. This dialectic is clearly culturally and historically attuned. Undoubtedly in the case of contemporary Western cinema such a dialectic has become increasingly media sophisticated. Not only does the audience recognise Tarantino, they recognise his media persona (hotshot, wunderkid director and so on).

Tarantino's involvement in *From Dusk Till Dawn* (as screenwriter, actor and producer) aligns him to Sade in one immediately obvious sense at least: both are disciples of the encyclopaedia, of encyclopaedic knowledge. Since the commercialization of the publishing industry in the eighteenth century we have become collectors of an increasing amounts of 'textual' evidence about the world (Sade's *The 120 Days of Sodom* is nothing if it is not a gigantic catalogue; Tarantino's work is nothing if not a encyclopaedia of references to 1970s film culture). The connection between the two figures is furthered by the fact that, in *From Dusk Till Dawn*, the director's self-conscious cameo appearance replicates the 'playful' role of Sade's knowing libertines. These remain mischievous, sadistic, thrill seeking agents whose actions are spurred on by the assembled audience and their knowledge: their individual desires are becoming, in this act of voyeurism, communal.

5 Guy Debord, *The Society of Spectacle*, (New York; Zone Books, 1995), first published 1967.

Because audiences are the location of communal as well as individual desire they are not merely harbouring *unseen* responses. Their responses are part of the same (yet, historically further developed community). This is something that Guy Debord identified as far back as 1967 in his book *The Society of Spectacle*.[5] Here, commodified mass spectators are able to combine

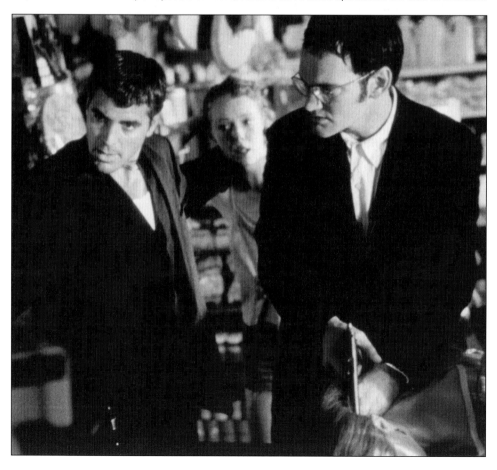

The Chaotic Text and the Sadean Audience

acts of communal and personal fantasy with a good knowledge of mass media practices and eager participation in new consumption-orientated media communities.

Meet The Avids: Audience, Introspection, Emotion and Knowledge.

"The first time I'd seen this movie I thought it was great... After I have seen it a couple of times I just jump straight to the part where they enter the bar (unless I feel like watching the whole thing)."[6]

"Unlike most of the people who have commented on this movie, I saw it with no previous knowledge of the plot. When it suddenly changed in mid-stream from a crime drama to a horror flick, I nearly had a heart attack. I was absolutely not expecting any vampires to be showing up at this seedy Mexican bar."[7]

The primary audience for a movie like *From Dusk Till Dawn* can be defined using the term 'Film Avids'. These are chiefly hedonistic contemporary film enthusiasts (broadly, the 17-24 age group). This is a group who insist upon a high degree of emotive involvement in the reception of the film. And yet, sophisticated in their knowledge of cinematic effects, techniques and readings they are capable of responding beyond this primary sensory reaction. Certainly in *From Dusk Till Dawn* the audience response, beginning in the sensory, shifts naturally because of the film's narrative transgression and the degree of 'self-referential' knowledge that is required to decipher both the text and the involvement of its key personnel.

The film uses its generic shift between realist, exploratory narrative and fantasy film (a shift initiated in Tarantino's master scene script) to greatly strengthen its emotive reach, and combines this with a strong niche expectation of 'knowledge acquisition'. As a result, the film's performative elements (shifting from the representational to the non-representational, from cinema references to pop music, vampire myth to popular histories of CGI) works to encourage its 'cultifying' effect amongst its Avids.

The important point, therefore, is that while it is possible to locate 'cult' primarily in the spectator or reader (as all 'critics' of cult currently do), we can see, through an application of Sade's understanding of the relationship between diegetic and extra-diegetic audience, that in a film like *From Dusk Till Dawn* it is possible likewise to locate a *textual* source of cult. That is: to argue for the notion of a 'cult text' on the basis of its narrative constructions, digressions and the multiple forms of recognitions that such pointed moments produce.

In the instant of the 'Titty Twister's grand switch, both creator and audience recognise, (as Sade hypothesised in his depictions of the dual effect of physiological liberation and textual alteration) that the development of excessive hedonistic responses (which 'cultifying' undoubtedly is) is first and foremost the product of an intersection of foreknowledge and emotion. These are qualities which are not merely gratified or unproblematically affirmed by the Sadean text, but rather act as features whereby the reader/viewer "must mobilize his introspection, look into his own motivations"[8] when considering the unexpected shifts in the work's structure.

This form of 'retroactive knowledge testing' is established in *From Dusk Till Dawn*'s initial sequences, which makes clear its relationship to previous Rodriguez and Tarantino productions. A prime example is the opening section of the film, which reveals that the Gecko brothers are on the run following a botched bank raid, recalling similar Tarantino tactics in *Reservoir Dogs*. Further engagement with these 'pre-established' audience positions is provided by the pair's brutal decent into squabbling and recrimination for the mounting loss of life which occurs during their flight to freedom. Equally, the opening sequence

[6] User comments by "Nick S." of Sydney, Australia (dated 7th August 1999) on the film's net page. See http://uk.imdb.com/CommentsShow?116367/10 26/8/99.

[7] User comments by "Jim Wilkins" of Northern Virginia (dated 2nd June 1999) on the film's net page See http://uk.imdb.com/CommentsShow?116367/20 26/8/99.

[8] Airaksinen, p. 149.

in which a gas station is destroyed in an extravaganza of gunplay is directly reminiscent of Rodriguez's film, *Desperado* (1995).

In addition, the brothers, who are now heading for Mexico, take a family hostage. This family is lead by a burnt-out preacher/father Jacob, played by Harvey Keitel (a key performer in earlier Tarantino productions). Jacob's revelation that his loss of faith and contempt for religion result from the sudden death of his wife provides us with a strong sense of *déjà vu*. After all, it's the theme of betrayal and redemption that likewise haunts Keitel's character, Mr White, in *Reservoir Dogs*.

Decisively, however, *From Dusk Till Dawn* uses such Avid audience familiarity to eschew generic expectations around its primary evolution as a violent heist/kidnap drama. The narrative trajectory is radically undercut, and the film's reception given an emotive charge, when the kidnappers and their captives find themselves marooned in the 'Titty Twister' bar. Here the now well-established characters are attacked by vampires who, soon to perform their own transformations, nevertheless inhabit the bar as archetypal rock musicians or exotic dancers. The radical alteration in the film's narrative drive, premised by Satanico's dance, soon after takes on a sublime air in the fatal wounding of Richie Gecko/Tarantino who, up until that point, had initiated almost all of the main action (holding the role of protagonist back from the more vocal, but less incisive Seth Gecko/Clooney).

In the sudden generic shift and 'killing off' of its central character, *From Dusk Till Dawn* problematizes notions of the normal and the pathological, robbing us of a character whom, while clearly perverse, has acted as an anchor point for our identifications. The question becomes 'Is it right to do this (to both the people and to the film text)?' This chaotic situation effectively redoubles Sade's parodic positioning of morality and codes of social power by forcing the oppressors, the Geckos, and their former hostages to band together to defeat the undead.

Avid audiences, struck by the incongruity of this movement but imbued with sufficient knowledge to engage with it, reach out therefore for the position not unlike Madame Duclos in Sade's *Sodom*: they become actors in a theatre, both part of an informed cinematic community and individuals struggling to determine the cognitive parameters from the contradictory emotive responses which the dramatic shift enforces.

Sadistic Responses: Creation and Destruction

A work such as *From Dusk Till Dawn* has readily been identified as 'sadistic' by both its critics and defenders because of the extremes of bodily alteration and punishment it depicts. As an outraged Mick La Selle commented in his review of the movie:

"Arms and legs are pulled from bodies. Beating hearts are yanked from chests. Blood splashes. Bodies explode. Faces cave in. At one point Clooney knocks the head off of a vampire, kicks it so it rolls, and then someone else shoots it through the eye with an arrow. It's forty minutes of this garbage."[9]

Beyond the film's preoccupation with such examples of physiological excess, the film should additionally be recognised as 'Sadistic', because it references simultaneously both creation and destruction. This is seen specifically in Tarantino's depiction of Richie Gecko as the supreme pleasure seeker: both Creator and Destroyer. In true libertine fashion, Richie's pleasure is the pleasure of the orgasmic; it is, to cite Timo Airaksinen, "extreme pleasure...related to deliberate acts of cruelty, perverse sex and the climax of sexual excitement".[10] These are features that mark all of Sade's anti-heroes. These qualities are evidenced in Richie's perversely rationalised justification of his unmotivated slaughter of otherwise compliant hostages as well as his

[9] Mick La Selle, 'Tarantino Continues to Stumble in the Dusk', *San Francisco Chronicle,* Friday, January 19th, 1996. See http://www.sfgate.com/cgi-bin/article.csi?file=/chronicle/archive/1996/01/19/DD/3044.DTL 26/8/99

[10] Airaksinen, p. 11.

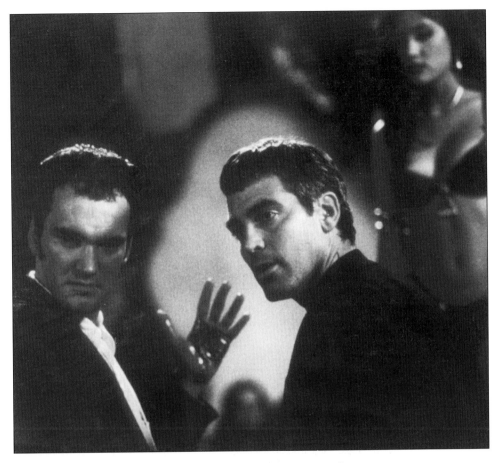

constant twisting of female victims pleas for mercy into sexual come-ons. Richie, lives (and dies), to celebrate the point at which creativity and destruction meet and he finds this meeting point in the elevation of evil.

It was Sade who suggested that evil without enjoyment is banal. Tarantino's works, whether *Natural Born Killers* (1994) or *Pulp Fiction*, whether *True Romance*, *Reservoir Dogs* or *From Dusk Till Dawn* have not backed away from this Sadean projection. In *Pulp Fiction,* for example, it is the easygoing murderousness of Jules and Vincent, the ruthless logic of Marsellus Wallace (which finally meets its match, of course). In *Reservoir Dogs* it is at very least the devil-may-care attitude of Mr. Blonde, Michael Madsen's now infamous sociopath. Tarantino has said, commenting on Madsen's torture of a bound and helpless cop, that:

"The thing that I am really proud of in the torture scene.... is the fact that it's truly funny up until the point that he cuts the cop's ear off. While he's up there doing that little dance to '*Stuck in the Middle With You*', I pretty much defy anybody to watch and not enjoy it . . . And then when he starts cutting the ear off that's not played for laughs. The cop's pain is not played like one big joke it's played for real. And then after that when he makes a joke, when he starts talking into the ear, that gets you laughing again. . . . And that's why I think that scene caused such a sensation, because you don't know how you're supposed to feel when you see it."[11]

Such filmic moments display evil as undesirable only if unimaginative. If, however, it is strong or grand or creative or spectacular or humorous then it becomes a new type of 'moral' problem, something to be privatized and

[11] Cited in Woods, p. 47.

unruly pleasures

enjoyed. In *From Dusk Till Dawn*'s grand switch, the sudden alteration heightens the sense of moral ambiguity underpinning these other works via a 'doubling effect' that vampiric possession (or its threat) implies. We see at least two of many characters who have previously been one, seeing first one side of their nature and then the other. Here, morally bankrupt truckers and rockers are temporarily redeemed as freedom fighters before being consumed into the ranks of the undead, while the experience briefly restores Jacob's belief in a divine, greater power - before he himself is transformed. It does not stretch the imagination too far to see such examples of this doppelganger effect as doubly suggestive of the idea that without evil there can be no virtue.

This feature is central to Sade's work and finds reference in his famous fictional sisters: Justine and Juliette. Although the two novels which detail their lives indicate shared childhood experiences, the adult lives of the pair are marked by disparate drives towards virtue and vice respectively. However, the fact that Juliette performs all the crimes for which Justine is accused underscores a doubling effect between the pair. Angela Carter has noted:

"Juliette's vision of the inevitable prosperity of vice, as shown in her triumphant career, and the vision of the inevitable misfortunes of virtue that Justine's life offers... mutually reflect one another like a pair of mirrors."[12]

This vice/virtue mirrored pair appears in Tarantino texts as the equation: to be 'a professional' or not to be 'professional'. As Seth Gecko says to his brother in *From Dusk Till Dawn* (having returned to their hotel to find he has raped and killed their female hostage): "This is not me. I'm a professional fucking thief. I steal money . . . What you're doin' ain't how it's done. Do you understand?"

Likewise, the reason why *Reservoir Dogs'* Mr. Blonde remains what Paul Woods has called "one of the most stylish, memorable and scarily convincing screen villains ever"[13] is because he is yet another self-mirrored paradox of social responsibility and moral transgression. When the film opens, Blonde is seen chastising his colleagues for their obscene interpretations of Madonna's song lyrics and for their unsympathetic refusal to tip waitresses. By the time the film ends he has calmly and methodically tortured a man. The audience can't help but recall Mr. White's earlier words: "A psychopath is not a professional. You can't work with a psychopath, 'cause ya don't know what those sick assholes are gonna do next."

The fact is, Tarantino's primarily Film Avid audiences don't want to *work* with these psychopaths, they don't want to be professional, or to adhere to rules of "how it's done". Rather, these characters present themselves and perform within an ethos of play which, in its multi-voiced fashion, and in its reflections from the mirror of vice/virtue and challenges to the social contract, is decidedly Sadean. This is what triggers the different modes of contemporary audience engagement. Not unnaturally, in fact, because the 'cultifying' response is largely based on a willingness to 'play the game' that the complex text is offering; that is: to personally *appropriate* a text which has been actively created to encourage such a response.

Body Shells and Narrative Holes.

If the provocative positioning of the film 'Avid' scenarios (spectacle, thrill, visual and moral excess) are central to the film's multiple appeal, this is made all the more dramatic because of earlier attempts to suppress these transgressive elements in its opening 'guise' as Tarantino bank/heist drama.

Here, Richie Gecko is wounded in the hand after the brothers destroy a bordertown gas station and its inhabitants. At this point the film playfully prefigures the use of special effects in the latter part of the film. Tarantino is initially shown looking through the hole in his hand that results from his injury

12 Angela Carter, *The Sadeian Woman*, (London: Virago, 1990), p. 79.

13 Woods, p. 34.

The Chaotic Text and the Sadean Audience

as the special effects team's credits appear on screen. However, the wound is taped at the point at which the special effects team's credits disappear from screen. The wound's disappearance behind the taping at this point reiterates the need to suppress excessive physiological/textual elements from the causal-based modes of narration that dominate the former part of the film.

14 Airaksinen, p. 158.

Importantly, it is in 'The Titty Twister' that Richie's wound is reopened when he is attacked with a knife by Satanico's henchmen. The assault on his hand provokes both the transformation of the bar's inhabitants into vampires, as well as the alteration of narrative flow. In fact, the hole (which is held as if it is evidence of crucifixion, in centre-frame) is a portal linking the inside of the body with the outside, metaphorically challenging a sense of mere 'in sidedness' which restricts an audiences' interaction with a film's cast and crew.

In the next few minutes *From Dusk Till Dawn* provides an insight into the Sadean metamorphosis where the disillusion of established body boundaries is reciprocated by a transformation in the text's structure and audience engagement. Both filmic discourse and blood openly flow, instead of life and death there will be multiple lives and multiple deaths, a truly chaotic and orgiastic replication of text and subjectivity.

It is pertinent that Sade identifies the notion of *the hole* as a paradoxical entity for both text and body. It "is the proper source of death, as well as birth, and it is the source of climax".[14] The hole thus represents a void which in the form of wounds or lacerations disturb the stability of the external body image while functioning as a break or alteration in the text's depiction and its established mode of narration.

Effectively, the second injury that Richie sustains functions as a symbolic wound, because not only does it compel 'The Titty Twister' inhabitants to transform into vampires, but alongside physical alteration comes a

Reservoir Dogs

Pulp Fiction

transition in narrative structure. This is a hole which shifts the text from causal-based narration into one where a plurality of audience desires are recognised, viewed and gratified.

We see, in the next few minutes of the film, how *From Dusk Till Dawn* becomes inter-generic as both subjectivity and formal structure change. It is not merely that the text shifts from realist heist drama to body horror narrative but via this change the film accelerates to take in divergent elements of the Kung-fu, Western, Blaxploitation and softcore genres alongside the vampire narrative. In this relentless shift and transformation, the narrative structure replicates the chaotic construction of the Sadean narrative (both of which depend on the high levels of involved spectatorship already mentioned). Although the film began with a tightly constructed diegetic frame, exploring the interrelations of Richie and Seth Gecko, 'The Titty Twister' becomes a site where narrative concerns widen to take in the multiple characters emerging in the small group of survivors gathered at the bar.

Importantly, characters such as Frost (played by Fred Williamson) and Sex Machine (played by Tom Savini) are not only characters, but story tellers who narrate their textual as well as non-fictional pasts. In this respect their placement in the film replicates the multilayered nature of the Sadean text for an avid audience who likewise feed off their own library of stored filmic knowledge. They are both storytellers and stars, objects of fantasy and, significantly, 'inside information'. Here:

"A story teller has free access to novelty and variety. Everything possible is bought up, told and explained. The stories are shared by listeners as if they were real life possibilities. Because the grammar of routine and conventional etiquette is broken, a new twisted grammar emerges where the relations of peoples, ideas and things are contorted."[15]

The fluidity of such characters' identities is here marked through a split between the discrete fictional role and the actor's past status. In the case of *From Dusk Till Dawn* the (undeveloped) character of Frost becomes a reference point for all the other roles undertaken by Fred Williamson. These characterisations were initiated in a number of Blaxploitation films such as *Mean Johnny Barrows* (1975) and *One Down, Two to Go* (1982), which Williamson also

15 Airaksinen, p.130.

The Chaotic Text and the Sadean Audience

directed. These cast him as a disaffected kung-fu fighting Vietnam vet who has to defeat inequality with physical prowess. *From Dusk Till Dawn* parodies these roles by showing how ineffectual his brand of martial arts is, when attempting to use kung-fu against a vampire. Equally, in one comic scene, Williamson provokes his own death by, delivering a 'Vietnam vet remembers' speech which prevents him from noticing that his friends are transforming into vampires around him.

This construction of characterisation points to subjectivity as a fragile shell. In the same way Sade "offers his readers heroes with which they cannot identify," Rodriguez's film reproduces a series of "mutually exclusive types, each person represents a conglomeration of attributes."[16] Here identity is reduced to an object, to be marked, discarded and destroyed. Cult comic Cheech Marin, for example, appears repeatedly throughout the film in a number of seemingly disposable guises.

The ultimate reducibility of identity is seen in the aforementioned casting of Tom Savini in the role of Sex Machine. This casting clearly draws on his earlier role as a biker in George A. Romero's zombie film *Dawn of the Dead* (1979). Again, the intertextual reference is taken to the point of parody. Whereas the Savini character in *Dawn of the Dead* was depicted fetishing a flick knife with a comb blade, Sex Machine's 'toy' is a gun mounted cod piece which opens to repel potential assailants. Equally, Savini's depiction in *From Dusk Till Dawn* not only replays his established cameos, but extends them. Whereas his status in *Dawn* was of a special effects man performing a cameo, in Rodriguez's film his performance literally *is* as a special effect: he suddenly transforms into a giant beast whom the survivors must then behead and destroy.

So What can Tarantino Tell Us About Vampires?

The key trigger for the generic shift in *From Dusk Till Dawn* is the seductive dance routine performed by Satanico Pandemonium. Her character is introduced by club commentator 'Razor Charlie' as being "For Your Viewing Pleasure", and in many respects the statement extends beyond her obvious coding as a site of erotic visual display. What the announcement equally declares is an increasing reference to the presence of the film's audience, something that increasingly occurs through direct address of characters to camera, as well as the increased focalization of mayhem and violence directly towards the camera lens.

Tarantino's screenplay advises at this point that: "the bikers and truckers who have been transfixed, watching the impossible, realize that the waitresses, naked dancers and whores who they were pawing five minutes ago, have turned into yellow-eyed, razor-fanged, drool-dripping vampires".[17] This script shift from realist to contemporary horror narrative is complicated by the playful and parodic incorporation of what is essentially actor-driven elements of slapstick into this transformation. Central to this textual alteration is the very Sadean re-centring of the comedic and the obscene.

As the film's invited and involved audience, we wait to see what transformations take place and we cheer for grotesquery. We cheer for the transformative human body which is not closed down by death nor subject to the ambivalence of work. Here monstrosity is a powerful way of organizing and understanding human experience, and of avoiding abstraction. The film seems at this point to be almost under cranked, to be unnaturally jerky and syncopated. In one scene, the remaining survivors square up against their undead opponents in a parodic, Romeroesque replay of Fred Zinnemann's *High Noon* (1952). In such moments, the gangsters/outlaws begin to trade off not only with themselves, but with the genre's generic history. The parody is distinctively outward looking and we as the text's audience are called to partic-ipate in the fun.

16 Airaksinen, p. 70.

17 Quentin Tarantino, *From Dusk Till Dawn*, (London: Faber and Faber, 1996), p. 82.

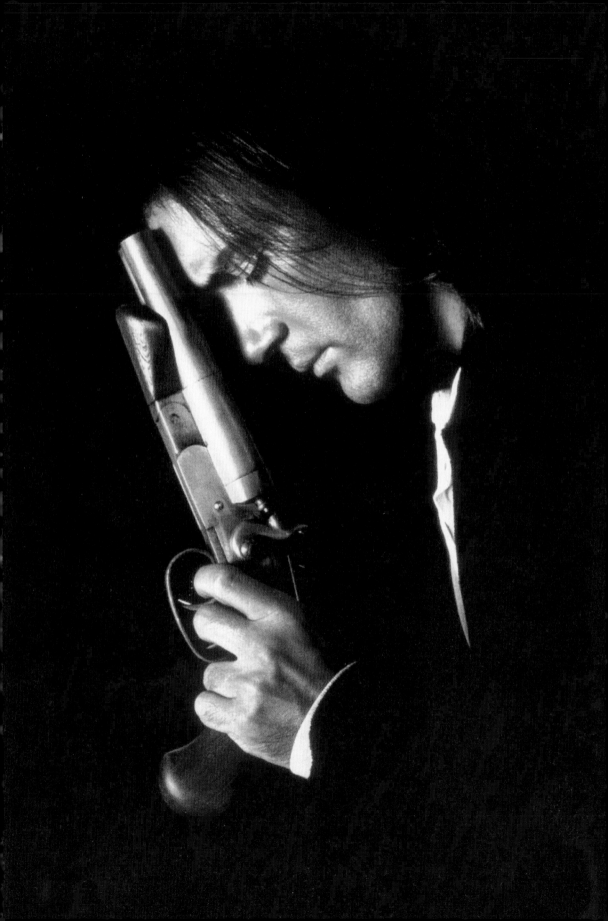

The Chaotic Text and the Sadean Audience

In this section of *From Dusk Till Dawn*, laughter and the forbidden are shown to go 'immorally' hand-in-hand as displayed communicative and communal strategies. Sexual, moral and generic boundaries are transgressed and discharged from the hands of individual, depicted psychopaths into the hands of the audience whose own pleasures, motivations and interests are as diffusely coded as the brutally created hole through which these forms of gratification have emerged.

opposite:
**promotional
artwork for
*Desperado***

Undoubtedly, it still remains for film theory to properly consider the role of the Film Avid audience in the reception, and making, of contemporary film. So we might ask: what can a Sadean reading tell us about contemporary film and the contemporary Film Avid audience?

Firstly, that such an audience functions not as a homogenized mass whose pleasure is dependent on a single aspect of the text, but rather as a series of 'pleasure seekers' able to take multiple forms of gratification from what they consume; and to 'cultify' them accordingly. As we have indicated, the 'pleasures' that such texts offer their viewers are by no means unproblematic. *From Dusk Till Dawn*, with its sudden generic shift, its bloody excess and the sudden loss of Richie as the guiding libertine, confirms that in the Sadean work "curiosity, fascination and sexual arousal will first draw the reader in, but if he is successful, Sade will replace them in the end with terror, disgust and aggression against the narrator."[18]

Secondly, the film indicates that contemporary cinema's collective experience is also the experience of the individual, a place where multiple pleasures separate and collide. For the Film Avid, born into a mass consumerist media culture, the natural response is to locate these texts (as Sade located his own work; both his literature and investigations of sexual and social contracts) at the point where individual and communal responses/ desires meet. This is the point at which cult is created.

And, finally, although contemporary 'cultified' films are always difficult to critically contain, a Sadean reading reveals that they are not simply a 'response' but also a textual imperative, films with a set of criteria which creator, audience and critic can equally locate and define. 'Cultifying', in that sense, is a celebration of this fact.

[18] Airaksinen, p. 13.

index

index

index

...and you will face the sea of darkness, and all therein that may be explored...

Master of the Macabre Lucio Fulci is celebrated in this lavishly illustrated in-depth study of his extraordinary films. From horror masterpieces like **The Beyond** and **Zombie Flesh-Eaters** to erotic thrillers like **One On Top of the Other** and **A Lizard in a Woman's Skin**; from his earliest days as director of manic comedies to his notoriety as the man behind the banned slasher epic **The New York Ripper**, every detail of his varied career is explored.

Stephen Thrower embarks on a journey through the wilder reaches of Italy's fertile film culture, taking a close-up look at the cinema's most daring and anarchic horror specialist - Lucio Fulci - a man willing to go ever further in search of the ultimate horrific set-piece.

email enquiries: harvey@fabpress.com

'Beyond Terror' is a deluxe collector's item - no expense has been spared to bring you what is universally acclaimed as being the most beautiful book on horror films ever published.

Copies can be ordered direct from the publishers for only **£24.99**. No hidden extras - this price is inclusive of delivery within the UK.

Quality guarantee - all books securely packaged to prevent damage in transit.

UK: £24.99 inc. delivery.
Europe: £30 inc. Airmail delivery. Cash or Eurocheques accepted.
USA: $50 inc. Airmail delivery. US$ cash & checks accepted.

312 large-format pages, luxury binding
*
40 full colour pages, over 800 illustrations in all
*
Introduction by Fulci's daughter Antonella
*
Complete credits for all 52 films
*
Filmographies for all of the major stars

To order this book please send your name, address and a cheque or postal order payable to **FAB Press** to:

FAB Press
PO Box 178
Guildford
Surrey
GU3 2YU
England, UK

Beyond Terror:
The Films of Lucio Fulci
by Stephen Thrower
ISBN 0 9529260 6 7
£19.99

BEYOND TERROR
THE FILMS OF LUCIO FULCI

MAKING MISCHIEF
The Cult Films of Pete Walker

by Steve Chibnall

ISBN 0 9529260 1 6

£12.95

Britain's Greatest Exploitation Film Director!

No other British film-maker achieved the level of transgression that Walker regularly delivered to cinema-goers in the 1970s. Beginning his career by making 'skinflicks', Walker went on to direct a trio of bona fide horror classics. **House of Mortal Sin**, **Frightmare** and **House of Whipcord** probe beneath the glossy surface of the permissive society to expose a malevolent underworld of madness, obsession and vindictive violence. The author, Steve Chibnall, teaches Film and Cultural Studies and co-ordinates the British Cinema and Television Research Group at De Montfort University, Leicester. *Making Mischief* is the only major critical study of the controversial director, and it received the full cooperation of Pete Walker and his screenwriters. 224 profusely illustrated pages.
"The highest possible compliment" (EMPIRE)

Order this book direct from FAB Press for only **£12.95** including p+p within the UK.
Europe: £15 inc. Airmail delivery. Eurocheques preferred.
USA: $30 inc. Airmail delivery. US$ Cash & standard US$ Checks accepted!
FAB Press, PO Box 178, Guildford, Surrey GU3 2YU, England, UK

COME PLAY WITH ME
The Life and Films of Mary Millington

by Simon Sheridan

ISBN 0 9529260 7 5

£14.99

Britain's Sex Superstar of the 70s!

Mary Millington was the girl next door who became the sex superstar of the 1970s. Her rise was meteoric, controversial and scandalous. Glamour model, cover girl and hardcore porn actress, Mary was an outspoken opponent of the Obscene Publications Act, and a forthright bisexual who promoted her ideals of sexual openness and equality. She starred in numerous British sex comedies, all of which are reviewed in depth here. Simon Sheridan's heavily illustrated, widely-acclaimed book re-visits the Seventies cycle of celebrity excess and casual sex (her lovers included PM Harold Wilson and actress Diana Dors) that would eventually lead to Mary's downward spiral through prostitution, klepto-mania, a celebrated trial at the Old Bailey, and cocaine abuse, to her tragic suicide at the age of 33.

Order this book direct from FAB Press for only **£14.99** including p+p within the UK.
Europe: £17 inc. Airmail delivery. Eurocheques preferred.
USA: $30 inc. Airmail delivery. US$ Cash & standard US$ Checks accepted!
FAB Press, PO Box 178, Guildford, Surrey GU3 2YU, England, UK

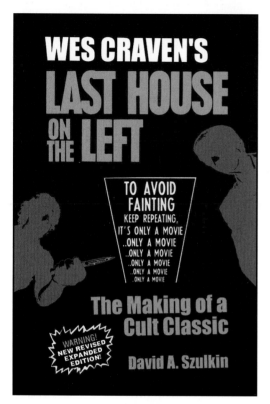